The Best of
Newspaper Design 24

THE 2002 SOCIETY FOR NEWS DESIGN ANNUAL COMPETITION

INTRODUCTION
Introducción
P. 4

Chapter 1 WORLD'S BEST-DESIGNED™
Mejores diseñados del mundo
P. 10

Chapter 2 JUDGES' SPECIAL RECOGNITION
Reconocimiento especial de los jueces
P. 26

Chapter 3 NEWS
Noticias
P. 38

A-section and page || Local news section and page || Sports section and page
Business section and page || Other section and other page
Inside page || Breaking news topics || Special news topics

Chapter 4 FEATURES
Reportajes
P. 70

Opinion section and page || Lifestyle/features section and page
Entertainment section and page || Food section and page
Fashion section and page || Home/real estate section and page || Travel section and page
Science/technology section and page || Other section and page

Chapter 5 SPECIALS
Especiales
P. 108

Special coverage/single subject || Special coverage/sections (no ads)
Special coverage/sections (with ads) || Special coverage/section cover page
Special coverage/section inside page || Reprints

Chapter 6 VISUALS
Visuales
P. 128

Illustration/single and multiple || Spot news photography
Photography spot sports, feature and illustration || Portrait photography || Photo series, project or story
Information graphics/breaking news || Information graphics/non-breaking news and features
Information graphics/charting and mapping || Miscellaneous

Chapter 7 MAGAZINES
Revistas
P. 200

Overall design || Special sections || Cover design || Page design

Chapter 8 PORTFOLIOS
Portafolios
P. 222

News, sports, features, magazine and combination design
Illustration/individual and staff || Photography/individual and staff
Information graphics/extended coverage || Information graphics/breaking news (individual and staff)
Information graphics/non-breaking news (individual and staff)

Chapter 9 REDESIGNS
Rediseños
P. 248

Overall newspaper || Section || Standing/regularly appearing page

INDEX
Indice
P. 265

By the numbers

A look at the 24th competition of the Society for News Design.

2002

is our contest year. Entries were published between Jan. 1 and Dec. 31, 2002. This book was published in 2003.

24th

edition of this newspaper-design annual, with 272 pages plus cover and more than 1,400 images. The first edition, published in 1980, offered 56 pages plus cover and 385 images.

15

years of support from Syracuse University's S.I. Newhouse School of Public Communications as host and co-sponsor.

12,760

entries judged for this 24th edition. That's the fourth-highest total in the 24 years of the contest, beaten only by 14,114 in 1999, 13,781 in 2000, and 13,008 in 1998.

3

circulation categories for individual awards.

**(A) 175,000 and over,
(B) 50,000-174,999, and
(C) 49,999 and under.**

The letters designating circulations appear in award captions, after the publication's location.

21

categories of the competition. From World's Best-Designed™, a mandatory category, through Miscellaneous, the categories included specialty subcategories, as well as the three circulation divisions.

26

judges for this edition at Syracuse, N.Y., in February 2003. Five judges devoted four days judging the World's Best-Designed™ category. Twenty-one judges spent three days on individual entries.

1,237

winning entries in this edition. In all, seven judges' special recognitions were given, three of them in recognition for a body of work by a publication or individual. That's the highest number of awards ever made, exceeding the 20th edition by 183 awards.

4

newspapers judged World's Best-Designed™. It's a mandatory category for the competition. This compares to five newspapers winning World's Best-Designed™ in the 23rd edition, and six winning World's Best Designed™ in the 22nd edition.

Introduction

No one said it would be easy, and it wasn't.

It took more than 90 people to make the 24th-edition competition happen. When the judging was done after seven long days, a record number of winners – 1,237 of 12,760 entries – were edited for this book.

What you'll find in these 272 pages is a feast of designs that should excite and even rejuvenate both novice and pro.

The competition, co-sponsored by the Society for News Design and Syracuse University's S.I. Newhouse School of Public Communications, recognizes excellence in newspaper design, graphics and photography as it has for the past 24 years.

One has to be at the judging to start to understand how so many entries can be reviewed in such a short period of time. It takes busloads of people; hundreds of tables; thousands of red, blue and yellow cups; multi-colored chips; and 26 talented, qualified judges to get the job done.

Judges may give as many awards as they wish in each of the 21 categories represented in the competition. Award definitions remain constant year after year, but the number granted continues to change from year to year, with this judging setting an all-time record of awards presented.

The results depend on the judging's dynamics, as well as the judges' predilections and preferences.

When a category has too many entries to be displayed all at once, a "first cut" is done by having judges pick the pages they'd like to see again in a smaller group. It takes only one vote for an entry to remain in the competition.

Once a first cut has been completed and all remaining entries in a category can be viewed at once, each judge casts his or her votes with a chip, color coded for that judge, by placing the chip in either a "yes" or a "no" cup. Cups are placed upside down with slits in the top so no judge sees how any other judge has voted.

If a conflict occurs because judges come across an entry from their publication, a publication where they have performed recent (18 months or less) consulting work, or a publication with which they compete, the judges place a yellow cup on the entry signifying to the team captain a conflict exists. At this point, a "floating" judge will vote instead of the judge with the conflict.

It takes three or more "yes" votes to remain in the competition. Entries receiving three votes are given an Award of Excellence. Entries receiving four or more votes in the first round go directly into the medal round.

During the medal round, any entry receiving four votes wins a silver medal. Any entry receiving five votes (a unanimous vote of the panel) wins a gold medal.

At the end of judging, all the judges re-examine the silver and gold medal winners. Medal winners can be re-negotiated up or down the award scale, and a best of show, if any, is awarded.

What follows, although subjective, represents the best for 2002. We hope your creative juices are stimulated as you review the images.

Marshall Matlock
24th Competition Committee Director & Judging Director
Syracuse University
Syracuse, N.Y.

Introducción

Nadie dijo que sería fácil y así fue.

Más de 90 personas hicieron posible la celebración de la edición 24 de la competición. Tras siete días largos de competición, se habían editado para este libro un récord de 1.237 piezas ganadoras de 12.760 piezas concursantes.

En las próximas 272 páginas encontrarás una fiesta del diseño que entusiasmará e incluso hará rejuvenecer a principiantes y profesionales.

La competición, patrocinada por la Society for News Design y el S.I. Newhouse School of Public Communications de la Syracuse University, reconoce la excelencia en el diseño de diarios, gráficos y fotografía y lleva haciéndolo durante 24 años.

Uno debe estar in situ en la competición para entender cómo pueden revisarse tantas piezas en un período de tiempo tan corto. Esto requiere mucho personal, cientos de mesas, miles de cubiletes rojos, azules y amarillos, fichas de muchos colores y 26 jueces cualificados y con mucho talento para realizar el trabajo.

Los jueces pueden premiar tantas piezas como deseen en cada una de las 21 categorías representadas en la competición. La definición de premios continúa siendo la misma año tras año aunque el número de premios va cambiando y este año hemos logrado un récord de premios otorgados.

Los resultados dependen de la dinámica de la competición así como de las predilecciones y preferencias de los jueces.

Cuando tenemos que desplegar a la vez muchas piezas de una categoría, realizamos una selección en la que los jueces deben elegir piezas para que éstas continúen en la competición. Con un voto, la página seguirá en la competición.

Al finalizar la primera manga y cuando puedan desplegarse al mismo tiempo todas las piezas de la categoría, cada juez vota con una ficha de color distinta para cada uno y la coloca en el cubilete de los "síes" para que la pieza continúe o en el de los "noes" para que quede fuera de la competición. Los cubiletes se colocan boca abajo con ranuras en la parte superior para que los jueces no vean las votaciones de otros compañeros.

Cuando un juez observa que una pieza pertenece a su publicación, a una publicación para la que ha trabajado recientemente (18 meses o menos) como consultor o una publicación con la que compite, éste advertirá que hay un conflicto. El juez coloca un cubilete amarillo en la pieza para comunicar al capitán del equipo que existe un conflicto y un "juez flotante" votará en su lugar.

Para continuar en la competición, una pieza debe obtener tres o más "síes". Las piezas que reciben tres votos obtienen un Premio a la excelencia. Aquéllas que reciben cuatro o más votos en la primera ronda pasan directamente a la ronda de medallas.

Durante la ronda de medallas, cualquier pieza que haya recibido cuatro votos obtendrá una medalla de Plata. Las piezas que hayan recibido cinco votos (un voto unánime del grupo) obtendrán una medalla de Oro.

Al finalizar la votación, todos los jueces volverán a examinar los ganadores de medallas de oro y plata. Las medallas podrán rebajarse o elevarse de nuevo en la escala de premios y se premiará a la Mejor de la competición si existe unanimidad.

Las páginas que vienen a continuación, si bien son subjetivas, representan lo mejor del año 2002. Esperamos que estas imágenes estimulen la creatividad de cada uno de los lectores.

Marshall Matlock
Director del Comité de Competición, Director de los Jueces
Syracuse University
Syracuse, N.Y.

0
best of show in this edition. Best of show is judged at the conclusion of individual judging. In 24 editions, judges have selected bests of show in 12 of the competitions.

4
types of awards given.

A **gold medal** defines state of the art.

A **silver medal** goes beyond excellence and stretches the limits of the medium.

Awards of excellence honor excellence beyond competency.

Judges' special recognition honors an entry or body of work beyond the other awards.

Unless otherwise designated, winning entries are awards of excellence.

4,157
award certificates printed and mailed to the individual winners and their publications for this edition.

11
golds in this edition. They honored 41 winners from nine publications.

77
silvers in this edition. They honored 279 winners.

1,868
individual winners in this edition.

206
publications winning awards in this edition. That includes newspapers and their magazines.

30
countries with publications winning awards.

590
awards honoring publications outside the United States.
Of them, 127 went to Spain,
78 went to México,
62 to Canada, 51 to Sweden,
47 to Portugal, 34 to Argentina,
32 to Germany and 21 to Brazil.

651
awards honoring publications in the United States.

48
awards — the most in the competition — went to The New York Times and its magazine. The Boston Globe and its magazine won 35, as did The Hartford Courant. Clarín, Buenos Aires, Argentina, won 31; The Plain Dealer, Cleveland, Ohio, won 30; and Público, Lisbon, Portugal, won 27.

The judges
Los jueces

World's Best-Designed™
Mejor diseñados del mundo™
Charles "Chas" Brown
Olga Lamas
Greg Leeds
Rexanna Keller Lester
Felix Soh

Photography/small papers
Fotografía/diarios pequeños
Kate Roberts Edenborg
Bill Gugliotta
Lawrence Mason Jr.
Tom Penix
Mark Thompson-Kolar

Graphics
Gráficos
Ed Gabel
Lorena Iñiguez
Gert K. Nielsen
Christopher Sloan
Juan Velasco

News
Noticias
James de Vries
Michelle Deal-Zimmerman
Ann McGettigan
Mark Porter
Dan Zedek

Features
Reportajes
Kim Germovsek Crow
Sergio Fernandez
José Merino
Tom Peyton
Adriana Libreros Purcell

Floater
Juez flotante
Christine McNeal

The floater is the judge who votes when another judge has a conflict of interest with an entry.

Charles "Chas" Brown is design director at The Dallas Morning News. He joined The News in 1996 after 13 years in page design and editing positions at newspapers in Texas, Alabama and Tennessee. During 2000-01, he served as in-house project leader for the redesign of The News, the first in 20 years.

Charles "Chas" Brown es director de diseño en el The Dallas Morning News. Se incorporó al diario The News en 1996 tras 13 años en puestos de diseño y edición de páginas en diarios de Texas, Alabama y Tennessee. Durante el año 2000-2001, fue jefe de proyecto del rediseño de The News, el primero en 20 años.

Kim Germovsek Crow has been a reporter, copy editor, news designer, features designer, design team leader and deputy graphics editor during the past 12 years at several North American newspapers. She's currently the assistant features editor at the Pittsburgh Post-Gazette. Her work has been honored by various design organizations.

Kim Germovsek Crow ha sido periodista, redactora de textos, diseñadora de noticias, diseñadora de reportajes, jefa del equipo de diseño y subeditora gráfica durante los últimos doce años en varios diarios norteamericanos. En la actualidad es subeditora de reportajes en el Pittsburgh Post-Gazette. Su trabajo ha sido premiado por diversas organizaciones relacionadas con el diseño.

Michelle Deal-Zimmerman is assistant managing editor for design and graphics at The Baltimore Sun. Prior to that, she spent four years as the paper's news design director. During this time, The Sun was named a World's Best-Designed Newspaper™ by SND. Before coming to Baltimore, she worked at The Palm Beach Post for eight years in a variety of positions, from copy editor to designer to assistant graphics director.

Michelle Deal-Zimmerman es subredactora ejecutiva de diseño y gráficos en The Baltimore Sun. Anteriomente, trabajó cuatro años como directora de diseño de noticias del diario y durante este período, la SND otorgó al periódico el galardón de Mejor diseñado del mundo (World's Best-Designed™). Antes de comenzar en Baltimore, trabajó en The Palm Beach Post durante ocho años y desempeñó varios puestos como redactora de textos, diseñadora y subdirectora gráfica.

James de Vries is director of de Luxe & Associates, Sydney, Australia. He has worked as a designer, illustrator and art director for magazines, books and corporate design until beginning at de Luxe & Associates in 1993. De Luxe & Associates has created or redesigned many of Australia's major newspapers. He lectures at conferences and is currently working on a book on relationships between art directors and editors.

James de Vries es director del De Luxe & Associates de Sydney, Australia. Ha trabajado como diseñador, ilustrador y director de arte de revistas, libros y diseño corporativo hasta comenzar en De Luxe & Associates en 1993. De Luxe & Associates ha creado y rediseñado muchos de los principales diarios australianos. Participa en muchas conferencias y actualmente tiene entre manos un libro sobre relaciones entre directores de arte y editores.

Kate Roberts Edenborg is a Ph.D. student at the University of Minnesota in the School of Journalism and Mass Communication. She is also an instructor teaching editing and page design. She has been an editor, reporter and designer at the Star Tribune, Minneapolis, Minn., and the Wausau (Wis.) Daily Herald.

Kate Roberts Edenborg es estudiante de doctorado del departamento de periodismo y comunicación de la University of Minnesota. También es profesora de edición y diseño de páginas. Ha trabajado como redactora, periodista y diseñadora en el Minneapolis Star Tribune y el Wausau Daily Herald (Wisconsin).

Sergio Fernández is art director at La Gaceta, Tucumán, Argentina. The team he leads received 145 awards from the SND between 1996 and 2002. During 1997-98 he was a lecturer at the Poynter Institute for Media Studies, St. Petersburg, Fla. He is a professor of editorial design at the University of Tucumán.

Sergio Fernández es director de arte de La Gaceta en Tucumán, Argentina. El equipo que él tiene a su cargo ha recibido 145 galardones de la SND entre los años 1996 y 2002. En el período de tiempo comprendido entre 1997 y 1998, fue conferenciante en el Poynter Institute for Media Studies de St. Petersburg, Florida. Es catedrático de diseño editorial en la Universidad de Tucumán.

Ed Gabel is an associate graphics director at Time magazine, where he creates diagrams that explain the week's news for the magazine's 5 million readers. Among his awards is a best of show given at the 2000 Malofiej infographics competition. His graphics have also appeared in Esquire, Sports Illustrated and Entertainment Weekly.

Ed Gabel es subdirector gráfico de la revista Time en la que diseña diagramas que relatan las noticias de la semana para sus cinco millones de lectores. Entre los premios recibidos, cuenta con la "Mejor de la competición" en la competición Malofiej de infográficos del año 2000. Sus gráficos han aparecido en las revistas Esquire, Sports Illustrated y Entertainment Weekly.

Bill Gugliotta is director of photography at The Plain Dealer in Cleveland, Ohio. Before coming to Cleveland five years ago, he directed photography at The State in Columbia, S.C., the Pittsburgh Post-Gazette and The Pittsburgh Press. He is a former designer and has been recognized nationally for his picture editing.

Bill Gugliotta es director de fotografía en The Plain Dealer de Cleveland, Ohio. Antes de llegar a Cleveland hace cinco años, dirigió la plantilla de fotografía del The State in Columbia, S.C., el Pittsburgh Post-Gazette y The Pittsburgh Press. Anteriormente ha sido diseñador y ha sido reconocido a nivel nacional por su edición de imágenes.

Lorena Iñiguez is a senior graphic artist at the Los Angeles Times, where she has been for 10 years. She assists in editing graphics, making sure the journalistic content is clear and the storytelling is organized logically and accurately. Prior to the Times, she was a graphic artist at The Press-Enterprise in Riverside, Calif., where she designed feature covers. She has been a member of two Pulitzer-Prize winning teams.

Lorena Iñiguez es artista gráfica principal del diario Los Angeles Times donde ha trabajado durante 10 años. Su papel consiste en editar gráficos, manteniendo la claridad en el contenido y la narración organizada con lógica y precisión. Antes de trabajar en The Times, fue artista gráfica del The Press-Enterprise de Riverside, en California donde ha diseñado portadas de reportajes. Ha sido miembro de dos equipos ganadores de premios Pulitzer.

Olga Lamas, a designer and journalist at Cases i Associats in Barcelona, Spain, since 1999, designs and redesigns newspapers, magazines and Web sites. She has participated in redesign projects in Latin America and Europe. Previously, Lamas worked in the art department at Barcelona's La Vanguardia newspaper and in several advertising agencies in Paris. Currently, Olga acts as coordinator at the center Diseny Periodístic Barcelona 95' at the Pompeu Fabra, University of Journalism in Barcelona.

Olga Lamas es diseñadora y periodista en Cases i Associats en Barcelona, España desde 1999. Diseña y realiza rediseños de diarios, revistas y sitios web. Ha participado en proyectos de rediseño en Latinoamérica y Europa. Anteriormente, Lamas trabajó en el departamento de arte del diario La Vanguardia de Barcelona y diversas agencias de publicidad de París. Actualmente trabaja como coordinadora del centro Diseny Periodístic Barcelona 95' en el departamento de periodismo de la Universidad Pompeu Fabra de Barcelona.

Greg Leeds is executive art director at The Wall Street Journal and currently oversees the domestic and international editions of The Wall Street Journal Reports, The Wall Street Journal Sunday and The Wall Street Journal Classroom and Campus editions. Leeds also develops graphics tools and technologies. He recently led a group that developed a Web-based tool that manages the production of all Journal graphics.

Greg Leeds es director de arte ejecutivo del The Wall Street Journal y actualmente revisa la edición nacional e internacional de The Wall Street Journal Reports, The Wall Street Journal Sunday y The Wall Street Journal Classroom and Campus. A su vez, Leeds se dedica a perfeccionar herramientas y tecnologías gráficas. Recientemente lideró un grupo que elaboró una herramienta web para manejar la producción de todos los gráficos del diario.

Rexanna Keller Lester has been the executive editor of the Savannah Morning News since 1995. Previously she was the Savannah (Ga.) Morning News managing editor, Morris News Service news editor and then managing editor. She was a Pulitzer judge in 1996 and 1997. She has been a news and feature designer for The Florida Times-Union and supervised photography and writing courses for college programs with the U.S. military in Germany.

Rexanna Keller Lester ha sido redactora ejecutiva del Savannah Morning News desde 1995. En el pasado ha trabajado como redactora ejecutiva en el Savannah Morning News, redactora de noticias en el Morris News Service y finalmente como redactora ejecutiva. Ha sido juez de los premios Pulitzer en 1996 y 1997, diseñadora de noticias y reportajes del The Florida Times-Union y ha supervisado los cursos de fotografía y redacción de programas universitarios con el ejército de Estados Unidos en Alemania.

Lawrence Mason Jr. is a photography professor at Syracuse University's S.I. Newhouse School of Public Communications and a freelance photographer currently working on book projects on Lockerbie, Scotland, and London, England. Dr. Mason has been a picture editor and photographer at the Syracuse Newspapers and has worked for United Press International.

Lawrence Mason Jr. es catedrático de fotografía en el departamento de periodismo y comunicación de la Syracuse University y en estos momentos es fotógrafo free-lance con proyectos de libros en Lockerbie, Escocia y Londres, Inglaterra. El señor Mason ha sido editor de imágenes y fotógrafo de plantilla en Syracuse Newspapers y ha trabajado en la United Press International.

Ann McGettigan, deputy managing editor for design, joined the Daily News (New York City) staff in 1998 as editorial art director. She was promoted to deputy managing editor for design in 1999. She has assisted with several redesigns, the launch of an afternoon newspaper called Express, the tabloid's Web page and the implementation of color into the newspaper. Prior to the Daily News, she was an art director at Crain Communications.

Ann McGettigan, subredactora ejecutiva de diseño, se incorporó a la plantilla del Daily News (Nueva York) en 1998 como directora de arte editorial. Ascendió a subredactora ejecutiva de diseño en 1999. Ha formado parte del grupo que ha rediseñado varias veces el diario, el lanzamiento del diario vespertino Express, la página web del tabloide y la introducción de color en el periódico. Antes de trabajar en el Daily News, era directora artística en Crain Communications.

Christine McNeal is assistant managing editor for visuals at the Milwaukee Journal Sentinel. Her career has included work as a reporter, copy editor, entertainment editor and graphics editor. She is currently studying towards a master's degree in media management from the University of Missouri at Columbia. She is also treasurer for SND.

Christine McNeal es subredactora ejecutiva visual del diario Milwaukee Journal Sentinel. Su carrera profesional incluye trabajo de periodista, redactora de textos, editora de la sección de ocio y editora de gráficos. En la actualidad está estudiando un máster en dirección de medios de comunicación de la University of Missouri en Columbia. También desempeña funciones de tesorera de la SND.

José Merino is the design director at the Arizona Daily Star, Tucson, Ariz., overseeing design and graphics. Before joining the Star two years ago, he served as graphic editor for the newspaper Mural in Guadalajara, México, and art director for El Imparcial in Hermosillo, México.

José Merino es director de diseño del Arizona Daily Star de Tucson, Arizona donde revisa el diseño y los gráficos. Antes de llegar al Star hace dos años, desempeñó el rol de redactor gráfico del diario Mural en Guadalajara, México y de director de arte de El Imparcial en Hermosillo, México.

Gert K. Nielsen has been graphics editor at Ekstra Bladet (Denmark) since 1995. He is best known for bringing together news graphic artists to discuss and explore the craft of visual journalism. He started in Denmark before he went global in 2001 with the launch of a web site on visual journalism.

Gert K. Nielsen ha sido redactor de gráficos del Ekstra Bladet (Dinamarca) desde 1995. Se le conoce por haber congregado a artistas gráficos de noticias para debatir y explorar la habilidad en el periodismo visual. Comenzó en Dinamarca antes de la globalización de 2001 con el lanzamiento de una página web con contenido de periodismo visual.

Tom Penix is assistant director of graphics for design at The Register-Guard, Eugene, Ore. Before joining that paper, he served as infographic artist and illustrator for The Orange County Register, The Virginian Pilot and the Los Angeles Times. His work has been recognized by SND, Picture of the Year and other print organizations.

Tom Penix es subdirector de gráficos para el diseño en The Register-Guard (Eugene, Oregon). Antes de incorporarse al diario, trabajó como infografista e ilustrador de los diarios The Orange County Register, The Virginian Pilot y Los Angeles Times. Su trabajo ha sido galardonado por la SND, POY y otras organizaciones de prensa.

Tom Peyton has been a visual editor at the South Florida Sun-Sentinel for two years. In his 15-year career in newspapers, he has been an illustrator, art director, picture editor, infographic artist and designer, winning numerous awards in many categories from SND and other organizations. He has worked at the Home News Tribune (New Jersey), Indianapolis Star (Indiana), Portland Press Herald (Maine), and other publications in North America.

Tom Peyton ha sido redactor visual en The South Florida Sun-Sentinel durante dos años. En su carrera profesional de 15 años en periódicos, ha sido ilustrador, director de arte, redactor de imágenes, infografista y diseñador de numerosos premios ganadores en diversas categorías de la competición de la SND y otras organizaciones. Ha trabajado en el Home News Tribune (New Jersey), Indianapolis Star (Indiana), Portland Press Herald (Maine) y otras publicaciones de norteamérica.

Mark Porter is creative director of The Guardian newspaper in London. He has been art director of Campaign, ES magazine, Wired (UK) and Colors. He has worked on newspaper and magazine projects in Belgium, Italy, Spain and Switzerland. Before becoming an editorial designer, he studied languages at Oxford.

Mark Porter es director creativo del The Guardian londinense. Ha sido director de arte de Campaign, ES, Wired (Reino Unido) y Colors. Ha trabajado en proyectos de diarios y revistas de Bélgica, Italia, España y Suiza. Antes de convertirse en diseñador editorial, estudió idiomas en Oxford.

Adriana Libreros Purcell, originally from Cali, Colombia, has been creative assistant at the Asbury Park Press, Neptune, N.J., since 2000. Before that, she was a creative assistant at the publication. She has redesigned several sections at the paper, including the Friday's Jersey Alive, the Sunday Entertainment and the Monday At Work sections. She has won national and international awards from SND, Print Magazine and Gannett Group.

Adriana Libreros Purcell, natural de Cali, Colombia, ha sido creadora adjunta desde el año 2000 en el Asbury Park Press (Neptune, N.J.). Anteriormente, era creadora adjunta de la publicación. Ha rediseñado varias secciones del diario, como la sección "Friday´s Jersey Alive", "The Sunday Entertainment" y la sección "Monday At Work". Ha obtenido premios nacionales e internacionales de la SND, Print Magazine y Gannett Group.

Christopher Sloan is the art director of National Geographic Magazine. Aside from his contribution to the graphic look of National Geographic, he is a science editor. He writes for the magazine and has been a contributing author to books on the art and information graphics at National Geographic.

Christopher Sloan es director de arte de la revista National Geographic. Además de contribuir al aspecto gráfico de la revista, es redactor científico. Escribe en la revista y ha contribuido artículos a libros sobre el arte y los infográficos de National Geographic.

Felix Soh, deputy editor of The Straits Times, Singapore, started his journalistic career as a copy editor. He has been a metro editor, foreign editor and design editor before becoming the number-two person at The Straits Times, Asia's largest circulation English-language newspaper. He was in charge of the team that redesigned the 157-year-old Straits Times in 1989. He also redesigned The Jakarta Post in 2001.

Felix Soh, viceredactor del The Straits Times de Singapur, comenzó su carrera periodística como redactor de textos. Ha sido redactor de las secciones metropolitana, internacional y de diseño antes de convertirse en el segundo de abordo en el The Straits Times, diario en inglés con más ejemplares de Asia. También estuvo al mando del equipo que rediseñó el diario Straits Times de 157 años en 1989 y en 2001 rediseñó el The Jakarta Post.

Mark Thompson-Kolar is editorial art director & design group leader at The Ann Arbor (Mich.) News. He had been a deputy graphics editor at the Detroit Free Press. He also has had design, editing and technology positions at The News-Sentinel and The Journal Gazette in Fort Wayne, Ind.

Mark Thompson-Kolar es director de arte editorial y jefe del grupo de diseño The Ann Arbor News de Michigan. Ha sido subredactor de gráficos en el Detroit Free Press. También ha desempeñado cargos de diseño, edición y tecnología en The News-Sentinel y The Journal Gazette de Fort Wayne, Indiana.

Juan Velasco is an infographics reporter, artist and consultant. He worked for El Mundo (Spain) from 1991 to 1996 and later as a graphic art director at The New York Times. In January 2002, Velasco established the infographics company, 5W Infographic. As a consultant, he has helped restructure graphics departments around the world. He is also an instructor for the "Show Don't Tell" infographics workshop at the Malofiej convention at the University of Pamplona (Spain). Velasco has won more than 50 SND awards and 10 Malofiej awards for infographics.

Juan Velasco es periodista infográfico artista y consultor. Ha trabajado en El Mundo (España) de 1991 a 1996 y algo después como director de arte gráfico en The New York Times. En enero de 2002, Velasco estableció su propia empresa de infográficos, 5W Infographic. Como consultor, ha facilitado la reestructuración de departamentos gráficos de todo el mundo. Es instructor en el Taller "Show Don't Tell" de infografía del congreso Malofiej que se celebra en la Universidad de Pamplona (España). Velasco ha obtenido más de 50 premios de la SND y 10 premios de infografía en la competición Malofiej.

Dan Zedek is the design director at The Boston Globe, where he supervises designers and infographics artists. His regular assignments include the front page, the Weekend entertainment section and news projects. Before joining the Globe in 1995, he was art director or assistant art director on a number of national and regional magazines, including Guitar World, Natural Health, Parenting and the Village Voice, as well as designing alternative weeklies in Nashville, Dallas, San Francisco and Seattle.

Dan Zedek es director de diseño del Boston Globe en el que revisa el trabajo de los diseñadores e infografistas. Su trabajo cotidiano incluye la portada del diario, la sección de ocio del fin de semana y proyectos de noticias. Antes de comenzar en el Boston Globe en 1995, era director de arte y subdirector de arte en gran número de revistas nacionales y regionales como Guitar World, Natural Health, Parenting y Village Voice así como en semanarios alternativos de Nashville, Dallas, San Francisco y Seattle.

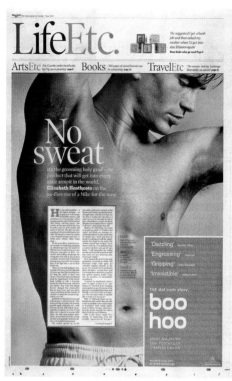

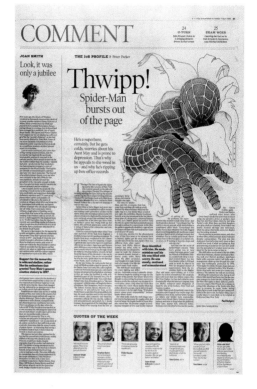

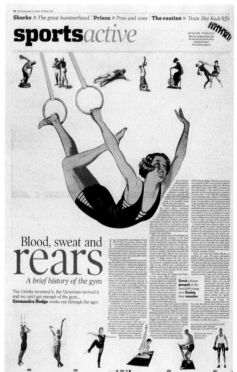

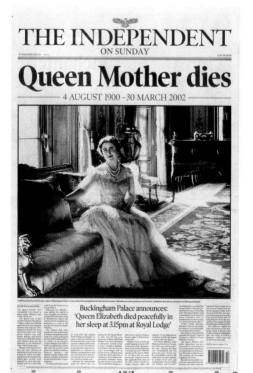

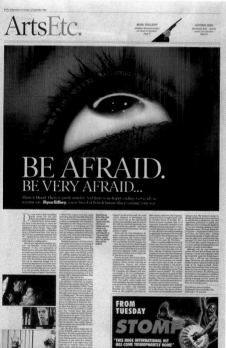

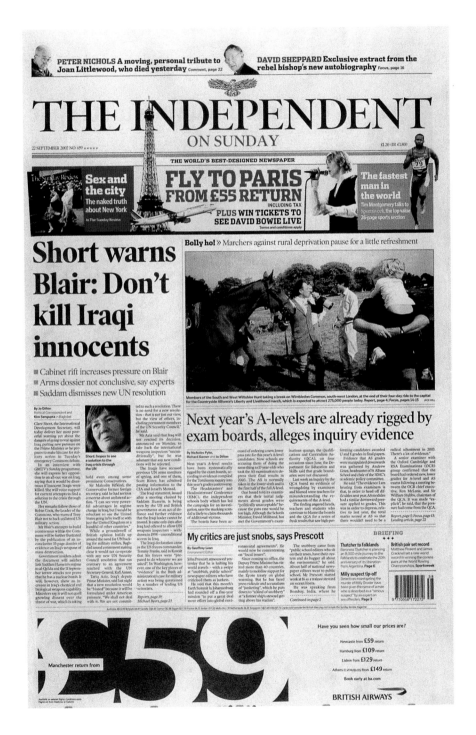

The Independent on Sunday

London, England
Circulation: 220,000

"Thwipp!"

The Independent celebrates language in its cheeky words and images.

Appealing to a young, smart set, it also has the wherewithal to present the Queen Mother's death with grace and elegance.

Sports is extensive, even taking the readers out of the arena to a history of gyms, humorously titled "Blood, sweat and rears."

Confident use of photography and illustrations calls attention to issues large and small, plain and racy. Urban and urbane, this publication lives up to its independent moniker.

The Independent on Sunday

Londres, Inglaterra
Circulación: 220.000 ejemplares

"Thwipp!"

The Independent on Sunday enaltece el lenguaje en su elección de palabras e imágenes descaradas.

Es un diario que atrae a gente joven e inteligente e incluso tiene suficientes recursos para presentar la muerte de la Reina Madre con elegancia.

La cobertura deportiva es amplia e incluso lleva a los lectores del deporte a una historia de gimnasios titulada con humor "Sangre, sudor y traseros".

La confianza en el uso de la fotografía y las ilustraciones pone de manifiesto asuntos de mayor o menor envergadura, con temas más o menos arriesgados. Metropolitana y cortés, esta publicación se manifiesta, como su nombre indica, de forma independiente.

The Independent
on Sunday / 2

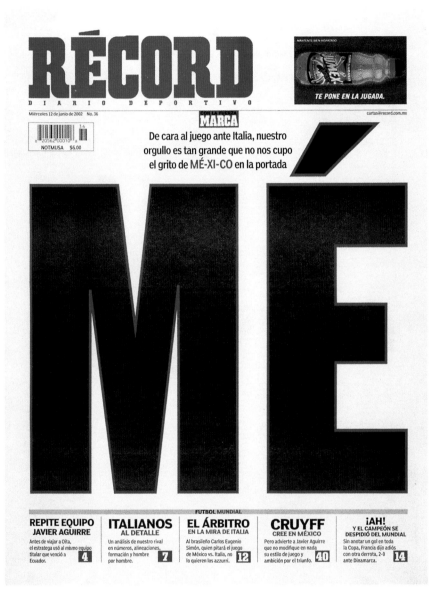

Récord

México City, México
Circulation: 35,000

With the confidence of youth, the Récord is a first-year, all-sports daily tabloid featuring bold, dynamic color and typography – particularly in numbers and statistics.

Boldness starts on the front page. On one, the pride for México's soccer team is so swelled that only the first two letters – M and É – are all that fit.

Multiple layers of information keep readers moving through pages. The tabloid format is fully exploited in vibrant spreads.

This publication captures the essence of what makes sports exciting.

Récord

México City, México
Circulación: 35.000 ejemplares

Con la confianza de la juventud, Récord es un periódico que participa por primera vez en la competición. Es un diario deportivo en formato tabloide con tipografía y colores atrevidos y dinámicos, especialmente en sus números y estadísticas.

El atrevimiento comienza en su portada y continúa en toda la publicación. El orgullo por el éxito del equipo de fútbol de México es tan grande, que sólo caben en la portada las dos primeras letras "M" y "E".

Los distintos niveles de información funcionan bien para guiar al lector a través del formato tabloide.

Esta publicación captura lo fundamental de la emoción del deporte.

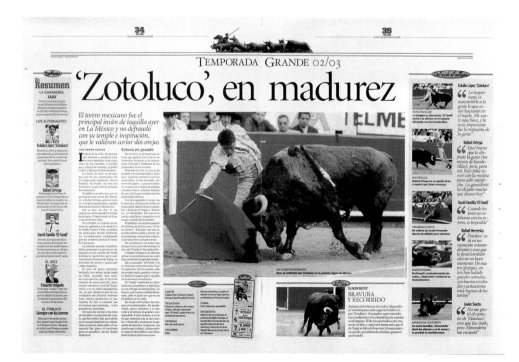

Récord / 2

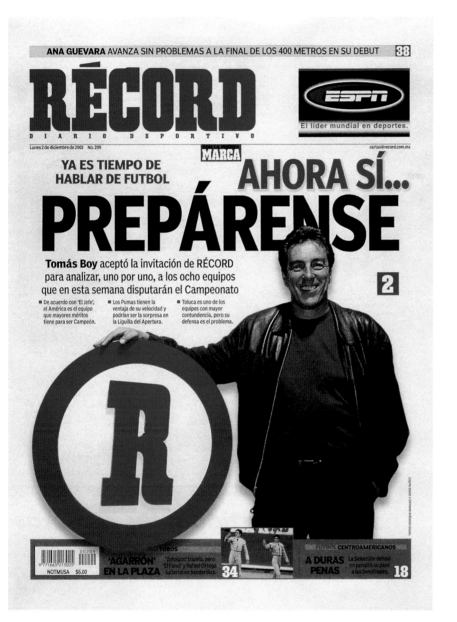

20 SPORT

Das Karussell dreht sich weiter

Minimalzeil erfüllt: Abstieg verhindert

Hacker ist auch als Psychologe Weltmeister

Valentino Rossi Weltmeister, Jenker stürzt

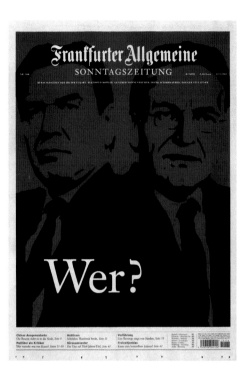

Frankfurter Allgemeine
SONNTAGSZEITUNG

Wer?

40 WIRTSCHAFT

Zuviel Kaffee aus Mittelamerika. Die Bauern sind verzweifelt. Der Anbau lohnt sich nicht mehr. Die Kaffee-Preise sinken dramatisch. Billig-Sorten aus Vietnam überschwemmen den Markt. Und ein Ende der Krise ist nicht in Sicht.

Gar nichts tun wäre billiger

GELD & MEHR 47

Schnäppchenjäger an der Börse

"Sie kaufen Stück für Stück und sehr diskret"

ERKENNTNIS & INTERESSE 69

Die Flügeltüren zur Erkenntnis

Das Bilderbuch der Naturgeschichte

Geld & Mehr

Autobanken rollen den Markt auf

Hilfe von ganz oben

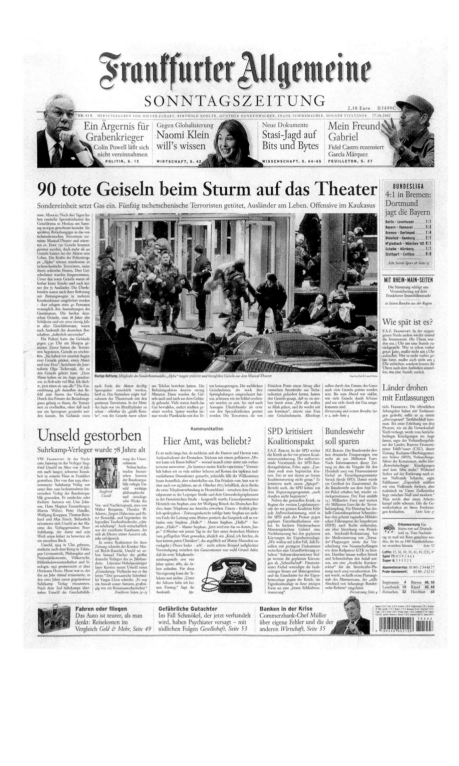

Frankfurter Allgemeine Sonntagszeitung

Frankfurt am Main, Germany
Circulation: 471,000

A classic that more than occasionally bucks tradition – the "Wer?" front page uses an unexpected high-contrast political propaganda style – this newspaper provokes its readers to contemplate current issues.

Rich, diverse graphics and illustrations, plus a sophisticated sense of humor, complement serious and extensive reporting.

The scope of the visual elements matches the reach of its coverage and invites its audience to read. Its clean organization makes it accessible and engaging.

Frankfurter Allgemeine Sonntagszeitung

Frankfurt am Main, Alemania
Circulación: 471.000 ejemplares

El Frankfurter Allgemeine Sonntagszeitung es un clásico conocido por romper moldes. La sección "Wer?" de la portada utiliza un estilo propagandístico inesperado de gran contraste para provocar a los lectores sobre asuntos de actualidad.

La gran riqueza de ilustraciones y gráficos y un sentido del humor sofisticado complementan los reportajes extensos con un tono serio.

El amplio abanico de elementos visuales combina a la perfección con la profundidad en la cobertura de noticias e invita al lector a seguir leyendo. El contenido limpio y organizado mantiene al lector absorto en los acontecimientos diarios.

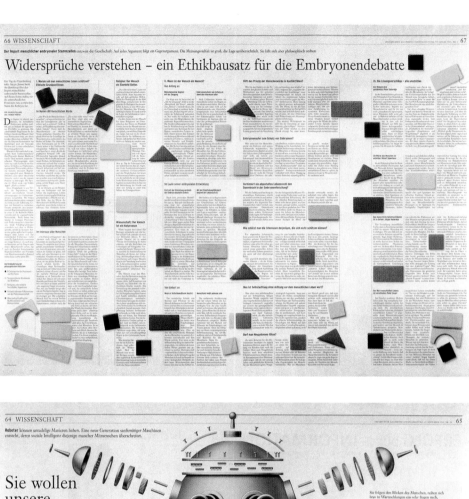

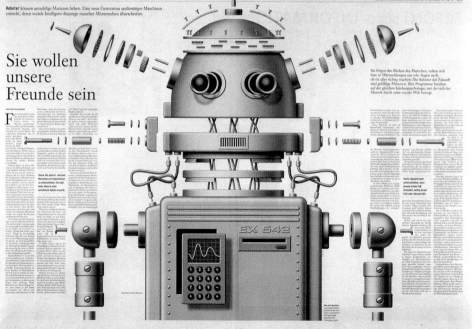

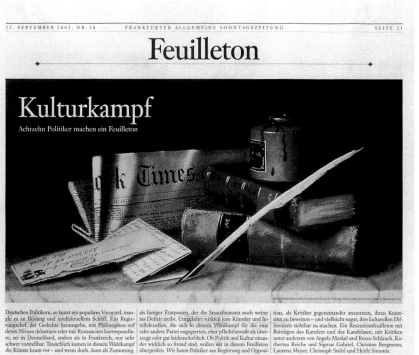

Feuilleton

Kulturkampf

Achtzehn Politiker machen ein Feuilleton

Deutschen Politikern, so lautet ein populäres Vorurteil, mangle es an Bildung und intellektuellem Schliff. Ein Regierungschef, der Gedichte herausgebe, mit Philosophen auf deren Niveau debattiere oder mit Romanciers korrespondiere, sei in Deutschland, anders als in Frankreich, nur sehr schwer vorstellbar. Tatsächlich kamen in diesem Wahlkampf die Künste kaum vor – und wenn doch, dann als Zumutung, als lästiger Etatposten, der die Staatsfinanzen noch weiter ins Defizit treibt. Umgekehrt wirkten jene Künstler und Intellektuellen, die sich in diesem Wahlkampf für die eine oder andere Partei engagierten, eher pflichtbewußt als überzeugt oder gar leidenschaftlich. Ob Politik und Kultur einander wirklich so fremd sind, wollen wir in diesem Feuilleton überprüfen. Wir baten Politiker aus Regierung und Opposition, als Kritiker gegeneinander anzutreten, ihren Kunstsinn zu beweisen – und vielleicht sogar, ihre kulturellen Differenzen sichtbar zu machen. Ein Rezensionsfeuilleton mit Beiträgen des Kanzlers und des Kandidaten, mit Kritiken unter anderem von Angela Merkel und Rezzo Schlauch, Katherina Reiche und Sigmar Gabriel, Christine Bergmann, Laurenz Meyer, Christoph Stölzl und Heide Simonis.

Ein starkes Stück Kunst

Gerhard Schröder (SPD) über den Katalog zur „Documenta 11"

Zugegeben: Zum Lesen dicker Romane, zur Beschäftigung mit künstlerischer Sprache und kühner literarischer Konstruktion reichen mir im Augenblick weder die Zeit noch die Muße. Aber zum Glück gibt es gerade für diese Tage, an denen man spätabends nach zig Kundgebungen und Regierungsterminen Abwechslung für Geist und Sinne braucht, noch eine andere Sorte dicker Bücher: Solche, die zum Blättern, zum Dazu-Spazierengehen, zum Vertiefen und, sicher, auch zur Entspannung geeignet sind. Und das muß nicht ein vom nach hinten durchgeladen sollte, sondern für die es eine eigene Dramaturgie braucht. Ich meine den Katalog zur „Documenta 11", die am 15. September zu Ende gegangen ist. Mehr als 600 großformatige Seiten Trost dafür, daß ich den Besuch dort in diesem Jahr nicht geschafft habe.

Natürlich kann ein Katalog die Sache selbst nicht ersetzen. Gerade die Documenta lebt schließlich vom sinnlichen Erleben der Installationen und Arrangements, von den großen Formaten und der frischen Luft um freistehende Skulpturen herum. Und ein wenig auch davon, daß man sich zwischen den verschiedenen Ausstellungsorten in Kassel die Füße müde läuft und am Ende des Tages buchstäblich „vor Kunst erschöpft" ist. Und wenn ich die Doppelseite von der „Großen Tischruine" des Künstlers Dieter Roth – den ich persönlich ein wenig kenne – betrachte, dann ist da auch ein bißchen Wehmut, weil man diese raumfüllende Installation, die so viel über die Arbeit des Künstlers mit seiner Kunst erzählt, selber begehen, die Farbtöne riechen möchte.

Seit ihrem ersten Stattfinden 1955 ist die Documenta stets mehr gewesen als eine bloße Kunst-Schau. Zunächst war der Versuch, in Deutschland nach der Nazi-Barbarei und der Verfolgung des „Entarteten" wieder internationale Avantgarde zu zeigen, ein wichtiger, bis dahin eher vernachlässigter Aspekt der Rückkehr Deutschlands in die Gemeinschaft der Völker und Kulturen. Im Lauf der Jahrzehnte ist daraus eine aktuelle, von den jeweiligen Kuratoren minutiös leicht aufjedem zusammengestellte Bestandsaufnahme der zeitgenössischen internationalen Kunst, ihrer Themen und Befindlichkeiten geworden. Damit ist die Documenta immer eine Art Statement zur gegenwärtigen Lage der Welt aus Sicht der Künste, und, nach dem Katalog zu urteilen, merkt man das auch der Documenta des Jahres 2002 an: Wie ein roter Faden ziehen sich die Themen auch „Zukunft der Stadt" durch die Arbeiten. Die Mehrzahl der Exponate stößt uns geradezu mit der Nase auf die Botschaft: „Es steht nicht zum besten um unsere Welt." Dieser explizit politische, gelegentlich auch pädagogische Ansatz gerät allerdings, für mich zumindest, bei manchen Exponaten auch ins Problem: Man spürt die Absicht und ist verstimmt.

Dabei wäre ich der letzte, der forderte würde, daß die Kunst keine politischen Absichten haben sollte. Als einer, der die Beschäftigung mit dem Wahren, Schönen und Guten nicht so zu Hause aus mitbekommen hat, habe ich erst relativ spät begonnen können, mich intensiver mit Kunst und Künstlern zu beschäftigen. Da war ich bereits in der Politik und entsprechend geprägt. Seitdem treibt und treibt mich eine enorme Neugier und Faszination nicht nur für die Werke – sondern auch für den „kreativen Prozeß" zwischen gesellschaftlichen Diskurs und der Finsternis des Antikers. Obgleich in mancherlei Hinsicht der Arbeit des Politikers nicht unähnlich, aber in ganz anderer Weise frei im Denken, in der Phantasie und natürlich auch in der Umsetzung.

Wenn man abends in diesem Katalog blättert oder sich, an einem der vorangestellten Essays festliest, kann es passieren, daß man über solche Fragen nachdenkt. Daß man Vergleiche nicht zwischen den Möglichkeiten des Künstlers und der Verantwortung des Politikers. Es ist schon wahr: Der Künstler darf sich die Welt wünschen – der Politiker muß sie gestalten. Aber beide müssen sie die Materie lösen, um im Sinne von Kunst.

Und wenn es nur solche Gedanken sind, die dieser Katalog hervorruft, dann hat er doch schon seinen fraglosen Nutzen – auch für den, der „Die Sache selbst" nicht gesehen hat.

In den letzten Wochen eines Wahlkampfs findet kein Kandidat die Muße zu ausführlicher und vor allem vollständiger Lektüre eines Buches. Dennoch blätterte ich immer wieder in einem politischen Buch, die mir in diesem Jahr aufgefallen ist: „Die deformierte Gesellschaft" von Meinhard Miegel. Das Buch reizt zu einer tiefgreifenden Auseinandersetzung und auch zum Widerspruch. Für politisch Interessierte ist es ein wichtiger Denkanstoß, an dem man sich reiben kann.

Ich habe Professor Miegel kennengelernt Mitte der neunziger Jahre als Vorsitzenden der Sächsisch-Bayerischen Zukunftskommission. Wer früher als Kassandra im Denken, in der Phantasie und natürlich auch in der Umsetzung.

The Making Of

Auch von uns bekamen beide Kandidaten gleich große Platz- und Zeilenzahl – diesmal war es Edmund Stoiber, der sich kürzer gefaßt hat.

Daß der Kanzler und der bayerische Ministerpräsident sich überhaupt, trotz Streß und Wahlkampf, an diesem Feuilleton beteiligten haben, verdient Anerkennung.

Daß sie sich nicht auf ein Werk einigen konnten, ist eben diesem Streß geschuldet: Worüber sie schreiben würden, entschied frühere Kritiker bis zum letzten Moment für sich, die Manuskripte trafen erst kurz vor Redaktionsschluß ein.

Angela Merkel hat, fast schon im letzten Mo-ment, noch um eine Woche Aufschub; Jena Hermels Buch „Zonenkinder" (Seite 22) gefiel mir so gut, daß sie es gerne noch ein zweites Mal gelesen hätte – ihre Kritik dichterte sie aus München, wo sie zur Eröffnung des Oktoberfests war. Günther Beckstein dagegen hatte eine Meinung zu Feridun Zaimoglu, schon bevor er dessen neuen Roman gelesen hatte (Seite 26).

Christoph Stölzl, dem wir eine Videokassette von Doris Dörries „Nackt" schicken wollten, bestand darauf, sich den Film im Kino anzusehen.

Abnagen gab es auch: Guido Westerwelle fand das ganze Projekt nicht sehr gelungen.

die strukturellen Probleme Deutschlands von der Krise des Sozialstaats bis ausführlicher und vor allem vollständiger Lektüre eines Buches. Dennoch blätterte ich immer wieder in einem politischen Buch, die mir in diesem Jahr aufgefallen ist: „Die deformierte Gesellschaft" von Meinhard Miegel. Das Buch reizt zu einer tiefgreifenden Auseinandersetzung und auch zum Widerspruch. Für politisch Interessierte ist es ein wichtiger Denkanstoß, an dem man sich reiben kann.

Meinhard Miegel hält aus seiner Sicht der Politik den Spiegel der Analyse vor und belegt, die Politik reagiere nur noch auf Entwicklungen und streite „jüngen-bürgeroll über Nebensächlichkeiten". Politik wende dem „wirklichen Leben" hinterherlaufen. In dieser Allgemeinheit kann ich seinem harten Urteil nicht zustimmen. Ohne Zweifel stellt Miegel Fragen einer Gesellschaft, die sich nicht an der Spitze der europäischen und globalen Forschung steht, sondern Mühe hat, Schritt zu halten.

Der Autor beklagt, daß manche „ihre Wirklichkeit verdrängen" – das gelte insbesondere angesichts der dramatischen zur Verkennung des Arbeitsmarktes diskutiert und Lösungsvorschläge formuliert.

Meinhard Miegel mahnt, die Zeit wenig knapp. Bei weiterem Verzögerung notwendiger Reformen drohen nach weiter Aufhörung harte weitläufige Brüche. Ein Kennzeichen der Verdrängung, wie in der Wissenschaft beklagt, wiege uns in falscher Sicherheit und sei die größte Gefahr für den solidarischen Zusammenhalt unserer Gemeinwesen. Die Menschen suchten nach Halt und Zusammenhalt im beschleunigten Wandel.

Der Autor ist Kanzler der Bundesrepublik Deutschland und Vorsitzender der Sozialdemokratischen Partei Deutschlands.

Ein starkes Stück Analyse

Edmund Stoiber (CSU) über Meinhard Miegels Buch „Die deformierte Gesellschaft"

Der Autor ist Ministerpräsident von Freistaat Bayern, Vorsitzender der Christlich-Sozialen Union und Kanzlerkandidat der CDU/CSU.

LEBENSGEFÜHL
Angela Merkel und Gabi Zimmer über „Zonenkinder", *Seiten 22/23*

LEBENSHILFE
Rezzo Schlauch und Christoph Stölzl über Doris Dörries „Nackt", *Seite 24*

LEBENSLÜGE
Günther Beckstein und Marieluise Beck über Zaimoglus „German Amok", *Seite 26*

Planetarium 14
M. Reich-Ranicki 15
Pro & Contra 17
Tele/dialog 19
Fernsehen 30

Frankfurter Allgemeine Sonntagszeitung 2

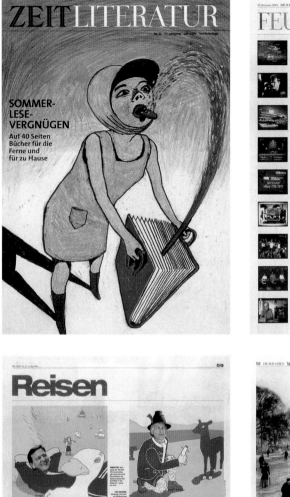

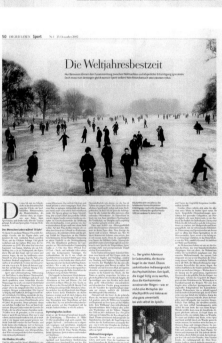

Die Zeit

Hamburg, Germany
Circulation: 450,000

Consistent excellence brings Die Zeit back to the podium for a fourth time.

Characterized by a refined, elegant and measured typography, this orderly German publication complements that typeface love affair with bold white space and diverse, expressive styles of illustration and photography.

Its pages celebrate politics, place and people. As beautiful as these pages appear in this annual, you must hold them in your hands to fully appreciate the perfect legibility of their body type.

Die Zeit

Hamburgo, Alemania
Circulación: 450.000 ejemplares

La excelencia consistente del diario Die Zeit lo lleva de nuevo al podio por cuarta vez.

Caracterizado por una tipografía refinada, elegante y medida, esta publicación alemana y bien organizada presenta una relación de amor entre la tipografía y los atrevidos espacios en blanco, los estilos expresivos y diversos de ilustraciones y la fotografía.

En el diario se encuentran páginas de política, lugares y gente. Aunque ese anuario presenta páginas verdaderamente bellas, para apreciar la legibilidad perfecta de la tipografía, debemos tener en nuestras manos esta publicación.

Die Zeit / 2

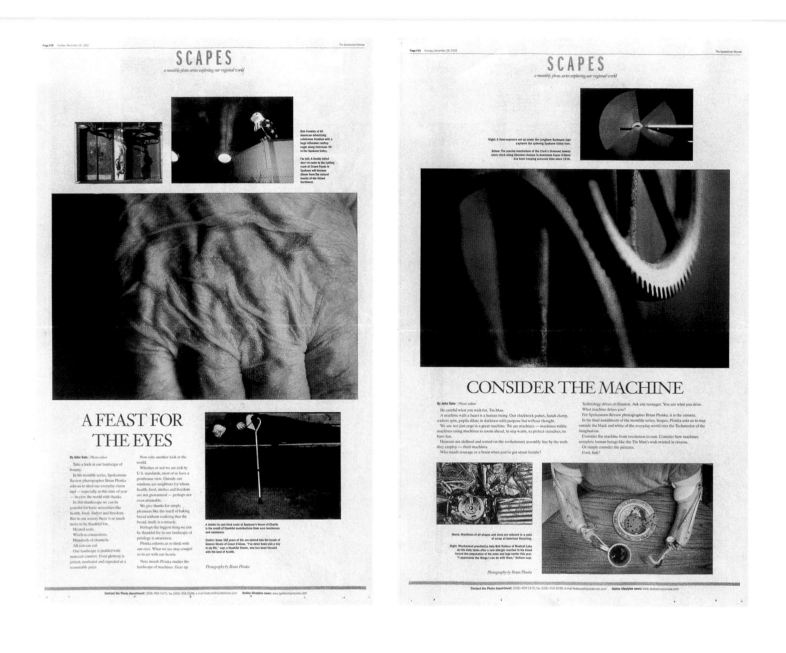

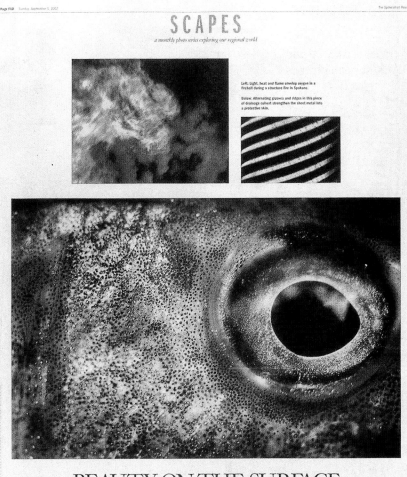

SCAPES
a monthly photo series exploring our regional world

Left: Light, heat and flame envelop oxygen in a fireball during a structure fire in Spokane.

Below: Alternating grooves and ridges in this piece of drainage culvert strengthen the sheet metal into a protective skin.

BEAUTY ON THE SURFACE

By John Sale / *Photo editor*

Consider the landscape of surfaces — a skinscape, if you will.

A field. A flame. A fish. Each has an outside surface, no matter how transitory. In the two-dimensional world of surfaces, each also has its own unique beauty, even if it's only skin deep.

In his Scapes series, The Spokesman-Review's Brian Plonka employs the artistic nature of photography to help us stretch our imaginations around new ways of looking at the world.

We normally see objects for what they are. But from a creative point of view, the everyday world can take on surprising features.

This month Plonka asks us to flatten the world and sail off the edge to a land where the third dimension has been skinned and had its pelt tacked to the wall.

In Plonka's flatland, an eye can be an island and a metal pipe becomes a stripe. You can harvest a field with soil shears and see a charging boar of flame put the roar in Rorschach.

What do you see in these photographs? A field? A flame? A fish? Or the skin of some other creature altogether?

Next month Plonka explores visual repetition.

See you then.

Above: The scales on the surface of this perch are brilliantly illuminated by a fisherman's flashlight along the shore of Newman Lake.

Right: Sharp farming equipment carved the intricate labyrinth of rows into the rich soil of the Palouse, bursting with wheat, as seen from the air.

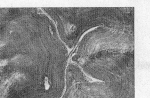

Photography by Brian Plonka

Contact the Photo department: (509) 459-5475; fax (509) 459-5098; e-mail photo@spokesman.com Online lifestyles news: www.spokesmanreview.com

Gold and Judges' Special Recognition
Photojournalism

The Spokesman-Review

Spokane, Wash. (B)

Brian Plonka, Photographer; **John Sale,** Director/Photography; **Jenny Johnson,** Designer; **John Nelson**

Judges: We awarded a JSR to Brian Plonka for his special photographic vision and his continued commitment to stretching newspaper photography.

This series of photos stretches the definition of newspaper photography. It is a risky concept that can be embraced by readers and should inspire colleagues and editors to reach beyond the obvious. It is refreshing to see these kinds of photographs in a newspaper.

Jueces: Otorgamos este premio a Brian Plonka por su única visión fotográfica y su compromiso continuado por mejorar la fotografía en los diarios.

Esta serie de fotos lleva la definición de fotografía a límites insospechados. Es un concepto atrevido que puede ser aprovechado por el lector y debe inspirar a colegas y editores a ir más alla de lo obvio. Encontrarte con fotografías de este tipo en un diario es un estímulo para la vista.

Two Silvers and a Judges' Special Recognition

Feature design

Frankfurter Allgemeine Sonntagszeitung

Frankfurt am Main, Germany (A)

Thomas Heumann, Infographics Director; **Ulf von Rauchhaupt,** Science Editor; **Alfred Beutelspacher,** Science Author; **Gero von Randow,** Science Editor; **Ulf von Rauchhaupt,** Science Editor; **Volker Stollorz,** Science Author; **Kathrin Zinkant,** Science Author; **Karl-Heinz Döring,** Infographic Artist; **Doris Oberneder,** Layout (Media Group Berlin); **Lukas Kircher,** Layout (Media Group Berlin)

Judges: You can feel the work and sweat in these pages. This person worked forever. The detail and care are awe-inspiring – the integration of story and text, the use of color in the subheads, the incredible graphics.

Jueces: Puedes sentir el trabajo y el sudor en estas páginas. Esta persona trabajó siempre. El detalle y cuidado inspiran admiración: la integración de la historia y el texto, el uso del color en los titulares y los gráficos son increibles.

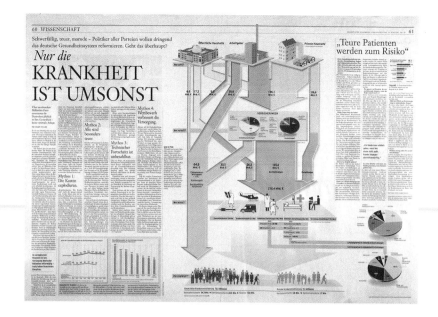

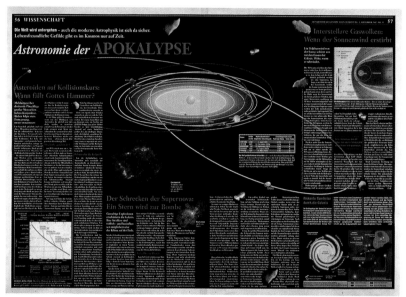

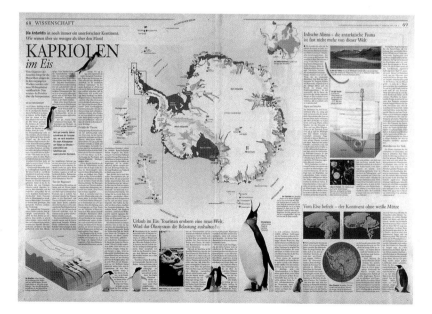

Silver

Judges: The quiet use of color and white space, guiding the eye through the text and graphics, is so thoughtful. It makes you want to explore the page. The quality of this work is intimidating.

Jueces: El uso moderado del color y el espacio blanco que guían al ojo por el texto y los gráficos están pensados con anterioridad. Pretende que el lector explore la página. La calidad de este trabajo es intimidante.

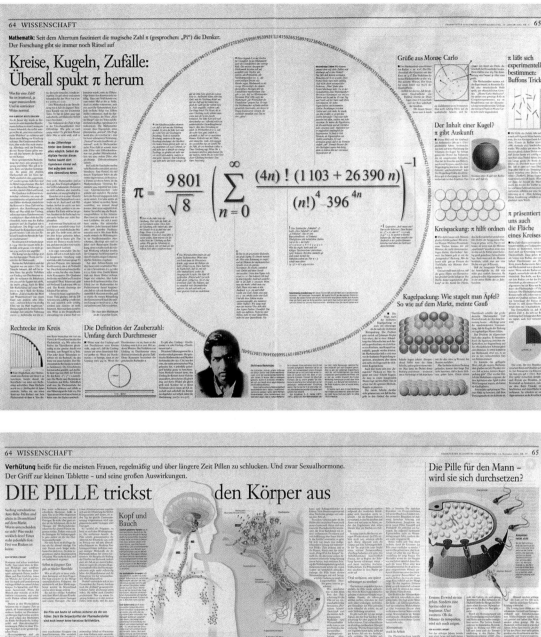

Silver

Judges: This is fascinating. The topic is very difficult to illustrate. It invites us in, and we can't resist.

Jueces: Es fascinante. El tema es muy difícil de ilustrar. Nos invita a que nos metamos en él y no podemos resistirnos.

Isabel Coutinho, Editor; Jorge Guimarães, Designer; Alain Corbel, Illustrator

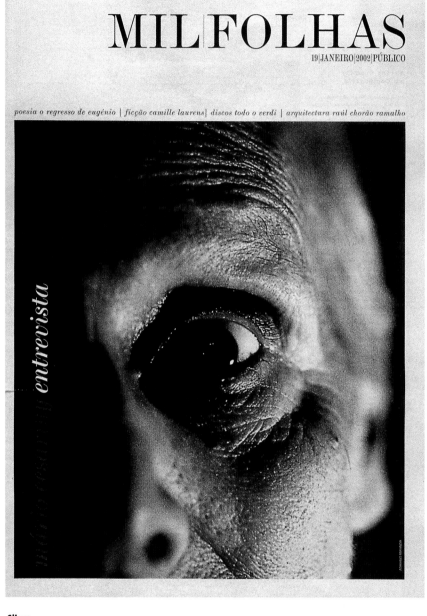

Silver

Feature design / entertainment

Isabel Coutinho, Editor; Hugo Pinto, Designer; Adriano Miranda, Photographer

Judges: The crop of the picture is expressive, and the use of black and white is effective. The light and contrast are excellent.

Jueces: La forma en que se ha cortado la foto es expresiva y el uso del blanco y negro es eficaz. La luz y el contraste son excelentes.

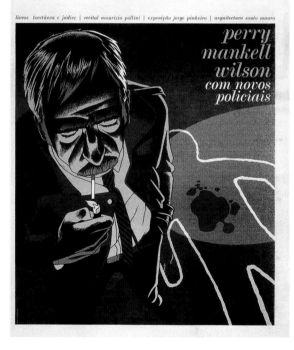

Isabel Coutinho, Editor; Jorge Guimarães, Designer; André Carrilho, Illustrator

Two Silvers and a Judges' Special Recognition
Feature design / entertainment

Público

Lisbon, Portugal (B)

Judges: All the images are incredibly creative and dynamic. The architecture doesn't change, but it uses the canvas differently and effectively every time.

Jueces: Todas las imágenes son realmente creativas y dinámicas. El arquitecto no cambia pero utiliza el lienzo de diversas formas y con eficacia cada vez.

MILFOLHAS
16|MARÇO|2002|PÚBLICO

livros restrepo, unamuno e wharton | entrevista leons briedis | exposições augusto alves da silva | concerto j.s. bach

flauta mágica no são carlos

Silver
Feature design / entertainment
Isabel Coutinho, Editor; **Ivone Ralha,** Designer; **João Fazenda,** Illustrator

Judges: The illustration is striking. The use of white space makes the illustration pop. Joyous.

Jueces: La ilustración llama la atención. El uso de espacios blancos realza la ilustración. Alegre.

Judges' Special Recognition

Lifestyle/features section

The Independent on Sunday

London, England (A)

Carolyn Roberts, Art Director; **Adele Brearley,** Deputy Art Director; **Keith Howitt,** Production Editor; **Matthew Glynn,** Picture Editor; **Nick Coleman,** Section Editor

Editor: The same confidence, the same spirit that propels The Independent among the World's Best-Designed Newspapers™ come alive on this page. Vivid color is well played and well executed in this exceptional entry.

Note, too, the use of the news hole to its fullest extent – another benchmark of The Independent on Sunday.

Redactor: La misma confianza, el mismo espíritu que impulsa a The Independent entre los "diarios mejor diseñados del mundo" surge en esta página. Buena utilización y práctica de los colores vivos en esta pieza excepcional.

También hay que destacar que el área de noticias ha sido utilizado en su totalidad, otro hito de The Independent on Sunday.

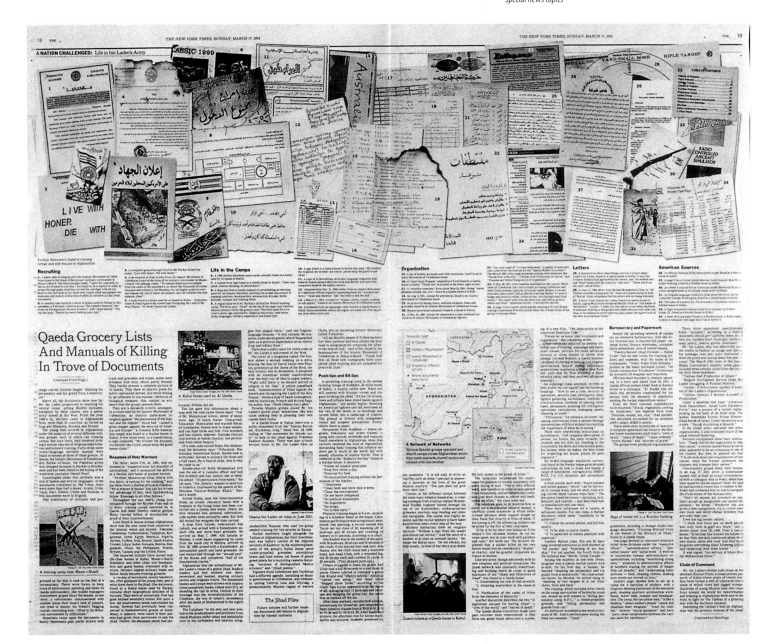

The New York Times

New York, N.Y. (A)

Corinne Myller, Art Director

Judges: This is an extraordinary effort of sourcing and displaying documents for readers in a clear, elegant fashion. The difficulty of gathering these documents is matched by the elegance of the design solution.

Jueces: Éste es un esfuerzo extraordinario de búsqueda de fuentes y despliegue de documentos para los lectores de forma limpia y elegante. La dificultad de agrupar estos documentos se combina con la elegancia del diseño.

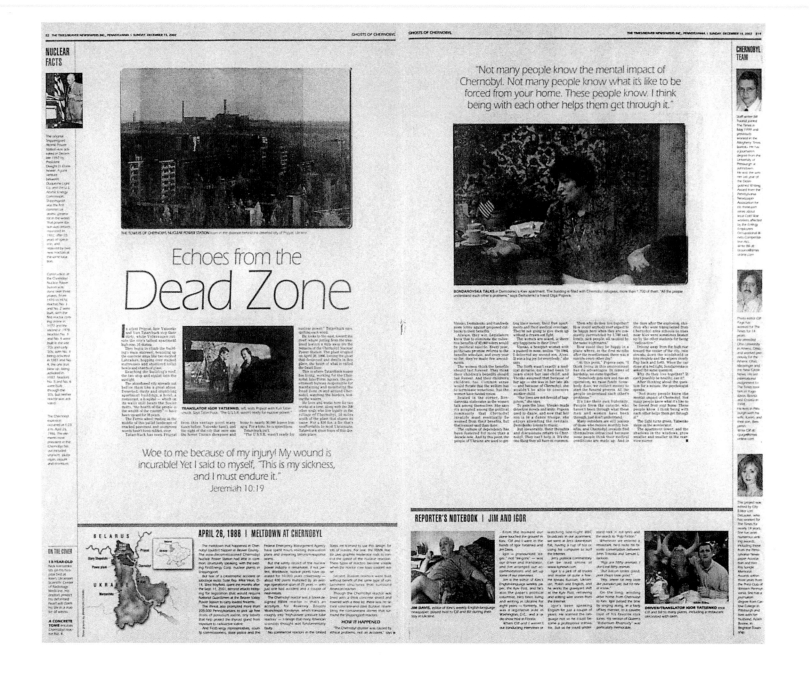

Silver and Judges' Special Recognition
Special coverage/sections (no ads)

Beaver County Times

Beaver, Pa. (C)

Cathy Benscoter, Design Editor; **Clif Page,** Photo Editor

Judges: Outstanding documentary photography that is sensitive but not sensational. These photos were not easy to get, and it's especially impressive for a smaller paper.

This special section is a mix of information and emotion. The photographs are beautiful and consistent, and the design doesn't get in the way of the storytelling.

Jueces: Sobresaliente fotografía documental que es sensible pero no sensacional. No fue fácil obtener estas fotos y es más impresionante por tratarse de un diario de menor tirada.

Esta sección especial es una mezcla de información y emoción. Las fotografías son bonitas y coherentes y el diseño no eclipsa la narración.

It's only a matter of time before we eradicate ourselves, and if Yatsenko were a betting man, he'd put money on nuclear annihilation. "This could be our future."

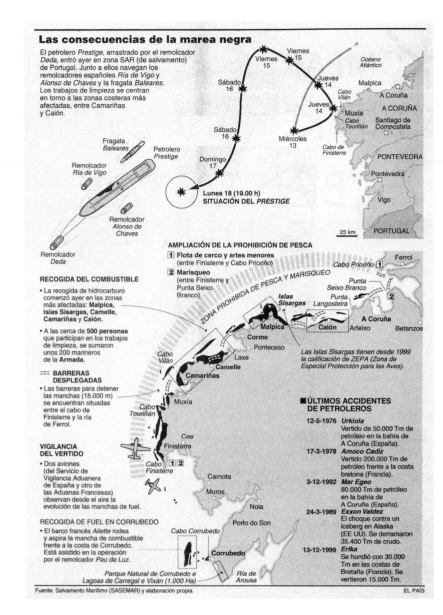

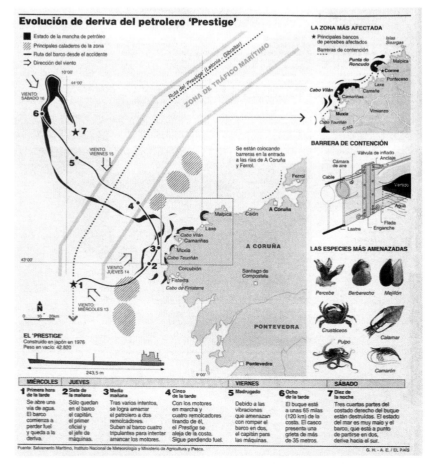

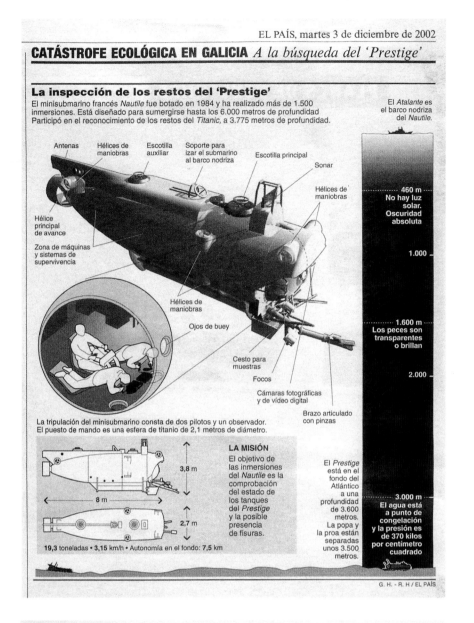

EL PAÍS, martes 3 de diciembre de 2002

CATÁSTROFE ECOLÓGICA EN GALICIA *A la búsqueda del 'Prestige'*

La inspección de los restos del 'Prestige'

El minisubmarino francés *Nautile* fue botado en 1984 y ha realizado más de 1.500 inmersiones. Está diseñado para sumergirse hasta los 6.000 metros de profundidad. Participó en el reconocimiento de los restos del *Titanic*, a 3.775 metros de profundidad.

El *Atalante* es el barco nodriza del *Nautile*.

Antenas
Hélices de maniobras
Escotilla auxiliar
Soporte para izar el submarino al barco nodriza
Escotilla principal
Sonar
Hélices de maniobras
Hélice principal de avance
Zona de máquinas y sistemas de supervivencia
Hélices de maniobras
Ojos de buey
Cesto para muestras
Focos
Cámaras fotográficas y de vídeo digital
Brazo articulado con pinzas

La tripulación del minisubmarino consta de dos pilotos y un observador. El puesto de mando es una esfera de titanio de 2,1 metros de diámetro.

LA MISIÓN
El objetivo de las inmersiones del *Nautile* es la comprobación del estado de los tanques del *Prestige* y la posible presencia de fisuras.

3,8 m
8 m
2,7 m
19,3 toneladas • **3,15** km/h • Autonomía en el fondo: **7,5** km

460 m
No hay luz solar.
Oscuridad absoluta

1.000

1.600 m
Los peces son transparentes o brillan

2.000

El *Prestige* está en el fondo del Atlántico a una profundidad de 3.600 metros. La popa y la proa están separadas unos 3.500 metros.

3.000 m
El agua está a punto de congelación y la presión es de 370 kilos por centímetro cuadrado

G. H. - R. H / EL PAÍS

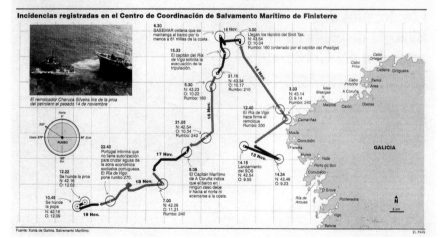

EL PAÍS, viernes 20 de diciembre de 2002

ESPAÑA / 23

CATÁSTROFE ECOLÓGICA *Un recorrido muy polémico*

Incidencias registradas en el Centro de Coordinación de Salvamento Marítimo de Finisterre

El remolcador *Charuca Silveira* tira de la proa del petrolero el pasado 14 de noviembre

GALICIA

Fuente: Xunta de Galicia, Salvamento Marítimo.

EL PAÍS

Judges' Special Recognition
Information graphics/extended coverage

El País

Madrid, Spain (A)

Tomás Ondarra, Editor in Chief; **Rafael Ferrer,** Editor; **Antonio Alonso,** Infographic Artist; **Nacho Catalán,** Infographic Artist; **Aitor Eguinoa,** Infographic Artist; **Angel Nava,** Infographic Artist; **Rodrigo Silva,** Infographic Artist; **Gustavo Hermoso,** Infographic Artist

Judges: The journalistic devotion of the graphics department was very impressive. Tracking the day-to-day movement of the oil spill for more than a month was very valuable to readers who depend on the coast for their livelihoods.

The scope of the work is incredible.

Jueces: La devoción periodística del departamento de gráficos fue impresionante. Rastrear los movimientos diarios del vertido de petróleo durante más de un mes se convirtió en algo valioso para los lectores que dependen del mar para vivir.

La competencia del trabajo es indiscutible.

A-section and page

Local news section and page

Sports section and page

Business section and page

Other section and page

Inside page

Breaking news topics

Special news topics

Awards

AWARDS OF EXCELLENCE, unless designated.

GOLD, exceptional work.

SILVER, outstanding work.

JUDGES' SPECIAL RECOGNITION, worthy of a singular, superior honor in the category, is in Chapter 2, pages 26-37.

Additional awards of excellence winners are in a gallery beginning on page 56.

Circulation

Indicated after each publication's location
(A) 175,000 & over
(B) 50,000-174,999
(C) 49,999 & under

Die Zeit
Hamburg, Germany (A)

A-section

Staff

The Independent
London, England (A)

A-section

Kevin Bayliss, Art Director

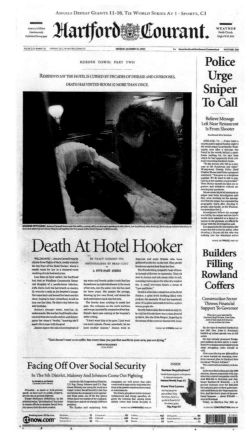

The Hartford Courant
Hartford, Conn. (A)

A-section

Staff

Sunday Herald
Glasgow, Scotland (B)

Sports section

David Dick, Sports Editor; **Neil Bennet,** Picture Editor; **Stephen Penman,** Deputy Sports Editor (Production)

The Times-Picayune
New Orleans, La. (A)

A-section page

Also winning in breaking news topics and in special news topics.
Also winning in spot news photography, page 159.

David Grunfeld, Photographer; **Doug Parker**, Photo Editor; **Adrianna Garcia**, Designer; **David Jack Browning**, Designer; **Grant C. Staublin**, Designer; **Chuck Cook**, Photographer; **Terry Baquet**, Page 1 Editor; **Brett Duke**, Photographer; **Michael DeMocker**, Photographer; **Alex Brandon**, Photographer; **Robert Steiner**, Assistant Photo Editor; **G. Andrew Boyd**, Assistant Photo Editor; **George Berke**, Design Director; **Dan Shea**, M.E.

The Times-Picayune

TIDAL SURGE FLOODS HUNDREDS OF HOMES

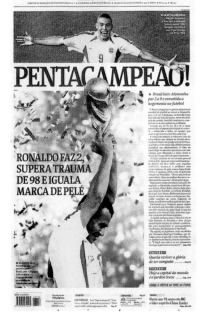

Tropical storm's last gasp sucker punches parish

Isidore is 'a terrific practice session'

FOLHA DE S.PAULO

PENTACAMPEÃO!

RONALDO FAZ 2, SUPERA TRAUMA DE 98 E IGUALA MARCA DE PELÉ

Folha de São Paulo
Sao Paulo, Brazil (A)

A-section page

Massimo Gentile, Art Editor; **Eleonora de Lucena**, M.E.; **Paula Cesarino Costa**, M.E.; **Renata Loprete**, Deputy Front Page Editor; **Fabio Marra**, Art Sub-Editor; **Moacir de Almeida**, Page Designer

SILVER
The Herald
Glasgow, Scotland (B)

Sports section
Staff

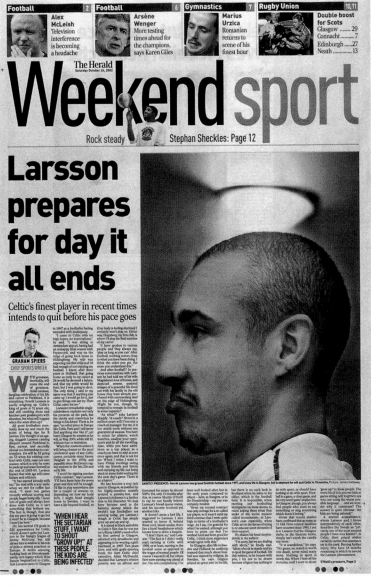

Judges: Great picture selection. We loved the way even the smallest details are crafted. Very dramatic, but under control.

Jueces: Gran selección en la imagen. Nos encantó la forma en la que se trataron todos los detalles. Muy dramático aunque bajo control.

RedEye
Chicago, Ill. (B)

A-section page

Chris Courtney, Designer

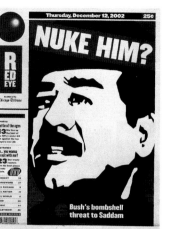

The Plain Dealer
Cleveland, Ohio (A)

A-section page

David Kordalski, A.M.E./Visuals; **Chuck Caton,** Designer; **Dale Omori,**
Photographer; **Bill Gugliotta,** Director/Photography; **James A. Fabris,**
Deputy M.E. News; **Ken Marshall,** Graphics Editor; **Denise Ritter,**
Designer; **Chuck Crow,** Photographer; **Stephen J. Beard,** Graphic
Artist; **Jeff Greene,** Photo Editor

Also winning in visuals/spot news photography, page 153.

Aftonbladet
Stockholm, Sweden (A)

A-section page

Staff

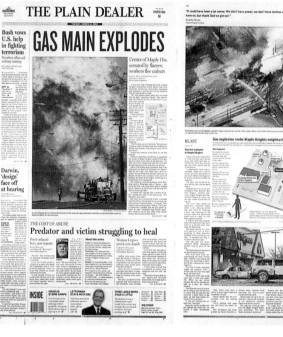

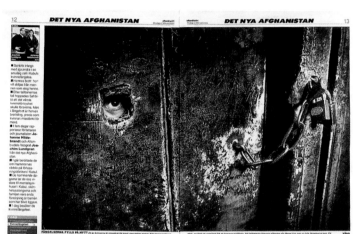

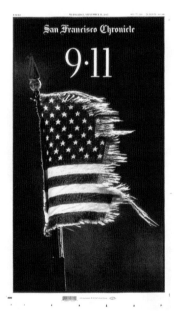

San Francisco Chronicle
San Francisco, Calif. (A)

A-section page

Matt Petty, Page Designer; **Dorothy Yule,** Page
Designer; **Mike Kepka,** Photographer; **Hulda
Nelson,** Art Director; **Nanette Bisher,** Creative
Director

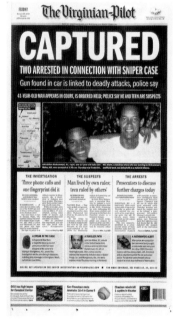

The Virginian-Pilot
Norfolk, Va. (A)

A-section page

Julie Elman, Designer; **Paul Nelson,** News Editor;
Roger Richards, Photo Editor; **Denis Finley,**
DME/Presentation

Die Zeit
Hamburg, Germany (A)

Business section

Staff

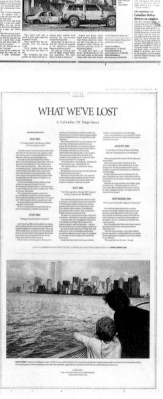

The Hartford Courant
Hartford, Conn. (A)

A-section page

John Scanlon, Director of Photography; **Suzette
Moyer,** Design Editor; **Ingrid Muller,** Designer

Detroit Free Press
Detroit, Mich. (A)

A-section page

Diane Weiss, Picture Editor; **Steve Dorsey,** Designer/Design &
Graphics Director; **Nancy Andrews,** Director/Photography; **Mandi
Wright,** Photographer; **Gene Myers,** Sports Editor; **Dave Robinson,**
Deputy Managing Editor; **Staff**

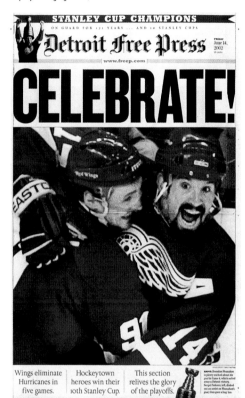

Folha de São Paulo
Sao Paulo, Brazil (A)

A-section page

Massimo Gentile, Art Editor; **Eleonora de Lucena,** M.E.; **Sandro
Falsetti,** Designer; **Melchiades Filho,** Sport Section Editor; **Fabio
Marra,** Art Sub-Editor

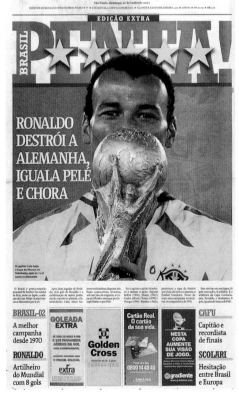

**SILVER
Politiken**
Copenhagen, Denmark (A)

Sports page

Søren Nyeland, Design Editor; **Per Bergsbo,** Designer; **Rasmus Bech,** Editor; **Søren-Mikael Hansen,** Senior
Editor; **Carsten Godtfredsen,** Copy Editor

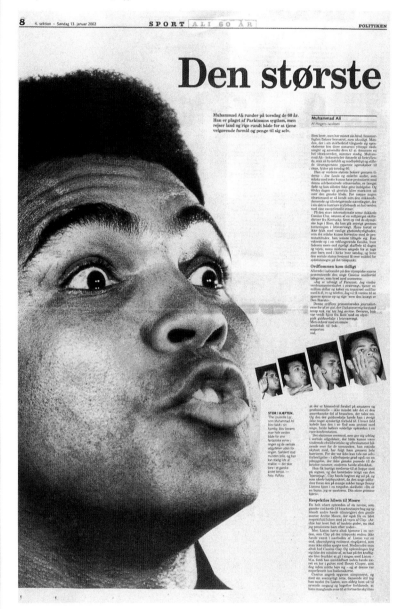

Judges: Among many sports pages telling Muhammad Ali's story, this one
offered impact and size. It's strong because of what's left out. Very arresting.

Jueces: Entre las muchas páginas deportivas sobre la historia de Muhammad
Ali, ésta es una que impacta y seduce por el tamaño. Es importante por lo que
no dice. Llama mucho la atención.

O Dia
Rio de Janeiro, Brazil (A)

Breaking news topics

Luiz Berri, Designer; **André Hippertt,** Art Director; **Léo Corrêa,** Photographer

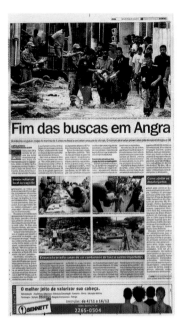

The Hartford Courant
Hartford, Conn. (A)

A-section page

John Scanlon, Director of Photography; **Suzette Moyer,** Design Editor; **Ingrid Muller,** Designer

Also winning in special news topics.

John Scanlon, Director of Photography; **Suzette Moyer,** Design Editor; **Ingrid Muller,** Designer; **Chris Moore,** Designer; **Timothy Reck,** Designer; **Greg Harmel,** Graphic Artist

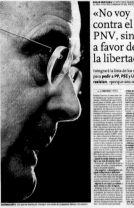

El Correo
Bilbao, Spain (B)

A-section page

Losu Onandia, Photographer; **Juan Ignacio Fernández,** Photo Editor; **Pacho Igartua,** Designer; **Ana Espligares,** Designer; **Mikel García Macías,** Designer; **Laura Piedra,** Designer; **Aurelio Garrote,** Designer; **María del Carmen Navarro,** Design Editor; **Alberto Torregrosa,** Editorial Art & Design Consultant; **Jesús Aycart,** Art Director

Aftonbladet
Stockholm, Sweden (A)

A-section page

Staff

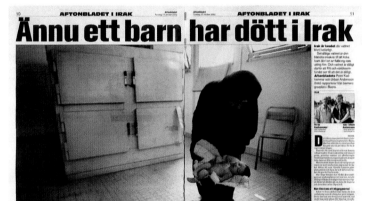

The Seattle Times
Seattle, Wash. (A)

A-section page

Denise Clifton, Designer; **Liz McClure,** News Graphics Director; **Paul Schmid,** Illustrator; **Scott Barry,** News Editor; **Mike Stanton,** Executive News Editor

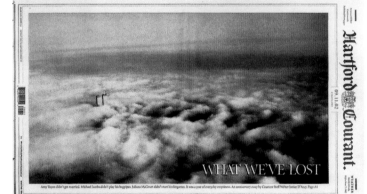

The Boston Globe
Boston, Mass. (A)

Breaking news topics

David L. Schutz, Designer; **Dan Zedek,** Design Director; **Lucy Bartholomay,** Deputy M.E./Design; **Ben Bradlee, Jr.,** Deputy M.E./Projects; **Walter V. Robinson,** Spotlight Editor

Die Zeit
Hamburg, Germany (A)

A-section page

Staff

Lexington Herald-Leader
Lexington, Ky. (B)

A-section page

Brian Simms, Designer; **Epha Riche,** Presentation Director; **Kim Parson,** A.M.E./Nights

The Honolulu Advertiser
Honolulu, Hawaii (B)

A-section page

David F. Montesino, M.E.

SILVER
Frankfurter Allgemeine Sonntagszeitung
Frankfurt am Main, Germany (A)

A-section page

Peter Breul, Art Director; **Nina Simon,** Designer; **Andreas Kuther,** Picture Editor; **Thomas Schmid,** Politics Editor

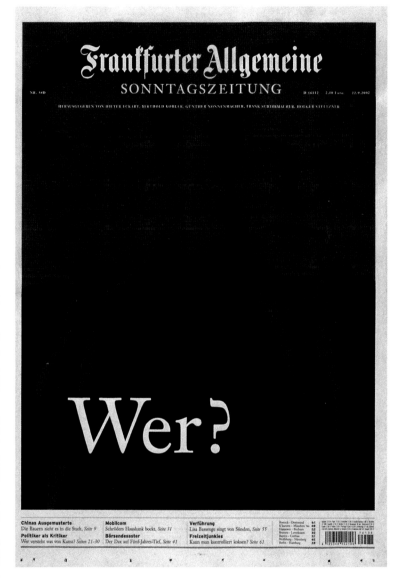

Judges: This entry breaks from the newspaper's standard front-page look. It ripped the front page for one of the biggest stories of the year. The type is nicely considered and balanced.

Jueces: Esta pieza rompe con el formato tradicional de la portada de un diario. Rompió con la portada por una de las historias más importantes del año. La tipografía tiene importancia y es equilibrada.

Mural
Jalisco, México (C)

A-section page

Jorge Sanz Cerrada, Designer, illustrator, photographer; **Rosa María Lutz,** Page Editor; **Mauricio Rangel,** Design Manager Editor; **Jorge Padilla,** Editorial Coordinator; **Guillermo Camacho,** Editorial Director; **Lázaro Ríos,** General Editorial Director

Mundo Deportivo
Barcelona, Spain (B)

Sports page

Miquel Mora, Designer; **Ferran Morales,** Designer

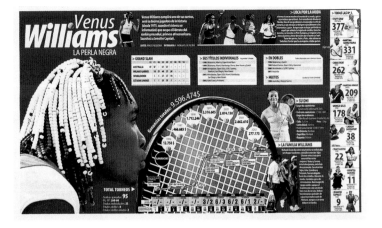

The Tuscaloosa News
Tuscaloosa, Ala. (C)

A-section page

Danny DeJarnette, News Editor

The Tribune
San Luis Obispo, Calif. (C)

A-section page

Joe Tarica, Presentation Editor

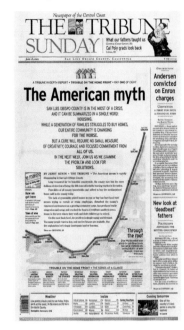

National Post
Toronto, Ont., Canada (A)

A-section page

Gayle Grin, A.M.E./Design & Graphics; **Kenneth Whyte,** Editor in Chief; **Martin Newland,** Deputy Editor; **Alison Uncles,** M.E.; **Steve Meurice,** Deputy M.E.; **Rob McKenzie,** Page One Editor; **Denis Paquin,** Photo Editor; **Laura Koot,** News Presentation; **Chris Bolin,** Photographer

The Boston Globe
Boston, Mass. (A)

Local news page

Skip Johnston, Designer

Los Angeles Times
Los Angeles, Calif. (A)

A-section page

Bill Gaspard, News Design Director

Also winning in reprints; in photo series, project or story; and in special coverage/single subject; page 154.

O Dia
Rio de Janeiro, Brazil (A)

Local news page

Luísa Bousada, Designer; **André Hippertt,** Art Director

Clarín
Buenos Aires, Argentina (A)

Local news page

Iñaki Palacios, Art Director; **Juan Elissetche,** Design Editor; **Federico Sosa,** Design Editor; **Carlos Vazquez,** Design Editor; **Soledad Calvo,** Graphic Designer; **Francisco Jurado Emery,** Graphic Designer; **Verónica Colombo,** Graphic Designer; **Osvaldo Estevao,** Graphic Designer; **Rosana Dillon,** Graphic Designer; **Victoria Quintiero,** Graphic Designer

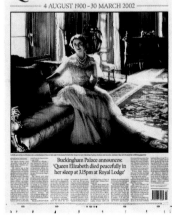

The Independent on Sunday
London, England (A)

Local news page

Carolyn Roberts, Art Director; **Tristan Davies,** Editor; **Sophie Batterbury,** Picture Editor; **Keith Howitt,** Production Editor

Also winning in portfolio/combination design, page 232.

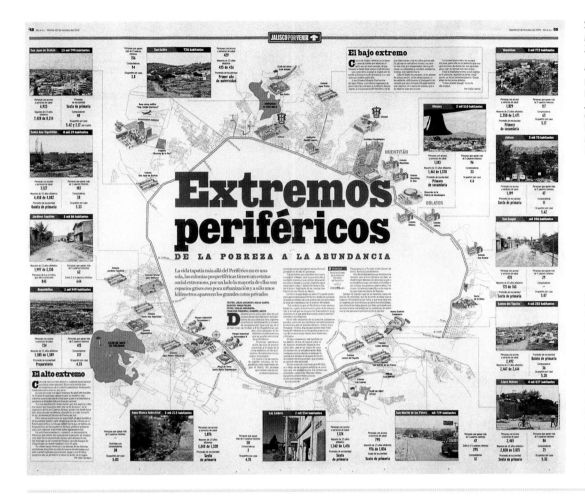

SILVER
Mural
Zapopan, México (C)

Inside page

Luis Armando Becerra Gil, Designer; **Felipe Lucero**, M.E./Design; **Galia García**, Page Editor; **Jaime Barrera**, Editorial Coordinator; **Lázaro Ríos**, General Editorial Director; **Guillermo Camacho**, Editorial Director; **Omar Pulido**, Illustrator; **Carlos Mosqueda**, Photographer; **Tonatiuh Figueroa**, Photographer

Judges: This spread provides a comprehensive amount of information in a logical, clean design. The designer knew when detail was appropriate – and when it was not.

Jueces: Este artículo proporciona amplia información con un diseño limpio y lógico. El diseñador sabía de antemano cuándo era apropiada la utilización de detalles y cuándo no.

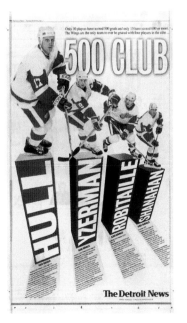

The Detroit News
Detroit, Mich. (A)

Sports page

Eric Millikin, Assistant Design Director/Sports; **Jason Karas**, Sports Designer; **Liz Wishaw**, Sports Designer; **Ed Ballotts**, Photo Editor

Heraldo de Aragon
Zaragoza, Spain (B)

Local news page

Jose Luis Minondo, Art Director; **Pilar Ostalé**, Designer; **Cristina Salvador**, Designer; **Cristina Urresti**, Designer; **Ana Pérez Errea**, Designer; **Javier Eslava**, Designer; **Javier Errea**, Design Consultant; **Carlos Moncín**, Photo Editor; **Staff**, Photographers

Mural
Zapopan, México (C)

Sports page

Jesús González, Designer/Illustrator; **Felipe Lucero**, M.E./Design; **Luis Enrique Rodríguez**, Page Editor; **Francisco Solares**, Editorial Coordinator; **Lázaro Ríos**, General Editorial Director; **Guillermo Camacho**, Editorial Director

Santa Maria Times
Santa Maria, Calif. (C)

Sports page

Billy Simkins, Design Editor

South Florida Sun-Sentinel
Fort Lauderdale, Fla. (A)

Sports page

Michael Laughlin, Photographer; **Dina Cappillo,** Designer; **Tom Peyton,** Visual Editor; **George Wilson,** Photo Editor; **Fred Turner,** Sports Editor

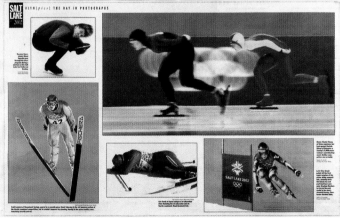

Rocky Mountain News
Denver, Colo. (A)

Special news topics

Randall K. Roberts, Presentation Editor; **Janet Reeves,** Director/Photography; **Staff**

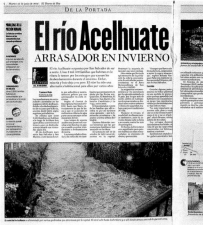

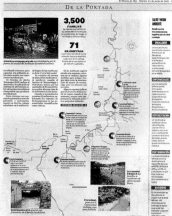

El Diario de Hoy
San Salvador, El Salvador (B)

Local news page

Isaac de Coss, Art Director; **Juan Durán,** Graphics Editor; **Daysy Amaya,** Section Editor; **Remberto Rodríguez,** Graphic Co-Editor/Designer; **Jorge Reyes,** Photographer; **Francisco Mejía,** Reporter

La Prensa Gráfica
San Salvador, El Salvador (B)

Local news page

Esteban Rodas, Designer; **Alfredo Hernández,** Editor; **Óscar Corvera,** Illustrator; **Mauricio Martínez,** Photographer; **Enrique Contreras,** Graphic Editor; **Gustavo Belmán,** Graphic Editor

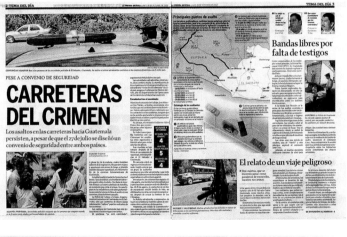

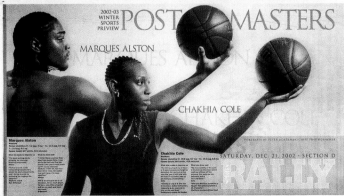

Asbury Park Press
Neptune, N.J. (B)

Sports page

Harris Siegel, M.E./Design & Photography; **Andrew Prendimano,** Art & Photo Director; **John V. Smith,** Sports Designer

El Norte
Monterrey, México (B)

Sports page

Jorge Obregón, Designer/Design Editor; **Ricardo Garza,** Section Editor; **Martha A. Treviño,** Editor; **José Francisco Grajeda,** M.E./Design

Récord
México City, México (C)

Sports page

Alejandro Belman, Designer; **José Luis Barros,** Graphics Editor; **Alejo Nájera,** Design Editor; **Alberto Nava,** Art Director; **Victor Edú Rodriguez,** Editor

SILVER
Mural
Zapopan, México (C)

Sports page

Emilio Muñoz, Designer; **Felipe Lucero,** M.E./Design; **Jorge Thamer,** Page Editor; **Francisco Solares,** Editorial Coordinator; **Lázaro Ríos,** General Editorial Director; **Guillermo Camacho,** Editorial Director; **Angel Guevara,** Photographer

Judges: The strong photography, typography and blow-by-blow look at the decisive moments of the match reach out to readers. This is a page a fan would love to read and keep.

Jueces: El carácter de la fotografía, la tipografía y la mirada atenta en los momentos decisivos del partido cautivan a los lectores. Ésta es una página que a un aficionado le gustaría leer y guardar.

The Hartford Courant
Hartford, Conn. (A)

Business page

Jim Kuykendall, Designer; **Rick Shaw,** Art Director; **Thom McGuire,**
A.M.E. Photo/Graphics

The Toronto Star
Toronto, Ont., Canada (A)

Business page

Catherine Pike, Designer; **Brian Hughes,** Illustrator; **Rick Haliechuk,**
Editor; **Rachel Ross,** Reporter

The Akron Beacon Journal
Akron, Ohio (A)

Business page

Rick Steinhauser, Illustrator/Art Director; **Charles Chambers,**
Designer

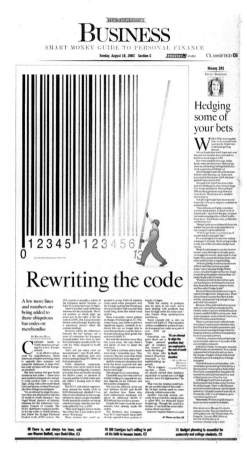

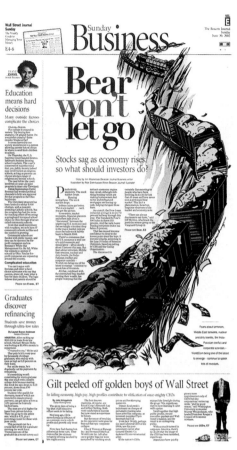

The Hartford Courant
Hartford, Conn. (A)

Business page

Timothy Reck, Graphic Artist

Frankfurter Allgemeine Sonntagszeitung
Frankfurt am Main, Germany (A)

Business page

Peter Breul, Art Director; **Benjamin Boch,** Designer; **Andreas
Kuther,** Picture Editor; **Marcus Kaufhold,** Photographer; **Rainer
Hank,** Business Editor

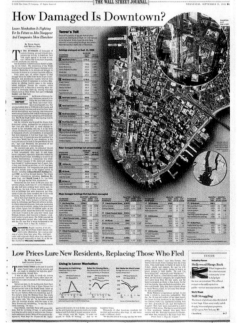

The Wall Street Journal
New York, N.Y. (A)

Business page

Joe Dizney, Design Director; **Dona Wong,** News Graphics Director;
Carlos Tovar, Senior Graphic Editor; **Robert Walter,** Graphic Artist;
Patrick Conlon, Imaging Manager; **Elizabeth Weinstein,** Reporting
Assistant

Detroit Free Press
Detroit, Mich. (A)

Inside page

Steve Dorsey, Page Designer, Design & Graphics Director; **J. Kyle Keener,** Chief Photographer, Picture Editor

South Florida Sun-Sentinel
Fort Lauderdale, Fla. (A)

Inside page

Robyn Wishna, Designer

SILVER
Heraldo de Aragon
Zaragoza, Spain (B)

Breaking news topics

Jose Luis Minondo, Art Director; **Pilar Ostalé,** Designer; **Cristina Salvador,** Designer; **Ana Pérez Errea,** Designer; **Cristina Urresti,** Designer; **Javier Eslava,** Designer; **Javier Errea,** Consultant; **Carlos Moncín,** Photo Editor; **Photo Staff**

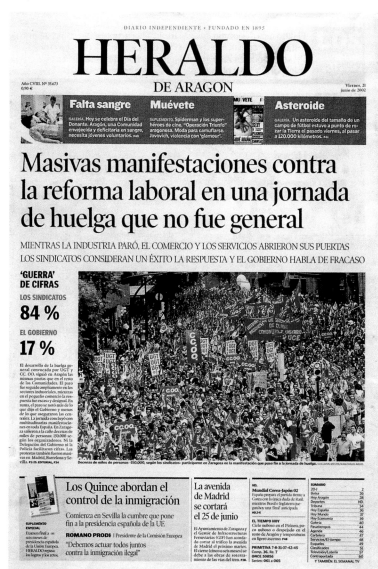

Judges: It's pretty incredible how the entry offered so many pages without being too repetitious. Beautifully paced, with all supporting elements nicely crafted. A good total palette of editorial coverage.

Jueces: Es realmente increíble cómo la pieza ofrece tantas páginas sin ser repetitiva. Buen ritmo y utilización de todos los elementos de apoyo con gran habilidad. Una buena paleta de cobertura editorial.

El Caribe
Santo Domingo, Dominican Republic (C)

Inside page

Iban Campo, Editor in Chief; **Yelidá Alcántara,** Art Director; **Karen Cortes,** Design Editor; **Glenny Elizabeth Veloz,** Designer; **Mabel Caballero,** Editor

The New York Times
New York, N.Y. (A)

Inside page

Anne Leigh, Art Director; **Steven Duenes,** Graphics Editor; **Archie Tse,** Graphics Editor; **Thomas Dallal,** Photographer; **Fred Conrad,** Photographer; **Tom Bodkin,** A.M.E. Design Director; **Linda Brewer,** Deputy Design Director

National Post
Toronto, Ont., Canada (A)

Inside page

Gayle Grin, A.M.E. Graphics/Design; **Kenneth Whyte,** Editor in Chief; **John Coborn,** Illustrator; **Dianna Symonds,** Weekend Editor; **Paul Wilson,** Review Editor

Detroit Free Press
Detroit, Mich. (A)

Inside page

David Dombrowski, News Designer; **J. Kyle Keener,** Photographer; **Jessica Trevino,** Gallery Page Coordinator; **Chris Clonts,** Deputy Design Director/News; **Steve Dorsey,** Design & Graphics Director

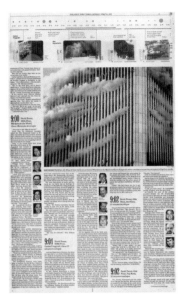

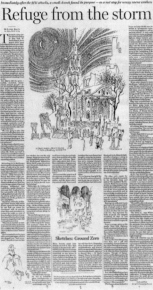

El Caribe
Santo Domingo, Dominican Republic (C)

Inside page

Iban Campo, Editor in Chief; **Yelidá Alcántara,** Art Director; **Karen Cortes,** Design Editor; **Ángel Martínez,** Designer; **Camilo Venegas,** Editor

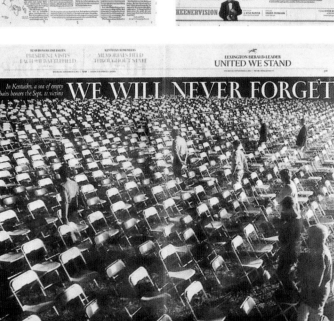

Lexington Herald-Leader
Lexington, Ky. (B)

Breaking news topics

Brian Simms, Designer; **Epha Riche,** Presentation Director; **Kim Parson,** A.M.E./Nights; **David Stephenson,** Photographer; **Helena Hau,** Imaging Specialist; **Ron Garrison,** Director/Photography

The San Diego Union-Tribune
San Diego, Calif. (A)

Inside page

Chris Barber, Designer; **Rose Wojnar,** Copy Editor

Mural
Zapopan, México (C)

Inside page

Daniela Nuño, Page editor; **Juan Carlos Garda,** Editorial coordinator; **Fernando Jauregui,** Designer/Illustrator/Design Managing Editor; **Lázaro Ríos,** General Editorial Director; **Guillermo Camacho,** Editorial Director

The Charlotte Observer
Charlotte, N.C. (A)

Breaking news topics

Cory Powell, Design Director; **Kerry Bean,** Design Team Leader; **Michael Whitley,** News Projects Designer; **Tom Tozer,** Deputy M.E.; **Christopher Dye,** Designer; **Leslie Wilkinson,** Designer; **Tom Ausman,** Designer; **Peter Weinberger,** Director/Photography; **Joanne Miller,** Graphic Director; **Staff**

Also winning in special news topics.

Cory Powell, Design Director; **Kerry Bean,** Design Team Leader; **Michael Tribble,** Designer; **Jack Russell,** Designer; **Christopher Dye,** Designer; **Leslie Wilkinson,** Designer; **Tom Ausman,** Designer; **Karen Williams,** Designer; **Michael Whitley,** News Projects Designer; **Staff**

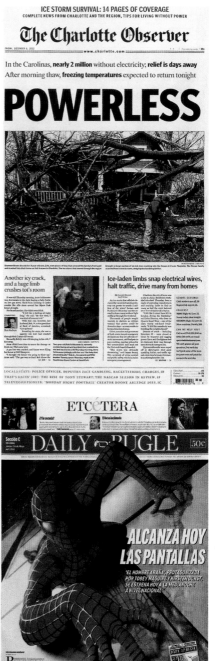

Palabra
Saltillo, México (C)

Other page

Laura Sánchez, Graphic Designer; **Carlos Mendoza,** Photo Artist; **David Brondo,** Editor Director; **Jorge Meléndez,** General Editor Director; **Alejandra Sólis,** Editor; **Vicente León,** Graphics Coordinator

SILVER
Clarín
Capital Federal, Argentina (A)

Breaking news topics

Iñaki Palacios, Art Director; **Juan Elissetche,** Design Editor; **Federico Sosa,** Design Editor; **Carlos Vazquez,** Design Editor; **Soledad Calvo,** Graphic Designer; **Francisco Jurado Emery,** Graphic Designer; **Verónica Colombo,** Graphic Designer; **Osvaldo Estevao,** Graphic Designer; **Rosana Dillon,** Graphic Designer; **Oscar Bejarano,** Graphic Designer

Also winning in information graphic/news.

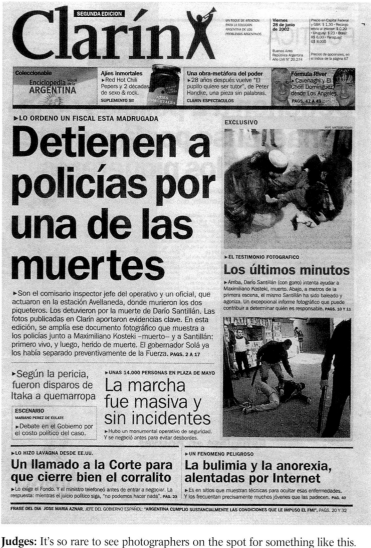

Judges: It's so rare to see photographers on the spot for something like this. The whole story can be told in pictures by this paper. Something messy and confusing has happened, and the entry organizes it into a story.

Jueces: Es muy extraño ver a fotógrafos en el lugar para relatar algo así. Este diario puede relatar toda la historia con fotos. Ha ocurrido algo desordenado y confuso y la pieza logra organizarlo en forma de historia.

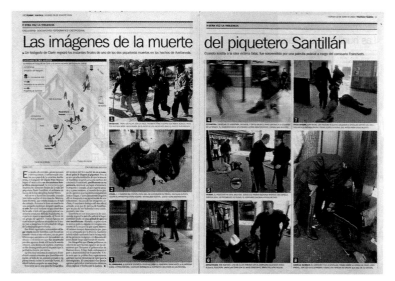

The Washington Post
Washington, D.C. (A)

Breaking news topics

Carla Fielder, Assistant News Editor; **Beth Broadwater,** Assistant News Editor; **Vince Bzdek,** News Editor; **News Desk**

Also winning in special news topics.

Carla Fielder, Assistant News Editor; **Beth Broadwater,** Assistant News Editor; **Vince Bzdek,** News Editor; **Laurel Dalrymple,** Assistant News Editor; **Chris Stanford,** Assistant News Editor; **Ed Thiede,** A.M.E./News Desk

Cape Cod Times
Hyannis, Mass. (B)

Breaking news topics

Andrea Smith Miller, Presentation Editor

The New York Times
New York, N.Y. (A)

Breaking news topics

Staff

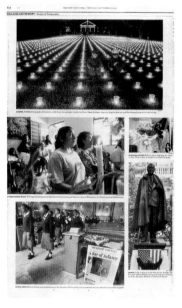

Star Tribune
Minneapolis, Minn. (A)

Special news topics

Staff

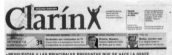
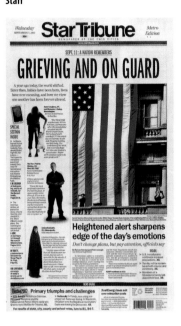

The Herald Sun
Durham, N.C. (B)

Breaking news topics

Jim Weaver, Design Director

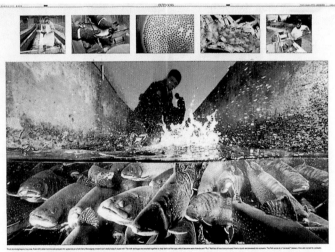

The Charlotte Observer
Charlotte, N.C. (A)

Sports page

Mary Ann Lawrence, Assistant Sports Editor; **John D. Simmons,** Photographer; **Susan Gilbert,** Director/Photography; **David Scott,** Assistant Sports Editor

Also winning in visuals/photography feature, page 151.

Clarín
Capital Federal, Argentina (A)

Breaking news topics

Iñaki Palacios, Art Director; **Juan Elissetche,** Design Editor; **Federico Sosa,** Design Editor; **Carlos Vazquez,** Design Editor; **Soledad Calvo,** Graphic Designer; **Francisco Jurado Emery,** Graphic Designer; **Verónica Colombo,** Graphic Designer; **Osvaldo Estevao,** Graphic Designer; **Rosana Dillon,** Graphic Designer; **Oscar Bejarano,** Graphic Designer

Correio Braziliense
Brasilia, Brazil (B)

Breaking news topics

Fabio Sales, Art Director; **Ricardo Cunha Lima,** Illustrator; **José Negreiros,** Executive Editor; **Ana Dubeux,** Executive Editor; **Claudio Versiani,** Photo Editor

San Jose Mercury News
San Jose, Calif. (A)

Breaking news topics

Tim Ball, Sports Design Director; **Wayne Begasse,** Photo Editor

SILVER
The Washington Post
Washington, D.C. (A)

Breaking news topics

News Desk

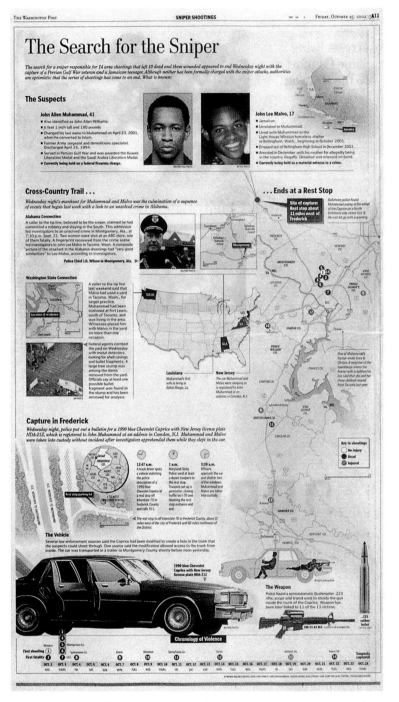

Judges: The entry offers a very strong backbone for coverage. The map and infographic support the information, and as the entry proceeds, the information goes deeper and deeper.

Jueces: La pieza ofrece una base de gran calidad para la cobertura de la noticia. El mapa y los infográficos ayudan al relato y al continuar la noticia, observamos cómo se profundiza cada vez más en el tema.

The Plain Dealer
Cleveland, Ohio (A)

Breaking news topics

John Kuntz, Photographer; **Greg Darroch,** Designer; **David Kordalski,** A.M.E./Visuals

The Boston Globe
Boston, Mass. (A)

Special news topics

Staff

Los Angeles Times
Los Angeles, Calif. (A)

Special news topics

Dan Santos, Design Editor

Chicago Sun-Times
Chicago, Ill. (A)

Special news topics

Robb Montgomery, Deputy News Editor/Design; **Dan Haar,** Deputy Metro Editor; **Eric White,** Design Director; **Nancy Stuenkel,** Photo Editor; **Robert A. Davis,** Photographer

Heraldo de Aragon
Zaragoza, Spain (B)

Breaking news topics

Jose Luis Minondo, Art Director; **Pilar Ostalé,** Designer; **Cristina Salvador,** Designer; **Cristina Urresti,** Designer; **Ana Pérez Errea,** Designer; **Javier Eslava,** Designer; **Javier Errea,** Design Consultant; **Isidro Gil,** Artist

National Post
Toronto, Ont., Canada (A)

Breaking news topics

Gayle Grin, A.M.E./Design & Graphics; **Kenneth Whyte,** Editor in Chief; **Martin Newland,** Deputy Editor; **Alison Uncles,** M.E.; **Steve Meurice,** Deputy M.E.; **Rob McKenzie,** Page One Editor; **Denis Paquin,** Photo Editor; **John Racovali,** News Editor; **Laura Koot,** News Presentation

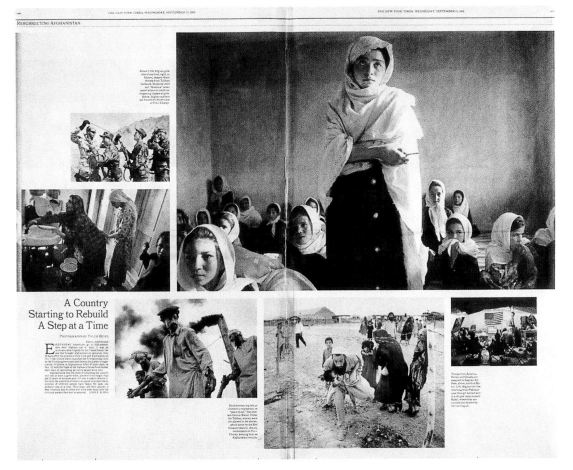

RESURRECTING AFGHANISTAN

A Country Starting to Rebuild A Step at a Time

PHOTOGRAPHY TYLER HICKS

SILVER
The New York Times
New York, N.Y. (A)

Special news topics

Rodrigo Honeywell, Art Director; **Pancho Bernasconi,** Picture Editor

Judges: This page should be held as an example of how to design a photo page, showing that there is another standard for photo layouts. The quality of colors is amazing – muted, and not too bright, like many newspapers.

Jueces: Esta página debería convertirse en ejemplo de cómo diseñar una página fotográfica que muestra que hay otra forma de diseñar fotografías. La calidad de los colores es fascinante: tenues y no muy llamativos, como en muchos diarios.

THE AGE

Flight from Bali

The Age
Melbourne, Australia (A)

Special news topics

Bill Farr, Art Director; **Michael Gawenda,** Editor; **Gavan O'Connor,** Night Editor; **De Luxe & Associates ,** Design Consultants

INTERNACIONAL

Vive Ucrania drama aéreo

Reforma
México City, México (B)

Breaking news topics

David Alvarado, Graphics Co-Editor; **Gonzálo Pérez,** Graphics Coordinator; **Yolanda Yebra,** Editor; **Homero Fernández,** Director of International Operations; **Emilio Deheza,** Graphic Director

FOURTH OF JULY

Austin American-Statesman
Austin, Texas (A)

Special news topics

Alex Brown, Designer; **Jason Whaley,** Designer; **G.W. Babb,** Design Director for News; **Taylor Johnson,** Photographer; **Robert Calzada,** Graphic Artist

NETS

JASON KIDD

Asbury Park Press
Neptune, N.J. (A)

Special news topics

Michael J. Treola, Photographer; **Tanya Breen,** Photographer; **John Quinn,** M.E./Sports; **Harris Siegel,** Designer

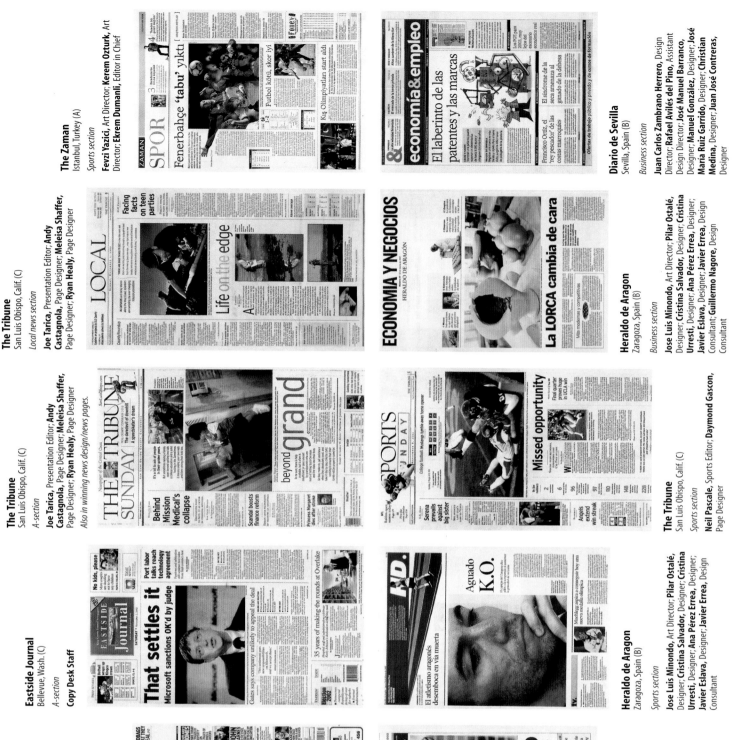

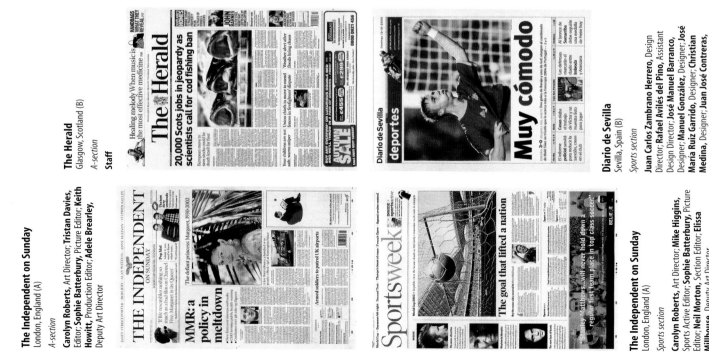

The Zaman
Istanbul, Turkey (A)
Sports section
Fevzi Yazici, Art Director; **Kerem Ozturk**, Art Director; **Ekrem Dumanli**, Editor in Chief

The Tribune
San Luis Obispo, Calif. (C)
Local news section
Joe Tarica, Presentation Editor; **Andy Castagnola**, Page Designer; **Meleisa Shaffer**, Page Designer; **Ryan Healy**, Page Designer

The Tribune
San Luis Obispo, Calif. (C)
A-section
Joe Tarica, Presentation Editor; **Andy Castagnola**, Page Designer; **Meleisa Shaffer**, Page Designer; **Ryan Healy**, Page Designer
Also in winning news design/news pages.

Eastside Journal
Bellevue, Wash. (C)
A-section
Copy Desk Staff

The Herald
Glasgow, Scotland (B)
A-section
Staff

The Independent on Sunday
London, England (A)
A-section
Carolyn Roberts, Art Director; **Tristan Davies**, Editor; **Sophie Batterbury**, Picture Editor; **Keith Howitt**, Production Editor; **Adele Brearley**, Deputy Art Director

The Independent on Sunday
London, England (A)
Sports section
Carolyn Roberts, Art Director; **Mike Higgins**, Sports Active Editor; **Sophie Batterbury**, Picture Editor; **Neil Morton**, Section Editor; **Elissa Millhouse**, Deputy Art Director

Diario de Sevilla
Sevilla, Spain (B)
Business section
Juan Carlos Zambrano Herrero, Design Director; **Rafael Avilés del Pino**, Assistant Design Director; **José Manuel Barranco**, Designer; **Manuel González**, Designer; **José María Ruiz Garrido**, Designer; **Christian Medina**, Designer; **Juan José Contreras**, Designer

Heraldo de Aragon
Zaragoza, Spain (B)
Business section
Jose Luis Minondo, Art Director; **Pilar Ostalé**, Designer; **Cristina Salvador**, Designer; **Cristina Urresti**, Designer; **Ana Pérez Errea**, Designer; **Javier Eslava**, Designer; **Javier Errea**, Design Consultant; **Guillermo Nagore**, Design Consultant

The Tribune
San Luis Obispo, Calif. (C)
Sports section
Neil Pascale, Sports Editor; **Daymond Gascon**, Page Designer

Heraldo de Aragon
Zaragoza, Spain (B)
Sports section
Jose Luis Minondo, Art Director; **Pilar Ostalé**, Designer; **Cristina Salvador**, Designer; **Cristina Urresti**, Designer; **Ana Pérez Errea**, Designer; **Javier Eslava**, Designer; **Javier Errea**, Design Consultant

Diario de Sevilla
Sevilla, Spain (B)
Sports section
Juan Carlos Zambrano Herrero, Design Director; **Rafael Avilés del Pino**, Assistant Design Director; **Manuel González**, Designer; **José María Ruiz Garrido**, Designer; **Christian Medina**, Designer; **Juan José Contreras**, Designer

The Virginian-Pilot
Norfolk, Va. (A)

A-section page

J.R. Withers, Designer; **Julie Elman**, Designer; **Jim Haag**, News Editor; **Denis Finley**, Deputy M.E./Presentation; **Norm Shafer**, Photo Editor; **Cecelia Jolley**, Photo Editor; **Vicki Cronis**, Photographer

Dagens Nyheter
Stockholm, Sweden (A)

A-section page

Hans Rosén, Page Designer; **Kerstin Wigstrand**, Picture Editor

San Jose Mercury News
San Jose, Calif. (A)

A-section page

Kevin Wendt, News Design Director; **Herschel Kenner**, A.M.E./Nights; **Matt Mansfield**, Deputy M.E.; **Staff**

Clarín
Buenos Aires, Argentina (A)

A-section page

Iñaki Palacios, Art Director; **Juan Elissetche**, Design Editor; **Federico Sosa**, Design Editor; **Carlos Vazquez**, Design Editor; **Soledad Calvo**, Graphic Designer; **Francisco Jurado Emery**, Graphic Designer; **Verónica Colombo**, Graphic Designer; **Osvaldo Estevao**, Graphic Designer; **Oscar Rosana Dillon**, Graphic Designer; **Bejarano**, Graphic Designer

The Plain Dealer
Cleveland, Ohio (A)

A-section page

David Kordalski, A.M.E./Visuals; **Lisa Griffis**, Designer; **Joshua Gunter**, Photographer; **Bill Gugliotta**, Director/Photography; **Christine Jindra**, Sunday Editor; **Ken Marshall**, Graphics Editor; **Reid Brown**, Graphics Artist; **Chuck Caton**, News Editor

Die Zeit
Hamburg, Germany (A)

A-section page

Staff

The Charlotte Observer
Charlotte, N.C. (A)

A-section page

Michael Whitley, News Projects Designer; **Cory Powell**, Design Director; **Tom Tozer**, Deputy M.E.; **John D. Simmons**, Photographer

The Oregonian
Portland, Ore. (A)

A-section page

Mark Friesen, Designer; **Galen Barnett**, Design Director; **Doug Beghtel**, Photographer; **Patty Reksten**, Photo Director

National Post
Toronto, Ont., Canada (A)

Other section

Gayle Grin, A.M.E./Design & Graphics; **Kenneth Whyte**, Editor in Chief; **Dianna Symonds**, Weekend Editor; **Paul Wilson**, Review Editor; **Laura Morrison**, Copy Editor

O Dia
Rio de Janeiro, Brazil (A)

A-section page

André Hippertt, Art Director; **Sérgio Costa**, News Editor; **Alexandre Freeland**, News Editor; **Nel Figueiredo**, News Editor; **Severano Silva**, Photographer; **Paula Alvadia**, Photographer

The Tribune
San Luis Obispo, Calif. (C)

Business section

Larry Mauter, Page Designer

Detroit Free Press
Detroit, Mich. (A)

A-section page
David Dombrowski, News Designer; **Steve Dorsey**, Design & Graphics Director; **Kent Phillips**, Photographer; **Jim Finkelstein**, Deputy News Editor; **Nancy Laughlin**, News Editor; **Chris Clonts**, Deputy Design Director/News

El Comercio
Lima, Peru (B)
A-section page
Carlos Sotomayor, Design Editor; **Xabier Díaz de Cerio,** Art Director

Lexington Herald-Leader
Lexington, Ky. (B)
A-section page
Randy Medema, Designer; **Epha Riche,** Presentation Director; **John Ireland,** Assistant News Editor; **Angie Muhs,** Government Editor

The Times of Northwest Indiana
Munster, Ind. (B)
A-section page
Erica Smith, Design Editor

The Press Democrat
Santa Rosa, Calif. (B)
A-section page
Steve Leone, Designer; **George Millener,** Senior Editor

Público
Lisbon, Portugal (B)
A-section page
José Manuel Fernandes, Director; **Miguel Dias,** Art Director; **Gil Lourenço,** Designer; **Desmond Boylan,** Reuters Photographer

El Comercio
Lima, Peru (B)
A-section page
Carlos Sotomayor, Design Editor; **Xabier Díaz de Cerio,** Art Director; **Jorge Andrade,** Designer; **Orlando Lazo,** Designer; **Victor Cuadros,** Designer; **Juvenal Gamero,** Designer; **Monica Sanchez,** Designer; **Gonzalo Podesta,** Designer; **Herman Schwarz,** Photo Editor; **Xabier Díaz de Cerio,** Art Director

El Norte
Monterrey, México (B)
A-section page
Erick Gallegos, Designer; **Roberto Cruz,** Section Editor; **Adrián Alvarez,** Design Editor; **José Francisco Grajeda,** M.E./Design; **Martha A. Treviño,** Editor

La Nación
Tibas, Costa Rica (B)
A-section page
Ricardo Kandler, Graphical Conceptor and Designer; **Luis Roberto Rojas,** Art Director; **Manuel Canales,** Illustrator

Dagens Nyheter
Stockholm, Sweden (A)
A-section page
Martin Johansson, Page Designer; **Lotta Ek,** Design Editor Projects; **Karin Dahlström,** Page Designer; **Paul Hansen,** Photographer

RedEye
Chicago, Ill. (B)
A-section page
Chris Courtney, Designer

O Dia
Rio de Janeiro, Brazil (A)
A-section page
Sérgio Costa, News Editor; **André Hippertt,** Art Director; **Alexandre Freeland,** News Editor; **Nel Figueiredo,** News Editor; **Márcio Mercante,** Photographer

The Honolulu Advertiser
Honolulu, Hawaii (B)
A-section page
Christine Strobel, Page Designer; **David F. Montesino,** M.E.

Heraldo de Aragon
Zaragoza, Spain (B)
A-section page

Jose Luis Minondo, Art Director; **Pilar Ostalé,** Designer; **Cristina Salvador,** Designer; **Cristina Urresti,** Designer; **Ana Pérez Errea,** Designer; **Javier Eslava,** Designer; **Javier Errea,** Design Consultant; **Guillermo Mestre,** Photographer

El Norte
Monterrey, México (B)
A-section page

Rodolfo Jiménez, Designer; **Nelly Ramírez,** Section Editor; **Adrián Alvarez,** Design Editor; **José Francisco Grajeda,** Art Managing Editor; **Martha A. Treviño,** Editor

Correio Braziliense
Brasilia, Brazil (B)
A-section page

Fabio Sales, Art Director; **Carlos Marcelo,** Editor; **Zuleika De Souza,** Photo Editor

Diário de Notícias
Lisbon, Portugal (B)
A-section page

Mário Bettencourt Resendes, Editor in Chief; **António Ribeiro Ferreira,** Deputy Editor in Chief; **José Maria Ribeirinho,** Art Director & Designer; **José Carlos Carvalho,** Photographer; **Cases i Associats ,** Design Consultant

La Opinión
Los Angeles, Calif. (B)
A-section page

Tadeo Guerrero, Designer; **David Jiménez,** Illustrator; **José Luis Sierra,** Editor

Winnipeg Free Press
Winnipeg, Canada (B)
A-section page

Gordon Preece, Art Director

Le Devoir
Montreal, P.Q., Canada (C)
A-section page

Michael Venne, News Editor; **Jules Richer,** News Editor; **Pierre Baulieu,** Desk Editor; **Louis Lapierre,** Desk Editor; **Bernard Descôteaux,** Publisher; **Jean-Robert Sansfaçon,** M.E.; **Christian Tiffet,** Art Director

Le Devoir
Montreal, P.Q., Canada (C)
A-section page

Michael Venne, News Editor; **Jules Richer,** News Editor; **Pierre Baulieu,** Desk Editor; **Louis Lapierre,** Desk Editor; **Bernard Descôteaux,** Publisher; **Jean-Robert Sansfaçon,** M.E.; **Christian Tiffet,** Art Director

Mural
Jalisco, México (C)
A-section page

Jorge Sanz Cerrada, Designer/Illustrator; **Christian Ortiz,** Photographer; **Mauricio Rangel,** Design Manager Editor; **Rosa Maria Lutz,** Page Editor; **Jorge Padilla,** Editorial Coordinator; **Guillermo Camacho,** Editorial Coordinator; **Lázaro Rios,** General Editorial Director

Mural
Jalisco, México (C)
A-section page

Mauricio Rangel, Designer/Illustrator/Design Manager Editor; **Tonatiuh Figueroa,** Photographer; **Rosa Maria Lutz,** Page Editor; **Jorge Padilla,** Editorial Coordinator; **Guillermo Camacho,** Editorial Director; **Lázaro Rios,** General Editorial Director

Periodico Provincia
Morelia, México (C)
A-section page

Raúl Olmos, Editor; **Acelia Guadarrama,** Editorial Coordinator; **Olin Augusto Pérez,** Co-editor; **Leopoldo García Lugo,** Co-editor; **Gustavo Vega,** Graphics Editor; **Julio César Munoz,** Designer

Asbury Park Press
Neptune, N.J. (B)
A-section page

Joe Zeff, Illustrator; **Robert Collins,** Publisher; **Skip Hidlay,** Executive Editor; **Harris Siegel,** Designer

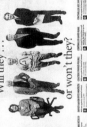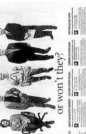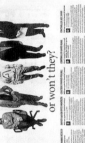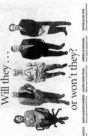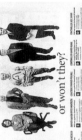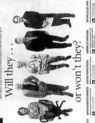

El Norte
Monterrey, México (B)

Local news page

Eduardo Gonzalez, Designer; **Humberto Castro**, Section Editor; **Carlos Arce**, Design Editor; **José Francisco Grajeda**, M.E./Design; **Martha A. Treviño**, Editor; **Juan Manuel Sánchez**, Photographer

Palabra
Saltillo, México (C)

Local news page

Francisco Chaires, Graphic Designer; **Vicente León**, Graphics Coordinator; **David Brondo**, Editor Director; **Jorge Meléndez**, General Editor Director; **Ana Patricia García**, Editor; **Alejandro Saucedo**, Photographer

The Boston Globe
Boston, Mass. (A)

Local news page

Skip Johnston, Designer; **Dan Zedek**, Design Director

The London Free Press
London, Ont., Canada (B)

Local news page

Susan Batsford, Designer; **Julie Carl**, City Editor; **Joe Ruscitti**, M.E.

El Norte
Monterrey, México (B)

Local news page

Viviana Garza, Designer; **Carlos Arce**, Design Editor/Designer; **Erik Meza**, Photographer; **Humberto Castro**, Section Editor; **Martha A. Treviño**, Editor; **José Francisco Grajeda**, M.E./Art

The London Free Press
London, Ont., Canada (B)

Local news page

Susan Batsford, Designer; **Julie Carl**, City Editor; **Joe Ruscitti**, M.E.

Santa Barbara News-Press
Santa Barbara, Calif. (C)

A-section page

Colin Powers, News Design Editor

The Washington Post
Washington, D.C. (A)

Local news page

Kenny Monteith, Assistant News Editor; **David Cackowski**, Cartographer; **Laura Stanton**, Assistant Art Director; **Keith Harriston**, Deputy M.E.; **Jo-Ann Armao**, A.M.E./Metro; **Michael Keegan**, A.M.E./News Art

Ta Nea
Athens, Greece (B)

A-section page

Dimitris Nikas, Art & Graphics Director; **Ioannis Kourtis**, Infographic Artist; **Makis Theophilopoulos**, Infographic Artist; **Dimitris Aggeloussis**, Infographic Artist

The Toronto Star
Toronto, Ont., Canada (A)

Local news page

Catherine Pike, Editor; **Mary Petek**, Designer; **Barb Gordon**, Reporter; **Natalie Alcoba**, Reporter; **Tannis Toohey**, Photographer; **Catherine Farley**, Graphics

Also winning in news design/local section.

¡Exito!
Chicago, Ill. (B)

Local news page

Héctor Sánchez, Senior Editor/Design; **Jorge Luis Mota**, Reporter; **Antonio Pérez**, Photographer; **Alejandro Escalona**, Editor; **Magdalena I. Garcia**, M.E.

Upsala Nya Tidning
Uppsala, Sweden (B)

Local news page

Staff, Design; **Dick Pettersson**, Photographer; **Pelle Johansson**, Photographer; **Tiia Derblom-Andersson**, Reporter

St. Petersburg Times
St. Petersburg, Fla. (A)
Sports page
Jim Melvin, Designer; **Don Morris,** Illustrator

The Independent on Sunday
London, England (A)
Sports page
Carolyn Roberts, Art Director; **Mike Higgins,** Section Editor; **Sophie Batterbury,** Picture Editor

Aftonbladet
Stockholm, Sweden (A)
Sports page
Staff

Fort Worth Star-Telegram
Fort Worth, Texas (A)
Sports page
Michael Currie, Sports Designer; **Coby Bailey,** Deputy Sports Editor; **Jeffery Washington,** Staff Photographer

Kristianstadsbladet
Kristianstad, Sweden (C)
Local news page
Maria Nilson, Page Designer; **Birgitta Mattisson,** Journalist; **Lasse Ottosson,** Photographer

Mural
Zapopan, México (C)
Local news page
Luis Armando Becerra Gil, Designer; **Erika Haro,** Photographer; **Enrique Ortiz,** Photographer; **Carlos Ibarra,** Photographer; **Rubén Maartinez,** Page Editor; **Guillermo Camacho,** Editorial Director; **Lázaro Rios,** General Editorial Director; **Felipe Lucero,** M.E./Design

The Boston Globe
Boston, Mass. (A)
Sports page
Brian Gross, Designer; **Dan Zedek,** Design Director

The Guardian
London, England (A)
Sports page
Staff

National Post
Don Mills, Ont., Canada (A)
Sports page
Gayle Grin, A.M.E. Design & Graphics; **Kenneth Whyte,** Editor in Chief; **Ron Wadden,** Deputy Sports Editor; **Jim Bray,** Sports Editor

Die Zeit
Hamburg, Germany (A)
Sports page
Staff

The Oregonian
Portland, Ore. (A)
Sports page
Lisa Cowan, Designer; **Bruce Ely,** Photographer; **Patty Reksten,** Photo Editor

O Globo
Rio de Janeiro, Brazil (A)
Sports page
Antonio Nascimento, Editor; **Edgar do Lago,** Designer; **Marcelo Theobald,** Photographer

Heraldo de Aragon
Zaragoza, Spain (B)

Sports page

Jose Luis Minondo, Art Director; Pilar Ostalé, Designer; Cristina Salvador, Designer; Cristina Urresti, Designer; Ana Pérez Errea, Designer; Javier Eslava, Designer; Javier Errea, Design Consultant

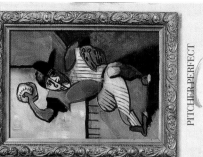

C.A. Diario Panorama
Maracaibo, Venezuela (B)

Sports page

Felix Orea, Designer

The Augusta Chronicle
Augusta, Ga. (B)

Sports page

Nate Owens, Graphic Artist; Traci Long, Night Sports Editor

Savannah Morning News
Savannah, Ga. (B)

Sports page

John Hancock, Sports Designer; Stephen Komives, Planning Editor

¡Exito!
Chicago, Ill. (B)

Local news page

Héctor Sánchez, Senior Editorial Designer; Antonio Pérez, Photographer; Gerardo Cárdenas, Reporter; Alejandro Escalona, Editor

Newsday
Melville, N.Y. (A)

Sports page

Joseph E. Baron, Art Director & Designer; Otto Strong, Photo Illustrator

The Boston Globe
Boston, Mass. (A)

Sports page

Jason McKean, Designer; Craig Newman, Designer; Dan Zedek, Design Director

The Hartford Courant
Hartford, Conn. (A)

Sports pages

Timothy Reck, Graphic Artist

El Norte
Monterrey, México (B)

Sports page

David Muñoz, Designer; Jorge Obregón, Design Editor; Ricardo Garza, Section Editor; José Francisco Grajeda, Art Managing Editor; Martha A. Treviño, Editor

The Palm Beach Post
West Palm Beach, Fla. (B)

Sports page

Sarah Franquet, Designer; Brennan King, Artist; Allen Eyestone, Photographer; Tim Burke, Executive Sports Editor; Nick Moschella, Deputy Sports Editor

Savannah Morning News
Savannah, Ga. (B)

Sports page

Moira McNichols, Sports Planner/Designer; Richard Burkhart, Photographer

RedEye
Chicago, Ill. (B)

Sports page

Michael Kellams, Sports Editor

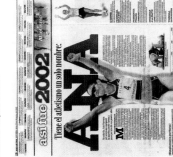

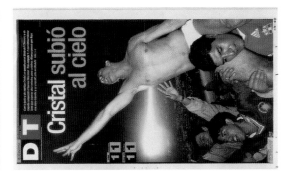

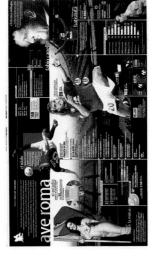

Reforma
México City, México (B)

Sports page

Alexander Probst, Designer; **Enrique Torres,** Graphics Coordinator; **Andrés Amieva,** Editor; **José Manuel Mendoza,** Graphics Editor; **Ernesto López,** Editorial Sub-Director; **Emilio Deheza,** Graphic Director

La Opinión
Los Angeles, Calif. (B)

Sports page

Jose Antonio Morales, Graphic Designer; **Tadeo Guerrero,** Design Editor/Designer; **Ruben Castro,** Editor

Heraldo de Aragon
Zaragoza, Spain (B)

Sports page

Jose Luis Minondo, Art Director; **Pilar Ostalé,** Designer; **Cristina Salvador,** Designer; **Cristina Urresti,** Designer; **Ana Pérez Errea,** Designer; **Javier Eslava,** Designer; **Javier Errea,** Design Consultant; **Carlos Moncín,** Photo Editor

The Hartford Courant
Hartford, Conn. (A)

Special news topics

Bill Sikes, Photo Editor; **Suzette Moyer,** Designer; **Michael McAndrews,** Photographer; **Thom McGuire,** A.M.E. Graphics/Photography; **Jim Kuykendall,** Graphic Artist

Asbury Park Press
Neptune, N.J. (B)

Sports page

Joe Zedalis, Assistant Sports Editor; **Harris Siegel,** Designer; **Brian Ferreira,** Staff Photographer

The Free Lance-Star
Fredericksburg, Va. (C)

Sports page

Tracy Montauk, Designer; **Dave Alexander,** H.S. Sports Coordinator; **Scott Carmine,** Graphic Artist; **Tim Rasmussen,** Photographer

RedEye
Chicago, Ill. (B)

Sports page

Michael Kellams, Sports Editor; **Chris Courtney,** Illustrator

El Comercio
Lima, Peru (B)

Sports page

Jorge Jauregui Barrientos, Designer; **Carlos Sotomayor,** Design Editor; **Rolly Reyna Yupanqui,** Photographer; **Xabier Díaz de Cerio,** Art Director

Heraldo de Aragon
Zaragoza, Spain (B)

Sports page

Jose Luis Minondo, Art Director; **Pilar Ostalé,** Designer; **Cristina Salvador,** Designer; **Cristina Urresti,** Designer; **Ana Pérez Errea,** Designer; **Javier Eslava,** Designer; **Javier Errea,** Design Consultant; **Alberto Aragon,** Artist

Mundo Deportivo
Barcelona, Spain (B)

Sports page

Joan Lanuza, Art Director

Mundo Deportivo
Barcelona, Spain (B)

Sports page

Vanessa Mauri, Designer

El Diario de Hoy
San Salvador, El Salvador (B)

Sports page

Juan Durán, Graphics Editor; **Héctor Ramírez,** Graphics & Design Editor; **Lafitte Fernández,** Newsroom Coordinator; **Claudio Martínez,** Sports Editor; **Rodrigo Baires Q.,** Sports Sub-Editor; **Osmín Herrera,** Photo Co-Editor

The San Diego Union-Tribune
San Diego, Calif. (A)
Business page
Michael Rocha, Features Design Editor

El Correo Espanol
Bilbao, Spain (B)
Breaking news topics
José Luis Nocito, Photo Editor; **Pacho Igartua**, Designer; **Rafael Marañon**, Designer; **Ana Espligares**, Designer; **Mikel García Macías**, Designer; **Laura Piedra**, Designer; **Aurelio Garrote**, Designer; **María del Carmen Navarro**, Design Editor; **Jesús Aycart**, Art Director; **Alberto Torregrosa**, Editorial Art & Design Consultant

The Times-Picayune
New Orleans, La. (A)
Business page
Charles Chauff, Designer; **Kenny Harrison**, Illustrator/Features Design Editor; **Kim Quillen**, Asst. Money Editor; **George Berke**, Design Director

Palabra
Saltillo, México (C)
Other page
Fabiola Pérez, Graphic Designer; **Alejandra Solís**, Editor; **David Brondo**, Editor Director; **Jorge Meléndez**, General Editor Director; **Vicente León**, Graphics Coordinator

The Boston Globe
Boston, Mass. (A)
Business page
Dan Zedek, Design Director; **Aude van Ryn**, Illustrator

Palabra
Saltillo, México (C)
Other page
Laura Sánchez, Graphic Designer; **Alejandra Solís**, Editor; **David Brondo**, Editor Director; **Jorge Meléndez**, General Editor Director; **Vicente León**, Graphics Coordinator; **Fernando Valdés**, Photographer; **Laura Sánchez Bravo**, Photo Artist

Palabra
Saltillo, México (C)
Sports page
Jorge Rodríguez, Graphic Designer; **Ramón Zertuche**, Photographer; **David Brondo**, Editor Director; **Jorge Meléndez**, General Editor Director; **Vicente León**, Graphics Coordinator

El Norte
Monterrey, México (B)
Inside page
Jorge Obregón, Design Editor; **Ricardo Garza**, Section Editor; **Lorena Leal**, Photo Artist; **José Francisco Grajeda**, Art Managing Editor; **Martha A. Treviño**, Editor

Heraldo de Aragon
Zaragoza, Spain (B)
Sports page
Jose Luis Minondo, Art Director; **Pilar Ostalé**, Designer; **Cristina Salvador**, Designer; **Cristina Urresti**, Designer; **Ana Pérez Errea**, Designer; **Javier Eslava**, Designer; **Javier Errea**, Design Consultant

Sunday Herald
Glasgow, Scotland (B)
Sports page
David Dick, Sports Editor; **Neil Bennet**, Picture Editor

The Orange County Register
Santa Ana, Calif. (A)
Business page
Patty Pitts, Designer; **Lisa Mertins**, Artist

Récord
México City, México (C)
Sports page
Alejandro Belman, Designer; **Hugo A. Sánchez**, Illustrator; **José Luis Tapia**, Editor; **Barbara Chavez**, Reporter; **Alberto Nava**, Art Director; **Alejo Nájera**, Design Editor; **José Luis Barros**, Graphics Editor; **Ivan Pirrón**, Section Editor

Reforma
México City, México (B)
Inside page

Aida García Castellanos, Designer; **Cristina Medrano**, Illustrator; **Ricardo del Castillo**, Graphics Editor; **Laura Cristina González**, Editor; **Roberto Castañeda**, Section Editor; **Roberto Zamarripa**, Sub-director Editorial; **René Delgado Ballesteros**, Director/Editorial; **Emilio Deheza**, Graphic Director; **Renata González**, Graphics Co-Editor; **Edgar Acosta**, Graphics Co-Editor

Mural
Zapopan, México (C)
Business page

José Juan González Morales, Designer/Illustrator; **Lázaro Ríos**, General Editorial Director; **Mauricio Rangel**, Design Managing Editor; **Ileana Murakami Ríos Velasco**, Page Editor; **José de Jesús Fajardo**, Editorial Coordinator; **Guillermo Camacho**, Editorial Director

Mural
Zapopan, México (C)
Business page

José Juan González Morales, Designer; **Georgina Martínez**, Photographer; **Mauricio Rangel**, Design Managing Editor; **Ileana Murakami Ríos Velasco**, Page Editor; **José de Jesús Fajardo**, Editorial Coordinator; **Guillermo Camacho**, Editorial Director; **Lázaro Ríos**, General Editorial Director

Reforma
México City, México (B)
Business page

Daniel Barbosa, Designer; **Javier Solís**, Designer; **Ramón Márquez**, Illustrator; **Gabriel Ortiz**, Graphics Co-Editor; **José Manuel Mendoza**, Graphics Editor; **Hugo Valenzuela**, Editor; **Martha Trejo**, Section Editor; **Enrique Quintana**, Editorial Director/Negocios; **Emilio Deheza**, Graphic Director

NY Teknik
Stockholm, Sweden (B)
Business page

Jonas Askergren, Graphic Artist; **Sara Westerberg**, Page Designer

NY Teknik
Stockholm, Sweden (B)
Business page

Jonas Askergren, Graphic Artist; **Eddie Pröckl**, Page Designer

NY Teknik
Stockholm, Sweden (B)
Business page

Jonas Askergren, Graphic Artist; **Sara Westerberg**, Page Designer

Palabra
Saltillo, México (C)
Inside page

Rolando Chacón, Editor; **Vicente León**, Graphics Coordinator; **David Brondo**, Editor Director; **Jorge Meléndez**, General Editor Director; **Carlos Mendoza**, Illustrator; **Patricia Ramos**, Editor

El País
Madrid, Spain (A)
Breaking news topics

Javier López, Design Editor; **Francisco Gómez**, Designer; **Teresa Fuente**, Designer; **Manuel González**, Designer

O Globo
Rio de Janeiro, Brazil (A)
Breaking news topics

Antonio Nascimento, Editor; **Mariana Morgado**, Designer; **Reuters**, Photographer

The Plain Dealer
Cleveland, Ohio (A)
Breaking news topics

Staff

Los Angeles Times
Los Angeles, Calif. (A)
Breaking news topics

Gary Metzker, Design Editor; **Kirk Christ**, Design Editor; **Dave Campbell**, Design Editor; **Susanna Timmons**, Design Editor

Correio Braziliense
Brasilia, Brazil (B)

Breaking news topics

Fabio Sales, Art Director; **Claudio Versiani,** Photo Editor; **Luis Costa Pinto,** Executive Editor; **José Negreiros,** Executive Editor; **Ricardo Noblat,** Newsroom Director

Diário de Notícias
Lisbon, Portugal (B)

Breaking news topics

Mário Bettencourt Resendes, Editor in Chief; **António Ribeiro Ferreira,** Deputy Editor in Chief; **José Maria Ribeirinho,** Art Director & Designer; **Luis Tenreiro,** Art Editor; **Carlos Jorge,** Designer; **Mário Henriques,** Designer; **Liliana Santos,** Designer; **Cases i Associats,** Design Consultant

O Globo
Rio de Janeiro, Brazil (A)

Breaking news topics

Antonio Nascimento, Editor; **Mariana Morgado,** Designer; **Reuters,** Photographer

El País
Madrid, Spain (A)

Breaking news topics

Javier López, Design Editor

Correio Braziliense
Brasilia, Brazil (B)

Breaking news topics

Fabio Sales, Art Director; **Claudio Versiani,** Photo Editor; **Luis Costa Pinto,** Executive Editor; **José Negreiros,** Executive Editor; **Ricardo Noblat,** Newsroom Director

Correio Braziliense
Brasilia, Brazil (B)

Breaking news topics

Fabio Sales, Art Director; **Luis Tajes,** Photo Editor; **Luis Costa Pinto,** Executive Editor; **José Negreiros,** Executive Editor; **Ricardo Noblat,** Newsroom Director

The New York Times
New York, N.Y. (A)

Breaking news topics

Grace Wong, Designer; **Pancho Bernasconi,** Picture Editor

The Virginian-Pilot
Norfolk, Va. (A)

Breaking news topics

Julie Elman, Designer; **Paul Nelson,** News Editor; **Denis Finley,** DME/Presentation

El Imparcial
Hermosillo, México (C)

Inside page

Guillermo Carrillo, Editor; **Manuel Lizárraga,** Designer; **Carlos René,** Illustrator; **Miyoshi Katsuda,** Art Director

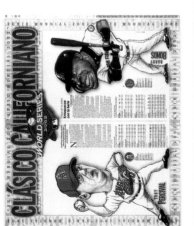

Frankfurter Allgemeine Sonntagszeitung
Frankfurt am Main, Germany (A)

Other page

Peter Breul, Art Director & Designer; **Andreas Kuther,** Picture Editor; **Martin Pudenz,** Photographer; **Gero von Randow,** Science Editor

Upsala Nya Tidning
Uppsala, Sweden (B)

Breaking news topics

Design Staff: Rolf Hamilton, Photographer; **Magnus Quennerstedt,** Reporter; **Tove Scherman,** Reporter; **Per Zettermark,** Reporter

Récord
México City, México (C)

Special news topics

Alejo Nájera, Design Editor; **Hugo A. Sánchez,** Illustrator; **Victor Edú Rodriguez,** Editor; **José Luis Barros,** Graphics Editor; **Alberto Nava,** Art Director; **Oswaldo Díaz,** Designer

The Washington Post
Washington, D.C. (A)

Breaking news topics

News Desk

San Jose Mercury News
San Jose, Calif. (A)

Breaking news topics

Staff

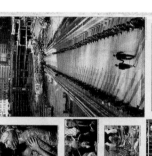

Daily News
New York, N.Y. (A)

Breaking news topics

Thomas Ruis, Design Director; **Bill St. Angelo**, Design Director, News; **Infographics Staff**

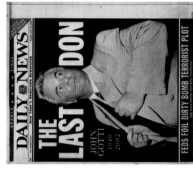

Corriere della Sera
Milano, Italy (A)

Breaking news topics

Gianluigi Colin, Art Director; **Bruno Delfino**, Acting Art Director; **Sergio Pilone**, Assistant Acting Art Director; **Marco Gillo**, Infographics Director; **Carlo Cardinale**, Senior Staffer; **Franca Gazzola**, Art Staff; **Rino Pucci**, Art Staff; **Stefano Salvia**, Art Staff; **Marcello Valoncini**, Senior Graphic Artist

Herald-Journal
Spartanburg, S.C. (B)

Breaking news topics

Brad Walters, Page Designer; **Jeff Zehr**, Design Editor; **Gloria Fair**, News Editor

0 Dia
Rio de Janeiro, Brazil (A)

Breaking news topics

Sérgio Costa, News Editor; **André Hippertt**, Art Director; **Alexandre Freeland**, News Editor; **Nel Figueiredo**, News Editor; **Ernesto Carrilo**, Photographer

20-PAGE SPECIAL REPORT

Daily News
New York, N.Y.

Breaking news topics

Thomas Ruis, Design Director; **Bill St. Angelo**, Design Director, News; **Infographics Staff**

El País
Madrid, Spain (A)

Breaking news topics

Javier Lopez, Design Editor; **Teresa Fuente**, Designer

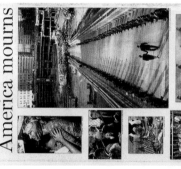

National Post
Toronto, Ont., Canada (A)

Breaking news topics

Gayle Grin, A.M.E./Design & Graphics; **Kenneth Whyte**, Editor in Chief; **Martin Newland**, Deputy Editor; **Alison Uncles**, M.E.; **Steve Meurice**, Deputy M.E.; **Rob McKenzie**, Page One Editor; **Denis Paquin**, Photo Editor; **Laura Koot**, News Presentation; **Kelly McParland**, Foreign Editor

Sur
Málaga, Spain (C)

Breaking news topics

Baldomero Villanueva, Section Designer; **Rafael Ruiz**, Designer; **M. Dolores Tortosa**, Researcher; **Bella Palomo**, Copy Editor; **José Juan Ruiz**, Sub-Editor; **José Vicente Astorga**, Section Editor; **Fernando González**, Photo Director; **Francisco Sánchez Ruano**, Art Director; **Alfredo Trivino**, Concept Designer; **Alberto Torregrosa**, Editorial Design Consultant

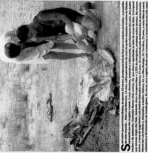

Sur
Málaga, Spain (C)

Breaking news topics

Baldomero Villanueva, Section Designer; **Rafael Ruiz**, Designer; **Pedro García**, Researcher; **Héctor Barbotta**, Copy Editor; **José Juan Ruiz**, Sub-Editor; **José Vicente Astorga**, Section Editor; **Fernando González**, Photo Director; **Francisco Sánchez Ruano**, Art Director; **Alfredo Trivino**, Concept Designer; **Alberto Torregrosa**, Editorial Design Consultant

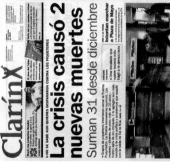

Clarín
Buenos Aires, Argentina (A)

Breaking news topics

Iñaki Palacios, Art Director; **Juan Elissetche**, Design Editor; **Carlos Vazquez**, Design Editor; **Soledad Calvo**, Graphic Designer; **Francisco Jurado Emery**, Graphic Designer; **Verónica Colombo**, Graphic Designer; **Osvaldo Estevao**, Graphic Designer; **Rosana Dillon**, Graphic Designer; **Oscar Bejarano**, Graphic Designer

San Jose Mercury News
San Jose, Calif. (A)

Breaking news topics

Tim Ball, Sports Design Director; **Jim Gensheimer**, Photographer; **Mike Guersch**, Executive Sports Editor; **Craig Lancaster**, Assistant Sports Editor

San Jose Mercury News
San Jose, Calif. (A)

Breaking news topics

Tim Ball, Sports Design Director; **Dave Curtis**, Copy Editor; **Gary Reyes**, Photographer

Corriere della Sera
Milano, Italy (A)

Breaking news topics

Gianluigi Colin, Art Director; **Bruno Delfino**, Acting Art Director; **Sergio Pilone**, Assistant Acting Art Director; **Marco Gillo**, Infographics Director; **Carlo Cardinale**, Senior Staffer; **Franca Gazzola**, Art Staff; **Rino Pucci**, Art Staff; **Stefano Salvia**, Art Staff; **Marcello Valoncini**, Senior Graphic Artist

Corriere della Sera
Milano, Italy (A)

Breaking news topics

Gianluigi Colin, Art Director; **Bruno Delfino**, Acting Art Director; **Sergio Pilone**, Assistant Acting Art Director; **Marco Gillo**, Infographics Director; **Carlo Cardinale**, Senior Staffer; **Franca Gazzola**, Art Staff; **Rino Pucci**, Art Staff; **Stefano Salvia**, Art Staff; **Marcello Valoncini**, Senior Graphic Artist

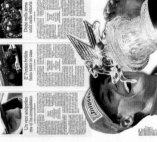

The Independent on Sunday
London, England (A)

Breaking news topics

Carolyn Roberts, Art Director; **Elissa Millhouse**, Deputy Art Director; **Keith Howitt**, Graphics; **Alan Marshall**, A.M.E./News; **Alan Christie**, National Editor; **Neil Ballantyne**, Photo Editor; **Clive Dinham**, Page One Editor; **Asmaa Malik**, News Editor

The Toronto Star
Toronto, Ont., Canada (A)

Breaking news topics

Carl Neustaedter, A.M.E. Design; **Catherine Pike**, Deputy Art Director; **Catherine Farley**, Graphics; **Alan Marshall**, A.M.E./News; **Alan Christie**, National Editor; **Neil Ballantyne**, Photo Editor; **Clive Dinham**, Page One Editor; **Asmaa Malik**, News Editor

The Hartford Courant
Hartford, Conn. (A)

Special news topics

Josue Evilla, Designer; **Rick Shaw**, Art Director; **Melanie Shaffer**, Design Editor

Corriere della Sera
Milano, Italy (A)

Special news topics

Gianluigi Colin, Art Director; **Sergio Pilone**, Acting Art Director; **Marco Gillo**, Infographics Director; **Carlo Cardinale**, Senior Staffer; **Franca Gazzola**, Art Staff; **Rino Pucci**, Art Staff; **Stefano Salvia**, Art Staff; **Marcello Valoncini**, Senior Graphic Artist

Heraldo de Aragon
Zaragoza, Spain (B)

Breaking news topics

Jose Luis Minondo, Art Director; **Pilar Ostalé**, Designer; **Cristina Salvador**, Designer; **Cristina Urresti**, Designer; **Ana Pérez Errea**, Designer; **Javier Eslava**, Designer; **Javier Errea**, Design Consultant; **Isidro Gil**, Artist

The San Diego Union-Tribune
San Diego, Calif. (A)

Special news topics

Chris Barber, Page Designer; **Greg Manifold**, Sports Designer; **Brian Gross**, Sports Designer; **K.C. Alfred**, Photographer; **Charles Starr**, Photo Editor; **Doug Williams**, Deputy Sports Editor; **Chuck Scott**, Sports Editor; **Andy Fenelon**, Sports Designer; **Kirk Kenney**, Sports Designer; **Staff**

The Seattle Times
Seattle, Wash. (A)

Special news topics

Jeff Paslay, Designer; **Dean Rutz**, Photographer; **Rod Mar**, Photographer; **Fred Nelson**, Photo Editor; **Angela Gottschalk**, Photo Editor; **Rick Lund**, Designer; **Mark Nowlin**, Infographic Artist; **Whitney Stensrud**, Graphics Editor; **Liz McClure**, Graphics Director; **David Miller**, Design Director

The Globe and Mail
Toronto, Ont., Canada (A)

Special news topics

Fred Lum, Photographer; **Eric Nelson**, Art Director, News; **Erin Elder**, Photo Editor; **David Pratt**, Design Director; **Steve McAllister**, Sports Editor; **Chuck Corley**, Layout Editor; **Phil King**, Layout Editor; **Mike Pasternak**, Copy Editor; **Richard Palmer**, Graphics Editor

La Voz de Galicia
Arteixo, Spain (B)
Special news topics
Jesus Gil, Art Director; María Pedreda, Design Coordinator; Xoang González, Graphics Coordinator; Xurxo Lobato, Photo Editor

Clarín
Buenos Aires, Argentina (A)
Special news topics
Iñaki Palacios, Art Director; Juan Elissetche, Design Editor; Federico Sosa, Design Editor; Carlos Vazquez, Design Editor; Soledad Calvo, Graphic Designer; Francisco Jurado Emery, Graphic Designer; Verónica Colombo, Graphic Designer; Osvaldo Estevao, Graphic Designer; Rosana Dillon, Graphic Designer; Victoria Quintiero, Graphic Designer

Kristianstadsbladet
Kristianstad, Sweden (C)
Special news topics
Maria Nilson, Page Designer; Birgitta Mattisson, Journalist; Lasse Ottosson, Photographer; Tommy Svensson, Photographer; Rickard Frank, News Graphic Artist

La Voz de Galicia
Arteixo, Spain (B)
Special news topics
Jesus Gil, Art Director; María Pedreda, Design Coordinator; Xoang González, Graphics Coordinator; Xurxo Lobato, Photo Editor

Heraldo de Aragon
Zaragoza, Spain (B)
Special news topics
Jose Luis Minondo, Art Director; Pilar Ostalé, Designer; Cristina Salvador, Designer; Ana Pérez Errea, Designer; Cristina Urresti, Designer; Javier Eslava, Designer; Javier Errea, Design Consultant; Isidro Gil, Artist

Heraldo de Aragon
Zaragoza, Spain (B)
Special news topics
Jose Luis Minondo, Art Director; Pilar Ostalé, Designer; Cristina Salvador, Designer; Ana Pérez Errea, Designer; Cristina Urresti, Designer; Javier Eslava, Designer; Javier Errea, Design Consultant; Carlos Moncín, Photo Editor; Photo Staff

National Post
Toronto, Ont., Canada (A)
Special news topics
Gayle Grin, A.M.E. Graphics/Design; Kenneth Whyte, Editor in Chief; Martin Newland, Deputy Editor; Alison Uncles, A.M.E.; Steve Meurice, Deputy M.E.; Laura Koot, News Presentation; John Racovali, News Editor; Denis Paquin, Photo Editor; Martina Blaskovic, Copy Editor

Corriere della Sera
Milan, Italy (A)
Special news topics
Gianluigi Colin, Art Director; Bruno Delfino, Acting Art Director; Sergio Pilone, Assistant Acting Art Director; Marco Gillo, Infographics Director; Carlo Cardinale, Senior Staffer; Franca Gazzola, Staffer; Rino Pucci, Staffer; Stefano Salvia, Staffer; Marcello Valoncini, Staffer

The Washington Post
Washington, D.C. (A)
Special news topics
Beth Broadwater, Assistant News Editor; News Desk

El Comercio
Lima, Peru (B)
Special news topics
Carlos Sotomayor, Design Editor; Verónica Salem, Photographer; Daniel Silva, Photographer; Marco Avilés, Researcher; Xabier Díaz de Cerio, Art Director

The Washington Post
Washington, D.C. (A)
Special news topics
News Desk; Vince Bzdek, News Editor; Ed Thiede, A.M.E./News Desk

The Toronto Star
Toronto, Ont., Canada (A)
Special news topics
Catherine Pike, Designer; Greg Smith, Editor; Moira Welsh, Reporter; Peter Power, Photographer; Michael Herman, Map

Opinion section and page

Lifestyle/features section and page

Entertainment section and page

Food section and page

Fashion section and page

Home/real estate section and page

Travel section and page

Science/technology section and page

Other section and page

Awards

AWARDS OF EXCELLENCE, unless designated.

GOLD, exceptional work.

SILVER, outstanding work.

JUDGES' SPECIAL RECOGNITION, worthy of a singular, superior honor in the category, is in Chapter 2, pages 26-37.

Additional awards of excellence winners are in a gallery beginning on page 86.

Circulation

Indicated after each publication's location
(A) 175,000 & over
(B) 50,000-174,999
(C) 49,999 & under

San Jose Mercury News
San Jose, Calif. (A)

Opinion page

Crystal Chappell, Designer; **Kevin Wendt,** News Design Director; **Kim Fararo,** Perspective Editor; **Matt Mansfield,** Deputy M.E.

The News & Observer
Raleigh, N.C. (B)

Opinion page

Scott Sharpe, Photographer; **Shyam Patel,** Illustrator; **Teresa Kriegsman,** Assistant Director/News Design

The Miami Herald
Miami, Fla. (A)

Opinion page

Kris Strawser, News Design Editor & Designer; **Suzy Mast,** Photo Editor; **Chuck Fadely,** Photographer

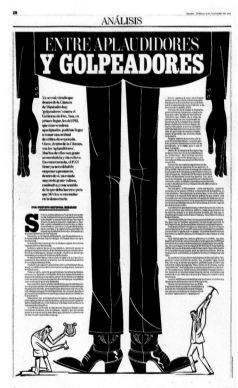

Palabra
Saltillo, México (C)

Opinion page

Francisco García, Graphic Designer; **Vicente León,** Graphics Coordinator; **David Brondo,** Editor Director; **Jorge Meléndez,** General Editor Director; **Carlos Mendoza,** Illustrator; **Patricia Ramos,** Editor

The Hartford Courant
Hartford, Conn. (A)

Lifestyle/features page

Chris Moore, Design Editor

SILVER
El Norte
Monterrey, México (B)

Lifestyle/features page

Gaspar Enrique Hernández Garcia, Designer; **René Almanza,** Illustrator; **Nohemí Bernal Garza,** Art Section Editor; **Carlos A. Martínez,** Section Editor; **Guillermo Reyes,** Design Managing Editor; **Martha A. Treviño,** Editor

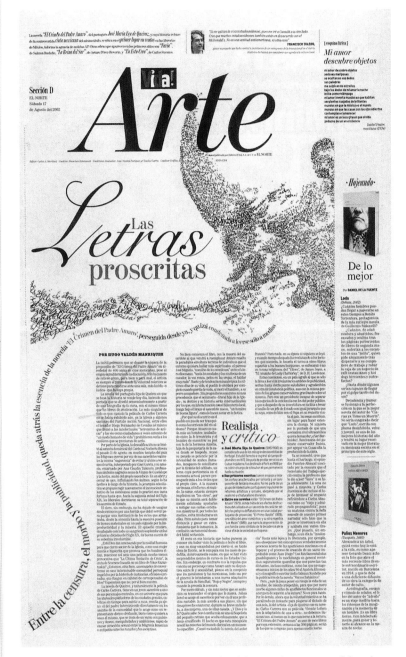

Judges: A very difficult, chaotic design to do, this entry is very graceful at the same time. Real artistry, and an excellent solution.

Jueces: Con diseño caótico y difícil de presentar, esta pieza está presentada con gracia. Gran calidad artística y solución excelente.

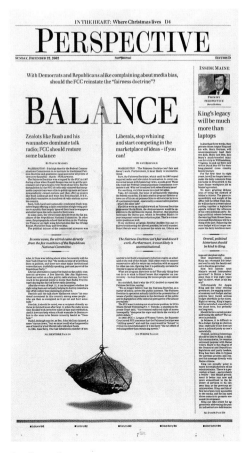

Sun Journal
Lewiston, Maine (C)

Opinion page

Heather McCarthy, Senior Designer; **Pete Gorski,** Artist

Brabants Dagblad
Hertogenbosch, The Netherlands (A)

Opinion page

John Back, Designer

South Florida Sun-Sentinel
Fort Lauderdale, Fla. (A)

Opinion page

Jeff Cercone, Designer; **John Rhodes,** Editor; **Tom Peyton,** Visual Editor

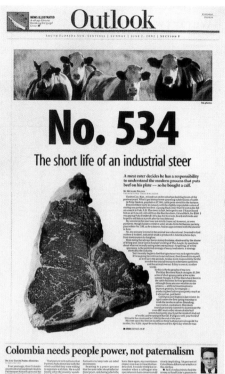

The Miami Herald
Miami, Fla. (A)

Lifestyle/features page

Nuri Ducassi, Designer/Illustrator

Also winning in illustration/single.

Mural
Zapopan, México (C)

Lifestyle/features page

Horacio Tortajada, Designer/Illustrator/Photographer; **Fernando Jauregui,** Design Managing Editor; **Karla Garduño,** Page Editor; **Juan Carlos Garda,** Editorial Coordinator; **Guillermo Camacho,** Editorial Director; **Lázaro Ríos,** General Editorial Director

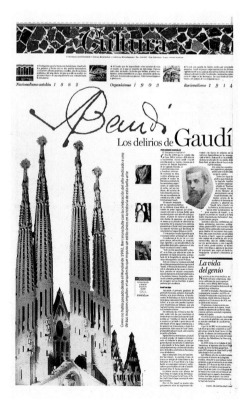

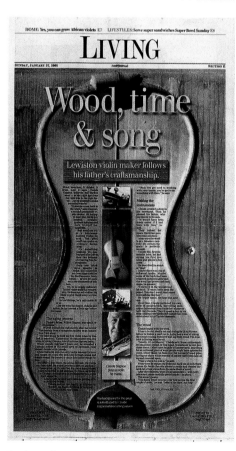

Sun Journal
Lewiston, Maine (C)

Lifestyle/features page

Ursula Albert, Features Editor; **Daryn Slover,** Staff Photographer

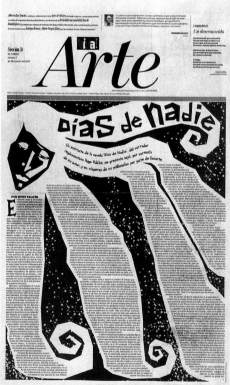

El Norte
Monterrey, México (B)

Lifestyle/features page

Edgar García Rodríguez, Designer; **Nohemí Bernal Garza,** Art Section Editor; **Carlos A. Martínez,** Section Editor; **René Almanza,** Illustrator; **Martha A. Treviño,** Editor; **Guillermo Reyes,** Design Managing Editor

SILVER
Dagens Nyheter
Stockholm, Sweden (A)

Lifestyle/features page

Lotta Ek, Art Director; **Lotta Holm,** Page Designer; **Pär Björkman,**
Photo Editor; **Miki Dedijek,** Photographer

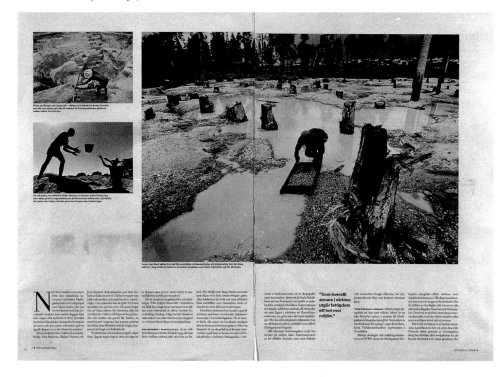

Judges: It's amazing for a paper to commit three color double-truck pages. Gorgeous photos, beautifully presented, with white space framing them eloquently. Amazing reproduction with no frames.

Jueces: Es increíble que un diario presente tres páginas dobles a color. Fotos preciosas, presentadas con gracia y espacios blancos que las enmarcan con elocuencia. Reproducciones fascinantes sin marcos.

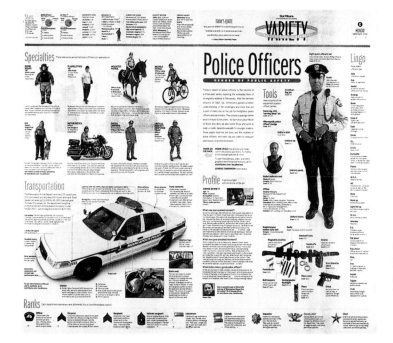

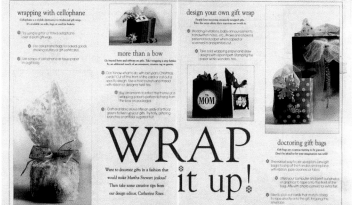

The Free Lance-Star
Fredericksburg, Va. (C)

Lifestyle/features page

Tracy Montauk, Designer; **Davis Turner,** Photographer

Star Tribune
Minneapolis, Minn. (A)

Lifestyle/features page

Denise M. Reagan, Designer; **Kim Yeager,** Project Editor; **Jane Friedmann,** Artist; **Mark Boswell,** Artist; **Tom Wallace,** Photographer; **Maria Baca,** Writer; **Susie Eaton Hopper,** A.M.E./Features; **Rhonda Prast,** Asst. Design Director/Features; **Randy Miranda,** Variety Editor

Sunday Herald
Glasgow, Scotland (B)

Lifestyle/features section

Andrew Jaspan, Editor; **Richard Walker,** Deputy Editor; **Roxanne Sorooshian,** Production Editor; **Neil Bennet,** Picture Editor; **Production Staff**

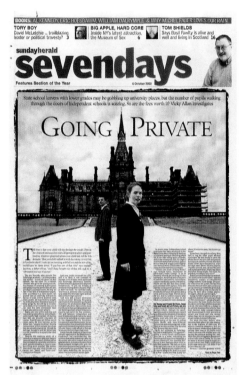

Arizona Daily Star
Tucson, Ariz. (B)

Lifestyle/features page

Maria Camou, Features Designer; **Chiara Bautista,** Illustrator; **José Merino,** Design Director; **Teri Hayt,** A.M.E./Presentation

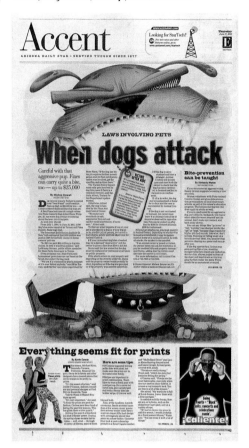

Le Soleil
Québec, P.Q., Canada (B)

Lifestyle/features page

Marc Duplain, Graphic Designer

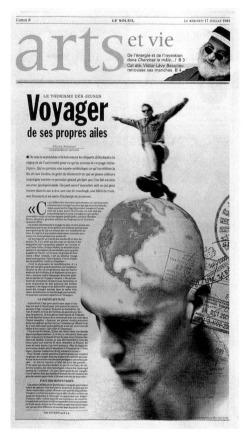

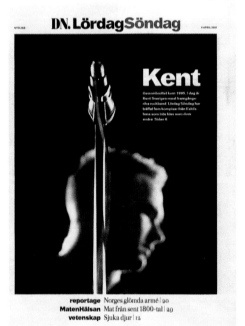

Dagens Nyheter
Stockholm, Sweden (A)

Lifestyle/features page

Anne-Marie Höglund, Page Designer; **Lotta Ek,** Art Director; **Pär Björkman,** Photo Editor; **Sofia Ekström,** Photographer

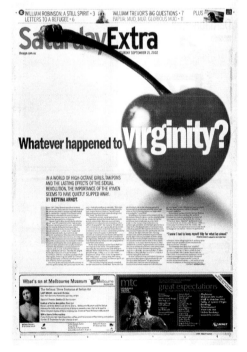

The Age
Melbourne, Australia (A)

Lifestyle/features page

Andrew Wolf, Art Director & Designer; **Sally Heath,** Saturday Extra Editor; **Andrew Ryan,** Production Editor

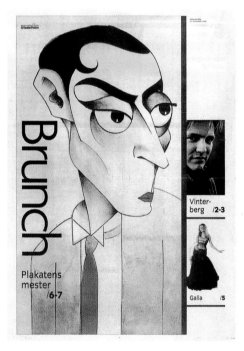

Morgenavisen Jyllands-Posten
Viby, Denmark (A)

Lifestyle/features page

Joergen Hoeg, Sub-Editor; **Finn Koch,** Sub-Editor

Mural
Zapopan, México (C)

Lifestyle/features page

Ricardo Soto, Designer/Illustrator; **Gabriel Anaya,** Photographer; **Fernando Jauregui,** Design Managing Editor; **Mireya Espinosa,** Page Editor; **Juan Carlos Garda,** Editorial Coordinator; **Guillermo Camacho,** Editorial Director; **Lázaro Ríos,** General Editorial Director

El Sol
Monterrey, México (C)

Entertainment page

Eliseo López Aquirre, Designer; **Raúl Urdiales,** Section Editor; **Alejandro Banuet Guiot,** M.E./Design; **Gil Jesús Chávez,** Editor

SILVER
Dagens Nyheter
Stockholm, Sweden (A)

Lifestyle/features section

Lotta Ek, Art Director; **Calle Skoglund,** Art Director; **Pär Björkman,** Photo Editor; **Pelle Asplund,** Art Director; **Jonas Unger,** Photo Editor; **Daniel Qvarnström,** Photo Editor

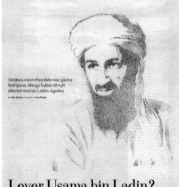

The Hartford Courant
Hartford, Conn. (A)

Entertainment page

JoEllen Black, Photo Editor/Features; **Suzette Moyer,** Design Editor; **Ingrid Muller,** Designer

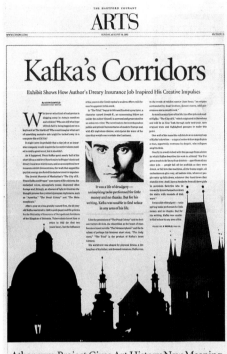

The Star-Ledger
Newark, N.J. (A)

Entertainment page

Peter Ambush, Illustrator; **George Frederick,** Graphics Editor

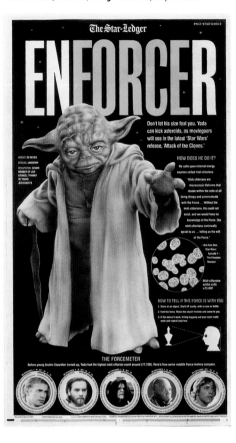

The Seattle Times
Seattle, Wash. (A)

Entertainment page

Jeff Neumann, Designer

Público
Lisbon, Portugal (B)

Entertainment page

Vasco Câmara, Editor; **Hugo Pinto,** Designer

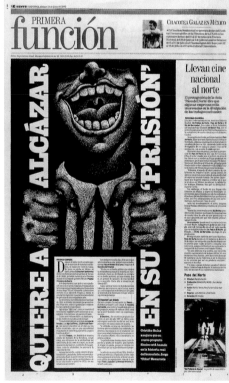

Reforma
México City, México (B)

Entertainment page

Nilton Torres, Graphics Co-editor; **Alma Cecilia Falcón,** Illustrator; **Hugo Lazcano,** Editor; **Raúl Espinosa de los Monteros,** Graphics Editor; **Rosa Ma. Villarreal,** Editorial Director; **Emilio Deheza,** Graphic Director

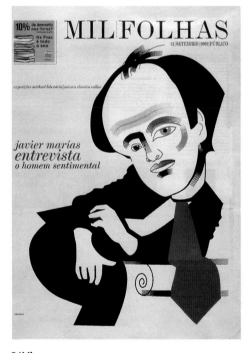

Público
Lisbon, Portugal (B)

Entertainment page

Isabel Coutinho, Editor; **Hugo Pinto,** Designer; **João Lázaro,** Illustrator

El Comercio
Lima, Peru (B)

Entertainment page

Lupe Aynayaque, Designer; **Carlos Sotomayor,** Design Editor; **Xabier Díaz de Cerio,** Art Director

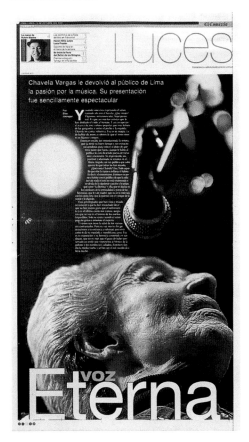

The Seattle Times
Seattle, Wash. (A)

Entertainment page

Jeff Neumann, Designer

SILVER
Siglo XXI
Guatemala, Guatemala (C)

Entertainment section

Luis Villacinda, Art Director; **Juan Pablo Dardon,** Editor; **Mauricio Acevedo,** Photographer; **Erick de León,** Designer; **Sergio Estrada,** Designer; **Daniel Lux,** Illustrator; **Billy Melgar,** Illustrator; **Alejandro Azurdia,** Illustrator; **Wendy García,** Reporter; **Fidel Celada,** Reporter

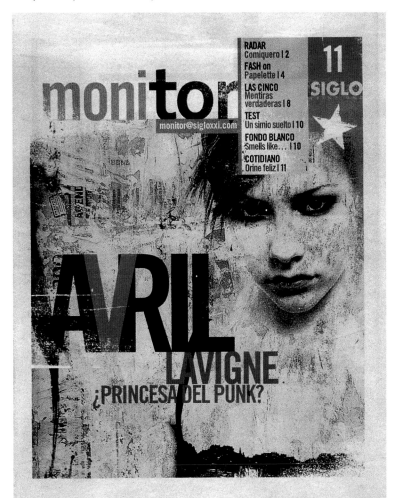

Judges: These sections are edgy. They are consistently clear and easy to follow – and they speak to young readers.

Jueces: Estas secciones son punzantes. Mantienen una coherencia porque son limpias, fáciles de leer y atraen a jóvenes lectores.

Mural
Zapopan, México (C)

Food page

Karina Aguirre Durán, Designer/Illustrator; **Eugenio Salas,** Photographer; **Fernando Jauregui,** Design Managing Editor; **Wendy Pérez Rios,** Page Editor; **Juan Carlos Garda,** Editorial Coordinator; **Guillermo Camacho,** Editorial Director; **Lázaro Ríos,** General Editorial Director

The Hartford Courant
Hartford, Conn. (A)

Food page

Chris Moore, Design Editor; **JoEllen Black,** Photo Editor; **John Woike,** Photographer

Liberty Times
Taipei, Taiwan (A)

Food page

Tung Ku-ying, Art Director; **Lu Ching-huei,** Designer

The Age
Melbourne, Australia (A)

Food section

Ian Warnecke, Designer; **Andrew Wolf,** Art Director/Sections; **Kylie Walker,** Editor; **De Luxe & Associates,** Design Consultants

Politiken
Copenhagen, Denmark (A)

Fashion page

Søren Nyeland, Design Editor; **Christine Cato,** Designer; **Marianne Gram,** Senior Editor; **Edel Hildebrandt,** Copy Editor; **Annette Nyvang,** Copy Editor; **Tine Harden,** Copy Editor

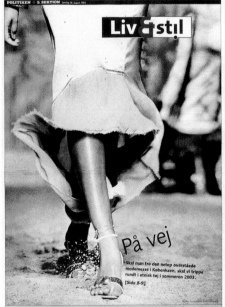

United Daily News
Taipei, Taiwan (A)

Fashion page

Wang Wei-Wei, Art Director/Designer; **Huang Ching-Ya,** Editor

GOLD
Göteborgs-Posten
Göteborg, Sweden (A)

Food page

Gunilla Wernhamn, Designer; **Jonny Mattsson,**
Designer/Photographer

Judges: One of the most striking entries we saw, this design and photo style were thoughtful all the way through. It makes you want to cook the food that you see. The cover gives you a clue of what's inside. Then each page connects with a surprise.

Jueces: Una de las piezas que nos llamó más la atención. Este diseño y estilo fotográfico se pensaron de antemano. Impulsa al lector a cocinar lo que ve en las páginas. La portada te da una idea de lo que contienen las páginas interiores. Luego cada pagina te sorprenderá.

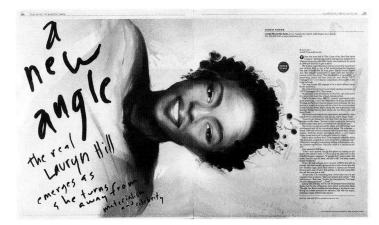

The Seattle Times
Seattle, Wash. (A)

Entertainment page

Susan Jouflas, Designer/Illustrator

Sun Journal
Lewiston, Maine (C)

Entertainment page

Ursula Albert, Entertainment Editor

El Norte
Monterrey, México (B)

Fashion page

Barbara Esquinca, Designer; **Angeles Nassar,** Graphics Coordinator; **Karime García-Travesí,** Photographer; **Jesús Aburto,** Digital Art; **Diana Marcos,** Senior Editor; **Guillermo Reyes,** Design Managing Editor; **Martha A. Treviño,** Director Editor

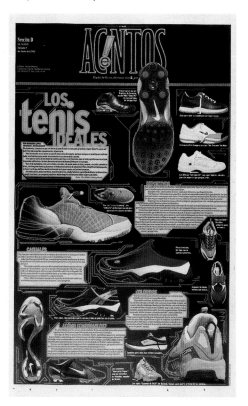

Bergens Tidende
Sandsli, Norway (B)

Fashion page

Arne Edvardsen, Design Editor; **Walter Jensen,** Designer

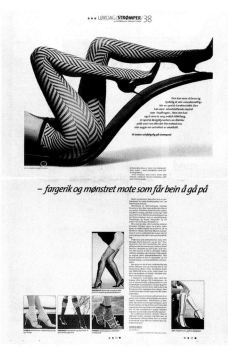

The Boston Globe
Boston, Mass. (A)

Home/real estate page

Chin Wang, Art Director & Designer; **Wendy Fox,** Editor; **Dan Zedek,** Design Director; **Juliette Borda,** Illustrator

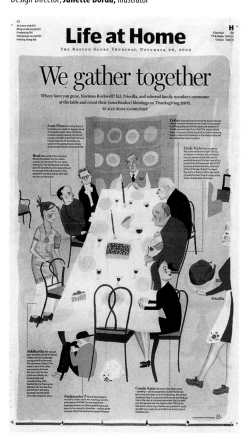

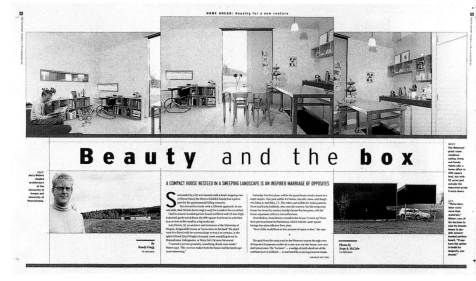

The Oregonian
Portland, Ore. (A)

Home/real estate page

Michelle D. Wise, Visuals Editor

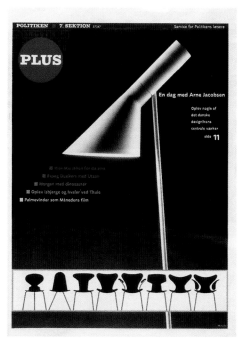

Politiken
Copenhagen, Denmark (A)

Home/real estate page

Søren Nyeland, Design Editor; **Per Bergsbo,** Designer; **Henrik Jacobsen,** Copy Editor

Liberty Times
Taipei, Taiwan (A)

Home/real estate page

Tung Ku-ying, Art Director; **Lu Ching-huei,** Designer

The Orange County Register
Santa Ana, Calif. (A)

Home/real estate page

Helayne Perry, Designer

SILVER
Liberty Times
Taipei, Taiwan (A)

Travel page

Tung Ku-ying, Art Director; **Tu Yu-pei,** Designer

Judges: The color, typography, composition, image, resolution – it's a very good page. The character means "river," and the entry uses legs of type to complete the form of the character. It's poetry.

Jueces: El color, la tipografía, la composición, la imagen y la resolución: es una página muy buena. El personaje es el "río" y la pieza utiliza columnas de tipografía para completar la forma del personaje. Es poesía.

El Comercio
Lima, Peru (B)

Travel page

Milagros Valenzuela, Designer; **Carlos Sotomayor,** Design Editor; **Xabier Díaz de Cerio,** Art Director

Chicago Tribune
Chicago, Ill. (A)

Travel page

Jason McKean, Art Director; **Randy Curwen,** Travel Editor

The Hartford Courant
Hartford, Conn. (A)

Travel page

Christian Potter Drury, Illustrator; **Suzette Moyer,** Designer

NY Teknik
Stockholm, Sweden (B)

Science/technology page

Jonas Askergren, Graphic Artist; **Eddie Pröckl,** Page Designer

Göteborgs-Posten
Göteborg, Sweden (A)

Travel page

Gunilla Wernhamn, Designer; **Ulf Sveningson,** Illustrator

The Boston Globe
Boston, Mass. (A)

Science/technology page

Cindy Daniels, Art Director; **Scott Allen,** Editor; **Agnieszka Biskup,** Asst. Editor; **Dan Zedek,** Design Director

The New York Times
New York, N.Y. (A)

Travel page

Barbara Richer, Art Director; **Dieter Braun,** Illustrator

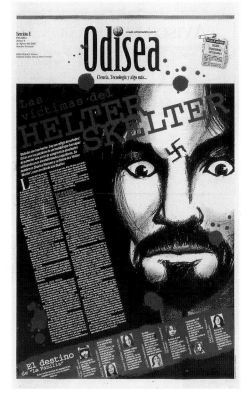

Palabra
Saltillo, México (C)

Science/technology page

Fabiola Pérez, Graphic Designer; **Carlos Mendoza,** Illustrator; **Miguel Barroso,** Editor; **Vicente León,** Graphic Coordinator; **David Brondo,** Editor Director; **Jorge Meléndez,** General Editor Director

SILVER
Periodico Provincia
Morelia, México (C)

Science/technology page

Raúl Olmos, Editor; **Gustavo Vega,** Graphics Editor; **Julio César Muñoz,** Designer

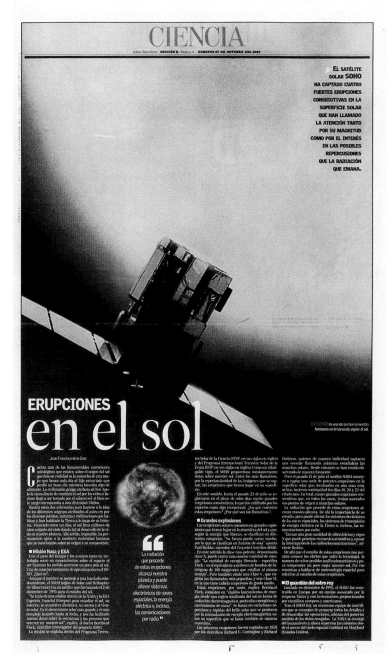

Judges: A dramatic topic received dramatic photo play, with a structural restraint that results in elegant simplicity.

Jueces: Un tema conmovedor recibió un despliegue fotográfico dramático con una restricción estructural que resulta en una simplicidad elegante.

Récord
México City, México (C)

Other section

Victor Cruz, Designer; **Dórica García,** Section Designer; **Cristina Porter,** Editor; **Andrea Flores,** Section Editor; **Alberto Nava,** Art Director; **Alejo Nájera,** Design Editor; **José Luis Barros,** Graphics Editor

Boston Herald
Boston, Mass. (A)

Other page

Gustavo Leon, Design Manager; **Kathleen M.G. Howlett,** Illustrator

El Norte
Monterrey, México (B)

Other section

Antonio Abimerhi, Designer; **Graciela Sánchez,** Graphics Coordinator; **Miguel Angel Chávez,** Photographer; **Guillermo Reyes,** Design Managing Editor; **Martha A. Treviño,** Editor Director; **Victor Alemán,** Senior Editor

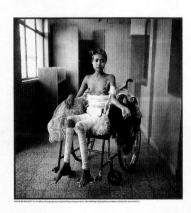

Bergens Tidende
Sandsli, Norway (B)

Other page

Arne Edvardsen, Design Editor; **Walter Jensen,** Designer; **Roar Christiansen,** Feature Editor; **Oddleiv Apneseth,** Photographer

El Norte
Monterrey, México (B)

Other page

Barbara Esquinca, Designer; **Angeles Nassar,** Graphic Coordinator; **Carolina Sáinz,** Photographer; **Diana Marcos,** Section Editor; **Guillermo Reyes,** Design Managing Editor; **Martha A. Treviño,** Editor Director

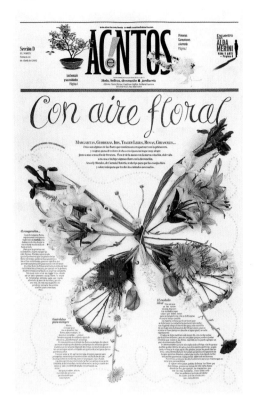

Liberty Times
Taipei, Taiwan (A)

Other page

Tung Ku-ying, Art Director; **Wang Feng-mai,** Designer

SILVER
Education Week
Bethesda, Md. (B)

Other page

Virginia B. Edwards, Editor & Publisher; **Gregory Chronister,** M.E.;
Karen Diegmueller, Deputy M.E.; **Laura Baker,** Design Director;
Allison Shelley, Photo Editor/Photographer; **James W. Prichard,**
Assistant Photo Editor

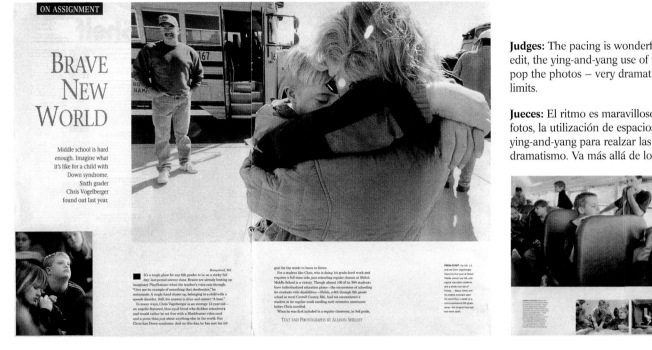

Judges: The pacing is wonderful. The photo edit, the ying-and-yang use of white space to pop the photos – very dramatic. It pushes the limits.

Jueces: El ritmo es maravilloso. La edición de fotos, la utilización de espacios blancos ying-and-yang para realzar las fotos consigue dramatismo. Va más allá de los límites.

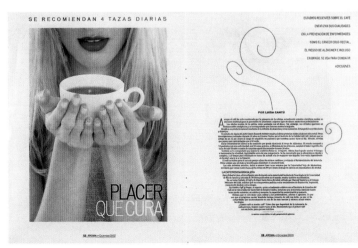

Reforma
México City, México (B)

Food page

Tsuki Shiraishi, Designer; **Bertha Herrera,** Photographer; **Regina Landa,** Graphics Coordinator; **Irma Aguilar,** Editor; **Rubén Hernández,** Editor; **Raúl Espinosa de los Monteros,** Graphics Editor; **Celia Marín,** Editorial Coordinator; **Rosa Ma. Villarreal,** Editorial Director; **Emilio Deheza,** Graphic Director

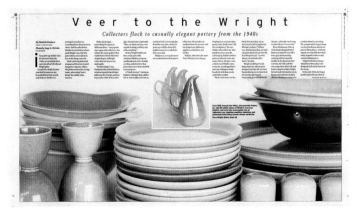

The Oregonian
Portland, Ore. (A)

Home/real estate section

Michelle D. Wise, Visuals Editor

Clarin
Buenos Aires, Argentina (A)
Opinion page
Iñaki Palacios, Art Director; Juan Elissetche,
Design Editor; Federico Sosa, Design Editor;
Carlos Vazquez, Design Editor; Soledad Calvo,
Graphic Designer; Francisco Jurado Emery,
Graphic Designer; Verónica Colombo, Graphic
Designer; Osvaldo Estevao, Graphic Designer;
Rosana Dillon, Graphic Designer; Oscar
Bejarano, Graphic Designer

The Virginian-Pilot
Norfolk, Va. (A)
Opinion page
Sam Hundley, Designer; Lynn Feigenbaum,
Editor

The New York Times
New York, N.Y. (A)
Opinion page
Michael Valenti, Art Director; Sarah
Weissman, Picture Editor

The Washington Post
Washington, D.C. (A)
Opinion page
Bonnie Benwick, Art Director; Steven
Luxenberg, Editor

Chicago Tribune
Chicago, Ill. (A)
Opinion page
Michael Miner, Art Director; Charles M.
Madigan, Editor; Drew Sottardi, Graphic
Reporter; Chris Soprych, Graphic Artist; Susan
Ryan, Photo Editor

Göteborgs-Posten
Göteborg, Sweden (A)
Opinion page
Albert Rosander, Designer; Ulf Sveningson,
Illustrator

The Boston Globe
Boston, Mass. (A)
Opinion page
Gregory Klee, Art Director & Designer; James
Concannon, Editor; Dan Zedek, Design Director

The Boston Globe
Boston, Mass. (A)
Opinion page
Gregory Klee, Art Director & Designer; James
Concannon, Editor; Dan Zedek, Design Director

**Frankfurter Allgemeine
Sonntagszeitung**
Frankfurt am Main, Germany (A)
Opinion page
Peter Breul, Art Director; Marianne Hartz,
Designer; Andreas Kuther, Picture Editor;
Alfons Holtgreve, Illustrator; Thomas Schmid,
Politics Editor

The Baltimore Sun
Baltimore, Md. (A)
Opinion page
Michelle Deal-Zimmerman, A.M.E.
Graphics/Design; Peter Yuill, Features Design
Director; Jay Judge, News Design Director

Corriere della Sera
Milano, Italy (A)
Opinion page
Gianluigi Colin, Art Director; Bruno Delfino,
Acting Art Director; Sergio Pilone, Assistant
Acting Art Director; Marco Gillo, Infographics
Director; Carlo Cardinale, Senior Staffer; Franca
Gazzola, Art Staff; Rino Pucci, Art Staff;
Stefano Salvia, Art Staff; Marcello Valoncini,
Senior Graphic Artist

Chicago Tribune
Chicago, Ill. (A)
Opinion page
Michael Miner, Art Director; Charles M.
Madigan, Editor

Democrat and Chronicle
Rochester, N.Y. (A)
Opinion page
Paulina Garces Reid, Assistant Graphics Editor

The Plain Dealer
Cleveland, Ohio (A)
Opinion page
David Kordalski, A.M.E./Visuals; **Pat McCubbin,** Designer

The Guardian
London, England (A)
Opinion page
Staff

St. Louis Post-Dispatch
St. Louis, Mo. (A)
Opinion page
Christine Zueck, Designer; **Tom Borgman,** Features Creative Director; **Roger Hensley,** Design Director

South Florida Sun-Sentinel
Fort Lauderdale, Fla. (A)
Opinion page
Jennifer Mellichamp, Designer; **John Rhodes,** Editor; **Tom Peyton,** Visual Editor; **George Wilson,** Photo Editor

Die Zeit
Hamburg, Germany (A)
Opinion page
Staff

The Plain Dealer
Cleveland, Ohio (A)
Opinion page
David Kordalski, A.M.E./Visuals; **Pat McCubbin,** Designer; **Andrea Levy,** Illustrator

South Florida Sun-Sentinel
Fort Lauderdale, Fla. (A)
Opinion page
Jeff Glick, Creative Director; **John Rhodes,** Editor; **Tom Peyton,** Designer

The Virginian-Pilot
Norfolk, Va. (A)
Opinion page
Sam Hundley, Designer; **Lynn Feigenbaum,** Editor

The Globe and Mail
Toronto, Ont., Canada (A)
Opinion page
David Woodside, Weekend Art Director; **David Pratt,** Editorial Design Director; **Moe Doirow,** Deputy Photo Editor; **Jerry Johnson,** Focus Editor

The New York Times
New York, N.Y. (A)
Opinion page
Greg Ryan, Art Director

The Globe and Mail
Toronto, Ont., Canada (A)
Opinion page
David Woodside, Weekend Art Director; **David Pratt,** Editorial Design Director; **Erin Elder,** Photo Editor; **Jerry Johnson,** Focus Editor

The Miami Herald
Miami, Fla. (A)
Lifestyle/features page
Juan Lopez, Senior Features Designer; Hiram Henriquez, Illustrator; Sara Frederick, Weekend Editor; Cary Darling, Arts Editor; Kendall Hamersly, Executive Features Editor; Nuri Ducassi, Design Director

Politiken
Copenhagen, Denmark (B)
Lifestyle/features page
Soren Nyeland, Design Editor; Mai-Britt Bernt Jensen, Designer; Jesper Friis, Culture Editor; Christian Ilsøe, Senior Editor; Henrik Bay, Copy Editor

Calgary Herald
Calgary, Canada (B)
Opinion page
Steve Young, Designer; Monica Zurowski, Editor

Dagens Nyheter
Stockholm, Sweden (A)
Lifestyle/features page
Dennis Eriksson, Illustrator; Johan Rutherhagen, Art Director; Calle Görman, Art Director

Calgary Herald
Calgary, Canada (B)
Opinion page
Kathryn Fisher, Graphic Designer/Illustrator; Dick Wallace, Design Editor; Monica Zurowski, Features Editor

The Free Lance-Star
Fredericksburg, Va. (C)
Opinion page
Jennifer Rochette, Designer; Scott Carmine, Graphic Artist

Taipei Times
Taipei, Republic of China (C)
Opinion page
Constance Chou, Design Editor; Kevin Hsu, Designer

Palabra
Saltillo, Mexico (C)
Opinion page
Francisco García, Graphic Designer; Vicente León, Graphics Coordinator; David Brondo, Editor Director; Jorge Meléndez, General Editor Director; Carlos Mendoza, Illustrator; Patricia Ramos, Editor

The News & Observer
Raleigh, N.C. (B)
Opinion page
Kate Frantz, News Designer

Sun Journal
Lewiston, Maine (C)
Opinion section
Tim Frank, M.E./Design; Pete Gorski, Artist; Cam Churchill, Design Editor; Heather McCarthy, Section Designer

El Comercio
Lima, Peru (B)
Opinion page
Carlos Sotomayor, Design Editor; Xabier Díaz de Cerio, Art Director; Jorge Andrade, Designer; Victor Aguilar, Illustrator

El Caribe
Santo Domingo, Dominican Republic (C)
Opinion page
Iban Campo, Editor in Chief; Yelidá Alcántara, Art Director; Karen Cortes, Design Editor; Jhonny Jiménez, Illustrator; Roberto Severino, Designer

Frankfurter Allgemeine Sonntagszeitung
Frankfurt am Main, Germany (A)

Lifestyle/features page

Peter Breul, Art Director & Designer; **Andreas Kuther**, Picture Editor; **Axel Scheffler**, Illustrator; **Joerg Albrecht**, Lifestyle Writer

Dagens Nyheter
Stockholm, Sweden (A)

Lifestyle/features page

Beata Holmquist, Page Designer; **Johan Rutherhagen**, Art Director; **Inga-Karin Eriksson**, Illustrator

The Plain Dealer
Cleveland, Ohio (A)

Lifestyle/features page

Andrea Levy, Illustrator/Photographer; **David Kordalski**, A.M.E./Visuals; **Scott Sheldon**, Features Design Director

Dagens Nyheter
Stockholm, Sweden (A)

Lifestyle/features page

Sophie Graalheim, Art Director & Page Designer

The Washington Post
Washington, D.C. (A)

Opinion page

Bonnie Benwick, Art Director; **Steven Luxenberg**, Editor

Scotland on Sunday
Edinburgh, Scotland (B)

Opinion page

John McLellen, Editor; **Tom Little**, Deputy Editor; **Gavin Munro**, Art Director; **Mark Grayson**, Deputy Art Director; **Tony Marsh**, Executive Picture Editor; **Chris Deerin**, Executive Editor; **Donald MacPhee**, Deputy Chief Sub-Editor

Style Weekly
Richmond, Va. (C)

Opinion page

Jeffrey Bland, Art Director

El Sol
Monterrey, México (C)

Opinion page

Victor Manuel Cabiedes, Designer; **David Nateras Tirado**, Illustrator; **Eliseo López Aquirre**, Design Editor; **Miguel Angel Reyes**, Section Editor; **Alejandro Banuet Guiot**, M.E./Design; **Gil Jesús Chávez**, Editor

Detroit Free Press
Detroit, Mich. (A)

Lifestyle/features page

Elio Leturia, Features Designer; **Todd Cross**, Features Photo Editor; **Mauricio Gutiérrez**, Deputy Design Director/Features; **Steve Dorsey**, Design & Graphics Director

The New York Times
New York, N.Y. (A)

Lifestyle/features page

Corinne Myller, Art Director; **John Papasian**, Illustrator; **Tony Cenicola**, Photographer

The Orange County Register
Santa Ana, Calif. (A)

Lifestyle/features page

Joelle Beckett, Designer; **Lisa Mertins**, Illustrator; **Peter Nguyen**, Art Director

Politiken
Copenhagen, Denmark (A)

Lifestyle/features page

Søren Nyeland, Design Editor; **Christine Cato**, Designer; **Marianne Gram**, Senior Editor; **Edel Hildebrandt**, Copy Editor; **Annette Nyvang**, Copy Editor; **Tine Harden**, Copy Editor

The Independent on Sunday
London, England (A)

Lifestyle/features page

Carolyn Roberts, Art Director; **Elissa Millhouse**, Deputy Art Director; **Keith Howitt**, Production Editor; **Sophie Batterbury**, Picture Editor; **Nick Coleman**, Section Editor

The Baltimore Sun
Baltimore, Md. (A)

Lifestyle/features page

Carrie Lyle, Designer; **Peter Yuill**, Features Design Director

The Seattle Times
Seattle, Wash. (A)

Lifestyle/features page

Tracy Porter, Designer

St. Petersburg Times
St. Petersburg, Fla. (A)

Lifestyle/features page

Nikki Life, Features Designer; **Brandon Jeffords**, Illustrator

The Hartford Courant
Hartford, Conn. (A)

Lifestyle/features page

Joseph Hilliman, Designer

Die Zeit
Hamburg, Germany (A)

Lifestyle/features page

Staff

The Times of Northwest Indiana
Munster, Ind. (B)

Lifestyle/features page

Kris Karnopp, Design Editor; **Jon L. Hendricks**, Photographer

The Times of Northwest Indiana
Munster, Ind. (B)

Lifestyle/features page

Kris Karnopp, Design Editor; **Amanda Raymond**, Graphics Team Leader

Dagens Nyheter
Stockholm, Sweden (A)

Lifestyle/features page

Ylva Magnusson, Page Designer; **Carl Anders Skoglund**, Art Director; **Daniel Qvarnström**, Photo Editor; **Peter Hoelstad**, Photographer

La Voz del Interior
Cordoba, Argentina (B)

Lifestyle/features page

Javier Candellero, Designer/Illustrator; **Jorge Londero**, Editor; **Miguel de Lorenzi**, Art Director; **Alberto Torregrosa**, Design Consultant

Correio Braziliense
Brasília, Brazil (B)

Lifestyle/features page

Fabio Sales, Art Director; **Chica Magalhães**, Page Designer; **Kido Guerra**, Editor

El Imparcial
Hermosillo, México (C)

Lifestyle/features page

Karla Valenzuela, Editor; **Rodolfo Larios**, Designer; **Miyoshi Katsuda**, Art Director

The Ottawa Citizen
Ottawa, Ont., Canada (B)

Lifestyle/features page

Kit Collins, Designer; **Wayne Cuddington**, Photographer; **Lynn McAuley**, M.E.; **Liz Payne**, Deputy Style Editor

The Herald
Jasper, Ind. (C)

Lifestyle/features page

Daniel Ross, Lifestyle Editor

La Voz del Interior
Cordoba, Argentina (B)

Lifestyle/features page

Javier Candellero, Designer/Illustrator; **Jorge Londero**, Editor; **Miguel de Lorenzi**, Art Director; **Alberto Torregrosa**, Design Consultant

El Imparcial
Hermosillo, México (C)

Lifestyle/features page

Karla Valenzuela, Editor; **Rodolfo Larios**, Designer; **Miyoshi Katsuda**, Art Director

Politiken
Copenhagen, Denmark (B)

Lifestyle/features page

Søren Nyeland, Design Editor; **Peter Sætternissen**, Designer; **Jesper Friis**, Culture Editor; **Christian Ilsøe**, Senior Editor

El Norte
Monterrey, México (B)

Lifestyle/features page

Gaspar Enrique Hernández García, Designer; **René Almanza**, Illustrator; **Nohemi Bernal Garza**, Art Section Editor; **Carlos A. Martinez**, Section Editor; **Guillermo Reyes**, Design Managing Editor; **Martha A. Treviño**, Editor

El Norte
Monterrey, México (B)

Lifestyle/features page

Gaspar Enrique Hernández García, Designer; **Nohemi Bernal Garza**, Art Section Director; **Carlos A. Martinez**, Section Editor; **Guillermo Reyes**, Art Managing Editor; **Martha A. Treviño**, Editor

El Norte
Monterrey, México (B)

Lifestyle/features page

Gaspar Enrique Hernández García, Designer; **René Almanza**, Illustrator; **Nohemi Bernal Garza**, Art Section Editor; **Carlos A. Martinez**, Section Editor; **Guillermo Reyes**, Design Managing Editor; **Martha A. Treviño**, Editor

The Augusta Chronicle
Augusta, Ga. (B)

Lifestyle/features page

John Gogick, News Editor; **Michael Holahan**, Photographer; **Elizabeth Adams**, Managing Editor

La Voz del Interior
Cordoba, Argentina (B)

Lifestyle/features page

Javier Candellero, Designer/Illustrator; **Jorge Londero**, Editor; **Miguel de Lorenzi**, Art Director; **Alberto Torregrosa**, Design Consultant

The Free Lance-Star
Fredericksburg, Va. (C)
Lifestyle/features page
Catherine Riser, Design Editor; **Joe Amon**, Photographer

Taloussanomat
Helsinki, Finland (C)
Lifestyle/features page
Ari Kinnari, Art Director; **Jarkko Sirkia**, Photo Artist

Sun Journal
Lewiston, Maine (C)
Lifestyle/features page
Tim Frank, M.E./Design; **Jose Leiva**, Staff Photographer

Taipei Times
Taipei, Taiwan (C)
Lifestyle/features page
Yi-Chun Chen, Design Editor; **June Hsu**, Designer

The Post-Star
Glens Falls, N.Y. (C)
Lifestyle/features page
Rhonda Triller, Copy Editor

Mural
Zapopan, México (C)
Lifestyle/features page
Ricardo Soto, Designer/Illustrator; **Fernando Jauregui**, Design Managing Editor; **Karla Garduño**, Page Editor; **Juan Carlos Garda**, Editorial Coordinator; **Guillermo Camacho**, Editorial Director; **Lázaro Ríos**, General Editorial Director

Jacksonville Journal-Courier
Jacksonville, Ill. (C)
Lifestyle/features page
Jason Lewton, Designer

Taloussanomat
Helsinki, Finland (C)
Lifestyle/features page
Ari Kinnari, Art Director; **Jukka Päivärinta**, Graphic Designer

The Telegraph
Alton, Ill. (C)
Lifestyle/features page
Corey Stulce, Lifestyle Editor

Taipei Times
Taipei, Taiwan (C)
Lifestyle/features page
Yi-Chun Chen, Design Editor

Taipei Times
Taipei, Taiwan (C)
Lifestyle/features page
Becky Ku, Designer; **Yi-Chun Chen**, Design Editor; **Hui-Tse Ho**, Illustrator

The Free Lance-Star
Fredericksburg, Va. (C)
Lifestyle/features page
Catherine Riser, Design Editor; **Staff**, Photographers

Style Weekly
Richmond, Va. (C)
Lifestyle/features page
Jeffrey Bland, Art Director

Style Weekly
Richmond, Va. (C)
Lifestyle/features page
Jeffrey Bland, Art Director

Svenska Dagbladet
Stockholm, Sweden (A)
Entertainment page
Anna Thurfjell, Art Director & Page Designer;
Giannie Mangs, Photographer

Público
Lisbon, Portugal (B)
Entertainment page
Vasco Câmara, Editor; **Ivone Ralha,** Designer

La Opinión
Los Angeles, Calif. (B)
Entertainment page
Tadeo Guerrero, Design Editor/Designer; **Hugo Quintana,** Editor

El Correo
Bilbao, Spain (B)
Lifestyle/features page
Javier Zarracina, Illustrator; **Rafael Marañon,** Designer; **Pacho Igartua,** Designer; **Ana Espligares,** Designer; **Mikel García Macías,** Designer; **Laura Piedra,** Designer; **Aurelio Garrote,** Designer; **Maria del Carmen Navarro,** Design Editor; **Jesús Aycart,** Art Director; **Alberto Torregrosa,** Editorial Art & Design Consultant

Dagens Naeringsliv
Oslo, Norway (B)
Lifestyle/features page
Cort Johnson, Editor; **Elin Høyland,** Photographer

Dagens Nyheter
Stockholm, Sweden (A)
Lifestyle/features page
Jesper Waldersten, Illustrator; **Johan Rutherhagen,** Art Director

Sur
Málaga, Spain (C)
Lifestyle/features page
Antonio Torres, Designer; **Rafael Ruiz,** Designer; **Lola de la Vega,** Section Designer; **Bella Palomo,** Copy Editor; **Antonio Ortin,** Sub-Editor; **Ana Barreales,** Section Editor; **Fernando González,** Photo Director; **Francisco Sánchez Ruano,** Art Director; **Alfredo Triviño,** Concept Designer; **Alberto Torregrosa,** Editorial Design Consultant

Prensa Libre
Guatemala City, Guatemala (B)
Entertainment page
Gonzalo Marroquín, Editorial Director; **Antonio Ramírez,** Design Director; **Viviana Ruiz,** Section Editor; **Joanne de Tellez,** Designer; **Dennys Mejía,** Graphic Artist

La Nación
Tibás, Costa Rica (B)
Lifestyle/features page
Mellania Villanueva, Designer; **Luis Roberto Rojas,** Art Director; **Rándall Araya,** Graphical Conceptor

The Boston Globe
Boston, Mass. (A)
Entertainment page
Gregory Klee, Art Director/Designer; **Scott Heller**, Editor; **James Turner**, Illustrator; **Dan Zedek**, Design Director

The Independent
London, England (A)
Lifestyle/features section
Kevin Bayliss, Art Director; **Matt Straker**, Deputy Art Director

Chicago Tribune
Chicago, Ill. (A)
Entertainment page
Joan Cairney, Art Director; **Linda Bergstrom**, Designer; **Chris Hill**, Sculpture

The Herald
Glasgow, Scotland (B)
Lifestyle/features section
Fiona Russell, Editor; **Dominic Ryan**, Production Editor; **Elaine Livingston**, Picture Editor

Austin American-Statesman
Austin, Texas (A)
Entertainment page
Mike Sutter, Art Director

The Ottawa Citizen
Ottawa, Ont., Canada (B)
Lifestyle/features section
Kit Collins, Designer; **Wayne Hiebert**, Photographer; **Lynn McAuley**, M.E.; **Liz Payne**, Deputy Style Editor; **Paula McLaughlin**, Designer; **Robert Cross**, Illustrator; **Laura Robin**, Travel Editor; **Andreas Heidebrecht**, Designer

The Detroit News
Detroit, Mich. (A)
Entertainment page
Rick Watkins, Features Designer; **Ray Stanczak**, Features Design Director; **Janice Kowalski**, Presentation Editor; **Nancy Hanus**, Director/Photography

The Asian Wall Street Journal
Hong Kong, Hong Kong S.A.R. (B)
Lifestyle/features section
Omar Vega, Art Director & Designer; **Stephanie Wood**, Editor; **Kerry Hardy**, Designer; **Janelle Carrigan**, Deputy Editor
Also winning in features/lifestyle page

The Hartford Courant
Hartford, Conn. (A)
Entertainment page
Ingrid Muller, Designer; **Suzette Moyer**, Design Editor

The Globe and Mail
Toronto, Ont., Canada (A)
Lifestyle/features section
David Woodside, Weekend Art Director; **David Pratt**, Editorial Design Director; **Erin Elder**, Photo Editor; **Moe Doirow**, Deputy Photo Editor; **Sheree-Lee Olson**, Style Editor

The Hartford Courant
Hartford, Conn. (A)
Entertainment page
Joseph Hilliman, Designer/Illustrator

The Tribune
San Luis Obispo, Calif. (C)
Lifestyle/features section
Joe Tarica, Presentation Editor; **Andy Castagnola**, Page Designer; **Meleisa Shaffer**, Page Designer; **Ryan Healy**, Page Designer; **Daymond Gascon**, Page Designer; **Rochelle Reed**, Features Editor

Pittsburgh Post-Gazette
Pittsburgh, Pa. (A)
Entertainment page
Diane Juravich, Page Designer; **Ted Crow,** Illustrator; **Scott Mervis,** Weekend Editor

Pittsburgh Post-Gazette
Pittsburgh, Pa. (A)
Entertainment page
Diane Juravich, Page Designer; **Scott Mervis,** Weekend Editor

Pittsburgh Post-Gazette
Pittsburgh, Pa. (A)
Entertainment page
Diane Juravich, Page Designer; **Stacy Innerst,** Illustrator; **Scott Mervis,** Weekend Editor

The Boston Globe
Boston, Mass. (A)
Entertainment page
Jane Martin, Art Director; **Scott Heller,** Editor; **Thomas Libetti,** Illustrator; **Dan Zedek,** Design Director

The Boston Globe
Boston, Mass. (A)
Entertainment page
Jane Martin, Art Director; **Scott Heller,** Editor; **Lane Turner,** Photographer

The Baltimore Sun
Baltimore, Md. (A)
Entertainment page
Joannah Hill, Designer; **Peter Yuill,** Features Design Director

Chicago Tribune
Chicago, Ill. (A)
Entertainment page
Joan Cairney, Art Director; **Linda Bergstrom,** Editor; **Yucel,** Illustrator

The Hartford Courant
Hartford, Conn. (A)
Entertainment page
Josue Evilla, Designer; **Rick Shaw,** Art Director; **JoEllen Black,** Photo Editor

The Dallas Morning News
Dallas, Texas (A)
Entertainment page
Mary Jennings, Designer

The Boston Globe
Boston, Mass. (A)
Entertainment page
Chin Wang, Art Director & Designer; **Scott Heller,** Editor; **Dan Zedek,** Design Director

The Boston Globe
Boston, Mass. (A)
Entertainment page
Chin Wang, Art Director & Designer; **Scott Heller,** Arts Editor; **Dan Zedek,** Design Director

The Baltimore Sun
Baltimore, Md. (A)
Entertainment page
Peter Yuill, Designer

Público
Lisbon, Portugal (B)
Entertainment page
Vasco Câmara, Editor; **Ivone Ralha**, Designer

Público
Lisbon, Portugal (B)
Entertainment page
Vasco Câmara, Editor; **Hugo Pinto**, Designer

Público
Lisbon, Portugal (B)
Entertainment page
Vasco Câmara, Editor; **Hugo Pinto**, Designer

Público
Lisbon, Portugal (B)
Entertainment page
Isabel Coutinho, Editor; **Jorge Guimarães**, Designer

Público
Lisbon, Portugal (B)
Entertainment page
Isabel Coutinho, Editor; **Jorge Guimarães**, Designer; **Miguel Madeira**, Photographer

Público
Lisbon, Portugal (B)
Entertainment page
Isabel Coutinho, Editor; **Hugo Pinto**, Designer; **Francisco Lobo**, Illustrator

Público
Lisbon, Portugal (B)
Entertainment page
Vasco Câmara, Editor; **Hugo Pinto**, Designer

Público
Lisbon, Portugal (B)
Entertainment page
Vasco Câmara, Editor; **Ivone Ralha**, Designer

Público
Lisbon, Portugal (B)
Entertainment page
Isabel Coutinho, Editor; **Jorge Guimarães**, Designer; **Paulo Nozolino**, Photographer

Público
Lisbon, Portugal (B)
Entertainment page
Isabel Coutinho, Editor; **Jorge Guimarães**, Designer; **Rui Gaudêncio**, Photographer

Público
Lisbon, Portugal (B)
Entertainment page
Isabel Coutinho, Editor; **Jorge Guimarães**, Designer; **João Fazenda**, Illustrator

The Orange County Register
Santa Ana, Calif. (A)
Entertainment page
Rick Ngoc Ho, Designer; **Peter Nguyen,** Art Director

St. Louis Post-Dispatch
St. Louis, Mo. (A)
Entertainment page
Nikola Maria Taylor, Designer; **Tom Borgman,** Features Creative Director; **Roger Hensley,** Design Director

El Comercio
Lima, Peru (B)
Entertainment page
Lupe Aynayaque, Designer; **Carlos Sotomayor,** Design Editor; **Xabier Díaz de Cerio,** Art Director; **Victor Aguilar,** Illustrator

Chicago Tribune
Chicago, Ill. (A)
Entertainment page
Michael Miner, Design Editor; **Catherine Whipple,** Art Director; **Barbara Schaffner,** TV Editor

Rockford Register Star
Rockford, Ill. (B)
Entertainment page
Javier Torres, Art Director/Graphics Editor; **Jenny Pollock,** Entertainment Editor; **Will Pfeifer,** Assistant Features Editor; **Brian Scott Ching,** Graphic Artist/Designer

Chicago Tribune
Chicago, Ill. (A)
Entertainment page
Michael Miner, Art Director; **Linda Bergstrom,** Editor; **Mike Zajakowski,** Photo Editor

St. Petersburg Times
St. Petersburg, Fla. (A)
Entertainment page
Christian Potter Drury, Design Editor

Bergens Tidende
Bergen, Norway (B)
Entertainment page
Arne Edvardsen, Design Editor; **Walter Jensen,** Designer; **Fred Ivar Utsi Klemmetsen,** Photographer

Albuquerque Journal
Albuquerque, N.M. (B)
Entertainment page
Leah Derrington, Designer; **Cathryn Cunningham,** Illustrator; **George Gibson,** Graphics Coordinator; **Fran Maher,** Design Director; **Joe Kirby,** A.M.E.

The Wichita Eagle
Wichita, Kan. (B)
Entertainment page
Rod Pocowatchit, Designer

Público
Lisbon, Portugal (B)
Entertainment page
Vasco Câmara, Editor; **Hugo Pinto,** Designer

Público
Lisbon, Portugal (B)
Entertainment page
Vasco Câmara, Editor; **Hugo Pinto,** Designer

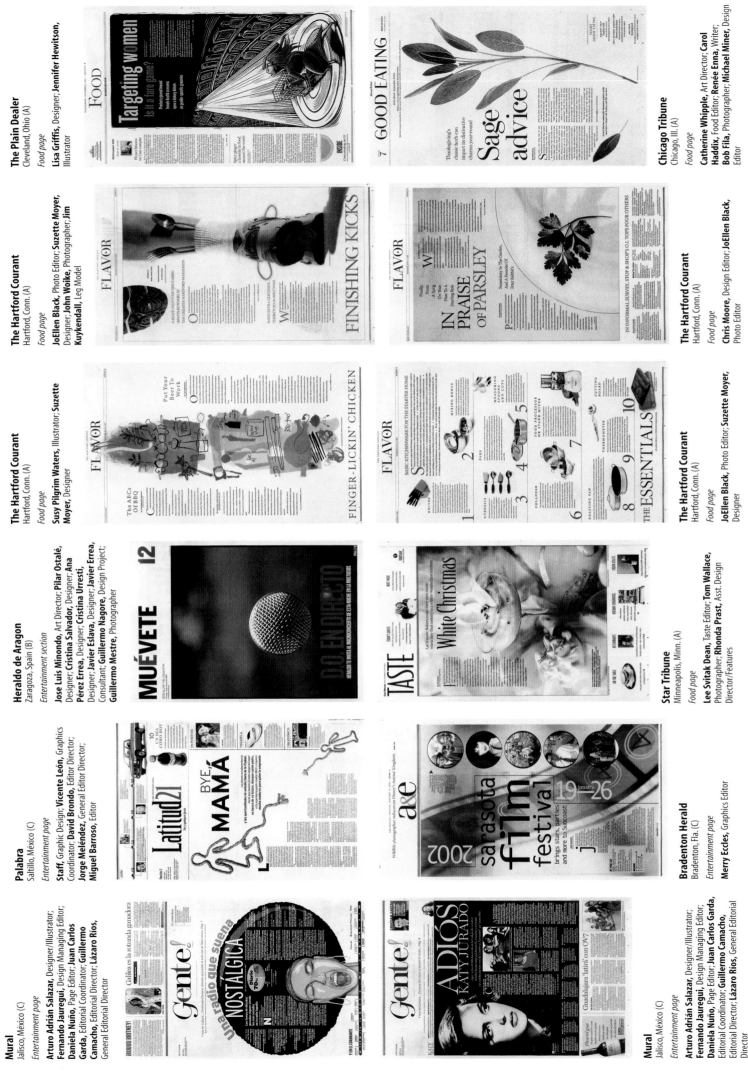

The Plain Dealer
Cleveland, Ohio (A)
Food page
Lisa Griffis, Designer; **Jennifer Hewitson**, Illustrator

The Hartford Courant
Hartford, Conn. (A)
Food page
JoEllen Black, Photo Editor; **Suzette Moyer**, Designer; **John Woike**, Photographer; **Jim Kuykendall**, Leg Model

The Hartford Courant
Hartford, Conn. (A)
Food page
Susy Pilgrim Waters, Illustrator; **Suzette Moyer**, Designer

Heraldo de Aragon
Zaragoza, Spain (B)
Entertainment section
Jose Luis Minondo, Art Director; **Pilar Ostalé**, Designer; **Cristina Salvador**, Designer; **Ana Pérez Errea**, Designer; **Cristina Urresti**, Designer; **Javier Eslava**, Designer; **Javier Errea**, Consultant; **Guillermo Nagore**, Design Project; **Guillermo Mestre**, Photographer

Palabra
Saltillo, México (C)
Entertainment page
Staff, Graphic Design; **Vicente León**, Graphics Coordinator; **David Brondo**, Editor Director; **Jorge Meléndez**, General Editor Director; **Miguel Barroso**, Editor

Mural
Jalisco, México (C)
Entertainment page
Arturo Adrián Salazar, Designer/Illustrator; **Fernando Jauregui**, Design Managing Editor; **Daniela Nuño**, Page Editor; **Juan Carlos Garda**, Editorial Coordinator; **Guillermo Camacho**, Editorial Director; **Lázaro Rios**, General Editorial Director

Mural
Jalisco, México (C)
Entertainment page
Arturo Adrián Salazar, Designer/Illustrator; **Fernando Jauregui**, Design Managing Editor; **Daniela Nuño**, Page Editor; **Juan Carlos Garda**, Editorial Coordinator; **Guillermo Camacho**, Editorial Director; **Lázaro Rios**, General Editorial Director

Chicago Tribune
Chicago, Ill. (A)
Food page
Catherine Whipple, Art Director; **Carol Haddix**, Food Editor; **Renée Enna**, Writer; **Bob Fila**, Photographer; **Michael Miner**, Design Editor

The Hartford Courant
Hartford, Conn. (A)
Food page
Chris Moore, Design Editor; **JoEllen Black**, Photo Editor

The Hartford Courant
Hartford, Conn. (A)
Food page
JoEllen Black, Photo Editor; **Suzette Moyer**, Designer

Star Tribune
Minneapolis, Minn. (A)
Food page
Lee Svitak Dean, Taste Editor; **Tom Wallace**, Photographer; **Rhonda Prast**, Asst. Design Director/Features

Bradenton Herald
Bradenton, Fla. (C)
Entertainment page
Merry Eccles, Graphics Editor

Público
Lisbon, Portugal (B)
Entertainment page
Vasco Câmara, Editor; **Hugo Pinto**, Designer

Público
Lisbon, Portugal (B)
Entertainment page
Vasco Câmara, Editor; **Ivone Ralha**, Designer

Público
Lisbon, Portugal (B)
Entertainment page
Vasco Câmara, Editor; **Hugo Pinto**, Designer;
Ivone Ralha, Designer

Frontera
Chula Vista, Calif. (C)
Entertainment page
Magdalena Miranda, Designer; **Jeanette Sanchez**, Editor; **Hugo Fernández**, Coordinator; **Julia María Crespo Freijo**, Design Coordinator

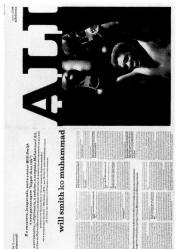

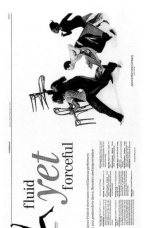

Politiken
Copenhagen, Denmark (B)
Entertainment section
Staff

Dagens Nyheter
Stockholm, Sweden (A)
Fashion page
Nina Andén, Page Designer; **Ylva Magnusson**, Page Designer; **Pelle Asplund**, Art Director; **Stina Wirsén**, Illustrator

Público
Lisbon, Portugal (B)
Entertainment page
Vasco Câmara, Editor; **Hugo Pinto**, Designer

Sun Journal
Lewiston, Maine (C)
Entertainment page
Ursula Albert, Entertainment Editor

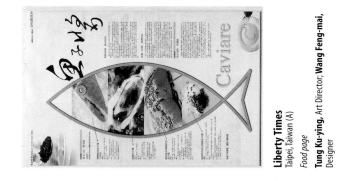

The Seattle Times
Seattle, Wash. (A)
Food page
Julie Notarianni, Designer/Illustrator

Liberty Times
Taipei, Taiwan (A)
Food page
Tung Ku-ying, Art Director; **Wang Feng-mai**, Designer

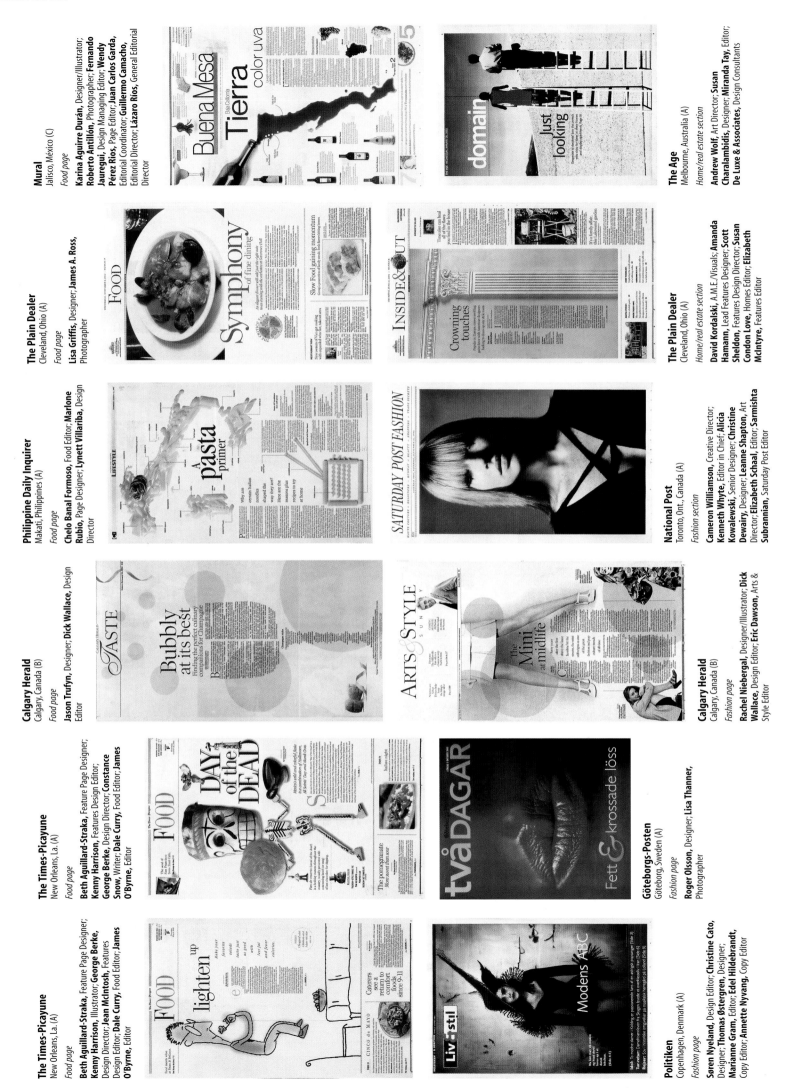

Mural
Jalisco, México (C)
Food page

Karina Aguirre Durán, Designer/Illustrator; Roberto Antillón, Photographer; Fernando Jáuregui, Design Managing Editor; Wendy Pérez Ríos, Page Editor; Juan Carlos Garda, Editorial Coordinator; Guillermo Camacho, Editorial Director; Lázaro Ríos, General Editorial Director

The Plain Dealer
Cleveland, Ohio (A)
Food page

Lisa Griffis, Designer; James A. Ross, Photographer

Philippine Daily Inquirer
Makati, Philippines (A)
Food page

Chelo Banal Formoso, Food Editor; Marlone Rubio, Page Designer; Lynett Villariba, Design Director

Calgary Herald
Calgary, Canada (B)
Food page

Jason Trufyn, Designer; Dick Wallace, Design Editor

The Times-Picayune
New Orleans, La. (A)
Food page

Beth Aguillard-Straka, Feature Page Designer; Kenny Harrison, Features Design Editor; George Berke, Design Director; Constance Snow, Writer; Dale Curry, Food Editor; James O'Byrne, Editor

The Times-Picayune
New Orleans, La. (A)
Food page

Beth Aguillard-Straka, Feature Page Designer; Kenny Harrison, Illustrator; George Berke, Design Director; Jean McIntosh, Features Design Editor; Dale Curry, Food Editor; James O'Byrne, Editor

The Age
Melbourne, Australia (A)
Home/real estate section

Andrew Wolf, Art Director; Susan Charalambidis, Designer; Miranda Tay, Editor; De Luxe & Associates, Design Consultants

The Plain Dealer
Cleveland, Ohio (A)
Home/real estate section

David Kordalski, A.M.E./Visuals; Amanda Hamann, Lead Features Designer; Scott Sheldon, Features Design Director; Susan Condon Love, Homes Editor; Elizabeth McIntyre, Features Editor

National Post
Toronto, Ont., Canada (A)
Fashion section

Cameron Williamson, Creative Director; Kenneth Whyte, Editor in Chief; Alicia Kowalewski, Senior Designer; Christine Dewairy, Designer; Leanne Shapton, Art Director; Elizabeth Schaal, Editor; Sarmishta Subrannian, Saturday Post Editor

Calgary Herald
Calgary, Canada (B)
Fashion page

Rachel Niebergal, Designer/Illustrator; Dick Wallace, Design Editor; Eric Dawson, Arts & Style Editor

Göteborgs-Posten
Göteborg, Sweden (A)
Fashion page

Roger Olsson, Designer; Lisa Thanner, Photographer

Politiken
Copenhagen, Denmark (A)
Fashion page

Søren Nyeland, Design Editor; Christine Cato, Designer; Thomas Østergren, Designer; Marianne Gram, Editor; Edel Hildebrandt, Copy Editor; Annette Nyvang, Copy Editor

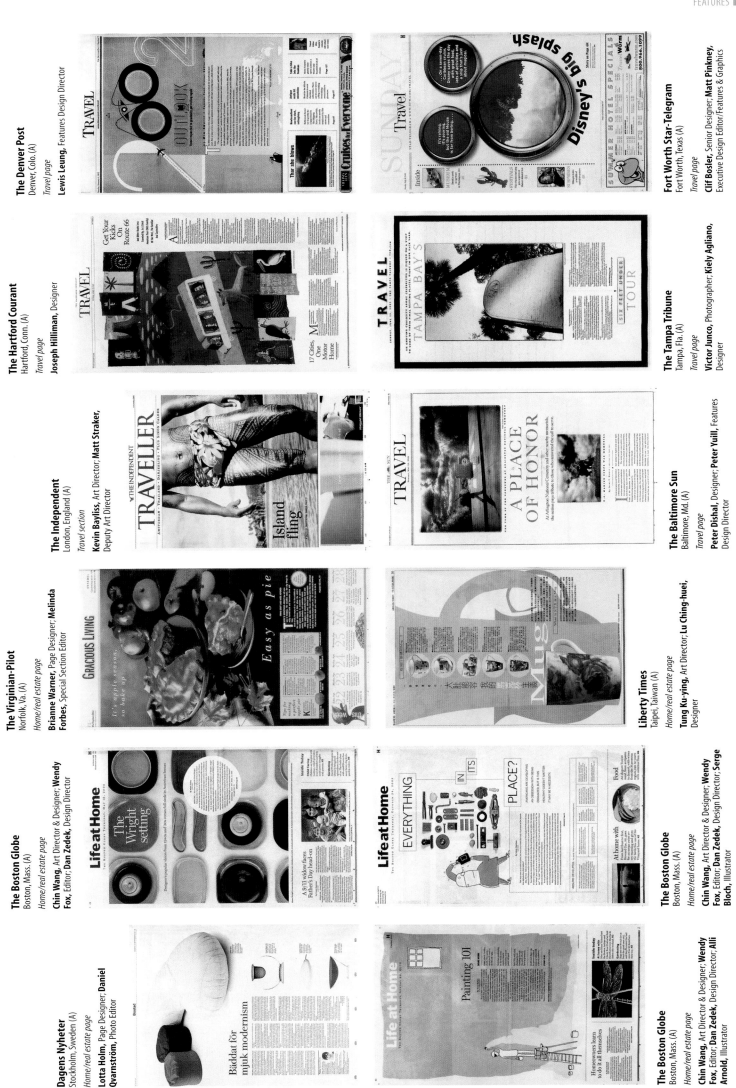

The Denver Post
Denver, Colo. (A)
Travel page
Lewis Leung, Features Design Director

The Hartford Courant
Hartford, Conn. (A)
Travel page
Joseph Hilliman, Designer

The Independent
London, England (A)
Travel section
Kevin Bayliss, Art Director; **Matt Straker**, Deputy Art Director

The Virginian-Pilot
Norfolk, Va. (A)
Home/real estate page
Brianne Warner, Page Designer; **Melinda Forbes**, Special Section Editor

The Boston Globe
Boston, Mass. (A)
Home/real estate page
Chin Wang, Art Director & Designer; **Wendy Fox**, Editor; **Dan Zedek**, Design Director

Dagens Nyheter
Stockholm, Sweden (A)
Home/real estate page
Lotta Holm, Page Designer; **Daniel Qvarnström**, Photo Editor

Fort Worth Star-Telegram
Fort Worth, Texas (A)
Travel page
Clif Bosler, Senior Designer; **Matt Pinkney**, Executive Design Editor/Features & Graphics

The Tampa Tribune
Tampa, Fla. (A)
Travel page
Victor Junco, Photographer; **Kiely Agliano**, Designer

The Baltimore Sun
Baltimore, Md. (A)
Travel page
Peter Dishal, Designer; **Peter Yuill**, Features Design Director

Liberty Times
Taipei, Taiwan (A)
Home/real estate page
Tung Ku-ying, Art Director; **Lu Ching-huei**, Designer

The Boston Globe
Boston, Mass. (A)
Home/real estate page
Chin Wang, Art Director & Designer; **Wendy Fox**, Editor; **Dan Zedek**, Design Director; **Serge Bloch**, Illustrator

The Boston Globe
Boston, Mass. (A)
Home/real estate page
Chin Wang, Art Director & Designer; **Wendy Fox**, Editor; **Dan Zedek**, Design Director; **Alli Arnold**, Illustrator

The Virginian-Pilot
Norfolk, Va. (A)
Opinion page
Sam Hundley, Designer; **Lynn Feigenbaum,** Editor
Also winning in illustration/single, page 142.

Los Angeles Times
Los Angeles, Calif. (A)
Travel page
Carrie Barber, Design Editor; **Jan Molen,** Design Editor; **Lisa Clausen,** Features Design Director

The San Diego Union-Tribune
San Diego, Calif. (A)
Science/technology page
Laurie Harker, Designer/Illustrator

Die Zeit
Hamburg, Germany (A)
Science/technology section
Staff

The Gazette
Montreal, Canada (B)
Travel page
Susan Ferguson, Designer; **Enza Micheletti,** Travel Editor; **Roland-Yves Carignan,** Design Director

Liberty Times
Taipei, Taiwan (A)
Travel page
Tung Ku-ying, Art Director; **Lu Ching-Huei,** Designer

Göteborgs-Posten
Göteborg, Sweden (A)
Travel page
Albert Rosander, Designer; **Bo Joelsson,** Photographer

Die Zeit
Hamburg, Germany (A)
Science/technology page
Staff

O Globo
Rio de Janeiro, Brazil (A)
Science/technology section
Leo Tavejnhansky, Art Director & Designer; **Marcelo Sayão,** Photographer; **Fernando Alvarus,** Asst. Art Editor/Infographics and Illustrator; **Alvim,** Asst. Art Editor/Infographics and Illustrator; **Walter Moreira,** Illustrator; **Ana Lucia Azevedo,** Editor

Liberty Times
Taipei, Taiwan (A)
Travel page
Tung Ku-ying, Art Director; **Lu Pei-feng,** Designer

National Post
Don Mills, Ont., Canada (A)
Home/real estate page
Laura Koot, News Presentation Editor; **Deborah Stokes,** Home Editor; **Dean Cummer,** Special Section Editor; **Gayle Grin,** A.M.E. Design & Graphics; **Kenneth Whyte,** Editor in Chief

The Ottawa Citizen
Ottawa, Ont., Canada (B)
Science/technology page
Paula McLaughlin, Designer; **Hugh Paterson,** Editor, Techweekly; **Lynn McAuley,** M.E.; **Scott Anderson,** Editor in Chief

Frankfurter Allgemeine Sonntagszeitung
Frankfurt am Main, Germany (A)

Science/technology page

Thomas Heumann, Infographics Director;
Volker Stollorz, Science Author; **Karl-Heinz Döring,** Infographic Artist; **Anja Horn,** Layout (MediaGroup Berlin)

Frankfurter Allgemeine Sonntagszeitung
Frankfurt am Main, Germany (A)

Science/technology page

Peter Breul, Art Director & Designer; **France Bourély,** Photographer; **Andreas Kuther,** Picture Editor; **Ulf von Rauchhaupt,** Science Writer

Frankfurter Allgemeine Sonntagszeitung
Frankfurt am Main, Germany (A)

Science/technology page

Thomas Heumann, Infographics Director; **Ulf von Rauchhaupt,** Science Editor; **Karl-Heinz Döring,** Infographic Artist; **Doris Oberneder,** Layout (Media Group Berlin)

Frankfurter Allgemeine Sonntagszeitung
Frankfurt am Main, Germany (A)

Science/technology page

Thomas Heumann, Infographics Director; **Volker Stollorz,** Science Author; **Karl-Heinz Döring,** Infographic Artist; **Doris Oberneder,** Layout (MediaGroup Berlin)

Palabra
Saltillo, México (C)

Science/technology page

Fabiola Pérez, Graphic Designer; **Carlos Mendoza,** Illustrator; **Miguel Barroso,** Editor; **Vicente León,** Graphic Coordinator; **David Brondo,** Editor Director; **Jorge Meléndez,** General Editor Director

Detroit Free Press
Detroit, Mich. (A)

Science/technology page

Elio Leturia, Features Designer; **Todd Cross,** Features Photo Editor; **Mauricio Gutiérrez,** Deputy Design Director/Features; **Steve Dorsey,** Design & Graphics Director; **Steve Grimmer,** Assistant Editor

BOOK PREACHES SPIRITUAL DIET

Göteborgs-Posten
Göteborg, Sweden (A)

Other page

Karin Teghammararell, Designer; **Per Wahlberg,** Photographer

Vägvisare på ständigt nya spår

Göteborgs-Posten
Göteborg, Sweden (A)

Other page

Mikael Hjerpé, Designer; **Anna von Brömssen,** Photographer

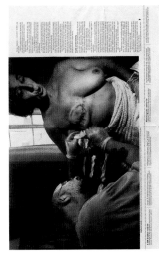

Göteborgs-Posten
Göteborg, Sweden (A)

Other page

Gunilla Wernhamn, Designer; **Lisa Thanner,** Photographer

Född på mammas gata

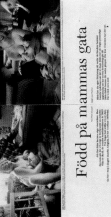

El Diario de Hoy
San Salvador, El Salvador (B)
Other page

Juan Durán, Graphics and Design Editor; **Jorge Castillo**, Infographic and Design Editor; **Lafitte Fernández**, Newsroom Coordinator; **Alvaro Cruz Rojas**, Newsroom Director; **Rolando Monterrosa**, Editor; **Mario Gonzáles**, Editor; **Porfirio Osorio**, Photo Editor; **Manuel Orellana**, Photo Co-Editor

Upsala Nya Tidning
Uppsala, Sweden (B)
Other page

John Hallstrom, Designer; **Liv Widell**, Illustrator; **Hannah Davidsson**, Reporter

El Comercio
Lima, Peru (B)
Other page

Jose Blanco, Designer; **Carlos Sotomayor**, Design Editor; **Xabier Díaz de Cerio**, Art Director

Kristianstadsbladet
Kristianstad, Sweden (C)
Other page

Rickard Frank, News Graphic Artist; **Ingela Rutberg**, Journalist; **Staff**

The Star-Ledger
Newark, N.J. (A)
Other page

Mark Morrissey, Designer; **Ed Murray**, Photographer; **Frank Cecala**, Writer & Researcher

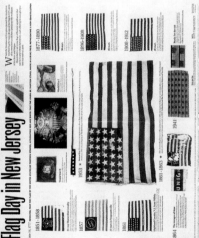

Frankfurter Allgemeine Sonntagszeitung
Frankfurt am Main, Germany (A)
Other page

Peter Breul, Art Director & Designer; **Klein Bros.**, Illustrators; **Andreas Kuther**, Picture Editor; **Gero von Randow**, Science Editor

The Hartford Courant
Hartford, Conn. (A)
Other page

Jim Kuykendall, Designer; **Rick Shaw**, Art Director; **Thom McGuire**, A.M.E. Graphics/Photography

Asbury Park Press
Neptune, N.J. (B)
Other page

Harris Siegel, ME/Design & Photography; **Cody Schneider**, Designer; **Andrew Prendimano**, Art & Photo Director

Reforma
México City, México (B)
Other page

Alicia Kobayashi, Graphics Co-Editor; **Beatriz De León**, Editor; **Raul Espinosa de los Monteros**, Graphics Editor; **Rosa Ma. Villarreal**, Editorial Director

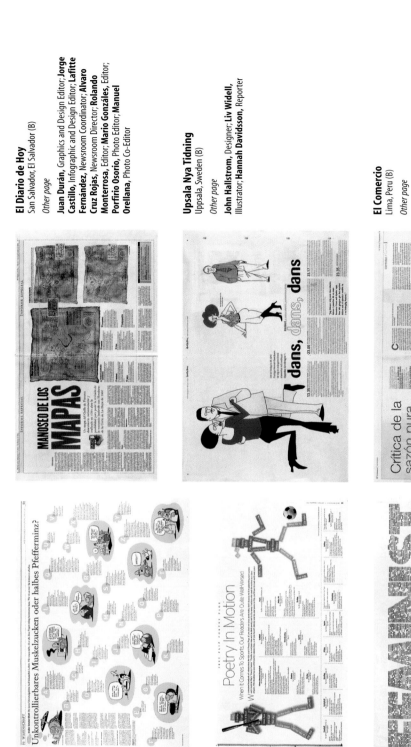

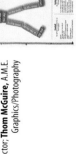

Clarín
Buenos Aires, Argentina (A)

Other page

Iñaki Palacios, Art Director; **Diego Bianchi**, Graphic Designer; **Pablo Ruiz**, Graphic Designer

Clarín
Buenos Aires, Argentina (A)

Other page

Iñaki Palacios, Art Director; **Diego Bianchi**, Graphic Designer; **Pablo Ruiz**, Graphic Designer

Heraldo de Aragón
Zaragoza, Spain (B)

Other section

Jose Luis Minondo, Art Director; **Pilar Ostalé**, Designer; **Cristina Salvador**, Designer; **Ana Pérez Errea**, Designer; **Cristina Urresti**, Designer; **Javier Eslava**, Designer; **Javier Errea**, Consultant; **Guillermo Nagore**, Consultant; **Luis Grañena**, Illustrator

Morgenavisen Jyllands-Posten
Viby, Denmark (A)

Other page

Thorgerd Broni Jensen, News Graphic Artist

The Age
Melbourne, Australia (A) / *Other section*

Andrew Wolf, Art Director; **Christina Carter**, Designer; Helen Shield, Editor; **De Luxe & Associates**, Design Consultants

Récord
México City, México (C)

Other section

Paola Ceja, Designer; **Mónica Carranza**, Designer; **Dórica García**, Section Designer; **Alejandro González**, Section Editor; **Alberto Nava**, Art Director; **Alejo Nájera**, Design Editor; **José Luis Barros**, Graphics Editor

The Guardian
London, England (A)

Other section

Staff

Récord
México City, México (C)

Other section

Paola Ceja, Designer; **Mónica Carranza**, Designer; **Dórica García**, Section Designer; **Alejandro González**, Section Editor; **Alberto Nava**, Art Director; **Alejo Nájera**, Design Editor; **José Luis Barros**, Graphics Editor

Los Angeles Times
Los Angeles, Calif.(A)

Other section

Stephen Sedam, Design Editor; **Wes Bausmith**, Design Editor; **Joe Hutchinson**, Deputy M.E.

Récord
México City, México (C)

Other section

Paola Ceja, Designer; **Mónica Carranza**, Designer; **Dórica García**, Section Designer; **Alejandro González**, Section Editor; **Alberto Nava**, Art Director; **Alejo Nájera**, Design Editor; **José Luis Barros**, Graphics Editor

Liberty Times
Taipei, Taiwan (A)
Other page
Tung Ku-ying, Art Director; **Chin Chang-ling**, Designer

The Hartford Courant
Hartford, Conn. (A)
Other page
Chris Moore, Design Editor; **Dave Plunkert**, Illustrator

Die Zeit
Hamburg, Germany (A)
Other page
Staff

The Hartford Courant
Hartford, Conn. (A)
Other page
JoEllen Black, Photo Editor; **Suzette Moyer**, Designer; **Michael McAndrews**, Photographer

Reforma
México City, México (B)
Other page
Roberto Canseco, Designer; **Marco A. Sotomayor**, Photographer; **Carlos Tomasini**, Editor; **Jezlia Vega**, Graphics Coordinator; **Raúl Espinoza de los Monteros**, Graphics Editor; **Rosa Ma. Villarreal**, Editorial Director; **Emilio Deheza**, Graphic Director; **Lourdes López**, Section Editor

Chicago Tribune
Chicago, Ill. (A)
Other page
Michael Miner, Design Editor; **Stephen Ravenscraft**, Art Director

Reforma
México City, México (B)
Other page
Roberto Canseco, Designer; **Marco A. Sotomayor**, Photographer; **Carlos Tomasini**, Editor; **Jezlia Vega**, Graphics Coordinator; **Raúl Espinoza de los Monteros**, Graphics Editor; **Rosa Ma. Villarreal**, Editorial Director; **Emilio Deheza**, Graphic Director; **Lourdes López**, Section Editor

Chicago Tribune
Chicago, Ill. (A)
Other page
Michael Miner, Design Editor; **Michael Kellams**, Design Editor; **Stephen Ravenscraft**, Art Director; **Roxanna Bikadoroff**, Illustrator

The Guardian Review
London, England (A)
Other page
Roger Browning, Art Director; **Zygmunt Januszewski**, Illustrator

San Jose Mercury News
San Jose, Calif. (A)
Other page
Steve Marinucci, TV Listings Editor; **Stephanie Grace Lim**, Designer/Illustrator

Seattle Post-Intelligencer
Seattle, Wash. (A)
Other page
Julie Simon, Designer

San Jose Mercury News
San Jose, Calif. (A)
Other page
David Frazier, Deputy Features Design Director

The Free Lance-Star
Fredericksburg, Va. (C)
Other page
Tracy Montauk, Designer; Mary Vignoles, Photo Editor; **Photo Staff**

Heraldo de Aragon
Zaragoza, Spain (B)
Other page
Jose Luis Minondo, Art Director; **Pilar Ostalé,** Designer; **Cristina Salvador,** Designer; **Ana Pérez Errea,** Designer; **Cristina Urresti,** Designer; **Javier Eslava,** Designer; **Javier Errea,** Design Consultant; **Alberto Aragon,** Artist; **Guillermo Nagore,** Consultant/Design Project

The Record
Kitchener, Canada (B)
Other page
Diane Shantz, Graphic Artist

The State
Columbia, S.C. (B)
Other page
Paul Morgan, Features Designer

Asbury Park Press
Neptune, N.J. (B)
Other page
Harris Siegel, NightOut Editor; **Cody Schneider,** Assistant NightOut Editor; **Nichole Faux,** Assistant NightOut Editor; **Michael Sypniewski,** Photographer

Asbury Park Press
Neptune, N.J. (B)
Other page
Harris Siegel, NightOut Editor; **Cody Schneider,** Assistant NightOut Editor; **Nichole Faux,** Assistant NightOut Editor

Bergens Tidende
Bergen, Norway (B)
Other page
Arne Edvardsen, Design Editor; **Walter Jensen,** Designer; **Marvin Halleraker,** Artist; **Anne Gjerde,** Weekend Editor

Daily Times-Call
Longmont, Colo. (C)
Other page
K.J. Deacon, Designer; **Adam Welch,** Photo Intern; **Patrick Kramer,** Chief Photography

Heraldo de Aragon
Zaragoza, Spain (B)
Other page
Jose Luis Minondo, Art Director; **Pilar Ostalé,** Designer; **Cristina Salvador,** Designer; **Ana Pérez Errea,** Designer; **Cristina Urresti,** Designer; **Javier Eslava,** Designer; **Javier Errea,** Consultant; **Guillermo Nagore,** Consultant/Design Project; **Alberto Aragón,** Artist

La Voz
Phoenix, Ariz. (B)
Other page
Mayela Trahin, Section Editor; **Luis Castillo,** Art Director

Naples Daily News
Naples, Fla. (B)
Other page
Eric Strachan, A.M.E./ Presentation

Bergens Tidende
Bergen, Norway (B)
Other page
Arne Edvardsen, Design Editor; **Walter Jensen,** Designer; **Arne Størksen,** Designer; **Knut Strand,** Photographer

Special coverage/single subject

Special coverage/sections (no ads)

Special coverage/sections (with ads)

Special coverage/section cover page

Special coverage/section inside page

Reprints

Awards

AWARDS OF EXCELLENCE, unless designated.

GOLD, exceptional work.

SILVER, outstanding work.

JUDGES' SPECIAL RECOGNITION, worthy of a singular, superior honor in the category, is in Chapter 2, pages 26-37.

Circulation

Indicated after each publication's location
(A) 175,000 & over
(B) 50,000-174,999
(C) 49,999 & under

Reforma
México City, México (B)

Special coverage/single subject

Sergio Alberto Ruiz Carrera, Designer; **Jorge Alberto Ramírez Santillán,** Designer; **Ricardo del Castillo,** Graphics Editor; **Leticia Gutiérrez,** Editor; **Lilián Estrada Arce,** Editor; **Leticia López,** Editor; **Roberto Castañeda,** Section Editor; **Roberto Zamarripa,** Editorial Sub-director; **René Delgado Ballesteros,** Editorial Director; **Emilio Deheza,** Graphic Director

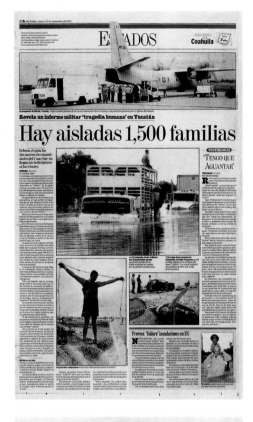

Folha de São Paulo
Sao Paulo, Brazil (A)

Special coverage/single subject

Massimo Gentile, Art Editor; **Fabio Marra,** Art Sub Editor; **Jair de Oliveira,** Art Sub Editor; **Melchiades Filho,** Sport Section Editor; **Eduardo Asta,** Infographic; **Adilson Secco,** Infographic; **Rodrigo Beuno,** Reporter; **Rodrigo Bertolotto,** Reporter

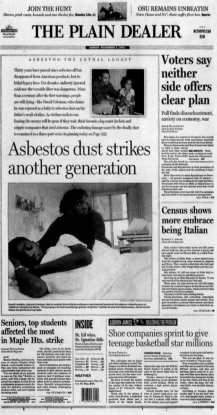

The Plain Dealer
Cleveland, Ohio (A)

Special coverage/single subject

David Kordalski, A.M.E./Visuals; **Lisa Griffis,** Designer; **Joshua Gunter,** Photographer; **Bill Gugliotta,** Director/Photography; **Reid Brown,** Graphics Artist; **Ken Marshall,** Graphics Editor

The Hartford Courant
Hartford, Conn. (A)

Special coverage/single subject

Rick Shaw, Director/Design & Graphics

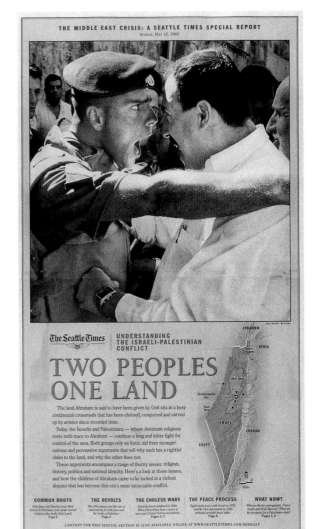

The Middle East Crisis: A Seattle Times Special Report
Sunday, May 12, 2002

The Seattle Times
UNDERSTANDING THE ISRAELI-PALESTINIAN CONFLICT

TWO PEOPLES ONE LAND

GOLD
The Seattle Times
Seattle, Wash. (A)

Special coverage/sections (no ads)

Denise Clifton, Designer; **Teri Boyd,** Photo Editor; **Aldo Chan,** News Artist

Judges: The presentation of this heavy topic makes you want to read the story. The storytelling speaks to your head, not your heart. The pages are clean and easy to use, and they guide you through the content.

Jueces: La presentación de este tema espeso te encauza a leer la historia. La narración llega al cerebro, no al corazón. Las páginas son limpias y fáciles de usar y te guían por el contenido.

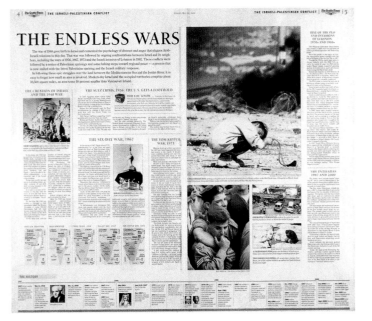

THE ENDLESS WARS

The Washington Post
Washington, D.C. (A)

Special coverage/single subject

Carla Fielder, Assistant News Editor; **Beth Broadwater,** Assistant News Editor; **News Desk**

The Star-Ledger
Newark, N.J. (A)

Special coverage/single subject

Pablo Colon, Designer; **Sharon Russell,** A.M.E. Design; **Patti Sapone,** Photographer; **Andre Malok,** Graphic Artist; **John O'Boyle,** Photographer; **Amy Nutt,** Reporter; **Joel Pisetzner,** Copy Editor

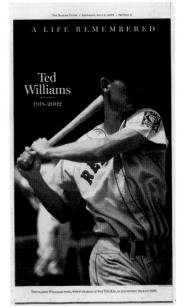

The Boston Globe
Boston, Mass. (A)

Special coverage/sections (no ads)

Jason McKean, Designer; **Dan Zedek,** Design Director

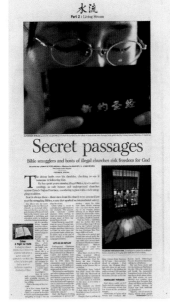

The Orange County Register
Santa Ana, Calif. (A)

Special coverage/sections (no ads)

Bill Cunningham, Designer; **Karen Kelso,** Design Team Leader; **Kris Viesselman,** Senior Design Team Leader; **Brenda Shoun,** Deputy Editor/Visuals; **Dan Anderson,** Photographer; **Mike Pilgrim,** Photo Editor; **John Gittlesohn,** Reporter; **Marcia Prowe,** Director/Photography

Star Tribune
Minneapolis, Minn. (A)

Special coverage/single subject

Denise M. Reagan, Designer; **Kim Yeager,** Project Editor; **Jane Friedmann,** Artist; **Mark Boswell,** Artist; **Tom Wallace,** Photographer; **Maria Baca,** Writer; **Susie Eaton Hopper,** A.M.E./Features; **Rhonda Prast,** Asst. Design Director/Features; **Randy Miranda,** Variety Editor; **Dave Denney,** Features Photo Editor

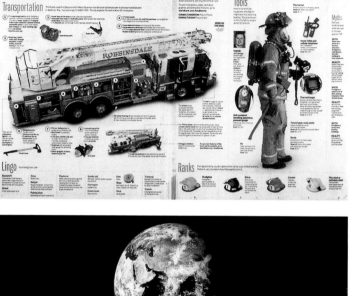

The Star-Ledger
Newark, N.J. (A)

Special coverage/single subject

Linda Grinbergs, Designer; **Mitsu Yasukawa,** Photographer; **Steve Chambers,** Reporter; **Andre Malok,** Graphic Artist; **Angela Porter,** Graphic Artist; **Donna Wallace,** Deputy Photo Editor; **Pim Van Hemmen,** A.M.E./Photography; **George Frederick,** Graphics Editor; **Steve Crabill,** Editor

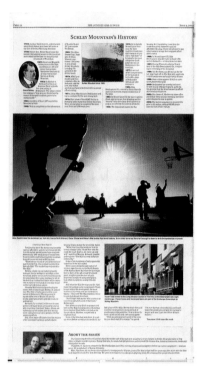

The Guardian
London, England (A)

Special coverage/sections (no ads)

Staff

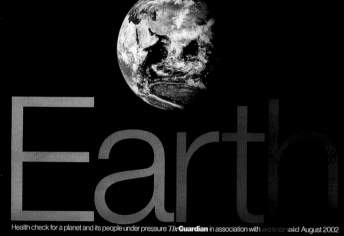

South Florida Sun-Sentinel
Fort Lauderdale, Fla. (A)

Special coverage/sections (no ads)

Ester Venouziou, Designer; **Tom Peyton,** Visual Editor; **Melissa Lyttle,** Photographer; **Robert Mayer,** Photographer; **George Wilson,** Photo Editor; **Jeff Glick,** Creative Director; **Sharon Rosenhouse,** M.E.; **Maren Bingham,** Editor

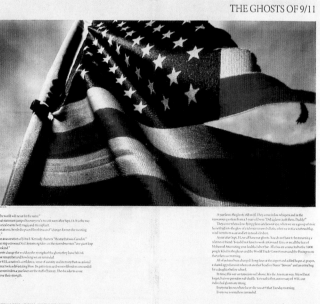

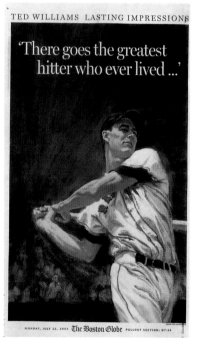

The Boston Globe
Boston, Mass. (A)

Special coverage/sections (no ads)

Jason McKean, Designer; **Chuck Pyle,** Illustrator; **Dan Zedek,** Design Director

Los Angeles Times
Los Angeles, Calif. (A)

Special news topics

Dan Santos, Design Editor

We remember the planes and the towers
The Pentagon and the Pennsylvania field
The sirens and the screams
The dust
We remember three thousand forty-three
The bond traders and laborers
Firefighters and police officers
Who awoke on a Tuesday morning
Sat for breakfast or hurried a cup of coffee
Kissed someone goodbye
Or rubbed a child's head
Then walked out a door

ONE YEAR LATER,
WE REMEMBER

We remember the heroes
We remember the flags
The anger and confusion and fear
The wary eyes at foreign faces
The doubts about our airports
Then later about our mail
Then later about our jobs
Now, the Trade Center debris is cleared
The Pentagon is largely repaired
A field is now a memorial
The ordinary has resumed
Weddings and breakups
First steps and family quarrels
Good meals and bad jobs
Our days are back to normal
Except not
Osama bin Laden is dead or alive
Al-Qaida is crippled or poised
Our economy is recovering or sputtering
We have learned to accommodate the uncertain
To value the present
To recognize that subtly and profoundly
We have changed

A CELEBRATION OF THE PEOPLE OF

NEW YORK

NATIONAL POST, WEDNESDAY, SEPTEMBER 11, 2002

I

*t is like
a nation itself — more tolerant
than the rest in a curious way.
Littleness gets swallowed up here.
All the viciousness that makes
other cities vicious is sucked up
and absorbed in New York.*

- John Steinbeck

The Statue of Liberty, early morning, Sept. 10, 2002.

National Post
Don Mills, Ont., Canada (A)

Special coverage/sections (no ads)

Gayle Grin, A.M.E. Graphics/Design; **Kenneth Whyte,** Editor in Chief;
Dianna Symonds, Weekend Editor; **Paul Wilson,** Review Editor;
Charlie Kopun, Presentation Editor; **Denis Paquin,** Photo Editor

Also winning in special coverage/single subject.

GOLD
El Correo
Bilbao, Spain (B)

Special coverage/section cover page

Javier Mingueza, Illustrator; **Pacho Igartua,** Designer; **Rafael Marañon,** Designer; **Ana Espligares,** Designer;
Mikel García Macías, Designer; **Laura Piedra,** Designer; **Aurelio Garrote,** Designer; **María del Carmen Navarro,**
Design Editor; **Jesús Aycart,** Art Director; **Alberto Torregrosa,** Editorial Art & Design Consultant

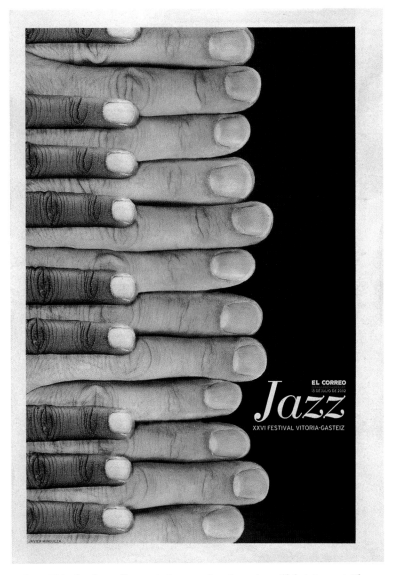

EL CORREO
15 DE JULIO DE 2002
Jazz
XXVI FESTIVAL VITORIA-GASTEIZ

JAVIER MINGUEZA

Judges: This simple, well-executed concept makes a beautiful statement. The illustration brings both races into jazz.

Jueces: Este concepto simple y bien realizado nos ofrece una bonita exposición. La ilustración nos envuelve a ambas razas en el jazz.

Sydsvenska Dagbladet
Malmo, Sweden (B)

Special coverage/sections (no ads)

Benjamin Peetre, Page Designer

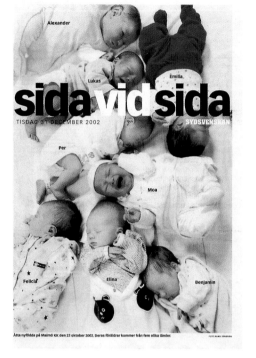

Brabants Dagblad
Hertogenbosch, The Netherlands (A)

Special coverage/sections (no ads)

Bob Derksen, Designer; **Erna van Eerderwijk,** Designer; **Cas van Overzier,** Editor; **Birgitta Hermans,** Art Director

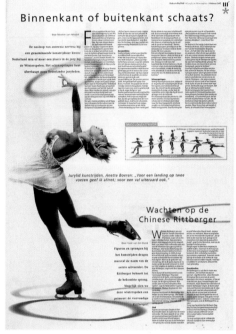

Brabants Dagblad
Hertogenbosch, The Netherlands (A)

Special coverage/sections (no ads)

Anouk Corstiaensen, Designer; **Eric Schreurs,** Designer; **Fons Knegtel,** Editor; **Birgitta Hermans,** Art Director

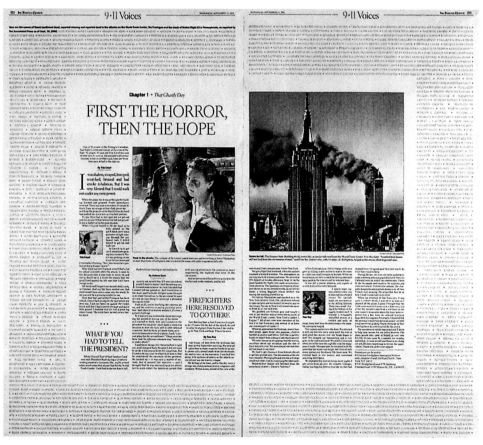

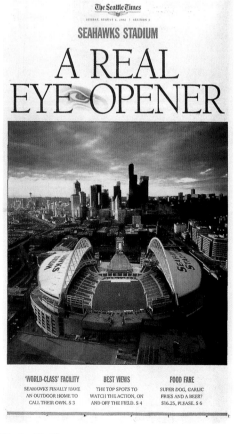

San Francisco Chronicle
San Francisco, Calif. (A)

Special coverage/sections (no ads)

Matt Petty, Designer; **Hulda Nelson,** Art Director; **Ron Mann,** Photo Editor; **Nanette Bisher,** Creative Director; **John Curley,** Section Editor; **Narda Zacchino,** Assistant Executive Director; **Phil Bronstein,** Senior Vice President/Exec. Editor

The Seattle Times
Seattle, Wash. (A)

Special coverage/sections (no ads)

Jeff Paslay, Designer; **Rick Lund,** Presentation editor; **Mark Nowlin,** News Artist; **Whitney Stensrud,** Graphics Editor; **Rod Mar,** Photographer; **Ben Benschneider,** Photographer

Rocky Mountain News
Denver, Colo. (A)

Special coverage/sections (no ads)

Brian James, Designer; **Todd Heisler,** Photographer; **Maria J. Avila,** Photographer; **Randall K. Roberts,** Presentation Director; **Janet Reeves,** Director/Photography; **Andres Fernandez,** Graphic Artist

Also winning in photo series/projects.

Maria J. Avila, Photographer; **Todd Heisler,** Photographer; **Janet Reeves,** Director/Photography; **Dean Krakel,** Assistant Director/Photography; **Mark Osler,** Editor; **Rick Giase,** Editor

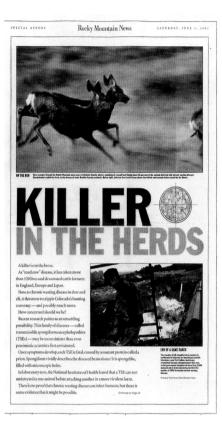

GOLD
The New York Times
New York, N.Y. (A)

Special coverage/sections (with ads)

Corinne Myller, Art Director; **Rodrigo Honeywell,** Designer; **Shelley Camhi,** Designer; **Anne Leigh,** Designer; **Pancho Bernasconi,** Picture Editor; **Andrew Phillips,** Graphics Coordinator

Also winning in special news topic.

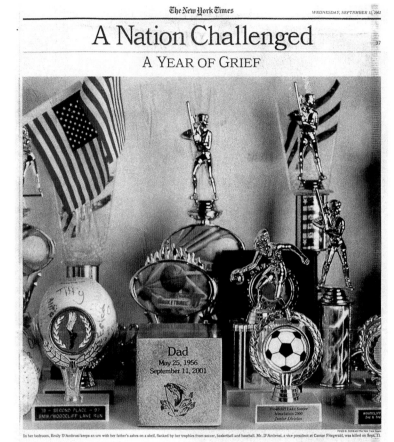

St. Petersburg Times
St. Petersburg, Fla. (A)

Special coverage/sections (no ads)

Christian Potter Drury, Design Editor; **Scott Demusey,** Photo Editor; **Sue Morrow,** A.M.E./Visuals

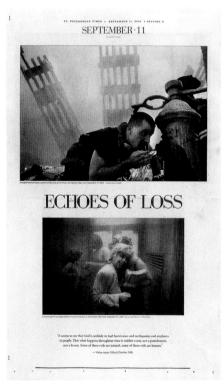

Judges: This section is comprehensive and touching, yet not overwhelming. The graphic and photos really shine through in this beautifully organized presentation.

Jueces: Esta sección es amplia y conmovedora sin resultar agobiante. Los gráficos y las fotos brillan por sí mismos a lo largo de esta presentación organizada de forma espléndida.

The Age
Melbourne, Australia (A)

Special coverage/sections (no ads)

Bill Farr, Art Director; **Steve Foley,** Editor; **De Luxe & Associates,** Design Consultant

National Post
Toronto, Ont., Canada (A)

Special coverage/sections (with ads)

Gayle Grin, A.M.E. Graphics/Design; **Kenneth Whyte,** Editor in Chief; **John Geiger,** Senior Editor; **Donna MacMullin,** Copy Editor

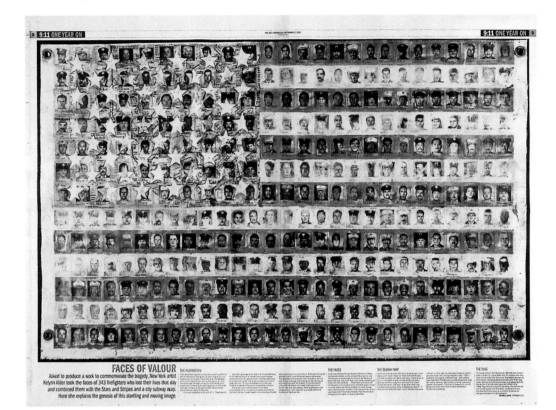

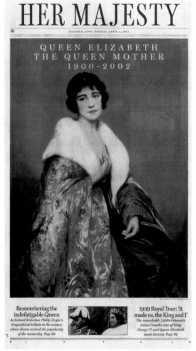

Dagens Nyheter
Stockholm, Sweden (A)

Special coverage/sections (no ads)

Johan Åhström, Page Designer; **Carl Anders Skoglund,** Art Director; **Daniel Qvarnström,** Photo Editor

Los Angeles Times
Los Angeles, Calif. (A)

Special coverage/sections (with ads)

Kelli Sullivan, Design Editor; **Paul Gonzales,** Design Editor; **Tim Hubbard,** Design Editor; **Pete Metzger,** Design Editor; **Kevin Bronson,** Design Editor; **An Moonen,** Design Editor; **Joe Hutchinson,** Deputy M.E.; **Lisa Clausen,** Deputy Design Director

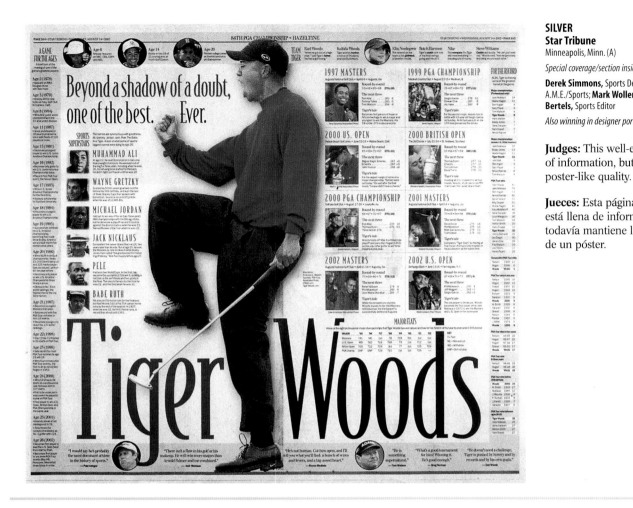

SILVER
Star Tribune
Minneapolis, Minn. (A)

Special coverage/section inside page

Derek Simmons, Sports Design Editor; **Glen Crevier,**
A.M.E./Sports; **Mark Wollemann,** Team Leader; **Kevin
Bertels,** Sports Editor

Also winning in designer portfolio/sports pages.

Judges: This well-edited page is full
of information, but it still keeps a
poster-like quality.

Jueces: Esta página bien editada
está llena de información pero
todavía mantiene la calidad
de un póster.

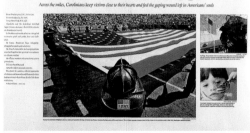

El Mundo
Madrid, Spain (A)

Special coverage/sections (no ads)

Carmelo Caderot, Design Director & Designer; **Jose Carlos Saiz,** Designer;
Ulises Culebro, Illustrator

The Charlotte Observer
Charlotte, N.C. (A)

Special coverage/sections (no ads)

Michael Whitley, News Projects Designer; **Cory Powell,**
Design Director; **Tom Tozer,** Deputy M.E.; **Michael Tribble,**
Designer; **Greg Schmidt,** Designer; **Peter Weinberger,**
Director/Photography

The Weekend Australian-Review
Sydney, Australia (A)

Special coverage/sections (no ads)

Simon Pipe, Art Director; **Petra Rees,** Editor; **Viki Sizgoric,**
Graphic Artist; **Edi Sizgoric,** Graphic Artist

The Washington Post
Washington, D.C. (A)

Special coverage/sections (with ads)

Mary Hadar, Editor; **Ellen Edwards,** Assistant Editor; **Kenny Monteith,** Art Director; **Sandra Schneider,** Art Director; **Michael Drew,** Graphic Artist; **James Smallwood,** Graphic Artist; **Julia Ewan,** Photographer; **Michael Keegan,** A.M.E./News Art

El Mundo
Madrid, Spain (A)

Special coverage/sections (with ads)

Carmelo Caderot, Design Director & Designer; **Jose Carlos Saiz,** Designer; **Raúl Arias,** Illustrator

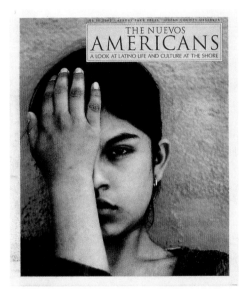

Asbury Park Press
Neptune, N.J. (A)

Special coverage/sections (with ads)

Adriana Libreros-Purcell, Art Director; **Toni Misthos,** Designer; **Andrea Clurfeld,** Editor; **Paul D'Ambrosio,** Editor; **James J. Connolly,** Photo Editor; **Peter Ackerman,** Photographer; **Tanya Breen,** Photographer; **Nuevos Americans Staff** ; **Andrew Prendimano,** Art & Photo Director; **Harris Siegel,** M.E./Design & Photography

Svenska Dagbladet
Stockholm, Sweden (A)

Special coverage/sections (with ads)

Kristofer Gustafsson, News Editor; **Erica Treijs,** Project Leader; **Tobias Erisson,** Sub-Editor; **Rickard Frank,** Design Editor; **Urban Tjernberg,** Sports Editor; **Anna Thurfjell,** Design Editor

Poughkeepsie Journal
Poughkeepsie, N.Y. (C)

Special coverage/sections (with ads)

Spencer Ainsley, Photo Editor; **Dean DiMarzo,** Art Director; **Laurie Hlavaty,** Lead Copy Editor; **Mark Bickel,** Coordinating Editor; **Larry Seil,** Graphic Artist; **Kathleen Dijamco,** Copy Editor

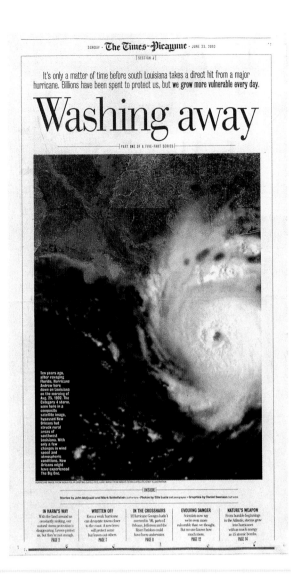

It's only a matter of time before south Louisiana takes a direct hit from a major hurricane. Billions have been spent to protect us, but **we grow more vulnerable every day.**

Washing away

[PART ONE OF A FIVE-PART SERIES]

Ten years ago, after ravaging Florida, Hurricane Andrew bore down on Louisiana on the morning of Aug. 25, 1992. The Category 4 storm, seen here in a composite satellite image, bypassed New Orleans but struck rural areas of southwest Louisiana. With only a few changes in wind speed and atmospheric conditions, New Orleans might have experienced The Big One.

Stories by John McQuaid and Mark Schleifstein *staff writers* · Photos by Ellis Lucia *staff photographer* · Graphics by Daniel Swenson *staff artist*

[INSIDE]

IN HARM'S WAY
With the land around us constantly sinking, our natural storm protection is disappearing. Levees protect us, but they're not enough.
PAGE 3

WRITTEN OFF
Even a weak hurricane can devastate towns closer to the coast. A new levee will protect some but leaves out others.
PAGE 7

IN THE CROSSHAIRS
If Hurricane Georges hadn't swerved in '98, parts of Orleans, Jefferson and the River Parishes could have been underwater.
PAGE 8

EVOLVING DANGER
Scientists now say we're even more vulnerable than we thought. But no one knows how much more.
PAGE 12

NATURE'S WEAPON
From humble beginnings in the Atlantic, storms grow into hurricanes with as much energy as 15 atomic bombs.
PAGE 14

SILVER
The Times-Picayune
New Orleans, La. (A)

Special coverage/sections (no ads)

Adrianna Garcia, Designer; **Richard Russell,** Sunday Editor; **Ellis Lucia,** Photographer; **Dan Swenson,** Graphic Artist; **Emmett Mayer III,** Graphic Artist; **Doug Parker,** Photo Editor; **Angela Hill,** Graphics Editor; **George Berke,** Design Director; **Dan Shea,** M.E.

Also winning in special coverage/cover and reprints.

Judges: This section is proactive, rather than reactive. There is good balance between story, photos and graphic information.

Jueces: Esta sección es proactiva más que reactiva. Existe un buen equilibrio de historia, fotos e información gráfica.

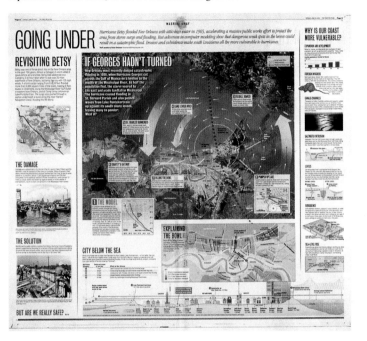

The Independent
London, England (A)

Special coverage/sections (with ads)

Kevin Bayliss, Art Director;
Matt Straker, Deputy Art Director

Rocky Mountain News
Denver, Colo. (A)

Special coverage/sections (with ads)

Brian James, Designer;
Steven G. Smith, Photographer; **Randall K. Roberts,** Presentation Director; **Janet Reeves,** Photography Director

Detroit Free Press
Detroit, Mich. (A)

Special coverage/section cover page

Steve Dorsey, Page Designer, Design & Graphics Director; **Diane Weiss,** Picture Editor; **Nancy Andrews,** Director/Photography; **Julian H. Gonzalez,** Photographer; **Gene Myers,** Sports Editor; **Dave Robinson,** Deputy M.E.; **Staff**

Also winning in portfolios/combination design, page 233.

The Journal News
White Plains, N.Y. (B)

Special coverage/sections (with ads)

Mark Faller, Sports Editor/Days; **Andrew Das,** Assistant Sports Editor; **Bill Becerra,** Graphic Artist; **Merrill Sherman,** Graphic Artist

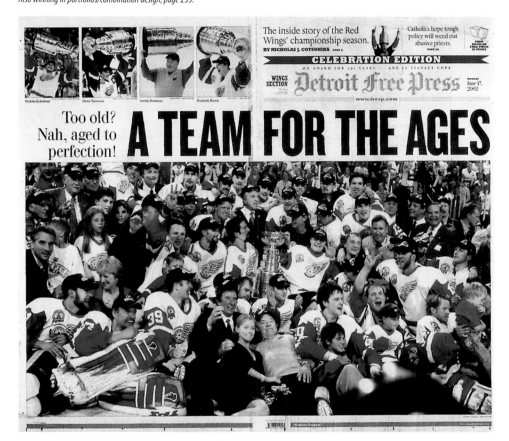

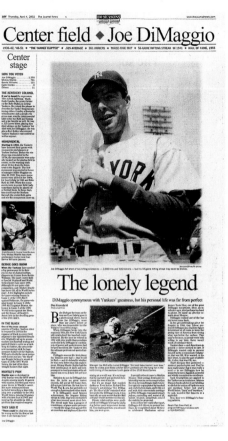

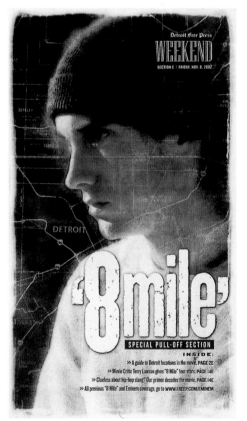

Detroit Free Press
Detroit, Mich. (A)

Special coverage/section cover page

Patrick Sedlar, Designer/Illustrator; **Mauricio Gutiérrez,** Deputy Design Director/Features; **Steve Dorsey,** Design & Graphics Director

The San Diego Union-Tribune
San Diego, Calif. (A)

Special coverage/section cover page

Brian Gross, Sports Designer; **Charles Starr,** Photo Editor

The Des Moines Register
Des Moines, Iowa (B)

Special coverage/section cover page

Mark Marturello, Graphic Artist

The Baltimore Sun
Baltimore, Md. (A)

Special coverage/section cover page

Jay Judge, News Design Director; **John Mattos,** Illustrator; **Michelle Deal-Zimmerman,** A.M.E. Graphics/Design

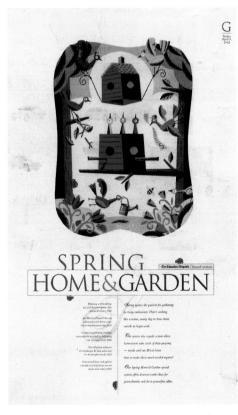

The Columbus Dispatch
Columbus, Ohio (A)

Special coverage/section cover page

Todd Bayha, Editorial Artist; **Richard Lillash,** Illustrator

SILVER
The Columbus Dispatch
Columbus, Ohio (A)

Special coverage/section cover page

Scott Minister, Art Director; **Richard Lillash,** Illustrator; **Becky Kover,** Section Editor

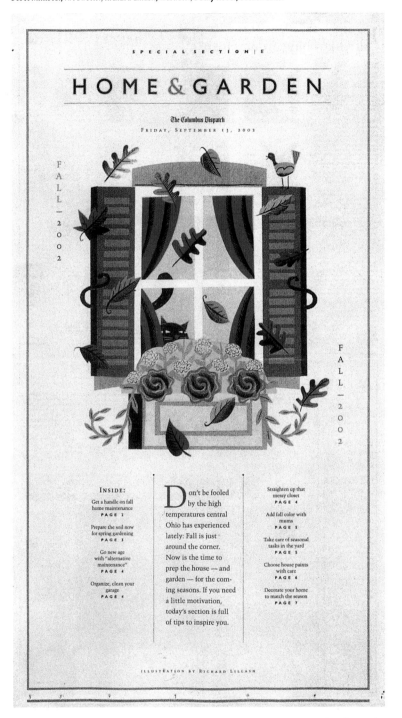

Judges: Judges were impressed with the use of white space on section fronts in The Columbus Dispatch. Many section fronts used simple placement of the elements to get the reader into the sections. It is refreshing to see cleanly designed pages where designers are not pressured to include a lot of elements on a page.

Jueces: A los jueces les impresionó el uso del espacio blanco en primeras páginas de secciones de The Columbus Dispatch. Muchas primeras páginas de secciones utilizaron una simple distribución de elementos para que el lector fuera a estas secciones. Es estimulante ver páginas diseñadas de forma limpia donde los diseñadores no se ven obligados a incluir muchos elementos en la página.

The Wall Street Journal
South Brunswick, N.J. (A)

Special coverage/section cover page

Craig Frazier, Illustrator; **Orlie Krauss,** Art Director; **Greg Leeds,**
Executive Art Director

Beaver County Times
Beaver, Pa. (C)

Special coverage/section cover page

Cathy Benscoter, Design Editor; **Clif Page,** Photo Editor

Also winning judges' special recognition, pages 34-35.

The Wall Street Journal
South Brunswick, N.J. (A)

Special coverage/section cover page
Also winning in illustration/single, page 141.

Ettienne Delesert, Illustrator; **Orlie Krauss,** Art Director; **Greg Leeds,**
Executive Design Director

San Francisco Chronicle
San Francisco, Calif. (A)

Special coverage/section cover page

Matt Petty, Page Designer; **Kerwin Berk,** Section Editor; **Hulda
Nelson,** Art Director; **Nanette Bisher,** Creative Director; **Glenn
Schwarz,** Sports Editor

National Post
Don Mills, Ont., Canada (A)

Special coverage/section cover page

Gayle Grin, A.M.E. Design & Graphics; **Kenneth Whyte,** Editor in Chief;
Gary Clement, Illustrator; **John Geiger,** Review Editor; **Dianna
Symonds,** Weekend Editor

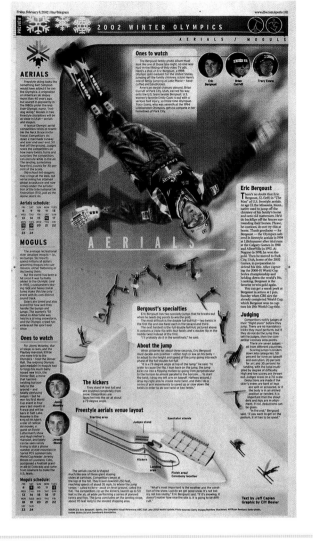

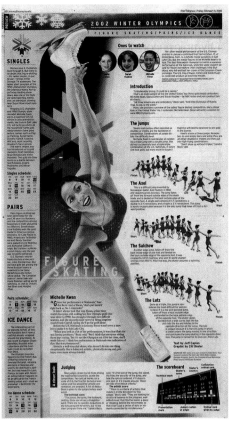

Judges: This section is full of useful information. It is comprehensive and well organized.

Jueces: Esta sección está llena de información útil. Es extensa y bien organizada.

Detroit Free Press
Detroit, Mich. (A)

Special coverage/section cover page

Christoph Fuhrmans, Sports Designer; **Tom Panzenhagen,** Asst. Sports Editor; **Gene Myers,** Sports Editor; **Martha Thierry,** Asst. Graphics Editor; **Steve Dorsey,** Design & Graphics Director

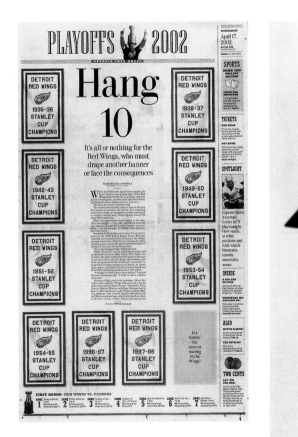

The Ball State Daily News
Muncie, Ind. (C)

Special coverage/section cover page

Emmet Smith, Designer; **John Seidel,** Editor in Chief; **Jennifer George-Palilonis,** Design Adviser

Asbury Park Press
Neptune, N.J. (A)

Special coverage/section cover page

Harris Siegel, M.E./Design & Photography; **Andrew Prendimano,** Art & Photo Director; **John V. Smith,** Sports Designer; **Tom Peyton,** Inspiration

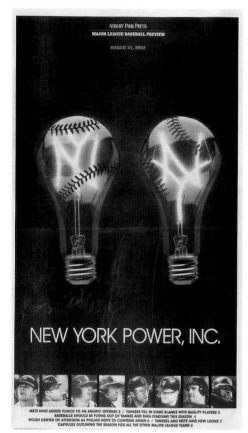

The Columbus Dispatch
Columbus, Ohio (A)

Special coverage/section cover page

Scott Minister, Art Director; **Becky Kover,** Section Editor

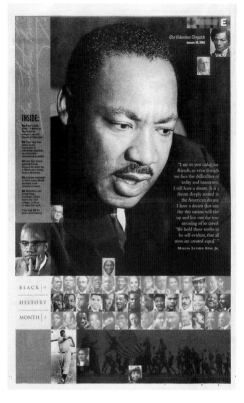

The Charlotte Observer
Charlotte, N.C. (A)

Special coverage/section inside page

Michael Whitley, News Project Designer; **Cory Powell,** Design Director; **Tom Tozer,** Deputy M.E.

WE REMEMBER | HONORING THE VICTIMS OF SEPTEMBER 11, 2001
The Charlotte Observer

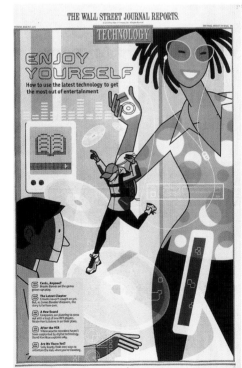

The Wall Street Journal
South Brunswick, N.J. (A)

Special coverage/section cover page

Orlie Krauss, Art Director; **Leo Espinosa,** Illustrator; **Greg Leeds,** Executive Art Director

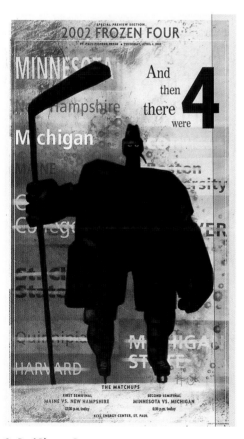

St. Paul Pioneer Press
St. Paul, Minn. (A)

Special coverage/section cover page

Kirk Lyttle, Illustrator; **Kevin Cusick,** Page Designer; **Dave Sell,** Editor

Also winning in illustration/single

St. Paul Pioneer Press
St. Paul, Minn. (A).

Special coverage/section cover page

Kirk Lyttle, Illustrator; **Kevin Cusick,** Editor; **Nosh Munar,** Page Designer

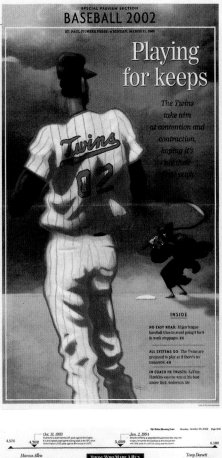

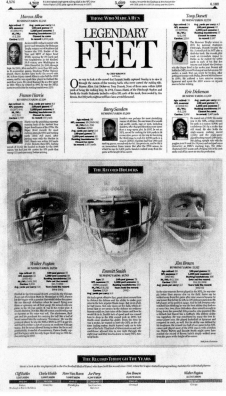

The Dallas Morning News
Dallas, Texas (A)

Special coverage/section inside page

Dave Wilson, Design Editor/Sports; **Michael Hall,** Graphics Director

SILVER
The Hartford Courant
Hartford, Conn. (A)

Special coverage/sections (with ads)

Mel Shaffer, Design Editor; **Josue Evilla,** Designer; **Bruce Moyer,** Photo Editor

Also winning an award of excellence in special sections.

Melanie Shaffer, Design Editor; **Bruce Moyer,** Photo Editor; **Steven Dunn,** Photographer; **Rick Shaw,** Director/Design & Graphics; **Thom McGuire,** A.M.E. Photography & Design; **Josue Evilla,** Designer

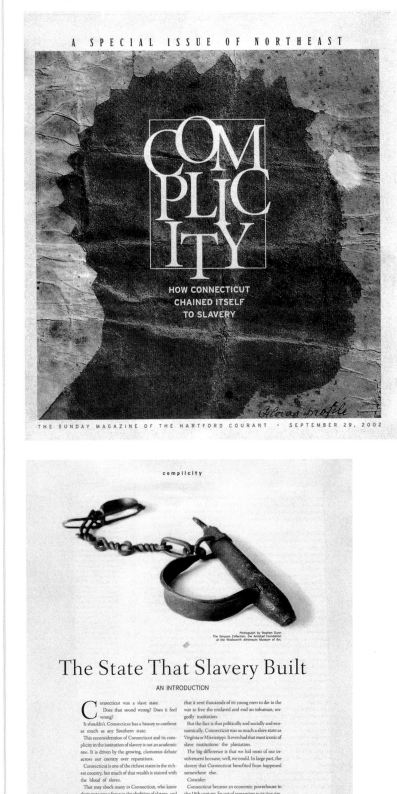

Judges: This was really unexpected from a daily newspaper. It stretches the limits of a tabloid section.

Jueces: Fue algo inesperado de un diario. Va más allá del límite de la sección de un tabloide.

Star Tribune
Minneapolis, Minn. (A)

Special coverage/section inside page

Mark Hvidsten, Designer; **Tom Wallace,** Photographer; **Glen Crevier,** Sports Editor; **Derek Simmons,** Sports Design Editor; **Anders Ramberg,** Design Director

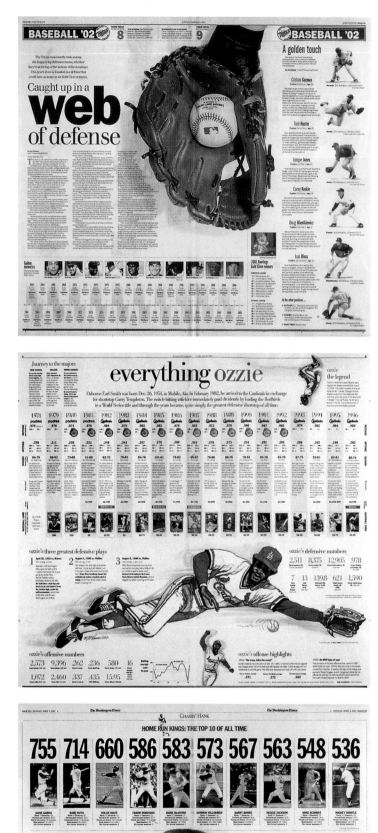

St. Louis Post-Dispatch
St. Louis, Mo. (A)

Special coverage/section inside page

Rob Schneider, Weekend Sports Editor

The Washington Times
Washington, D.C. (B)

Special coverage/section inside page

Scott J. Haring, Design Editor; **Mark Hartsell,** Sports Editor

Milwaukee Journal Sentinel
Milwaukee, Wis. (A)

Reprints

Lonnie Turner, Design Editor/Features; **Bob Helf,** Designer; **Dale Guldan,** Photographer

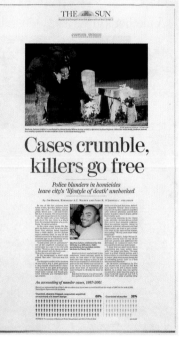

The Baltimore Sun
Baltimore, Md. (A)

Reprints

Jay Judge, News Design Director; **Robert K. Hamilton,** Director/Photography; **Michelle Deal-Zimmerman,** A.M.E. Graphics/Design

Judges: This section has value – worth more than you would pay to get the paper that day.

Jueces: Esta sección tiene valor. Vale más de lo que se pagó ese día por el diario.

SILVER
The Virginian-Pilot
Norfolk, Va. (A)

Special coverage/sections (with ads)

Terry Chapman, Projects Designer; **Alex Burrows,** Photo Editor

Judges: This keepsake section was smartly done. It chronicles the whole event while maintaining a local perspective.

Jueces: Esta sección de recuerdo se realizó de forma inteligente. Nos propone una crónica de todo el acontecimiento manteniendo una perspectiva local.

THE ENTERPRISE RETURNS

Suddenly at war, carrier came home safe and sound...

Two squadrons of F-14s from the Enterprise flew in formation as they arrived at Oceana Naval Air Station on Nov. 9. Family members and friends waved flags as the planes passed overhead.

More than 15,000 waited at Norfolk Naval Station for the Enterprise to sail into view. Maame Boateng, left, and her sister Nana from Washington, D.C., prepared to greet their brother.

THE ENTERPRISE was wrapping up its deployment when terrorists attacked New York City and the Pentagon on Sept. 11. The carrier immediately turned around and headed back to the Arabian Sea to deliver America's response. The Enterprise and the destroyer McFaul, another Norfolk-based ship, participated in the first wave of attacks on Taliban and al-Qaida installations in Afghanistan on Oct. 7. For the next three weeks, flying mainly at night, pilots off the Enterprise dropped more than 1.4 million pounds of ordnance on training camps and front lines, propelling the Northern Alliance into an easy rout of their once-formidable enemies. When the Enterprise returned from a deployment that lasted 16 days longer than the normal six months, it was with a sense of accomplishment. Not a single pilot or aircraft had been lost. Garth Brooks brought his show to the deck in November in appreciation, and on Dec. 7, the 60th anniversary of the Japanese attack on Pearl Harbor, President Bush boarded the Enterprise to thank American heroes, past and present.

ABOVE: When the destroyer McFaul finally arrived home on Dec. 12, Petty Officer First Class Javier Joglar was ready. The sonar technician blew a kiss to his wife, Arlinda.

LEFT: After their extended deployment, flag-waving Enterprise sailors manned the rails as their ship neared the Navy base on Nov. 10.

ST. PETERSBURG TIMES / JULY 28, 2002 / SECTION 1

A SPECIAL REPORT

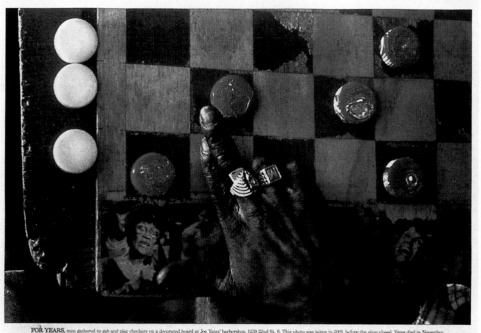

FOR YEARS, men gathered to gab and play checkers on a decorated board at Joe Yates' barbershop, 1219 22nd St. S. This photo was taken in 2001, before the shop closed. Yates died in November.

THE DEUCES

TO KNOW THIS CITY — FIRST KNOW THIS STREET

ON A NOVEMBER NIGHT in 1921, two explosions rattled the Dream, a new movie house on Ninth Street S for black residents of St. Petersburg. No one was hurt, but the message was as loud as the blasts: Whites didn't want blacks congregating so close by. The theater closed, and as so often happened in the decades that followed, black residents were pushed out of the whites' way. On what was then the edge of town, African-Americans began to create a community of their own, on 22nd Street S, a place nicknamed The Deuces. ✦ Neon glittered and energy crackled on The Deuces, once the busiest and most popular thoroughfare in the black community. In this new home, residents could forget at least for a while that the segregated society judged them first and foremost by the color of their skin. ✦ The now-desolate view above was once its heart, and the street's lively past has vanished like a fading blues note as integration opened up opportunities elsewhere. But in this new and better world, residents also lost something: a community that could nurture and sustain itself with its stores, its schools, its skills, its people. Could such a place live again?

STORY BY JON WILSON ✦ PHOTOGRAPHS BY JAMIE FRANCIS ✦ GRAPHICS BY DON MORRIS
OF THE TIMES STAFF

SILVER
St. Petersburg Times
St. Petersburg, Fla. (A)

Special coverage/sections (with ads)

Jon Wilson, Reporter; **Don Morris,** Graphic Artist; **Jamie Francis,**
Photographer

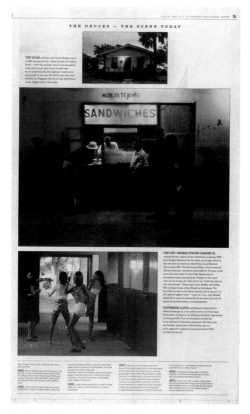

Judges: This section has all the pieces working together to tell a story. It is easy to access, and it's inviting.

Jueces: Esta sección combina todas las piezas para contar la historia. Es fácil de acceder a ella e invita al lector a seguir leyendo.

Illustration

Photography

Informational graphics

Miscellaneous

Awards

AWARDS OF EXCELLENCE, unless designated.

GOLD, exceptional work.

SILVER, outstanding work.

JUDGES' SPECIAL RECOGNITION, worthy of a singular, superior honor in the category, is in Chapter 2, pages 26-37.

Circulation

Indicated after each publication's location
(A) 175,000 & over
(B) 50,000-174,999
(C) 49,999 & under

O Globo
Rio de Janeiro, Brazil (A)

Illustration/single

Cláudio Duarte, Illustrator & Designer

The Wall Street Journal
South Brunswick, N.J. (A)

Illustration/single

Joe Zeff, Illustrator; **Orlie Krauss,** Art Director; **Greg Leeds,** Executive Art Director

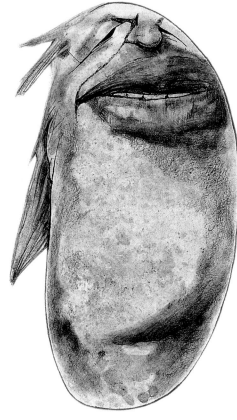

El País
Madrid, Spain (A)

Illustration/single

Agustín Sciamarella, Illustrator

Los Angeles Times
Los Angeles, Calif. (A)

Illustration/multiple

Jennifer Hewitson, Illustrator

Cape Cod Times
Hyannis, Mass. (B)

Illustration/single

Jim Warren, Artist

The Globe and Mail
Toronto, Ont., Canada (A)

Illustration/single

Lino, Illustrator; **David Woodside,** Weekend Art Director; **David Pratt,** Editorial Design Director

GOLD
Dagens Nyheter
Stockholm, Sweden (A)

Illustration/multiple

Jesper Waldersten, Illustrator

Judges: The idea that a newspaper would commit this space to a book excerpt is incredible. This interpretation stretches the bounds of all illustration.

Jueces: La idea de que un diario dedique este espacio a un extracto de un libro es increible. Esta interpretación va más allá de lo que supone una ilustración.

Cape Cod Times
Hyannis, Mass. (B)

Illustration/single

Jim Warren, Artist

The Toronto Star
Toronto, Ont., Canada (A)

Illustration/single

Raffi Anderian, Illustrator; **Ian Somerville,** Art Director; **Bill Schiller,** Editor

Chicago Tribune
Chicago, Ill. (A)

Illustration/single

Michael Miner, Art Director; **Stephen Ravenscraft,** Art Director; **Horatio Cardo,** Illustrator

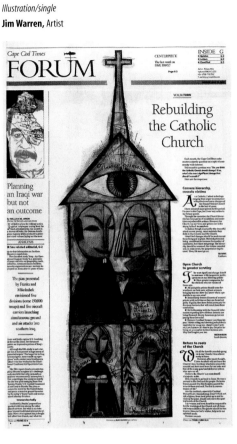

The Virginian-Pilot
Norfolk, Va. (A)

Illustration/single

Sam Hundley, Illustrator

The Seattle Times
Seattle, Wash. (A)

Illustration/multiple

Tracy Porter, Designer/Illustrator

GOLD
The New York Times
New York, N.Y. (A)

Illustration/single

Mirko Ilic, Illustrator; **Gigi Fava,** Art Director;
Tom Bodkin, A.M.E. Design Director

Judges: Extraordinary technique.
It's perfect. It takes computer
illustration to an entirely new level
– and goes beyond. It's haunting.
It's so well executed technically,
with 3D and transparency giving it
a realistic touch.

Jueces: Técnica extraordinaria. Es
perfecto. Lleva la ilustración en la
computadora a límites
insospechados. Es obsesionante.
Está realizado con muy buena
técnica, con imágenes en tres
dimensiones y transparencias que
dan un toque realista.

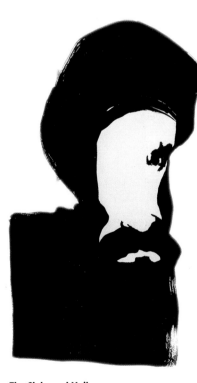

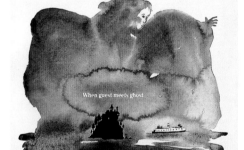

The Seattle Times
Seattle, Wash. (A)

Illustration/single

Susan Jouflas, Illustrator

The Globe and Mail
Toronto, Ont., Canada (A)

Illustration/single

Anthony Jenkins, Illustrator; **David Woodside,** Weekend
Art Director; **David Pratt,** Editorial Design Director

The Columbus Dispatch
Columbus, Ohio (A)

Illustration/single

Evangelia Philippidis, Ilustrator

Reforma
México City, México (B)

Illustration/single

Alma Cecilia Falcón, Illustrator; **Esteban Saldaña,** Fotoarte; **Alicia Kobayashi,** Designer; **Beatriz de León,** Editor; **José Manuel Mendoza,** Graphics Editor; **Emilio Deheza,** Graphic Director

The Age
Melbourne, Australia (A)

Illustration/single

Mick Connolly, Illustrator; **Sally Heath,** Saturday Extra Editor; **Robin Cowcher,** Illustration Editor

Dagens Nyheter
Stockholm, Sweden (A)

Illustration/multiple

Anne-Li Karlsson, Illustrator

The Plain Dealer
Cleveland, Ohio (A)

Illustration/single

Ellie Rhyner, Illustrator

The New York Times Magazine
New York, N.Y. (A)

Illustration/multiple

Janet Froelich, Art Director; **Maira Kalman,** Illustrator; **Andy Port,** Style Director

The Globe and Mail
Toronto, Ont., Canada (A)

Illustration/single

Anita Kunz, Illustrator; **David Woodside,** Weekend Art Director; **David Pratt,** Editorial Design Director; **Jerry Johnson,** Focus Editor; **Moe Doirow,** Deputy Photo Editor

Heraldo de Aragon
Zaragoza, Spain (B)

Illustration/multiple

Enrique Royo Romeo; Santiago Lorén Berdusán; Vicente Villarrocha Ardisa; Eduardo Salavera Moreno; Natalio Bayo Rodríguez; José Luis Cano Rodríguez

SILVER
Diário de Notícias
Lisbon, Portugal (B)

Illustration/multiple

Mário Bettencourt Resendes, Editor in Chief; **José Maria Ribeirinho,** Design Editor; **Pedro Rolo Duarte,** Editor; **Paulo Barata Corrêa,** Art Editor; **Nuno Janela,** Designer; **Pedro Falcão,** Designer; **Rui Fazenda,** Illustrator; **Cases i Associats,** Design Consultant

Judges: How do you present a story about pornography in a newspaper? The degree of difficulty makes this an even greater success. It shows the obvious, without having to show it all.

Jueces: ¿Cómo presentas una historia sobre pornografía en un periódico? El grado de dificultad convierte a esta pieza en un éxito mayor. Muestra lo obvio sin tener que enseñarlo todo.

The Indianapolis Star
Indianapolis, Ind. (A)

Illustration/single

Deborah Strzeszkowski, Illustrator

The New York Times
New York, N.Y. (A)

Illustration/single

Stephen Savage, Illustrator; **Steven Heller,** Art Director

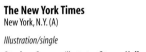

Sarasota Herald-Tribune
Sarasota, Fla. (B)

Illustration/single

Jennifer F.A. Borresen, Graphic Artist; **Sara Quinn,** A.M.E./Visuals;
Nicole Sneed, Graphics Editor

The Plain Dealer
Cleveland, Ohio (A)

Illustration/single

David Kordalski, A.M.E./Visuals

Politiken
Copenhagen, Denmark (A)

Illustration/single

Poul Holck, Artist

The Hartford Courant
Hartford, Conn. (A)

Illustration/single

Josue Evilla, Designer/Illustrator

Seattle Post-Intelligencer
Seattle, Wash. (A)

Illustration/single

David Badders, Ilustrator

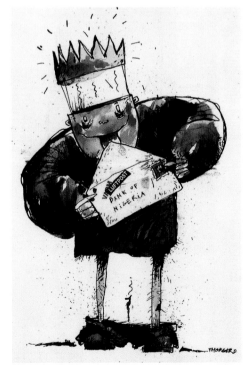

Dagens Nyheter
Stockholm, Sweden (A)

Illustration/multiple

Jesper Waldersten, Illustrator

SILVER
El País
Madrid, Spain (A)

Illustration/single

Agustín Sciamarella, Illustrator

Judges: The artist summarizes Woody Allen with one nose.
The caricature's simplicity and directness give it an effortless feel.

Jueces: El artista resume a Woody Allen con una nariz.
La simplicidad de la caricatura transmite fácilmente al lector.

Los Angeles Times
Los Angeles, Calif. (A)

Travel page

Carrie Barber, Design Editor; **Jan Molen,** Design Editor; **Lisa Clausen,**
Features Design Director

Seattle Post-Intelligencer
Seattle, Wash. (A)

Illustration/single

Wendy Wahman, Illustrator

Asbury Park Press
Neptune, N.J. (B)

Illustration/multiple

Harris Siegel, M.E./Design & Photography; **Andrew Prendimano,**
Art & Photo Director/Illustrator; **Mark Voger,** Illustrator;
Jeff Colson, Illustrator; **Toni Misthos,** Illustrator

Chicago Tribune
Chicago, Ill. (A)

Illustration/single

Michael Kellams, Design Editor; **Stephen Ravenscraft,** Art Director;
Richard Beckerman, Illustrator

National Post
Don Mills, Ont., Canada (A)

Illustration/multiple

Paul Davis, Illustrator; **Kenneth Whyte,** Editor in Chief; **Leanne
Shapton,** Design Consultant; **Cameron Williamson,** Creative Director

Judges: The presidential pendulum – the tangled mess this guy's in, the fall, the struggle. He's trying to figure things out. It's controlled chaos.

Jueces: El péndulo presidencial: el lío en el que se encuentra este individuo, la caída, la lucha. Está intentando descifrar qué pasa. Es un caos controlado.

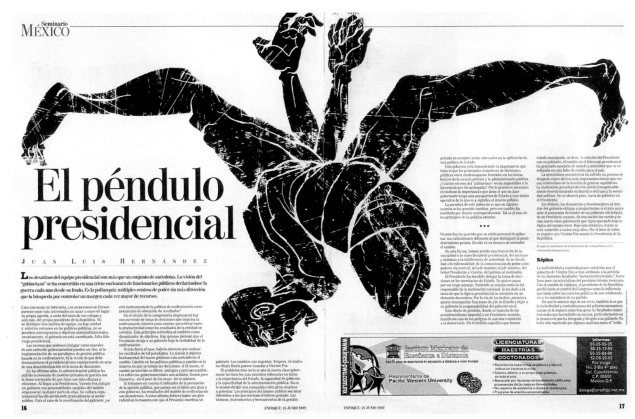

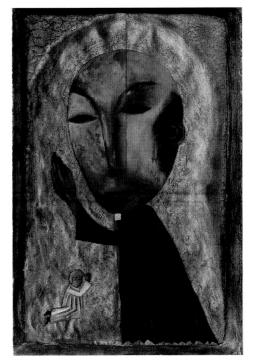

Cape Cod Times
Hyannis, Mass. (A)

Illustration/single

Jim Warren, Artist

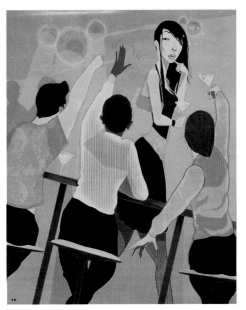

The Boston Globe Magazine
Boston, Mass. (A)

Illustration/single

Brendan Stephens, Art Director; **Nick King,** Editor; **Marcos Chin,** Illustrator; **Dan Zedek,** Design Director

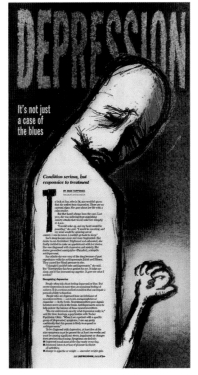

Richmond Times-Dispatch
Richmond, Va. (A)

Illustration/single

Kerry P. Talbott, Artist

Pittsburgh Post-Gazette
Pittsburgh, Pa. (A)

Illustration/single

Diane Juravich, Designer; **Anita Dufalla,** Art Director

The New York Times
New York, N.Y. (A)

Illustration/single

Marc Boutavant, Illustrator; **Steven Heller,** Art Director

The Philadelphia Inquirer Magazine
Philadelphia, Pa. (A)

Illustration/single

José Luis Merino, Illustrator; **Lisa Zollinger Tobia,** Art Director; **Susan Syrnick,** Assistant Art Director & Designer

The Tampa Tribune
Tampa, Fla. (A)

Illustration/multiple

David O'Keefe, Illustrator; **Jay Conner,** Photographer; **Malanda Saxton,** Art Director; **Andrew Smith,** Designer; **Greg Williams,** Art Director/Design

Contra Costa Times
Walnut Creek, Calif. (A)

Illustration/single

Chuck Todd, News Artist

The Seattle Times
Seattle, Wash. (A)

Illustration/single

Michelle Kumata, Illustrator

Arkansas Democrat-Gazette
Little Rock, Ark. (A)

Illustration/multiple

John Deering, Artist

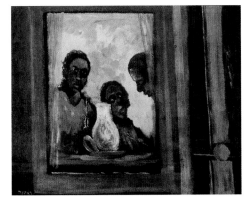

The San Diego Union-Tribune
San Diego, Calif. (A)

Illustration/single

David Mollering, Illustrator; **Michelle Carlin,** Designer

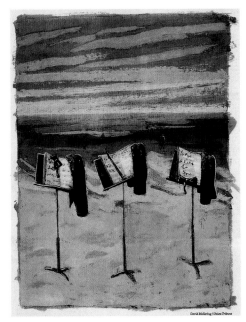

The Journal News
White Plains, N.Y. (B)

Illustration/single

Aaron Porter, Graphic Artist

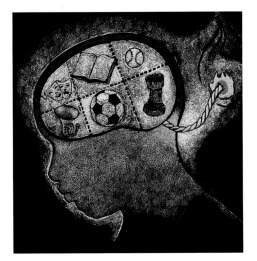

SILVER
Svenska Dagbladet
Stockholm, Sweden (A)

Illustration/single

Guje Engström, Illustrator

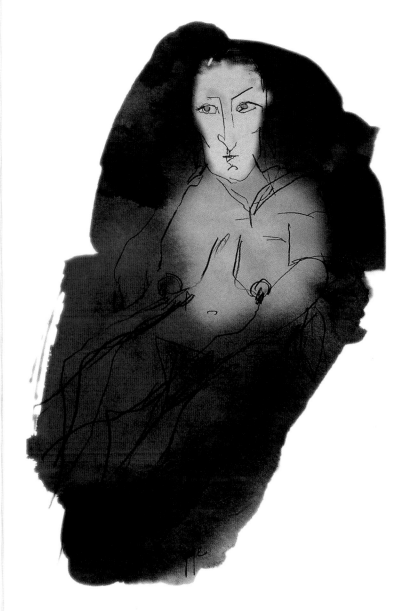

Judges: It shows a reflective attitude, looking inside herself. Her eyes say so much. The artist uses simple lines to tell a complicated story.

Jueces: Muestra una actitud reflexiva, mirándose por dentro. Sus ojos dicen mucho. El artista usa líneas simples para contar una historia complicada.

Dagens Nyheter
Stockholm, Sweden (A)

Illustration/single

Stina Wirsén, Illustrator

O Globo
Rio de Janeiro, Brazil (A)

Illustration/single

Cruz, Illustrator

A literatura do crime

Profusão de obras sobre violência revela que mercado editorial absorve a barbárie

The Boston Globe
Boston, Mass. (A)

Illustration/single

Jon Ritter, Illustrator; **Dan Zedek,** Design Director; **Susan Levin,** Art Director; **Gregory Klee,** Art Director; **James Concannon,** Editor; **Justin Cronin,** Writer

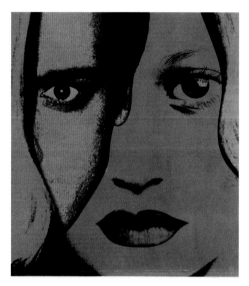

Seattle Post-Intelligencer
Seattle, Wash. (A)

Illustration/single

David Badders, Illustrator

The Washington Times
Washington, D.C. (B)

Illustration/single

Rich Pope, Illustrator

The Dallas Morning News
Dallas, Texas (A)

Illustration/single

Lamberto Alvarez, Illustration Director/Illustrator

Pittsburgh Post-Gazette
Pittsburgh, Pa. (A)

Illustration/single

Stacy Innerst, Illustrator; **Bill Pliske,** Designer

The Wall Street Journal
South Brunswick, N.J. (A)

Illustration/single
Also winning in special coverage/section cover page, page 120.

Ettienne Delesert, Illustrator; **Orlie Krauss,** Art Director; **Greg Leeds,**
Executive Art Director

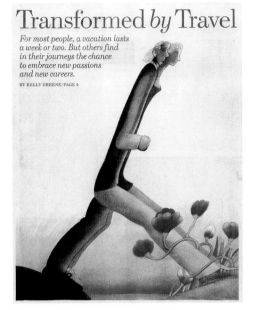

The Philadelphia Inquirer Magazine
Philadelphia, Pa. (A)

Illustration/single

Tifenn Python, Illustrator; **Lisa Zollinger Tobia,** Art Director; **Susan
Syrnick,** Assistant Art Director & Designer

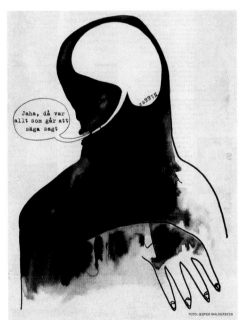

Dagens Nyheter
Stockholm, Sweden (A)

Illustration/single

Jesper Waldersten, Illustrator

Seattle Post-Intelligencer
Seattle, Wash. (A)

Illustration/individual
Also winning in portfolio/illustration/individual, page 237.

David Badders, Illustrator

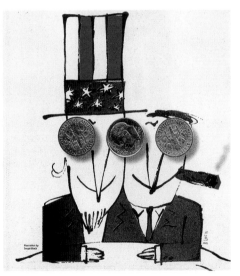

Chicago Tribune
Chicago, Ill. (A)

Illustration/single

Michael Kellams, Design Editor; **Stephen Ravenscraft,** Art Director;
Serge Bloch, Illustrator

Politiken
Copenhagen, Denmark (B)

Illustration/single

Roald Als, Artist

El Norte
Monterrey, México (B)

Illustration/single

René Almanza, Illustrator; **Eddie Macias,** Illustrator Manager

The Palm Beach Post
West Palm Beach, Fla. (B)

Illustration/single

Brennan King, Illustrator

The New York Times
New York, N.Y. (A)

Illustration/single

Mark Summers, Illustrator; **Steven Heller,** Art Director

The Virginian-Pilot
Norfolk, Va. (A)

Illustration/single

Sam Hundley, Designer; **Lynn Feigenbaum,** Editor

Also winning in opinion page, page 102.

National Post
Toronto, Ont., Canada (A)

Illustration/single

Gayle Grin, A.M.E./Design & Graphics; **Kenneth Whyte,** Editor in Chief; **Lauren Redniss,** Illustrator; **Dianne de Fenoyl,** Life Editor; **Samantha Grice,** Writer; **Alicia Kowalewski,** Consultant; **Christine Dewairy,** Consultant

Chicago Tribune
Chicago, Ill. (A)

Illustration/single

Claire Innes, Art Director; **David Ho,** Illustrator; **Jim Warren,** M.E./Features; **Denise Joyce,** Senior Editor

The Globe and Mail
Toronto, Ont., Canada (A)

Illustration/single

Lino, Illustrator; **David Woodside,** Weekend Art Director; **David Pratt,** Editorial Design Director

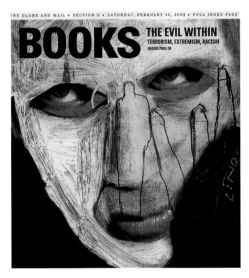

The Des Moines Register
Des Moines, Iowa (B)

Illustration/single

Mark Marturello, Illustrator

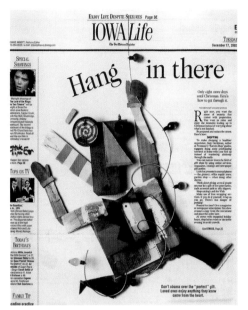

The Boston Globe
Boston, Mass. (A)

Illustration/single

Jane Martin, Art Director; **Scott Pettersen,** Illustrator

Morgenavisen Jyllands-Posten
Viby, Denmark (A)

Illustration/multiple

Thorgerd Broni Jensen, News Graphic Artist; **Steen Kilde Christensen,** Sub-Editor

Diário de Notícias
Lisbon, Portugal (B)

Illustration/multiple

Mário Bettencourt Resendes, Editor in Chief; **José Maria Ribeirinho,** Design Editor; **José Sarmento de Matos,** Editor; **Jorge Silva,** Art Director/Designer; **Daniel Lima,** Illustrator

The Boston Globe
Boston, Mass. (A)

Illustration/single

Jane Martin, Art Director; **Thomas Libetti,** Illustrator

The Washington Post
Washington, D.C. (A)

Illustration/single

Malcolm Tarlofsky, Illustrator; **Kelly Doe,** Art Director

Milwaukee Journal Sentinel
Milwaukee, Wis. (A)

Illustration/single

Lonnie Turner, Illustrator

Cape Cod Times
Hyannis, Mass. (B)

Illustration/single

Jim Warren, Artist

Reforma
México City, México (B)

Illustration/single

Fabricio Vanden Broeck, Illustrator; **Ernesto Montes de Oca,** Coeditor Graphics; **Alberto Aguirre,** Editor; **Ricardo del Castillo,** Graphics Editor; **Miguel de la Vega,** Coordinating Editor; **René Delgado Ballesteros,** Director/Editorial; **Emilio Deheza,** Graphic Director; **Cecilia Peña,** Designer

The New York Times
New York, N.Y. (A)

Illustration/single

Leszek Wisniewski, Illustrator; **Jerelle Kraus,** Art Director

The New York Times
New York, N.Y. (A)

Illustration/single

Zachary Pullen, Illustrator; **Steven Heller,** Art Director

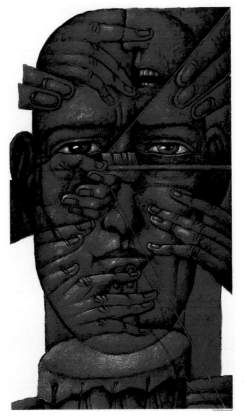

The Philadelphia Inquirer Magazine
Philadelphia, Pa. (A)

Illustration/multiple

Lisa Zollinger Tobia, Art Director; **Susan Syrnick,** Assistant Art
Director & Designer; **Isabelle Arsenault,** Illustrator

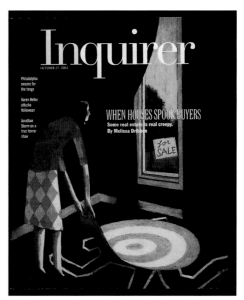

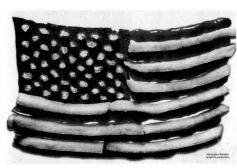

Chicago Tribune
Chicago, Ill. (A)

Illustration/single

Tom Heinz, Illustrator; **Bob Fila,** Photographer; **Tim Bannon,** Editor

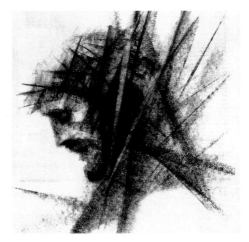

El Norte
Monterrey, México (B)

Illustration/single

René Almanza, Illustrator; **Eddie Macias,** Illustrator Manager

El Comercio
Lima, Peru (B)

Illustration/single

Alonso Nuñez, Illustrator; **Xabier Díaz de Cerio,** Art Director

St. Augustine Record
St. Augustine, Fla. (C)

Spot news photography

Ralph D. Priddy, Photographer

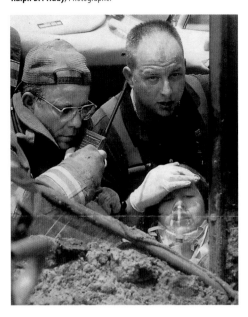

San Gabriel Valley Tribune
West Covina, Calif. (B)

Spot news photography

Leo Jarzomb, Photographer

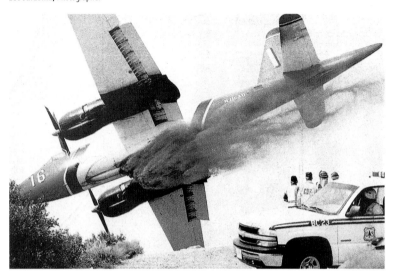

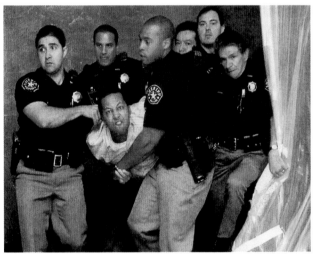

Rocky Mountain News
Denver, Colo. (A)

Spot news photography

George Kochaniec, Jr., Photographer

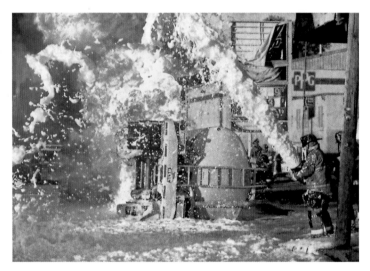

Pittsburgh Post-Gazette
Pittsburgh, Pa. (A)

Spot news photography

Annie O'Neill, Photographer

The Herald
Everett, Wash. (B)

Photo series, project or story

Stephanie S. Cordle, Staff Photographer

The Wenatchee World
Wenatchee, Wash. (C)

Spot news photography

Tom Williams, Photographer

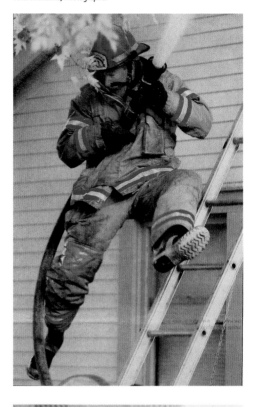

El Comercio
Lima, Peru (B)

Spot news photography

Ines Menacho, Photographer; **Herman Schwarz,** Photo Editor; **Xabier Díaz de Cerio,** Art Director

GOLD
The Plain Dealer
Cleveland, Ohio (A)

Photo illustration. Also winning an award of excellence in illustration/individual.

Andrea Levy, Illustrator/Photographer

Also winning an award of excellence in features/food page.

David Kordalski, A.M.E./Visuals; **Lisa Griffis,** Designer; **Andrea Levy,** Illustrator; **Amanda Hamann,** Designer

Judges: This illustration jumped off the page. The concept is well executed through technically flawless combinations of subtle touches and use of color. A whimsical winner.

Jueces: Esta ilustración sobresalió. El concepto está bien realizado a través de combinaciones de toques sutiles y uso de color sin un sólo error técnico. Un ganador caprichoso.

Bangor Daily News
Bangor, Maine (B)

Spot news photography
Stephen M. Katz, Photographer

Star Tribune
Minneapolis, Minn. (A)

Photo series, project or story
Brian Peterson, Photographer; **Greg Branson,** Designer; **Vickie Kettlewell,** Photo Editor

Los Angeles Times
Los Angeles, Calif. (A)

Spot news photography
Brian Vander Brug,
Photographer

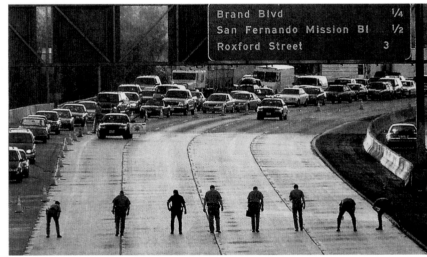

The Press Democrat
Santa Rosa, Calif. (A)

Spot news photography
Chris Chung, Photographer

The Times-Picayune
New Orleans, La. (A)

Spot news photography
Bryan S. Berteaux,
Staff Photographer;
Doug Parker, Photo
Editor; **Grant C.
Staublin,** Designer

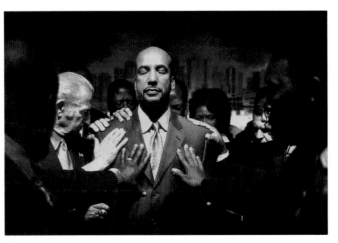

SILVER
The Miami Herald
Miami, Fla. (A)

Photo series, project or story

Peter Andrew Bosch, Photographer; **Carl Juste,** Photographer; **Maggie Steber,** Director/Photography; **David Walters,** Senior Photo Editor; **Eduardo M. Alvarez,** Deputy News Design Director; **David Wilson,** A.M.E.; **Alberto Ibargüen,** Publisher

Also winning special coverage/sections (no ads).

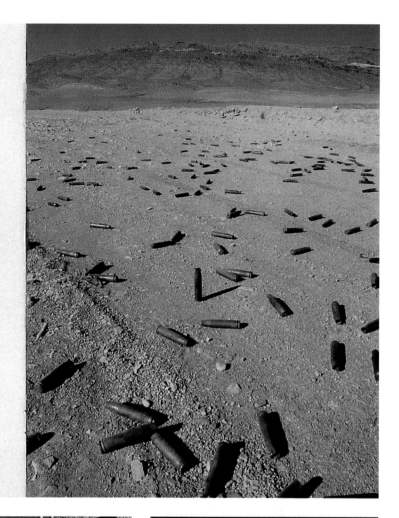

2 | THE MIAMI HERALD
MAY 26, 2002

AFGHANISTAN

INTRODUCTION

When America went to war after Sept. 11, we were reminded that events occurring half-a-world away – quite literally – directly affect our lives in South Florida. Many of our sons and daughters responded by their military service. Likewise, The Miami Herald mobilized to connect this distant story to our community. As we reflect on America's past conflicts this Memorial Day weekend, we asked the staffers who fulfilled that historic assignment to describe a memorable moment in their experience. Please enjoy this keepsake section.
– TOM FIEDLER, executive editor

ACKNOWLEDGEMENTS

PETER ANDREW BOSCH, photographer
CARL JUSTE, photographer
MARTIN MERZER, senior writer
MEG LAUGHLIN, writer
CAROL ROSENBERG, writer
NANCY SAN MARTIN, writer
JUAN O. TAMAYO, writer
ALBERTO IBARGÜEN, publisher
DAVID WILSON, editor
MAGGIE STEBER, photo director
DAVID WALTERS, photo editor
EDUARDO M. ALVAREZ, designer
GUS PEREZ, production coordinator
RONALD R. ROEDER, technical editor
NATIONAL LITHO, LLC, printer

ON THE COVER: A young boy peers from among the burqas of women attending a meeting of the Afghanistan Women's Council in Kabul.

ABOVE: While American B-52 bombers circle high above Tora Bora, Afghan fighters pause during the major battle that rooted out hundreds of al Qaeda fighters from caves.

OPPOSITE PAGE: Empty shell casings litter the road leading to Charika, where the Taliban and Northern Alliance fought in late November.
PHOTOS BY PETER ANDREW BOSCH

COPYRIGHT © 2002 THE MIAMI HERALD

WHEN THE WAR ON TERRORISM PUT AFGHANISTAN ON THE MAP, HERALD JOURNALISTS BROUGHT THE STORY HOME TO SOUTH FLORIDA. THEIR PHOTOGRAPHS PAINT VIVID IMAGES OF THE STARK LAND, AND THEIR STORIES DEPICT PROUD BUT DESPERATE PEOPLE.

A SPECIAL PUBLICATION OF THE MIAMI HERALD ▪ MAY 26, 2002

Judges: These images show Afghanistan in a different light than previously available. The strong colorful photos and editing paint a picture of the place that seems more real.

Jueces: Estas imágenes describen Afganistán de forma distinta a lo que habíamos visto anteriormente. Las fotos de color intenso y la edición pintan un cuadro del lugar que parece más real.

Arizona Daily Star
Tucson, Ariz. (B)

Spot news photography

David Sanders, Photographer; **Teri Hayt,** A.M.E./Presentation; **Sergey Shayevich,** Picture Editor

Rocky Mountain News
Denver, Colo. (A)

Spot news photography

Matt Inden, Photographer; **Dean Krakel,** Photo Editor

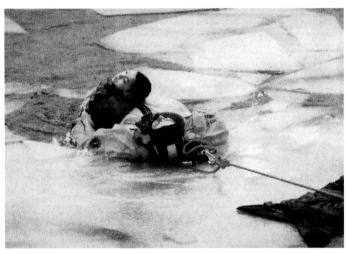

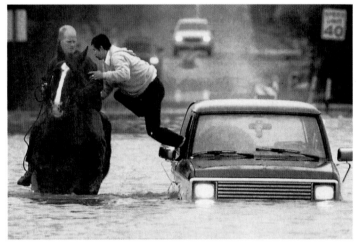

The Eagle-Tribune
North Andover, Mass. (C)

Spot news photography

Lisa Poole, Staff Photographer

The Press Democrat
Santa Rosa, Calif. (A)

Spot news photography

Kent Porter, Photographer

Portland Tribune
Portland, Ore. (B)

Spot news photography

L.E. Baskow, Photographer

Pittsburgh Post-Gazette
Pittsburgh, Pa. (A)

Spot news photography

Darrell Sapp, Photographer

Judges: The detail in this stunning photo stretches the limits of the medium. The angle, composition and crop add to the surreal quality of the fish and water.

Jueces: Los detalles de esta foto sensacional van más allá de lo esperado. El ángulo, la composición y cómo ha sido cortada se suman a la calidad surreal del pez y el agua.

SILVER
The Charlotte Observer
Charlotte, N.C. (A)

Photography feature

John D. Simmons, Photographer; **Mary Ann Lawrence,** Assistant Sports Editor; **Susan Gilbert,** Director/Photography; **David Scott,** Assistant Sports Editor

Also winning in news/sports pages, page 52.

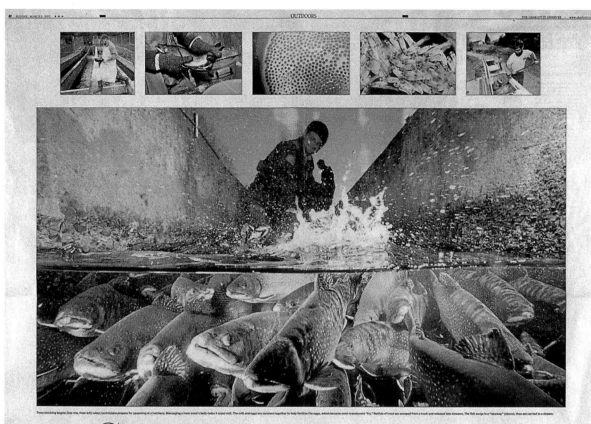

Stocked with a splash

N.C.'s 1,000 miles of hatchery-supported streams are replenished by an annual spawning of trout

Rocky Mountain News
Denver, Colo. (A)

Photo series, project or story
Photo Staff, Photo Editors

Cape Cod Times
Hyannis, Mass. (A)

Spot news photography

Kevin Mingora, Photographer

Rocky Mountain News
Denver, Colo. (A)

Spot news photography

Barry Gutierrez,
Photographer

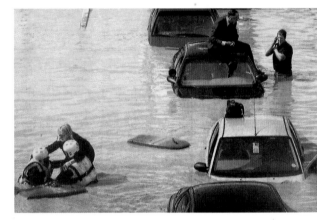

San Francisco Chronicle
San Francisco, Calif. (A)

Photo series, project or story

Lea Suzuki, Photographer

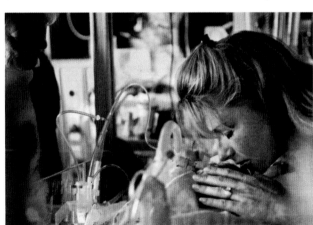

The Charlotte Observer
Charlotte, N.C. (A)

Photo series, project or story
Also winning in portfolios/photography/individual, page 241.

Patrick Schneider, Photographer; **Susan Gilbert,** Photo Editor; Peter Weinberger, Photo Editor; **Michael Whitley,** Designer; **Cory Powell,** Design Director; **Tom Tozer,** Deputy M.E./Presentation

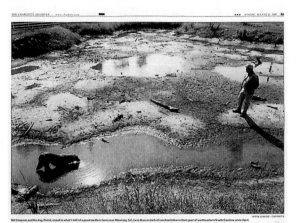

The Wenatchee World
Wenatchee, Wash. (C)

Spot news photography

Don Seabrook, Photo Editor

The Plain Dealer
Cleveland, Ohio (A)

Photo series, project or story

David Kordalski, A.M.E./Visuals; **Eustacio Humphrey,** Photographer; **Bill Gugliotta,** Director/Photography; **Jeff Greene,** Picture Editor; **Lisa Griffis,** Designer; **Scott Sheldon,** Designer

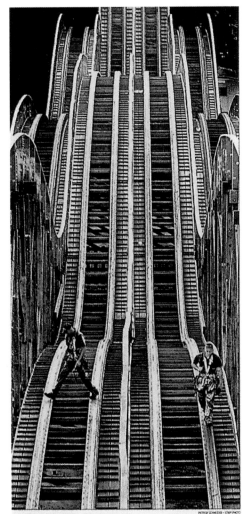

Tracking trouble

Every day before the summer crowds line up at Paramount's Carowinds, carpenters Ricky Miller (left) and Patrick Heckman inspect and repair the 3,819 feet of Thunder Road, one of four wooden roller coasters at the amusement park. Observer photographer Patrick Schneider joins them for a tour of what thrill riders never see.
A PHOTO ESSAY ON CAROWINDS' THUNDER ROAD : 6G

The Charlotte Observer
Charlotte, N.C. (A)

Photography feature

Patrick Schneider, Photographer

SILVER
The Plain Dealer
Cleveland, Ohio (A)

Spot news photography

Dale Omori, Photographer

Also winning in news/A-section page, page 40.

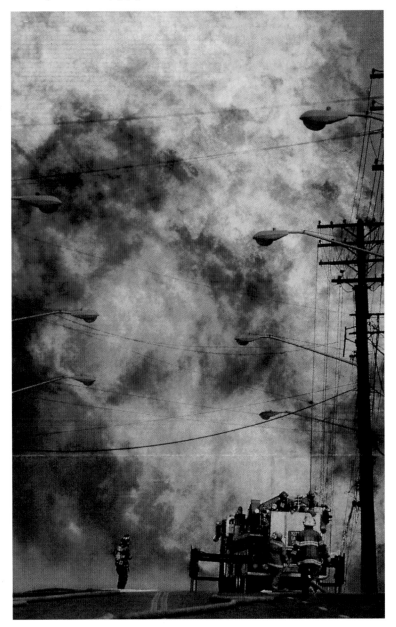

Judges: This image shows great response to the situation by the photographer. It is the epitome of a breaking-news photograph.

Jueces: El fotógrafo muestra con esta imagen una gran respuesta a la situación. Es un epitoma de una fotografía de noticia de última hora.

Los Angeles Times
Los Angeles, Calif. (A)

Reprints

Bill Gaspard, News Design Director

Also winning in photo series, project or story, and in special coverage/single subject.

Don Bartletti, Photographer; **Bill Gaspard,** News Design Editor; **Colin Crawford,** Photo Editor; **Gail Fisher,** Photo Editor; **Lorena Iñiguez,** Senior Artist; **Jerald Council,** Graphics Editor; **Kevin Bronson,** Design Editor

Also winning in A-section page, page 44.

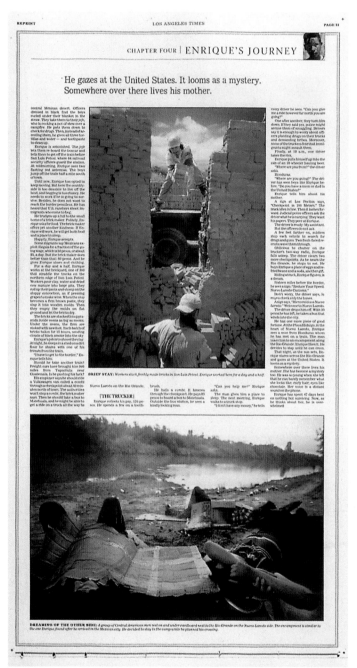

The Toronto Star
Toronto, Ont., Canada (A)

Spot news photography

Peter Power, Photographer

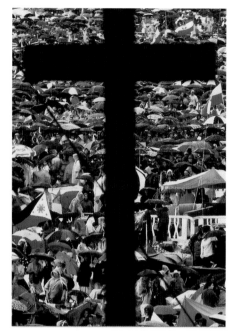

The Spokesman-Review
Spokane, Wash. (B)

Photo series, project or story

Kathy Plonka, Photographer; **John Sale,** Director/Photography; **Ralph Walter,** Designer

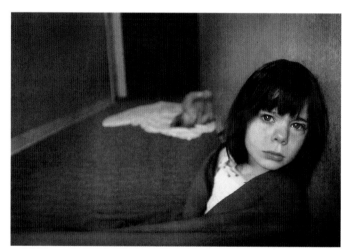

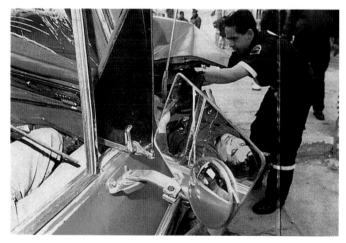

Metro
Benito Juárez, México (C)

Spot news photography

Agustin Márquez, Photographer; **Arturo Sánchez,** Editor; **Ignacio Guerrero,** Graphics Editor; **Roberto Paniagua,** Graphics Coordinator; **Alejandro Islas,** Designer; **Ricardo Elizondo,** Editorial Director; **Emilio Deheza,** Graphics Director

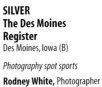

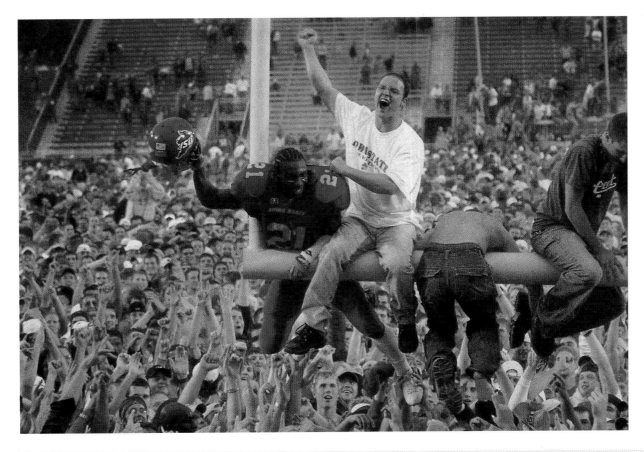

Judges: What might have been a predictable goal-post photo becomes an exciting tribute to the spirit of college athletics.

Jueces: Lo que podría haber sido una foto predecible de un balón de gol al poste se convierte en un tributo emocionante del espíritu atlético universitario.

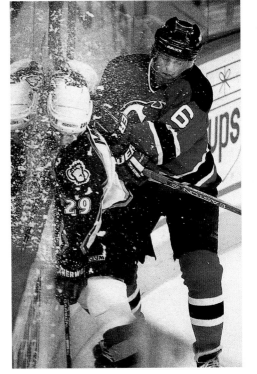

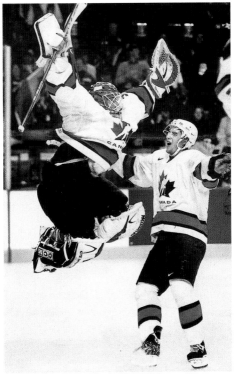

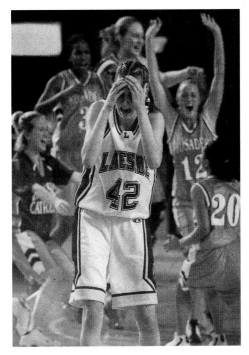

Rocky Mountain News
Denver, Colo. (A)

Photography spot sports
Marc Piscotty, Photographer

The Toronto Star
Toronto, Ont., Canada (A)

Photography spot sports
Peter Power, Photographer

Seattle Post-Intelligencer
Seattle, Wash. (A)

Photography spot sports
Mike Urban, Photographer

Rocky Mountain News
Denver, Colo. (A)

Photography spot sports

Dennis Schroeder, Photographer

Telegraph Herald
Dubuque, Iowa (C)

Photography spot sports

Gabriel Hacker, Photographer

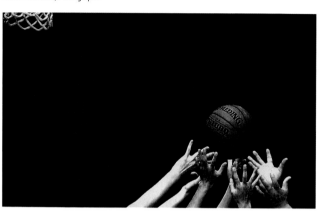

The Plain Dealer
Cleveland, Ohio (A)

Photography spot sports

John Kuntz, Photographer

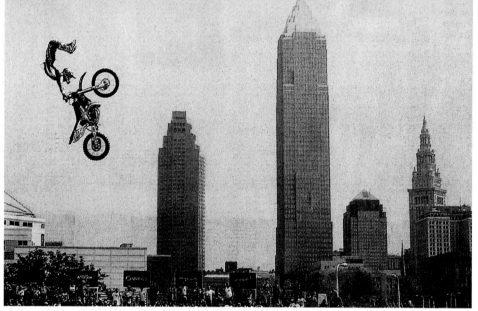

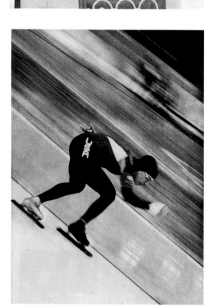

Rocky Mountain News
Denver, Colo. (A)

Photography spot sports

Steven G. Smith, Photographer

Austin American-Statesman
Austin, Texas (A)

Photography feature

Laura Skelding, Photographer; **Zach Ryall,** Director/Photography

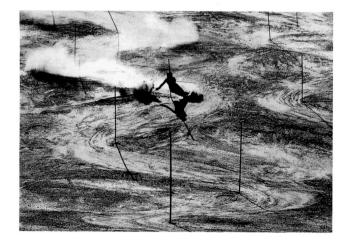

Dagens Nyheter
Stockholm, Sweden (A)

Photography spot sports

Jonas Lindkvist, Photographer

SILVER
Detroit Free Press
Detroit, Mich. (A)

Photography spot sports

Julian H. Gonzalez, Staff Photographer; **Steve Dorsey,** Page Designer, Design & Graphics Director; **Diane Weiss,** Picture Editor; **Craig Porter,** Deputy Director/Photography; **Nancy Andrews,** Director/Photography

Judges: This image takes readers somewhere they cannot go. The composition and details in the photo draw you in and invite you to stay a while.

Jueces: Esta imagen lleva al lector a donde éste no puede llegar. La composición y los detalles de la fotografía le cautivan para que se quede admirándola.

Dominik Hasek,
The Dominator

Dominik Hasek in goal against the St. Louis Blues.

Rocky Mountain News
Denver, Colo. (A)

Photography spot sports

Dennis Schroeder, Photographer

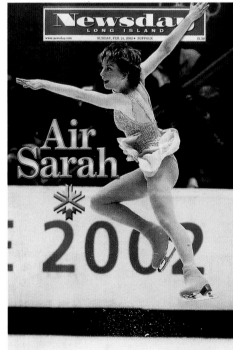

Newsday
Melville, N.Y. (A)

Photography spot sports

Paul J. Bereswill, Photographer

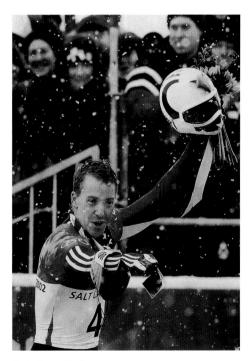

Rocky Mountain News
Denver, Colo. (A)

Photography spot sports

Dennis Schroeder, Photographer

The Tampa Tribune
Tampa, Fla. (A)

Photography spot sports

Cliff McBride, Photographer; **Andrew Smith,** Designer

San Francisco Chronicle
San Francisco, Calif. (A)

Photography spot sports

Carlos Avila Gonzalez, Photographer

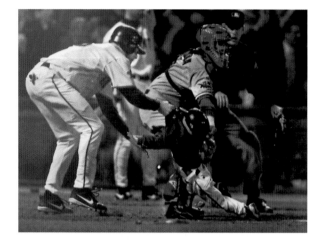

**San Jose
Mercury News**
San Jose, Calif. (A)

Photography spot sports

Meri Simon,
Photographer; **Eric
Pinkela,** Designer;
Wayne Begasse,
Picture Editor; **Matt
Mansfield,** Deputy
M.E.

C.A. Diario Panorama
Maracaibo, Venezuela (B)

Photography feature

Luis Bravo, Photographer

**The Dallas
Morning News**
Dallas, Texas (A)

Portrait photography

Damon Winter, Staff
Photographer

Pittsburgh Post-Gazette
Pittsburgh, Pa. (B)

Photography spot sports

Peter Diana, Photographer

SILVER
The Times-Picayune
New Orleans, La. (A)

Spot news photography

Also winning in A-section page and in breaking news topics and in special news topics, page 139.

David Grunfeld, Photographer; **Doug Parker,** Photo Editor; **George Berke,** Design Director

Judges: This intimate photograph brings the reader right into the situation. It conveys an emotional sense of the flood and the human struggle to cope with it.

Jueces: Esta fotografía íntima conduce al lector a la situación. Transmite un sentido emocional sobre las inundaciones y la lucha del hombre por hacer frente a éstas.

El Periódico de Catalunya
Barcelona, Spain (B)

Photography spot sports

Joan Carles Armengol, Writer; **Emilio Pérez de Rozas,** Sports Editor; **Reuters; EPA**

National Post
Don Mills, Ont., Canada (A)

Spot news photography

Chris Bolin, Photographer; **Denis Paquin,** Photo Editor; **Gayle Grin,** A.M.E. Design and Graphics; **Kenneth Whyte,**
Editor in Chief

The Star-Ledger
Newark, N.J. (A)

Photo series, project or story

Matt Rainey, Photographer; **Aris Economopoulos,** Photographer

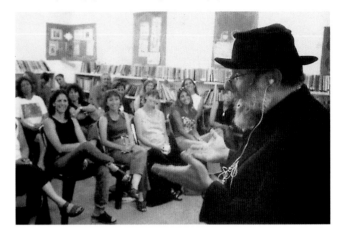

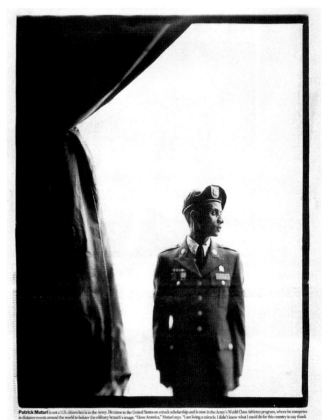

Patrick Muturi is not a U.S. citizen but is in the Army. He came to the United States on a track scholarship and is now in the Army's World Class Athletes program, where he competes in distance events around the world to bolster the military branch's image. "I love America," Muturi says. "I am living a miracle. I didn't know what I could do for this country to say thank you. That's when I came to the conclusion that I would like to join the Army."

'I am a living miracle'

Rocky Mountain News
Denver, Colo. (A)

Portrait photography

Steven G. Smith, Photographer

The Times-Picayune
New Orleans, La. (A)

Spot news photography

Ted Jackson, Photographer;
Doug Parker, Photo Editor

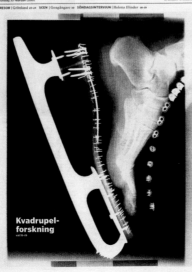

Svenska Dagbladet
Stockholm, Sweden (A)

Photo illustration

Staffan Löwstedt,
Photographer, Photo Editor

SILVER
Rocky Mountain News
Denver, Colo. (A)

Spot news photography

Hal Stoelzle, Photographer

Judges: Graphically beautiful, this image conveys the scale of destruction from a forest fire.

Jueces: Esta imagen, preciosa gráficamente, transmite la escala de destrucción de un incendio forestal.

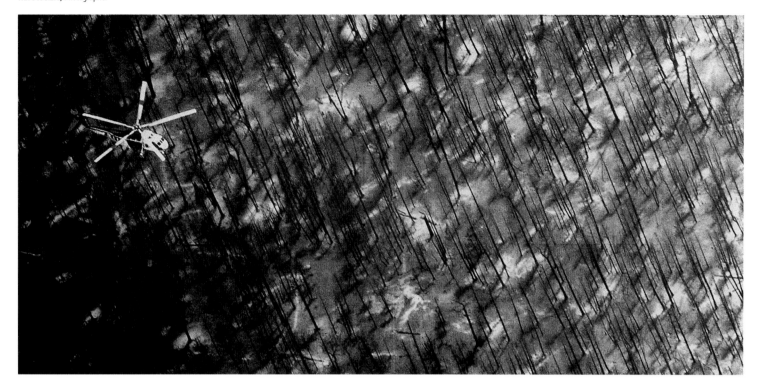

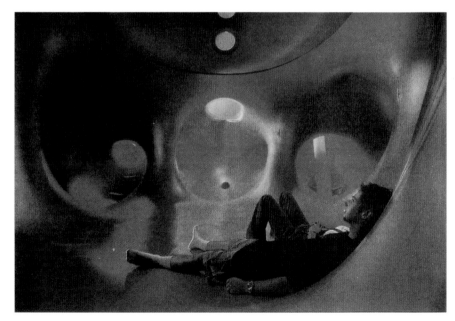

Detroit Free Press
Detroit, Mich. (A)

Photography feature

J. Kyle Keener, Chief Photographer; **Craig Porter,** Deputy Director/Photography; **Nancy Andrews,** Director/Photography; **Steve Dorsey,** Design & Graphics Director

Sarasota Herald-Tribune
Sarasota, Fla. (B)

Photography feature

Bert Cass, Staff Photographer, **Mike Lang,** Director of Photography, **Sara Quinn,** AME Visuals

The Toronto Star
Toronto, Ont., Canada (A)

Photography feature

Peter Power, Photographer

The Plain Dealer
Cleveland, Ohio (A)

Photography feature

John Kuntz,
Photographer

The News & Observer
Raleigh, N.C. (B)

Spot news photography

Scott Lewis, Photographer

Rocky Mountain News
Denver, Colo. (A)

Photography feature

Ellen Jaskol, Photographer

Rocky Mountain News
Denver, Colo. (A)

Photography feature

Steven G. Smith, Photographer

SILVER
National Post
Don Mills, Ont., Canada (A)

Spot news photography

Gayle Grin, A.M.E. Design & Graphics; **Kenneth Whyte,** Editor in Chief; **Carlo Allegri,** Photographer; **Denis Paquin,** Photo Editor

The Fresno Bee
Fresno, Calif. (A)

Photography feature

John Walker, Staff Photographer

Judges: This photograph evokes strong emotion. The picture demonstrates great sensitivity and draws its power from that sensitivity.

Jueces: Esta fotografía evoca una intensa emoción. La foto muestra sensibilidad y su fuerza emana de la sensibilidad.

Rocky Mountain News
Denver, Colo. (A)

Portrait photography

Steven G. Smith, Photographer

Detroit Free Press
Detroit, Mich. (A)

Portrait photography

J. Kyle Keener, Chief Photographer; **Betty Bazemore,** Page Designer; **Jessica Trevino,** Gallery Page Coordinator; **Craig Porter,** Deputy Director/Photography; **Nancy Andrews,** Director/Photography; **Steve Dorsey,** Design & Graphics Director

Also winning in portfolio, photography/individual, page 240.

**Pittsburgh
Post-Gazette**
Pittsburgh, Pa. (B)

Photography feature

Steve Mellon,
Photographer

Rocky Mountain News
Denver, Colo. (A)

Spot news photography

Maria J. Avila, Photographer

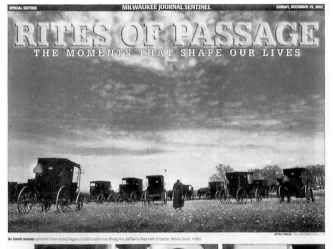

An Amish woman carries her shoes among buggies at a barn auction near Moody Ave. and Neville Road north of Caiston, Monroe County, in May.

RITES OF PASSAGE
THE MOMENTS THAT SHAPE OUR LIVES

Whatever form or shape it takes, a rite of passage marks a watershed moment, a change in a person's life, a point to mark time.

At the beginning of this year, the Milwaukee Journal Sentinel staff photographers were given the challenge of documenting these significant events in the lives of the people of Wisconsin. Throughout 2002, the photo staff found rich stories filled with texture and tenderness that paint a vivid picture of people in transition.

The section is also a part of a rite of passage for the Milwaukee Journal Sentinel. It is the first full-color section to be printed at our new printing facility. The new press has a smaller page size, which has become an industry standard.

The new presses eventually will bring clearer reproduction of photos and graphics, as well as sharper typography for easier-to-read stories. Some sections of the Journal Sentinel will begin printing on the new presses this winter, with production of the entire paper moving to the new facility by spring.

Milwaukee Journal Sentinel
Milwaukee, Wis. (A)

Photo series, project or story

Staff, Photographers; **Sherman Williams,** Senior Editor/Visuals; **Ed Brud,** News Design

Detroit Free Press
Detroit, Mich. (A)

Portrait photography

J. Kyle Keener, Chief Photographer; **Chris Clonts,** Deputy Design Director/News; **Jessica Trevino,** Gallery Page Coordinator; **Craig Porter,** Deputy Director of Photography; **Nancy Andrews,** Director/Photography; **David Dombrowski,** Page Designer; **Steve Dorsey,** Design & Graphics Director

SILVER
Dagens Nyheter
Stockholm, Sweden (A)

Portrait photography

Eva Tedesjö, Photographer

Judges: This image is risky and atypical for newspaper portraiture. The strong design pulls you into the environment and reveals the personality of the subject.

Jueces: Esta imagen es atrevida y es atípica en un retrato de un periódico. El diseño intenso te acerca al ambiente y revela la personalidad del sujeto.

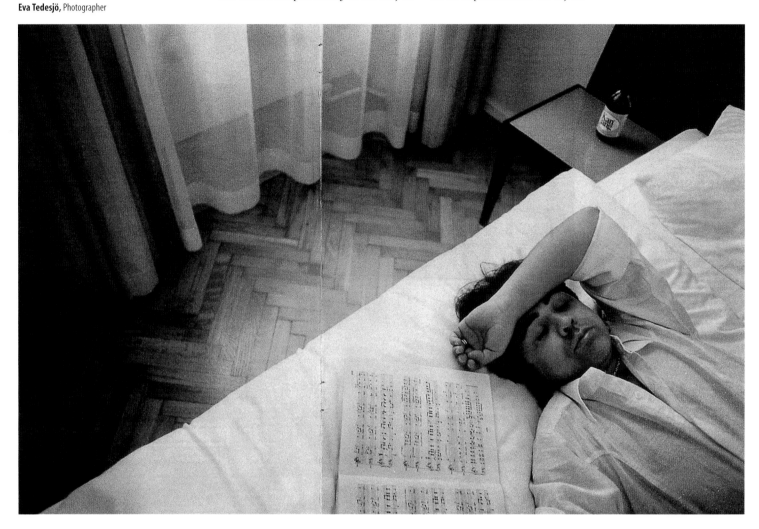

The Times-Picayune
New Orleans, La. (A)

Spot news photography

Ted Jackson, Photographer; **Doug Parker,** Photo Editor

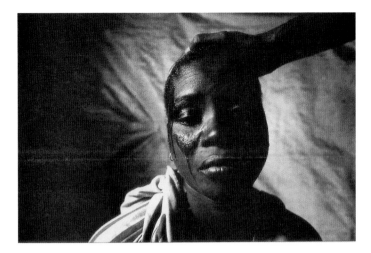

St. Petersburg Times
St. Petersburg, Fla. (A)

Photo series, project or story

John Kaplan; **Sue Morrow,** Picture Editor

Rocky Mountain News
Denver, Colo. (A)

Spot news photography

Ellen Jaskol, Photographer

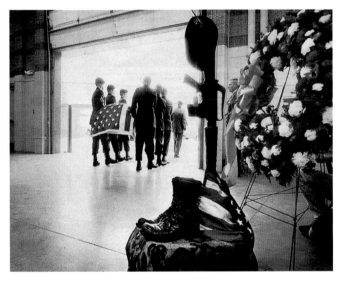

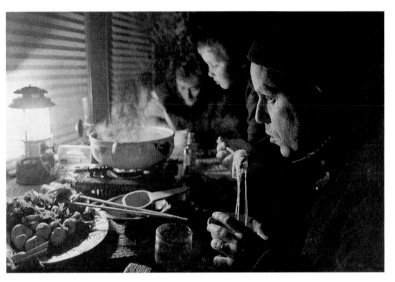

The News & Observer
Raleigh, N.C. (A)

Spot news photography

Mel Nathanson, Photographer;
Robert Miller, Picture Editor;
John Hansen, Picture Editor;
Kevin Keister, Picture Editor

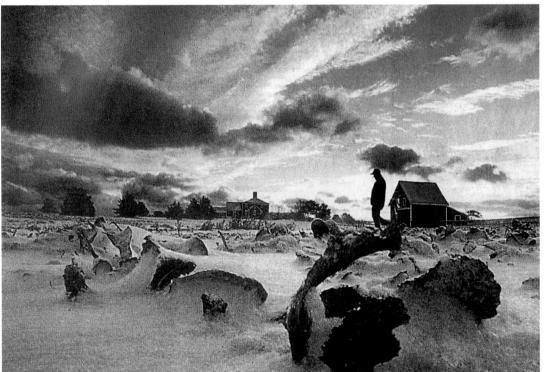

Cape Cod Times
Hyannis, Mass. (B)

Photography feature

Steve Heaslip, Chief Photographer

Los Angeles Times
Los Angeles, Calif. (A)

Photography feature

Al Schaben, Photographer

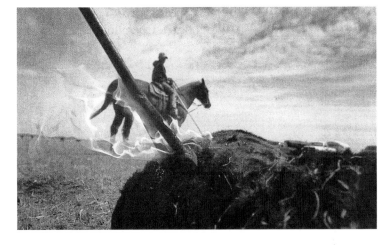

Detroit Free Press
Detroit, Mich. (A)

Photo illustration

J. Kyle Keener, Chief Photographer; **Steve Dorsey,** Page Designer, Design & Graphics Director; **Craig Porter,** Deputy Director/Photography; **Nancy Andrews,** Director/Photography

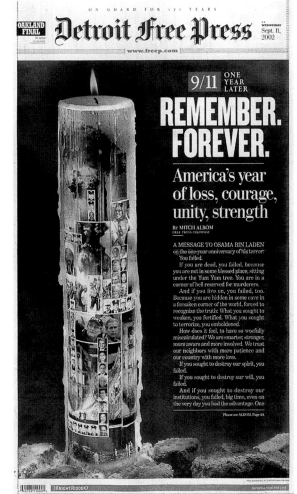

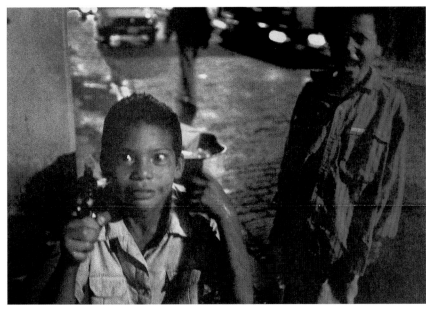

Los Angeles Times
Los Angeles, Calif. (A)

Photography feature

Don Bartletti, Photographer

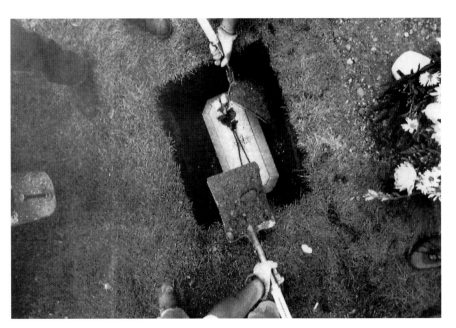

Rocky Mountain News
Denver, Colo. (A)

Spot news photography

Barry Gutierrez, Photographer

Los Angeles Times
Los Angeles, Calif. (A)

Photo illustration

Kirk McKoy, Photo Editor; **Mei Lisa Luther,** Design Editor

**The San Diego
Union-Tribune**
San Diego, Calif. (A)

Spot news photography

Nelvin Cepeda,
Photographer; **Gerald
McClard,** Photo
Editor/News

The Plain Dealer
Cleveland, Ohio (A)

Photography feature

John Kuntz, Photographer

The Oregonian
Portland, Ore. (A)

Photo series, project or story

Motoya Nakamura, Photographer; **Patrick Sullivan,** Photo Editor; **Grant Butler,** A&S
Editor; **Stan Shaw,** Designer

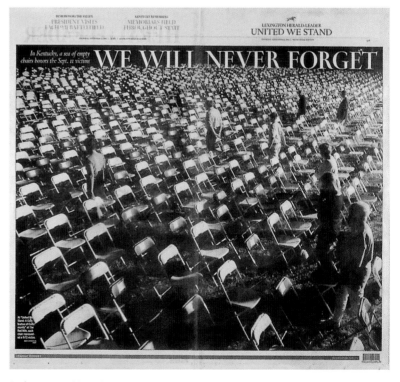

Lexington Herald-Leader
Lexington, Ky. (B)

Spot news photography

David Stephenson, Photographer

SILVER
Austin American-Statesman
Austin, Texas (A)

Photo series, project or story

Rodolfo Gonzalez, Photographer; **Zach Ryall,**
Director/Photography; **Gladys Rios,** Designer

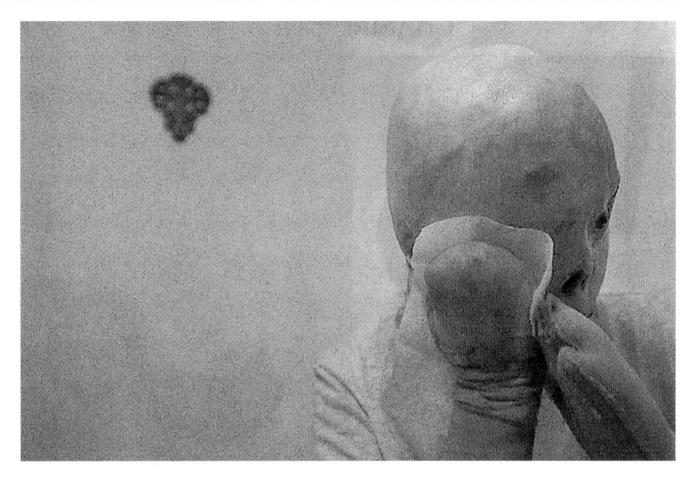

Judges: The pictures of the father with his daughter, a burn victim, are incredible. The photographer was able to build a trust with the family and put the reader into the story without being intrusive.

Jueces: Las imágenes del padre con la hija, una víctima quemada, son increibles. El fotógrafo ha sido capaz de forjar un sentimiento de confianza con la familia y sitúa al lector en la historia sin ser un intruso.

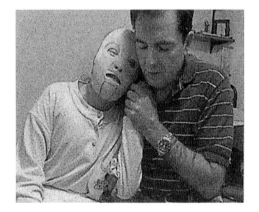

Chicago Tribune
Chicago, Ill. (A)

Photography feature

Bob Fila, Photographer; **Catherine Whipple,** Art Director; **Carol Haddix,** Food Editor; **Andy Badeker,** Writer; **Michael Kellams,** Design Editor

Chicago Tribune
Chicago, Ill. (A)

Photography feature

Bob Fila, Photographer; **Catherine Whipple,** Art Director; **Carol Haddix,** Food Editor; **William Rice,** Writer; **Michael Kellams,** Design Editor

The Toronto Star
Toronto, Ont., Canada (A)

Photography feature

Peter Power, Photographer

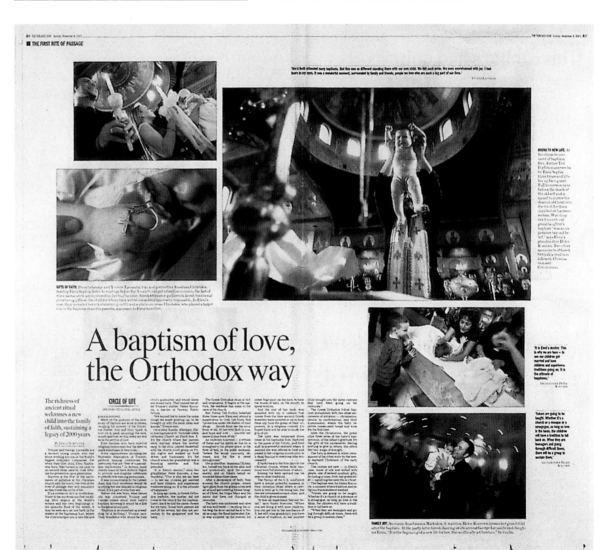

A baptism of love, the Orthodox way

The richness of ancient ritual welcomes a new child into the family of faith, sustaining a legacy of 2000 years

SILVER
The New York Times Magazine
New York, N.Y. (A)

Portrait photography

Janet Froelich, Art Director; **Robert Maxwell,** Photographer;
Kathy Ryan, Photo Editor; **Lisa Naftolin,** Designer

Judges: The movement and grace of this simple, elegant photograph draw you into the page.

Jueces: El movimiento y la gracia de esta fotografía simple y elegante te envuelven en la página.

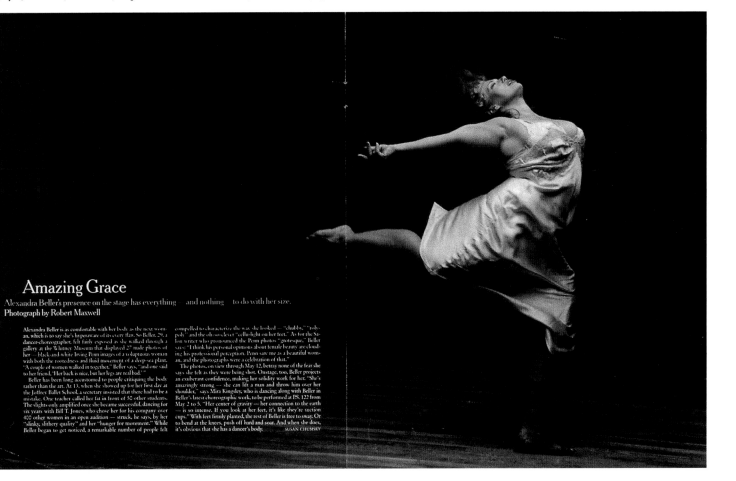

Amazing Grace

Alexandra Beller's presence on the stage has everything — and nothing — to do with her size.
Photograph by Robert Maxwell

Alexandra Beller is as comfortable with her body as the next woman, which is to say she's hyperaware of its every flaw. So Beller, 29, a dancer-choreographer, felt fairly exposed as she walked through a gallery at the Whitney Museum that displayed 27 nude photos of her — black-and-white Irving Penn images of a voluptuous woman with both the rootedness and fluid movement of a deep-sea plant. "A couple of women walked in together," Beller says, "and one said to her friend, 'Her back is nice, but her legs are real bad.'"

Beller has been long accustomed to people critiquing the body rather than the art. At 13, when she showed up for her first day at the Joffrey Ballet School, a secretary insisted that there had to be a mistake. One teacher called her fat in front of 30 other students. The slights only amplified once she became successful, dancing for six years with Bill T. Jones, who chose her for his company over 400 other women in an open audition — struck, he says, by her "slinky, slithery quality" and her "hunger for movement." While Beller began to get noticed, a remarkable number of people felt compelled to characterize the way she looked — "chubby," "roly-poly" and the obsolescent "cellu-light on her feet." As for the Salon writer who pronounced the Penn photos "grotesque," Beller says: "I think his personal opinions about female beauty are clouding his professional perception. Penn saw me as a beautiful woman, and the photographs were a celebration of that."

The photos, on view through May 12, betray none of the fear she says she felt as they were being shot. Onstage, too, Beller projects an exuberant confidence, making her solidity work for her. "She's amazingly strong — she can lift a man and throw him over her shoulder," says Mira Kingsley, who is dancing along with Beller in Beller's latest choreographic work, to be performed at P.S. 122 from May 2 to 5. "Her center of gravity — her connection to the earth — is so intense. If you look at her feet, it's like they're suction cups." With feet firmly planted, the rest of Beller is free to sway. Or to bend at the knees, push off hard and soar. And when she does, it's obvious that she has a dancer's body. SUSAN CHUMSKY

The Toronto Star
Toronto, Ont., Canada (A)

Photography feature

Lucas Oleniuk,
Photographer

The Globe and Mail
Toronto, Ont., Canada (A)

Portrait photography

Fred Lum, Photographer; **Moe Doirow,** Deputy Photo Editor; **Erin Elder,** Photo Editor; **David Pratt,** Editorial Design Director

Los Angeles Times
Los Angeles, Calif. (A)

Portrait photography

Wally Skalij, Photographer

The New York Times Magazine
New York, N.Y. (A)

Photo series, project or story

Janet Froelich, Art Director; **Joele Cuyler,** Designer; **Emily Crawford,** Designer; **Kathy Ryan,** Photo Editor; **Rodney Smith,** Photographer

Pittsburgh Post-Gazette
Pittsburgh, Pa. (A)

Photography feature

Bob Donaldson, Photographer

The Plain Dealer
Cleveland, Ohio (A)

Photo illustration

Andrea Levy, Illustrator

The Dallas Morning News
Dallas, Texas (A)

Photo illustration

Evans Caglage, Senior Staff Photographer

SILVER
The New York Times Magazine
New York, N.Y. (A)

Photo illustration

Janet Froelich, Art Director; **Michael Elins,** Photographer; **Claude Martel,** Designer;
Elizabeth Stewart, Style Director

Judges: These images required much creativity and planning. The execution is wonderful. It pushes the limits of newspaper fashion photography and delivers more than you would expect.

Jueces: Estas imágenes requieren mucha creatividad y planificación. La realización es maravillosa. Va más allá de la fotografía de moda de un diario y más allá de lo esperado.

Detroit Free Press
Detroit, Mich. (A)

Photography feature

J. Kyle Keener, Chief Photographer; **Steve Anderson,** Page Designer; **Jessica Trevino,** Gallery Page Coordinator; **Craig Porter,** Deputy Director/Photography; **Nancy Andrews,** Director/Photography; **Steve Dorsey,** Design & Graphics Director

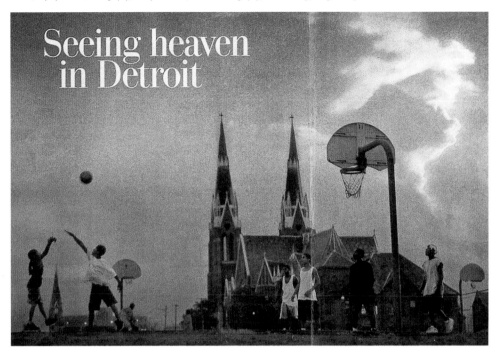

The New York Times Magazine
New York, N.Y. (A)

Photo series, project or story

Janet Froelich, Art Director; **Joele Cuyler,** Designer; **Kathy Ryan,** Photo Editor; **Brigitte Lacombe,** Photographer/Illustrator

St. Paul Pioneer Press
St. Paul, Minn. (A)

Portrait photography
Richard Marshall, Photographer

The Sun News
Myrtle Beach, S.C. (B)

Portrait photography
Mark Adams, Photographer

The Sun News
Myrtle Beach, S.C. (B)

Portrait photography
Mark Adams, Photographer

Richmond Times-Dispatch
Richmond, Va. (A)

Photo illustration

Mark Gormus, Staff
Photographer

Seattle Post-Intelligencer
Seattle, Wash. (A)

Photography feature

Scott Eklund, Photographer

Fort Worth Star-Telegram
Fort Worth, Texas (A)

Portrait photography

Ralph Lauer, Photographer

Pittsburgh Tribune-Review
Pittsburgh, Pa. (B)

Photo illustration

Kerry Johnson, Graphics Editor; **Chaz Palla,** Photographer; **Kevin Smith,** Sports Editor; **Mike Orfanopoulos,** Asst. Sports Editor; **Frank Craig,** Editor

Detroit Free Press
Detroit, Mich. (A)

Portrait photography

J. Kyle Keener, Chief Photographer; **Todd Cross,** Picture Editor; **Mauricio Gutiérrez,** Designer/, Deputy Design Director/Features; **Craig Porter,** Deputy Director/Photography; **Nancy Andrews,** Director/Photography; **Steve Dorsey,** Design & Graphics Director

SILVER
Diario De Sevilla
Sevilla, Spain (B)

Information graphics/non-breaking news, features

Manuel Romero Tortosa, Graphics Editor; **Carlos Gámez Kindelán,** Graphic Artist; **Cristina García Rivera,** Graphic Artist

Judges: Full of information, the entry doesn't have too much text. The renderings are very nice. The entry teaches us to look everywhere for graphics subjects.

Jueces: Lleno de información, la pieza no presenta mucho texto. Las interpretaciones son muy buenas. Nos enseña a buscar por todos lados elementos gráficos.

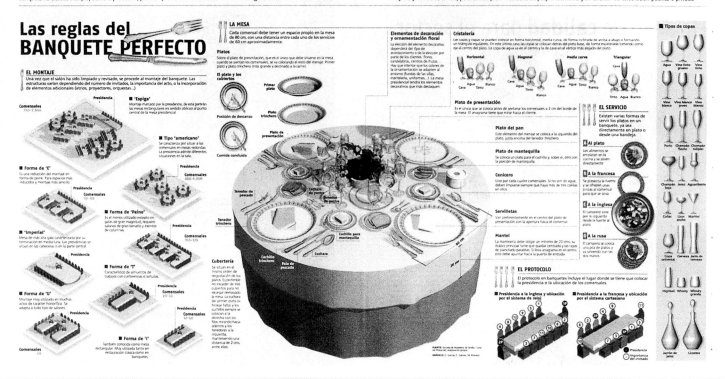

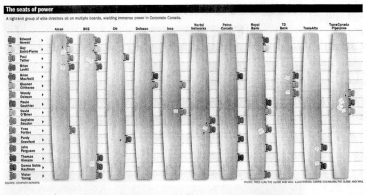

Powerful directors linked

The Globe and Mail
Toronto, Ont., Canada (A)

Information graphics/breaking news

Carrie Cockburn, Graphic Artist; **David Pratt,** Presentation Editor

Brabants Dagblad
Hertogenbosch, The Netherlands (A)

Information graphics/breaking news

Julius Wintermans, Infographic Editor

SILVER
The New York Times
New York, N.Y. (A)

Information graphics/mapping

Charles M. Blow, Graphics Director

Judges: Combining map with timeline, the graphic brings attention to developments in the case. We appreciate graphics based upon investigative journalism. Only by using the map can you see the problems with the case the prosecution originally presented. The colors are excellent. Content and use are superb.

Jueces: Con la combinación del mapa y la línea del tiempo, el gráfico intenta enfocar la atención de los descubrimientos que se han producido en el caso. Podemos apreciar los gráficos basados en un periodismo de investigación. Sólo al utilizar el mapa, se observan los problemas que los fiscales presentaron en principio en el caso. Los colores son excelentes. El contenido y el uso de éste son sorprendentes.

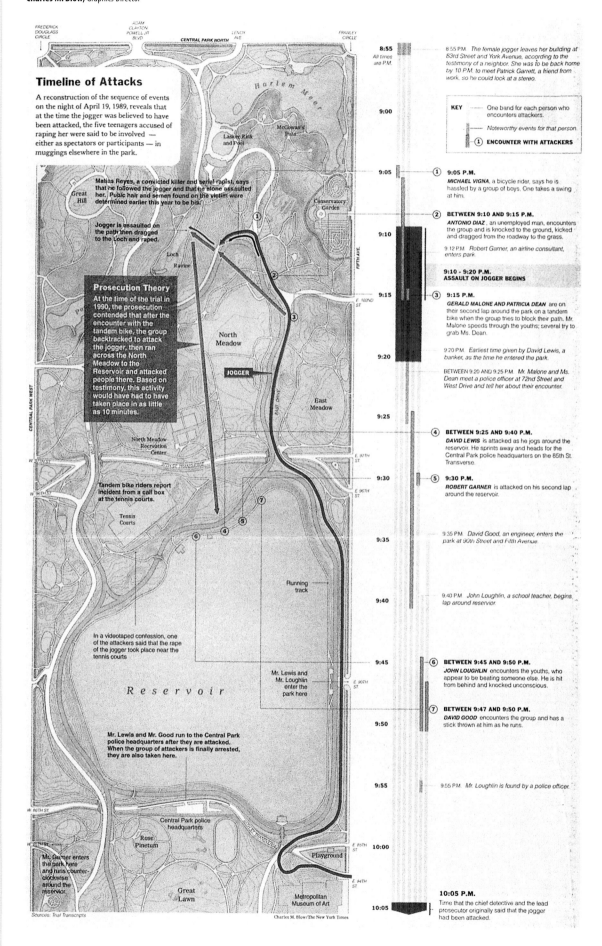

Timeline of Attacks

A reconstruction of the sequence of events on the night of April 19, 1989, reveals that at the time the jogger was believed to have been attacked, the five teenagers accused of raping her were said to be involved — either as spectators or participants — in muggings elsewhere in the park.

Matias Reyes, a convicted killer and serial rapist, says that he followed the jogger and that he alone assaulted her. Pubic hair and semen found on the victim were determined earlier this year to be his.

Jogger is assaulted on the path then dragged to the Loch and raped.

Prosecution Theory
At the time of the trial in 1990, the prosecution contended that after the encounter with the tandem bike, the group backtracked to attack the jogger, then ran across the North Meadow to the Reservoir and attacked people there. Based on testimony, this activity would have had to have taken place in as little as 10 minutes.

JOGGER

North Meadow

East Meadow

Tandem bike riders report incident from a call box at the tennis courts.

Tennis Courts

In a videotaped confession, one of the attackers said that the rape of the jogger took place near the tennis courts

Running track

Mr. Lewis and Mr. Loughlin enter the park here

R e s e r v o i r

Mr. Lewis and Mr. Good run to the Central Park police headquarters after they are attacked. When the group of attackers is finally arrested, they are also taken here.

Central Park police headquarters

Rose Pinetum

Mr. Garner enters the park here and runs counter-clockwise around the reservoir.

Great Lawn

Metropolitan Museum of Art

Sources: Trial Transcripts

Charles M. Blow/The New York Times

8:55 All times are P.M. — 8:55 P.M. The female jogger leaves her building at 83rd Street and York Avenue, according to the testimony of a neighbor. She was to be back home by 10 P.M. to meet Patrick Garrett, a friend from work, so he could look at a stereo.

9:00

KEY — One band for each person who encounters attackers.
Noteworthy events for that person.
① ENCOUNTER WITH ATTACKERS

9:05 ① 9:05 P.M.
MICHAEL VIGNA, a bicycle rider, says he is hassled by a group of boys. One takes a swing at him.

② BETWEEN 9:10 AND 9:15 P.M.
ANTONIO DIAZ , an unemployed man, encounters the group and is knocked to the ground, kicked and dragged from the roadway to the grass.

9:10 9:12 P.M. Robert Garner, an airline consultant, enters park.

9:10 - 9:20 P.M.
ASSAULT ON JOGGER BEGINS

9:15 ③ 9:15 P.M.
GERALD MALONE AND PATRICIA DEAN are on their second lap around the park on a tandem bike when the group tries to block their path. Mr. Malone speeds through the youths; several try to grab Ms. Dean.

9:20 P.M. Earliest time given by David Lewis, a banker, as the time he entered the park.

9:20 BETWEEN 9:20 and 9:25 P.M. Mr. Malone and Ms. Dean meet a police officer at 72nd Street and West Drive and tell her about their encounter.

9:25 ④ BETWEEN 9:25 AND 9:40 P.M.
DAVID LEWIS is attacked as he jogs around the reservoir. He sprints away and heads for the Central Park police headquarters on the 85th St. Transverse.

9:30 ⑤ 9:30 P.M.
ROBERT GARNER is attacked on his second lap around the reservoir.

9:35 P.M. David Good, an engineer, enters the park at 90th Street and Fifth Avenue.

9:35

9:40 P.M. John Loughlin, a school teacher, begins lap around reservoir.

9:40

9:45 ⑥ BETWEEN 9:45 AND 9:50 P.M.
JOHN LOUGHLIN encounters the youths, who appear to be beating someone else. He is hit from behind and knocked unconscious.

⑦ BETWEEN 9:47 AND 9:50 P.M.
DAVID GOOD encounters the group and has a stick thrown at him as he runs.

9:50

9:55 9:55 P.M. Mr. Loughlin is found by a police officer.

10:00

10:05 10:05 P.M.
Time that the chief detective and the lead prosecutor originally said that the jogger had been attacked.

El Correo
Bilbao, Spain (B)

Information graphics/breaking news

Javier Zarracina, Infographic Editor; **Fernando G. Baptista,** Infographic Artist;
José Miguel Benítez, Infographic Artist

The New York Times
New York, N.Y. (A)

Information graphics/non-breaking news, features

Archie Tse, Graphics Editor

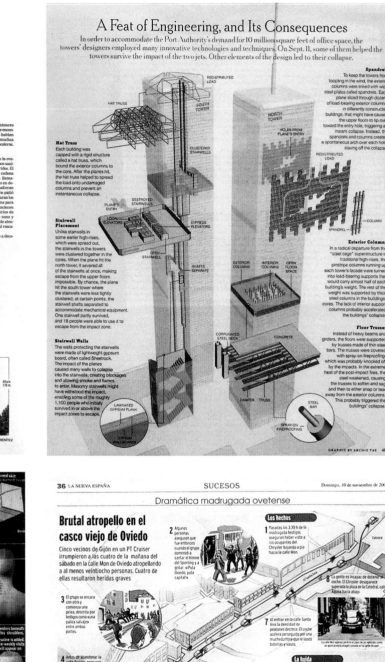

The Arizona Republic
Phoenix, Ariz. (A)

Information graphics/non-breaking news, features

Dan Kempton, Visual Journalist; **Jim Wambold,** Graphic Reporter; **James Abundis,** Graphic Editor

La Nueva España
Oviedo, Spain (B)

Information graphics/breaking news

Jorge Martinez, Infographic Editor; **Juan Ferreira,** Infographic Artist; **Pablo Garcia,** Infographic Artist;
Santiago Cuesia, Infographic Artist

SILVER
Dagens Nyheter
Stockholm, Sweden (A)

Information graphics/non-breaking news, features

Johan Andersson, Infographic Artist; **Johan Jarnestad,** Infographic Artist; **Lena Larsson Meyer,** Infographic Artist; **Stefan Rothmaier,** Infographic Artist; **Johnny Öberg,** Infographic Artist; **Barbro Ingvaldsson,** Infographic Artist

Judges: The idea is very neat. Timelines aren't usually structured and displayed like this, with information based on population, architecture and people. It is intuitive and easy to get into. Much information is presented, and white space is appropriate.

Jueces: La idea es innovadodra. Las líneas en el tiempo no suelen estructurarse de este modo, con información basada en la población, la arquitectura y la gente. Es intuitiva y fácil de navegar. Presenta mucha información y los espacios blancos son apropiados.

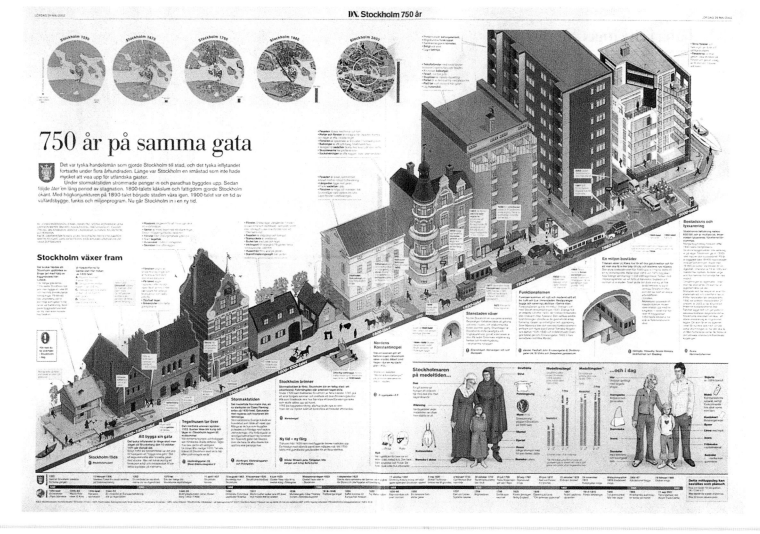

Diario de Sevilla
Sevilla, Spain (B)

Information graphics/non-breaking news, features

Manuel Romero Tortosa, Graphic Editor; **Carlos Gámez Kindelán,** Graphic Artist; **Cristina García Rivera,** Graphic Artist

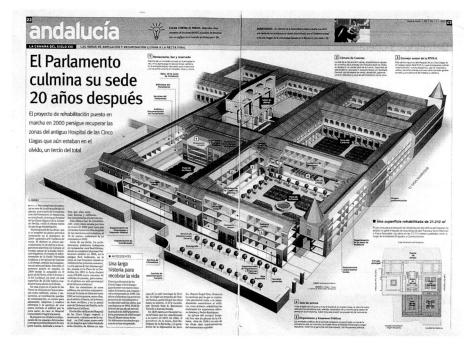

The Cincinnati Enquirer
Cincinnati, Ohio (A)

Information graphics/non-breaking news, features

Randy Mazzola, Graphic Artist

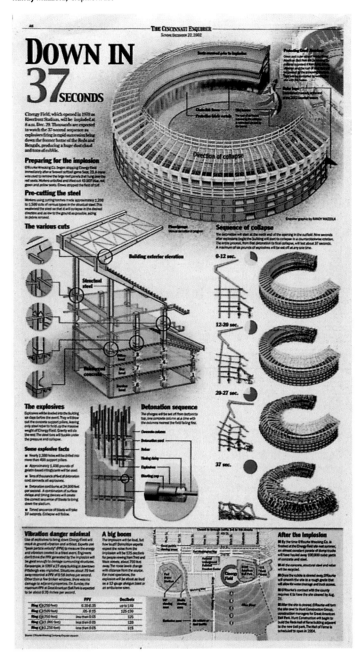

The New York Times
New York, N.Y. (A)

Information graphics/breaking news

Graphics Staff

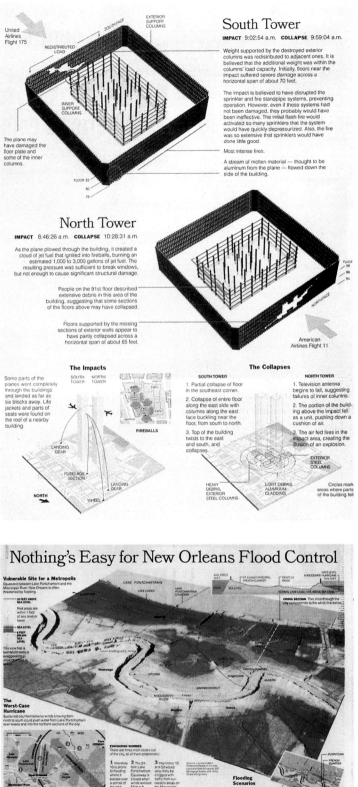

The Boston Globe
Boston, Mass. (A)

Information graphics/breaking news

David Butler, Graphic Artist; **James Bennett,** Deputy Graphics Editor; **Jim Karaian,** Graphics Editor

The New York Times
New York, N.Y. (A)

Information graphics/mapping

William McNulty, Graphics Editor; **Bill Marsh,** Graphics Editor

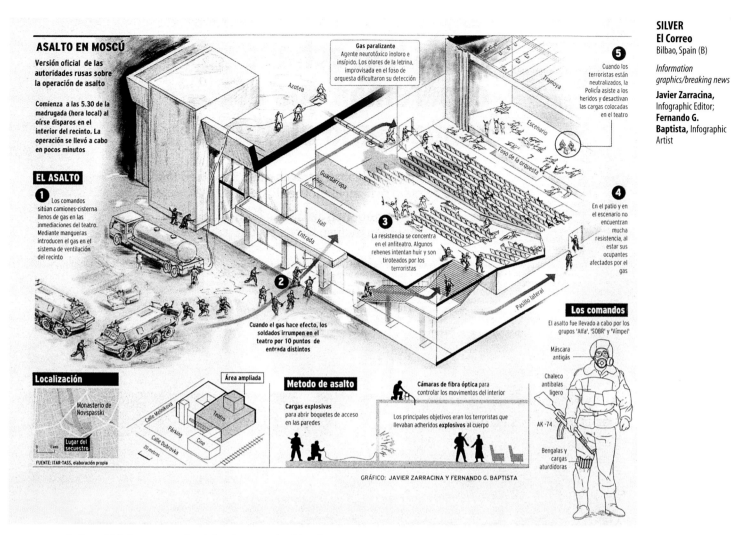

ASALTO EN MOSCÚ

Versión oficial de las autoridades rusas sobre la operación de asalto

Comienza a las 5.30 de la madrugada (hora local) al oírse disparos en el interior del recinto. La operación se llevó a cabo en pocos minutos

EL ASALTO

1 Los comandos sitúan camiones-cisterna llenos de gas en las inmediaciones del teatro. Mediante mangueras introducen el gas en el sistema de ventilación del recinto

Gas paralizante
Agente neurotóxico inoloro e insípido. Los olores de la letrina, improvisada en el foso de orquesta dificultaron su detección

5 Cuando los terroristas están neutralizados, la Policía asiste a los heridos y desactivan las cargas colocadas en el teatro

Cuando el gas hace efecto, los soldados irrumpen en el teatro por 10 puntos de entrada distintos

2

3 La resistencia se concentra en el anfiteatro. Algunos rehenes intentan huir y son tiroteados por los terroristas

4 En el patio y en el escenario no encuentran mucha resistencia, al estar sus ocupantes afectados por el gas

Azotea
Tramoya
Escenario
Foso de la orquesta
Guardarropa
Hall
Entrada
Pasillo lateral

Los comandos

El asalto fue llevado a cabo por los grupos 'Alfa', 'SOBR' y 'Vímpel'

Máscara antigás
Chaleco antibalas ligero
AK -74
Bengalas y cargas aturdidoras

Localización

Monasterio de Novspaski
Lugar del secuestro

FUENTE: ITAR-TASS, elaboración propia

Área ampliada

Calle Melnikova
Párking
Teatro
Cine
Calle Dubrovka
20 metros

Metodo de asalto

Cargas explosivas para abrir boquetes de acceso en las paredes

Cámaras de fibra óptica para controlar los movimientos del interior

Los principales objetivos eran los terroristas que llevaban adheridos **explosivos** al cuerpo

GRÁFICO: JAVIER ZARRACINA Y FERNANDO G. BAPTISTA

SILVER
El Correo
Bilbao, Spain (B)

Information graphics/breaking news

Javier Zarracina, Infographic Editor;
Fernando G. Baptista, Infographic Artist

Judges: This is an example of the clean, reader-friendly look of a complex graphic – a style that seems to be consistent with this publication. Not only does the clean look help the reader through this double-truck, but the numbers provide additional structure to each segment.

Jueces: Este es un ejemplo de gráfico complejo con aspecto limpio y fácil para el lector, un estilo que parece coherente con esta publicación. Este aspecto limpio ayuda al lector a avanzar por las páginas dobles y además los números proporcionan estructura adicional a cada segmento.

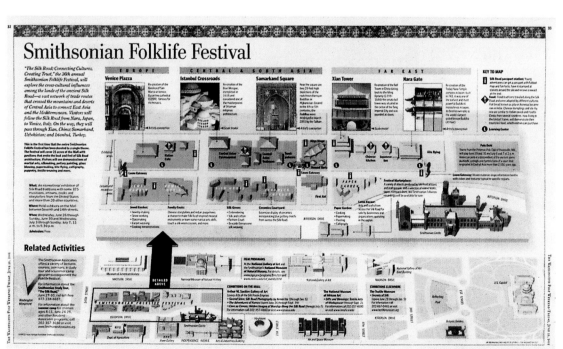

Smithsonian Folklife Festival

The Washington Post
Washington, D.C. (A)

Information graphics/mapping

Doug Steven, Artist;
Brenna Maloney, Graphics Editor

Clarín
Buenos Aires, Argentina (A)

Information graphics/non-breaking news, features

Iñaki Palacios, Art Director; **Alejandro Tumas,** Graphic Director; **Pablo Loscri,** Design Editor; **Juan Zaramella,** Artist; **Stella Bin,** Researcher; **Lucas Varela,** Artist; **Eduardo Grossman,** Photographer

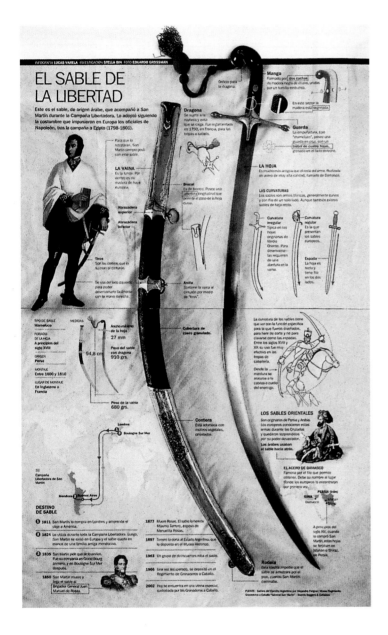

Clarín
Buenos Aires, Argentina (A)

Information graphics/breaking news

Iñaki Palacios, Art Director; **Alejandro Tumas,** Artist/Graphic Director; **Pablo Loscri,** Design Editor, Artist; **Jorge Portaz,** Artist

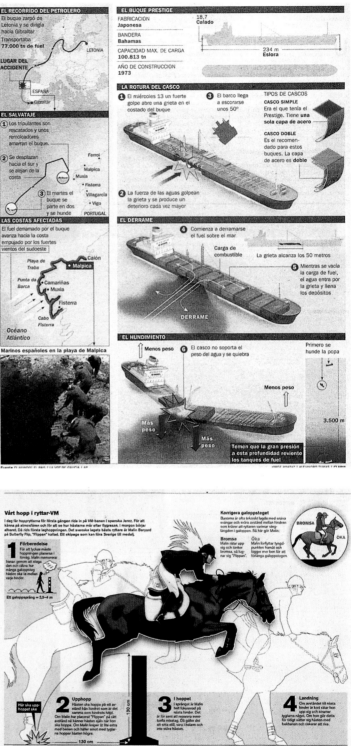

Dagens Nyheter
Stockholm, Sweden (A)

Information graphics/non-breaking news, features

Stefan Rothmaier, Infographics Artist

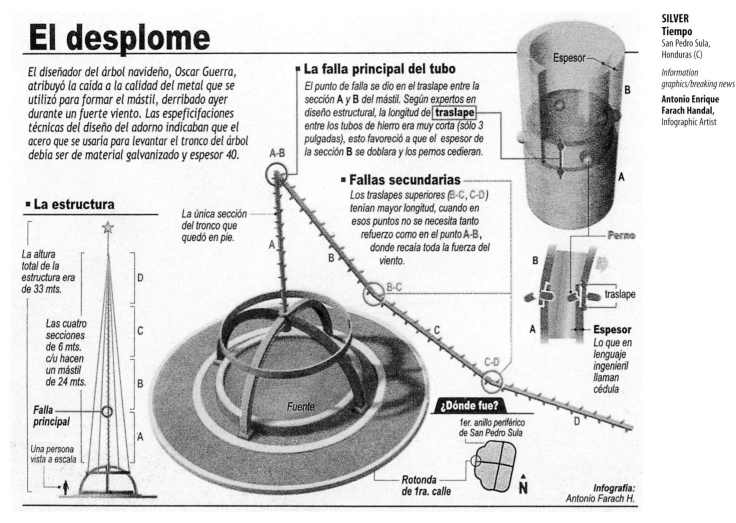

El desplome

El diseñador del árbol navideño, Oscar Guerra, atribuyó la caída a la calidad del metal que se utilizó para formar el mástil, derribado ayer durante un fuerte viento. Las especificaciones técnicas del diseño del adorno indicaban que el acero que se usaría para levantar el tronco del árbol debía ser de material galvanizado y espesor 40.

■ La estructura

La altura total de la estructura era de 33 mts.

Las cuatro secciones de 6 mts. c/u hacen un mástil de 24 mts.

Falla principal

Una persona vista a escala

D
C
B
A

■ La falla principal del tubo

El punto de falla se dio en el traslape entre la sección A y B del mástil. Según expertos en diseño estructural, la longitud de traslape entre los tubos de hierro era muy corta (sólo 3 pulgadas), esto favoreció a que el espesor de la sección B se doblara y los pernos cedieran.

■ Fallas secundarias

Los traslapes superiores (B-C, C-D) tenían mayor longitud, cuando en esos puntos no se necesita tanto refuerzo como en el punto A-B, donde recaía toda la fuerza del viento.

La única sección del tronco que quedó en pie.

A-B
A
B
B-C
C
C-D
D

Fuente

Espesor
B
A

Perno
B
A
traslape

Espesor
Lo que en lenguaje ingenieril llaman cédula

¿Dónde fue?

1er. anillo periférico de San Pedro Sula

Rotonda de 1ra. calle

N

Infografía:
Antonio Farach H.

SILVER
Tiempo
San Pedro Sula,
Honduras (C)

Information graphics/breaking news

Antonio Enrique Farach Handal,
Infographic Artist

Judges: Judges were impressed with the clean look of this graphic. Elements are carefully placed so the reader is not confused. To do this detailed work on deadline adds to the impressive effort of this entry that is well planned.

Jueces: Los jueces se quedaron impresionados con el aspecto limpio de este gráfico. Los elementos están distribuidos con cuidado para que el lector pueda seguirlo sin confusión. La realización de este trabajo con sumo detalle y los reducidos plazos de tiempo se aúnan al esfuerzo impresionante de esta pieza bien planificada.

Aliments recollits els últims set anys
XIFRES EN TONES

1995	1996	1997	1998	1999	2000	2001
1.053	1.233	1.026	1.251	1.350	2.050	2.084

Persones beneficiades

1995	1996	1997	1998	1999	2000	2001
42.000	45.000	45.000	44.000	43.000	47.000	48.000

Font: Elaboració pròpia

Tipus de beneficiaris el 2001
Entre parèntesis, 1996

Família
28.570 (31.567)

Immigrants
5790 (2.129)

Infància
2.920 (4.012)

Altres
10.720 (6.292)

Transeünt	2.170
Avis	2.200
Toxicòmans / Malalts de sida	1.300
Incapacitats	850
Minories ètniques	500
Presos i exreclusos	200
Joventut	2.650
Dona	820
Refugiats	30

CRISTINA CLAVERO

El Periódico de Catalunya
Barcelona, Spain (A)

Information graphics/charting

Cristina Clavero, Inforgraphic Artist; **Jordi Català,** Chief of Infographics

THE 2002 ELECTIONS
THE POLLING PLACES
How It Looked Inside the Booth

MAP KEY
Shadings represent current voting systems
Counties that changed voting equipment since the 2000 elections have black borders

The New York Times
New York, N.Y. (A)

Information graphics/mapping

William McNulty, Graphics Editor; **Hugh K. Truslow,** Graphics Editor

Reforma
México City, México (B)

Information graphics/non-breaking news, features

Julio López, Infographic Designer

Clarín
Buenos Aires, Argentina (A)

Information graphics/non-breaking news, features

Iñaki Palacios, Art Director; **Alejandro Tumas,** Graphic Director; **Pablo Loscri,** Design Editor/Artist; **Stella Bin,** Researcher; **Jorge Portaz,** Artist

Clarín
Buenos Aires, Argentina (A)

*Information graphics/
non-breaking news, features*

Iñaki Palacios, Art Director;
Alejandro Tumas, Graphic
Director; **Pablo Loscri,** Design
Editor/Artist; **Aldo Chiappe,**
Illustrator

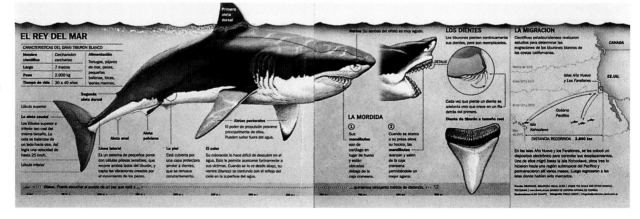

SILVER
Diario De Sevilla
Sevilla, Spain (B)

Information graphics/non-breaking news, features

Manuel Romero Tortosa, Graphics Editor; **Carlos Gámez Kindelán,** Graphic Artist; **Cristina García Rivera,** Graphic Artist

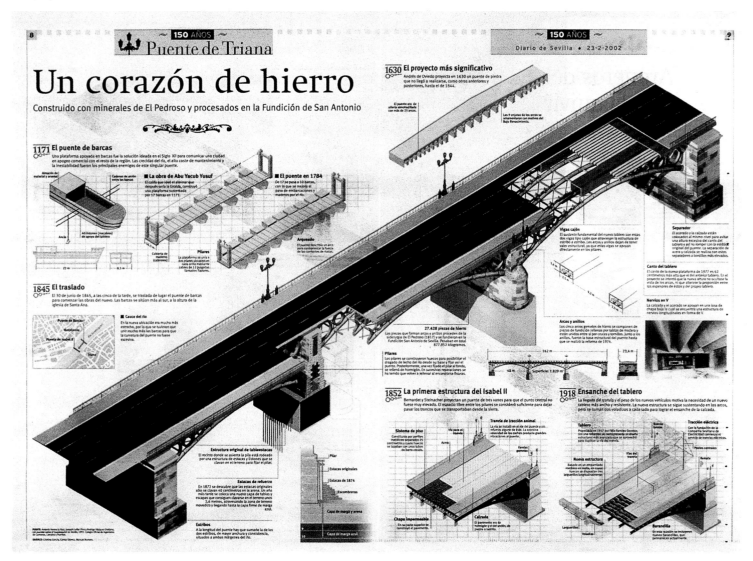

Judges: The strong content and vibrant color of the dominant visual introduces readers to layer after layer of information.

Jueces: El gran contenido y el color vibrante del aspecto visual dominante introducen al lector en estratos y estratos de información.

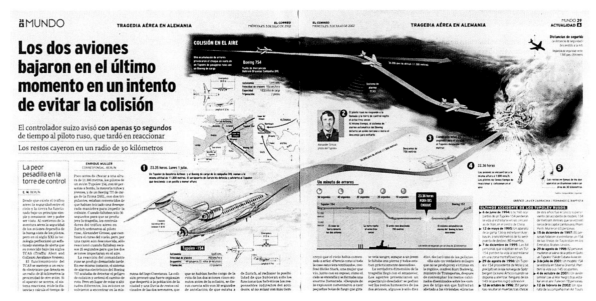

El Correo
Bilbao, Spain (B)

Information graphics/breaking news

Javier Zarracina, Infographic Editor; **Fernando G. Baptista,** Infographic Artist

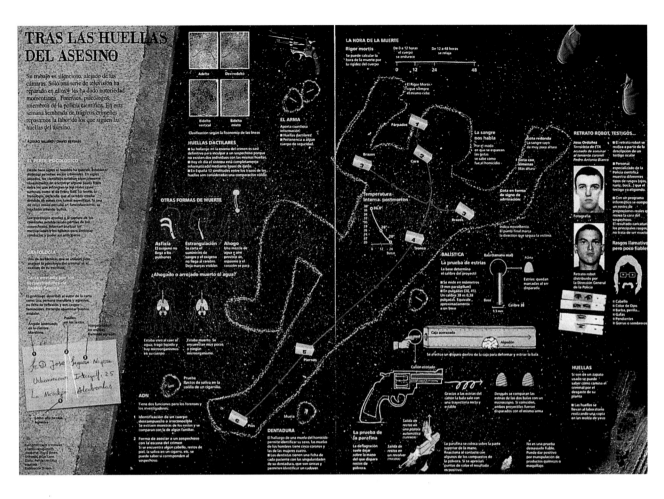

TRAS LAS HUELLAS DEL ASESINO

Su trabajo es silencioso, alejado de las cámaras. Sólo una serie de televisión ha reparado en ellos y les ha dado notoriedad momentánea. Forenses, psicólogos, miembros de la policía científica. En esta semana sembrada de trágicos crímenes, repasamos la labor de los que siguen las huellas del asesino.

La Voz de Galicia
Arteixo (A Coruña), Spain (B)

Information graphics/non-breaking news, features

Alvaro Valiño, Infographist; **David Beriain,** Copy Editor; **Jesus Gil,** Art Director

Pittsburgh Post-Gazette
Pittsburgh, Pa. (A)

Information graphics/breaking news

James Hilston, Artist; **Stacy Innerst,** Artist; **Steve Thomas,** Artist

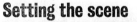

Setting the scene

Nine men escape, nine men are trapped and rescuers must work aggressively yet cautiously to avert tragedy.

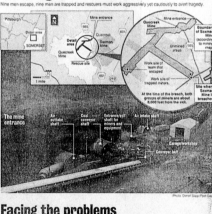

Facing the problems

TIROTEO EN SAN SEBASTIÁN

El escolta de una concejala socialista resulta muerto en un tiroteo, al confundir a agentes de la Guardia Civil de paisano con miembros de un comando terrorista

GRÁFICO: JAVIER ZARRACINA / FERNANDO G. BAPTISTA

El Correo
Bilbao, Spain (B)

Information graphics/breaking news

Javier Zarracina, Infographic Editor; **Fernando G. Baptista,** Infographic Artist

SILVER
Marca
Madrid, Spain (A)

Miscellaneous

Antonio Martín Hervás, Design Coordinator; **José Juan Gámez**, Art Director; **Nacho Romero**, Designer; **Mercedes Suils**, Graphic Artist; **Mariangel González**, Graphic Artist; **Julian de Velasco**, Graphics Coordinator; **Marcos Jiménez**, Graphic Artist; **Ana Sinova**, Designer

Judges: This section gives readers something extra to keep. It is both informative and commemorative.

Jueces: Esta sección da al lector algo más para guardar. Es informativa y conmemorativa.

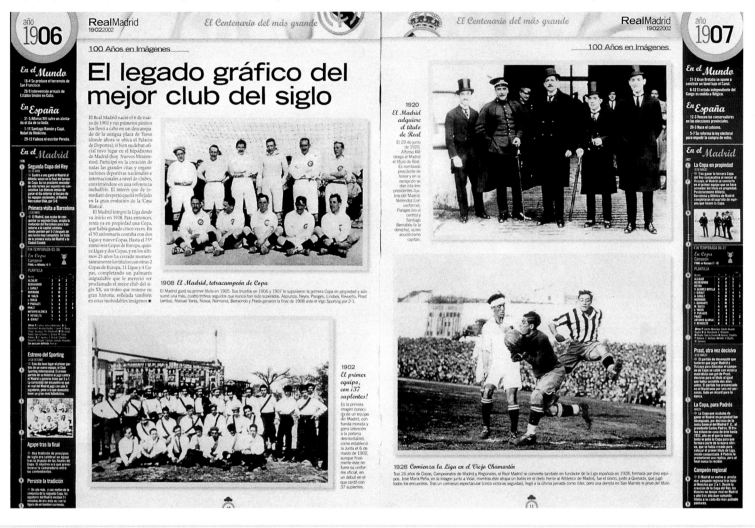

El legado gráfico del mejor club del siglo

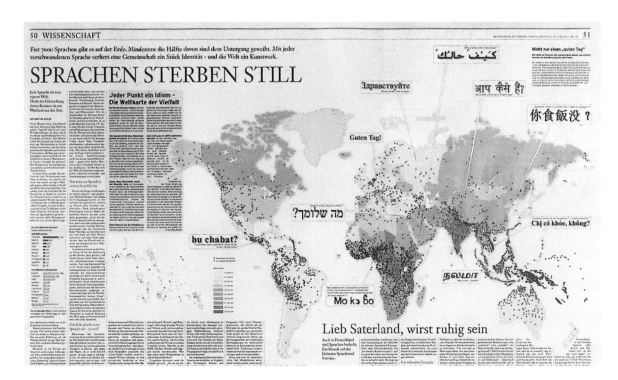

Frankfurter Allgemeine Sonntagszeitung
Frankfurt am Main, Germany (A)

Information graphics/mapping

Thomas Heumann, Infographics Director; **Martina Keller**, Science Author; **Karl-Heinz Döring**, Infographic Artist; **Doris Oberneder**, Layout (MediaGroup Berlin); **Ulf von Rauchhaupt**, Science Editor; **Hans-Michael Peiter**, Basic GIS Map (Frankfurt University)

Diario de Sevilla
Sevilla, Spain (B)

Information graphics/non-breaking news, features

Manuel Romero Tortosa, Graphics Editor; **Carlos Gámez Kindelán,** Graphic Artist; **Cristina García Rivera,** Graphic Artist

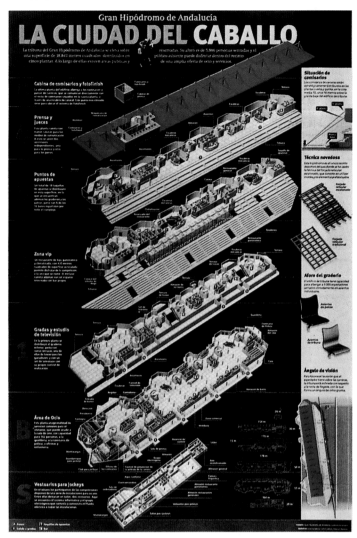

The New York Times
New York, N.Y. (A)

Information graphics/charting

William McNulty, Graphics Editor

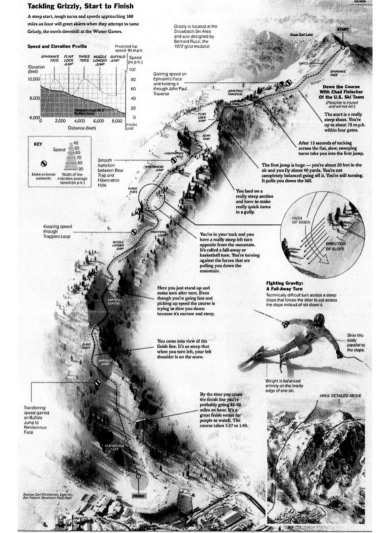

Clarín
Buenos Aires, Argentina (A)

Information graphics/breaking news

Iñaki Palacios, Art Director; **Alejandro Tumas,** Graphic Director; **Pablo Loscri,** Design Editor/Artist; **Jorge Portaz,** Artist

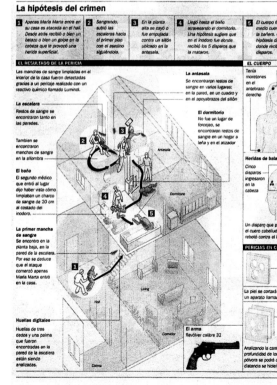

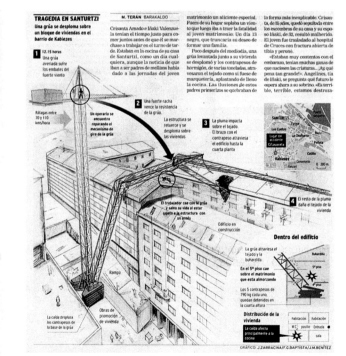

El Correo
Bilbao, Spain (B)

Information graphics/breaking news

Javier Zarracina, Infographic Editor; **Fernando G. Baptista,** Infographic Artist; **José Miguel Benítez,** Infographic Artist

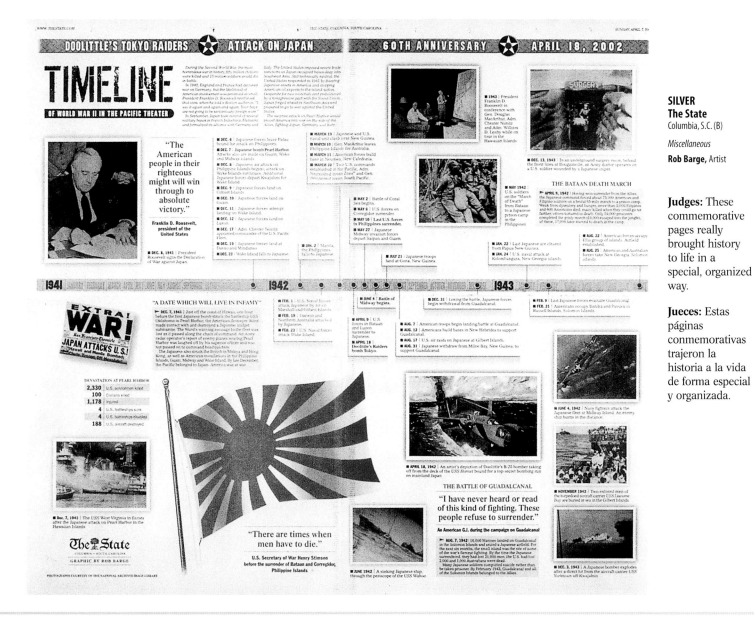

SILVER
The State
Columbia, S.C. (B)

Miscellaneous

Rob Barge, Artist

Judges: These commemorative pages really brought history to life in a special, organized way.

Jueces: Estas páginas conmemorativas trajeron la historia a la vida de forma especial y organizada.

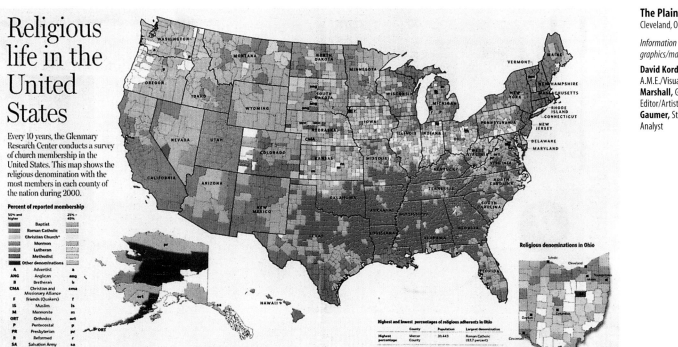

The Plain Dealer
Cleveland, Ohio (A)

Information graphics/mapping

David Kordalski, A.M.E./Visuals; **Ken Marshall,** Graphic Editor/Artist; **Thomas Gaumer,** Statistics Analyst

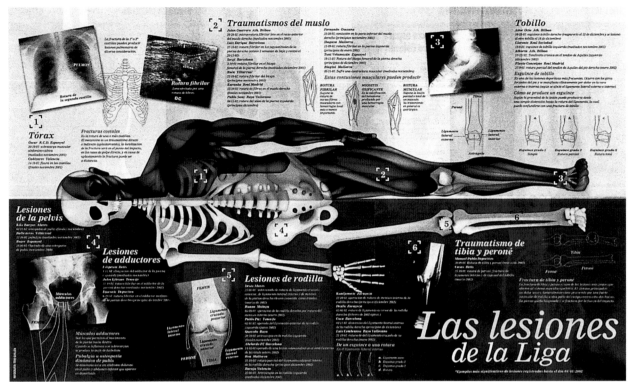

Las lesiones de la Liga

Ejemplos más significativos de lesiones registradas hasta el día 04-01-2002

Mundo Deportivo
Barcelona, Spain (B)

*Information graphics/
non-breaking news, features*

Toni Guillén, Infographic
Designer

JUGA AL TRUCO CON CLARIN

Nociones básicas del juego más criollo

Clarín
Buenos Aires, Argentina (A)

Information graphics/non-breaking news, features

Iñaki Palacios, Art Director; **Alejandro Tumas,** Graphic Director; **Pablo Loscri,** Design Editor; **Juan Zaramella,** Artist; **Gerardo Moral,** Artist

Not all shared in boom decade

On the whole, Chicago prospered during the 1990s. Median incomes and home values soared in trendy neighborhoods surrounding the Loop, but poverty remained entrenched in many South and West Side neighborhoods with large minority populations.

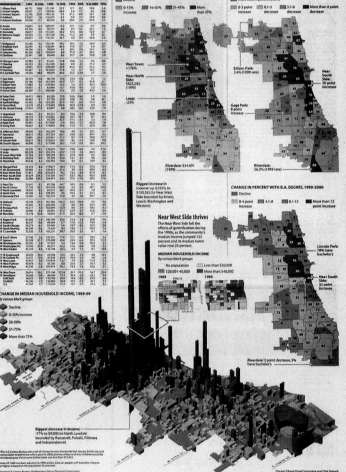

Chicago Tribune
Chicago, Ill. (A)

Information graphics/charting

David Constantine, Graphics Reporter; **Chris Soprych,** Graphics Artist

The New York Times
New York, N.Y. (A)

Information graphics/mapping

William McNulty, Graphics Editor; **Andrew Phillips,** Graphics Editor

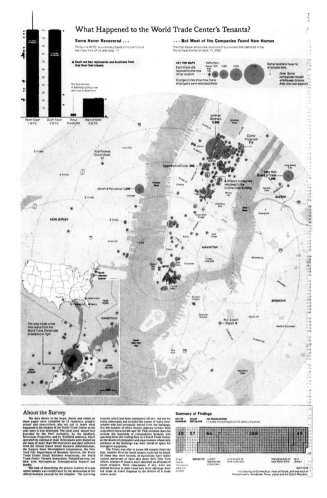

What Happened to the World Trade Center's Tenants?

La Voz de Galicia
Artexio (Coruña), Spain (B)

La Voz de Galicia
Artexio (Coruña), Spain (B)

Information graphics/charting

Manuela Mariño, Graphic Artist;
Jesus Gil, Art Director

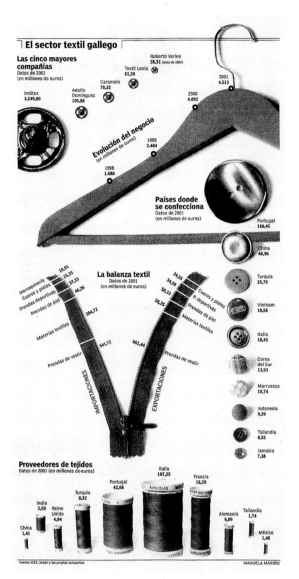

El sector textil gallego

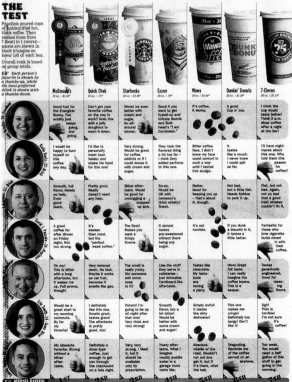

JAVA'S WITNESSES

THE TEST

Panelists poured cups of unidentified hot, black coffee. Then ranked them from 7 (best) to 1 (worst) — scores are shown in black triangles on lower left of each box.

Overall rank is based on group totals.

Each person's favorite is shown by a thumbs-up, while the least-preferred drink is shown with a thumbs-down.

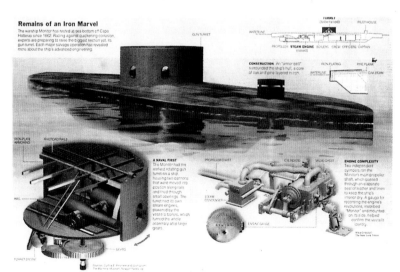

Remains of an Iron Marvel

The New York Times
New York, N.Y. (A)

Information graphics/non-breaking news, features

Mika Gröndahl, Graphics Editor

Asbury Park Press
Neptune, N.J. (B)

Information graphics/charting

Harris Siegel, NightOut Editor

Poughkeepsie Journal
Poughkeepsie, N.Y. (C)

Information graphics/mapping

Larry Seil, Artist

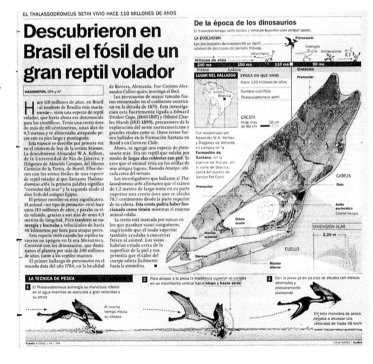

The New York Times
New York, N.Y. (A)

Information graphics/mapping

William McNulty, Graphics Editor; **Archie Tse,** Graphics Editor

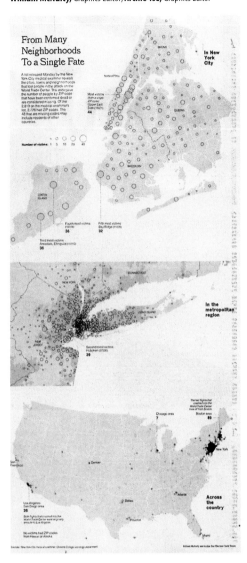

Clarín
Buenos Aires, Argentina (A)

Information graphics/breaking news

Iñaki Palacios, Art Director; **Alejandro Tumas,** Graphic Director; **Pablo Loscri,** Design Editor; **Jorge Portaz,** Artist

The Orange County Register
Santa Ana, Calif. (A)

Information graphics/non-breaking news, features

Joelle Beckett, Designer; **Sharon Henry,** Artist/Reporter; **Robin Murphy,** Graphics Editor; **Kris Viesselman,** Senior Art Director; **Susan Jacobs,** Section Editor

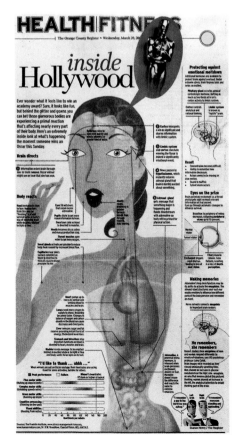

South Florida Sun-Sentinel
Fort Lauderdale, Fla. (A)

Information graphics/non-breaking news, features

Rich Rokicki, Graphics reporter; **Don Wittekind**, Graphics Director; **R. Scott Horner**, Asst. Graphics Director; **Len DeGroot**, Asst. Graphics Director

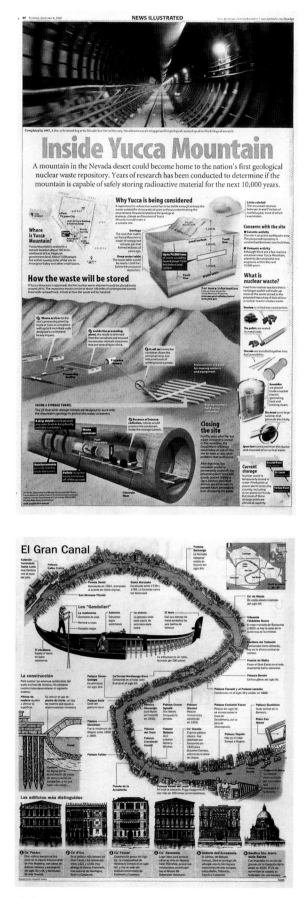

Clarín
Buenos Aires, Argentina (A)

Information graphics/mapping

Iñaki Palacios, Art Director; **Alejandro Tumas**, Graphic Director; **Pablo Loscri**, Design Editor/Artist; **Aldo Chiappe**, Illustrator

SILVER
Detroit Free Press
Detroit, Mich. (A)

Miscellaneous

Mike Thompson, Editorial Cartoonist; **Christoph Fuhrmans**, Sports Designer; **Gene Myers**, Sports Editor; **Steve Schrader**, Assistant Sports Editor; **John Fleming**, Deputy Graphcis Editor; **Steve Dorsey**, Design & Graphics Director

Judges: The voodoo doll of Patrick Roy is interactive, and it builds a sense. It has a sense of humor about it and makes you glad you got the paper that day.

Jueces: La muñeca de vudú de Patrick Roy es interactiva. Mantiene un sentido del humor sobre el tema y puedes agradecer haber comprado el periódico ese día.

The Washington Post
Washington, D.C. (A)

Information graphics/mapping

Richard Furno, Director of Cartography

Poughkeepsie Journal
Poughkeepsie, N.Y. (C)

Information graphics/non-breaking news, features

Dean DiMarzo, Art Director

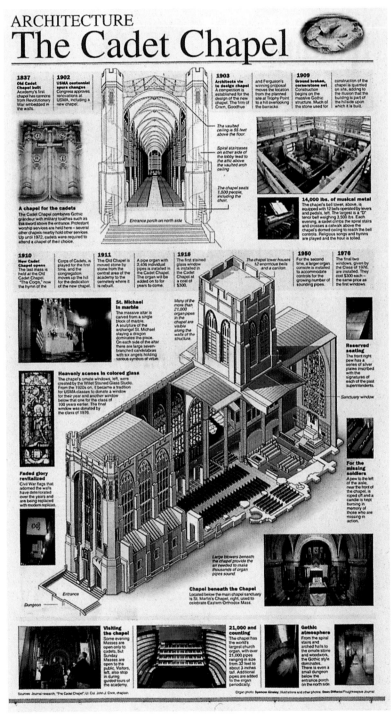

Clarín
Buenos Aires, Argentina (A)

Information graphics/breaking news

Iñaki Palacios, Art Director; **Alejandro Tumas,** Graphic Director, Artist; **Pablo Loscri,** Design Editor/Artist; **Gerardo Morel,** Artist; **Jorge Portaz,** Artist

The New York Times
New York, N.Y. (A)

Information graphics/charting

Farhana Hossain, Graphics Editor

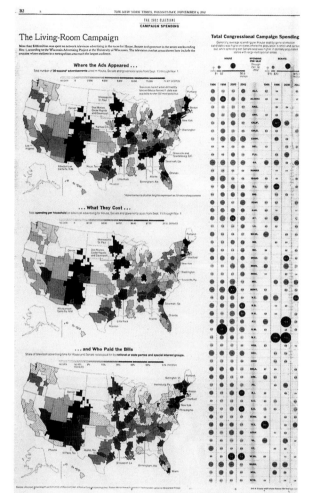

Clarín
Buenos Aires, Argentina (A)

Information graphics/non-breaking news, features

Iñaki Palacios, Art Director; **Alejandro Tumas,** Graphic Director; **Pablo Loscri,** Design Editor; **Juan Zaramella,** Artist; **Stella Bin,** Researcher; **Ruben Digilio,** Photographer

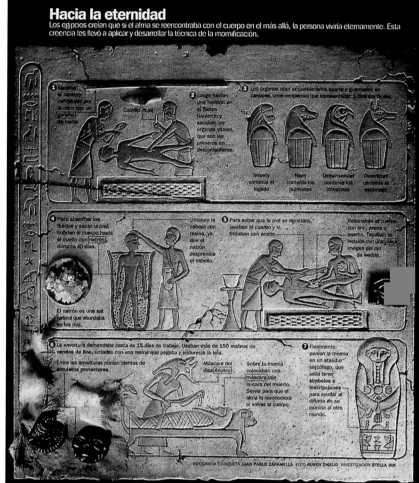

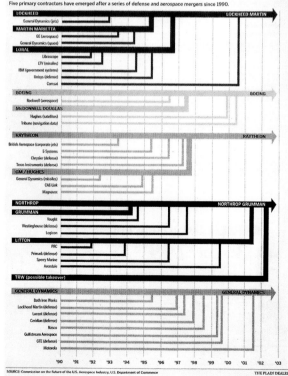

The Plain Dealer
Cleveland, Ohio (A)

Information graphics/charting

David Kordalski, A.M.E./Visuals; **Ken Marshall,** Graphics Editor/Artist

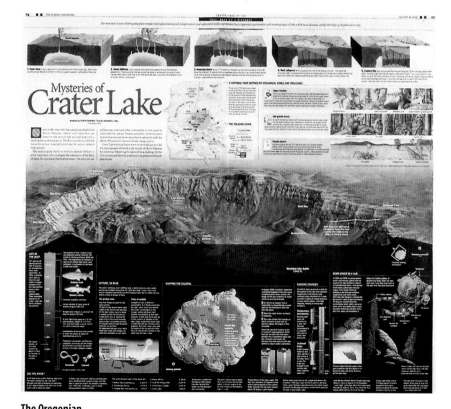

The Oregonian
Portland, Ore. (A)

Information graphics/non-breaking news, features

Steve McKinstry, Art Director; **Steve Cowden,** Artist

Also winning in features/science-technology and special coverage/inside pages.

The Washington Post
Washington, D.C. (A)

Information graphics/mapping

Laris Karklis, Cartography

A Pipeline Runs Through It

Environmental groups opposed a plan by the U.S. Overseas Private Investment Corp. to finance a natural-gas pipeline to Brazil through the last, largest chunk of undeveloped Chiquitano forest in Bolivia. Instead, environmentalists urged sponsors Enron Corp. and Royal Dutch/Shell Group to go around the forest along existing roads. OPIC accepted the Enron route with slight changes, promised $200 million financing and the pipeline was completed last year. But the loan was canceled in February after Enron missed OPIC paperwork deadlines.

Inroads to Destruction
The maps at right are from an environmental assessment made in 1999 by environmental groups to predict the impact of either pipeline route on the forest ecosystem.

Status in 1999
Forest in 1999 shows slight degradation along existing roads, but not along Enron's proposed pipeline route.

In 10 Years Without Pipeline
Forest degradation would continue along the proposed alternate route even if the pipeline was built there.

In 10 years With Pipeline
Ecosystem destruction likely would accelerate along the pipeline right-of-way route Enron chose.

The Boston Globe
Boston, Mass. (A)

Information graphics/mapping

Joan McLaughlin, Graphic Artist; **Jim Karaian,** Graphics Editor

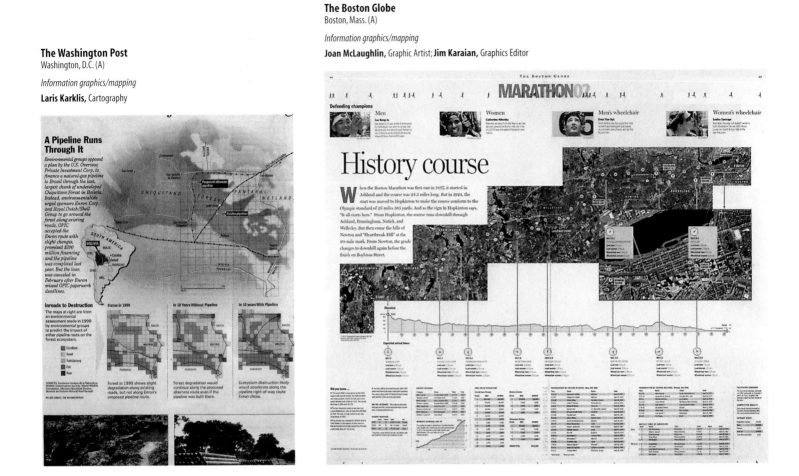

The New York Times
New York, N.Y. (A)

Information graphics/breaking news

Graphics Staff

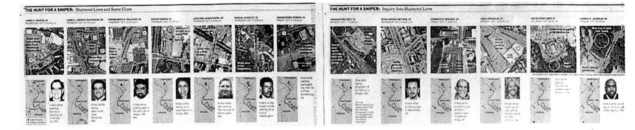

El Mundo Del Siglo XXI
Madrid, Spain (A)

Information graphics/ non-breaking news, features

Juancho Cruz, Infographics Director; **Modesto J. Carrasco,** Infographic Editor; **Rafa Estrada,** Artist; **Beatriz Santacruz,** Artist; **Chema Matia,** Artist

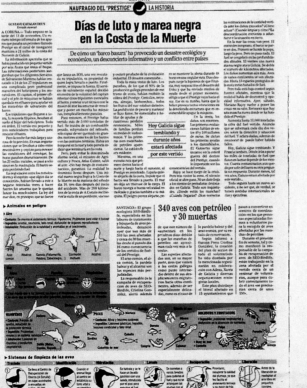
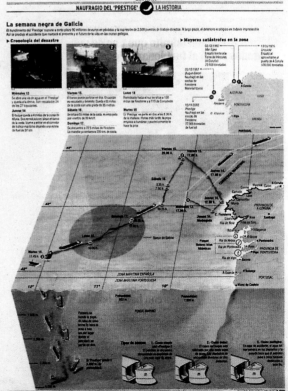

Diario de Sevilla
Sevilla, Spain (B)

Information graphics/non-breaking news, features

Manuel Romero Tortosa, Graphic Editor; **Carlos Gámez Kindelán,** Graphic Artist; **Cristina García Rivera,** Graphic Artist

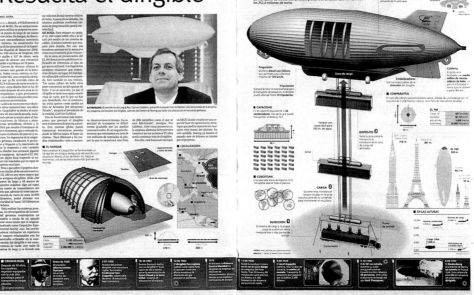

Frankfurter Allgemeine Sonntagszeitung
Frankfurt am Main, Germany (A)

Information graphics/non-breaking news, features

Thomas Heumann, Infographics Director; **Volker Stollorz,** Science Author; **Karl-Heinz Döring,** Infographic Artist; **Doris Oberneder,** Layout (MediaGroup Berlin)

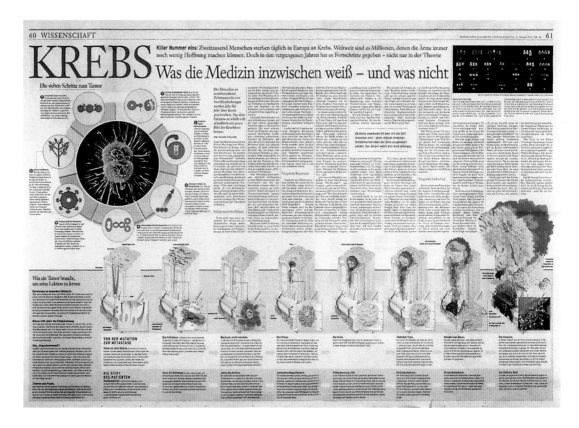

Diario de Sevilla
Sevilla, Spain (B)

Information graphics/non-breaking news, features

Manuel Romero Tortosa, Graphic Editor; **Carlos Gámez Kindelán,** Graphic Artist; **Cristina García Rivera,** Graphic Artist

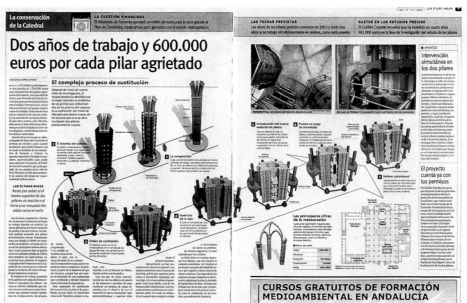

Clarín
Buenos Aires, Argentina (A)

Information graphics/breaking news

Iñaki Palacios, Art Director; **Alejandro Tumas,** Graphic Director; **Pablo Loscri,** Design Editor/Artist; **Jorge Portaz,** Artist

The Washington Post
Washington, D.C. (A)

Information graphics/charting

Michael Drew, Art Director/New Art; **Lucy Shackelford,** Researcher; **Margot Williams,** Research Editor; **Michael Keegan,** A.M.E./News Art

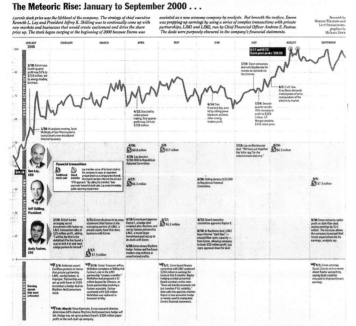

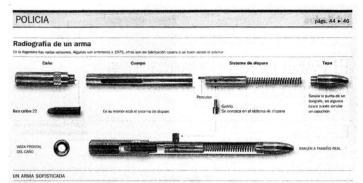

The Toronto Star
Toronto, Ont., Canada (A)

Miscellaneous

Carl Neustaedter, Designer; **Lesley Taylor,** Editor; **Steve Russell,** Photographer

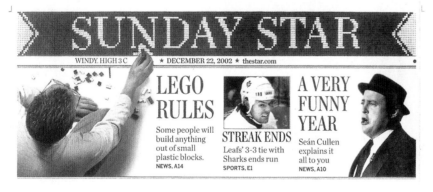

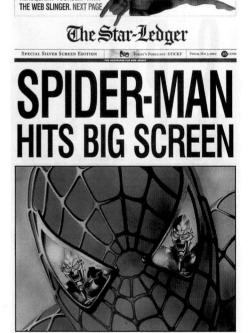

The Star-Ledger
Newark, N.J. (A)

Miscellaneous

Peter Ambush, Illustrator; **George Frederick,** Deputy Design Director; **Wally Stroby,** Feature Editor

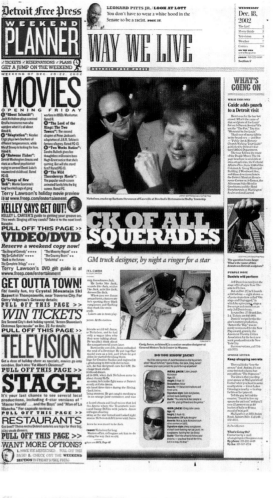

Detroit Free Press
Detroit, Mich. (A)

Miscellaneous

Dale Parry, DME/Features; **Tina Croley,**
Features Editor; **Mauricio Gutiérrez,** Designer,
Deputy Design Director/Features; **Steve
Dorsey,** Design & Graphics Director

SILVER
The Salt Lake Tribune
Salt Lake City, Utah (B)

Miscellaneous

Chris Magerl, A.M.E./Presentation; **Jim Halley,** News Editor/Winter Sports; **Todd Adams,** News
Editor/Graphics

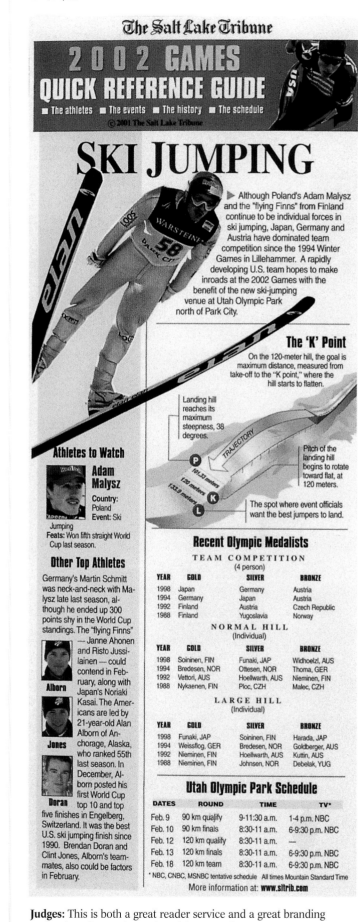

Judges: This is both a great reader service and a great branding
tool. It is an innovative and useful approach.

Jueces: Éste es un servicio bueno para el lector y una herramienta
excelente de branding.

Special section

Page design

Cover design

Overall design

Awards

AWARDS OF EXCELLENCE, unless designated.

GOLD, exceptional work.

SILVER, outstanding work.

JUDGES' SPECIAL RECOGNITION, worthy of a singular, superior honor in the category, is in Chapter 2, pages 26-37.

Circulation

Indicated after each publication's location
(A) 175,000 & over
(B) 50,000-174,999
(C) 49,999 & under

The Herald Sun
Melbourne, Australia (C)

Special sections

Pauline Schulz, Art Director; **Tony Fawcett,** Editor; **Chris Groenhout,** Photographer; **Mark Taylor,** Photographer; **John Best,** Photographer; **Jeff Kilpatrick,** Photographer; **Dan Magree,** Photographer

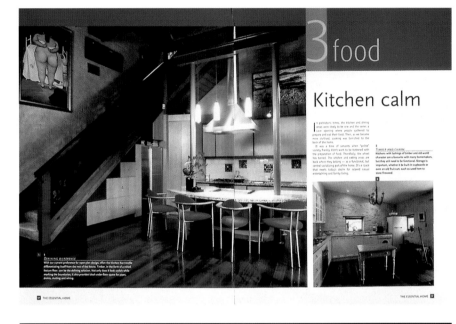

La Vanguardia
Barcelona, Spain (A)

Special sections

Rosa Mundet Poch, Project Manager; **Xavier Monsalve,** Designer

El Mundo Del Siglo XXI
Madrid, Spain (A)

Special sections

Carmelo Caderot, Design Director; **Manuel de Miguel,** Art Director & Designer

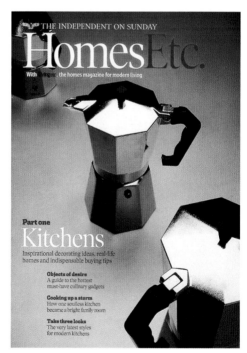

The Independent on Sunday
London, England (A)

Special sections

Carolyn Roberts, Art Director; **Elissa Millhouse,** Deputy Art Director; **Andrew Tuck,** Editor

GOLD
El Mundo Del Siglo XXI
Madrid, Spain (A)

Special sections

Carmelo Caderot, Design Director & Designer; **Manuel de Miguel,** Art Director & Designer

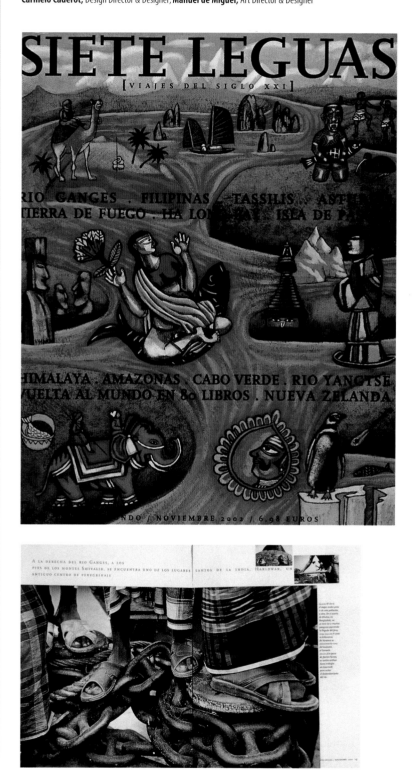

Judges: A bold, dramatic cover with a distinct theme introduces us to intriguing dominant images, offset with sharply contrasting details.

Jueces: Una portada descarada y conmovedora con un tema bien determinado nos acerca a imágenes dominantes intrigantes compensadas con detalles que contrastan bruscamente.

El Mundo Magazine
Madrid, Spain (A)

Special sections

Rodrigo Sánchez, Art Director & Designer; **María González,** Designer;
Javier Sanz, Designer; **Natalia Buño,** Designer; **Carmelo Caderot,**
Design Director

El Mundo Magazine
Madrid, Spain (A)

Special sections

Rodrigo Sánchez, Art Director & Designer; **María González,** Designer;
Javier Sanz, Designer; **Natalia Buño,** Designer; **Carmelo Caderot,**
Design Director

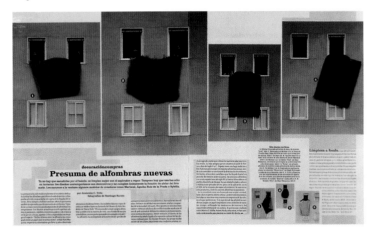

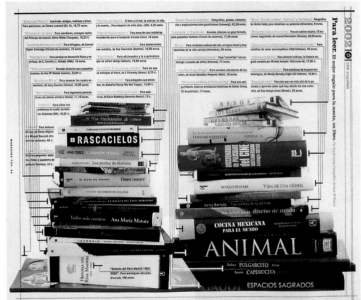

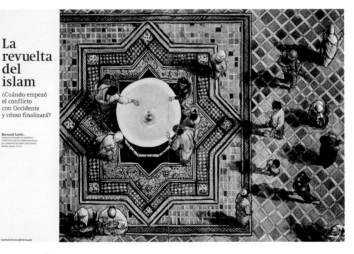

El Mundo Magazine
Madrid, Spain (A)

Special sections

Rodrigo Sánchez, Art Director & Designer; **María González,** Designer;
Javier Sanz, Designer; **Natalia Buño,** Designer; **Carmelo Caderot,**
Design Director

La Vanguardia
Barcelona, Spain (A)

Special sections

Rosa Mundet Poch, Project Manager; **Xavier Monsalve,** Designer

El Mundo Magazine
Madrid, Spain (A)

Special sections

Rodrigo Sánchez, Art Director & Designer; **María González,**
Designer; **Javier Sanz,** Designer; **Natalia Buño,** Designer; **Carmelo
Caderot,** Design Director

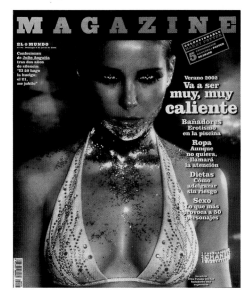

El Mundo Magazine
Madrid, Spain (A)

Special sections

Rodrigo Sánchez, Art Director & Designer; **María González,**
Designer; **Javier Sanz,** Designer; **Natalia Buño,** Designer; **Carmelo
Caderot,** Design Director

GOLD
El Mundo Metropoli
Madrid, Spain (A)

Cover design

Rodrigo Sánchez, Art Director & Designer; **María González,** Designer; **Carmelo Caderot,** Design Director

Judges: Metropoli chose a concept to depict "Star Wars Episode II: Attack of the Clones," instead of the handout art everyone else used. The designers were the only ones to think outside the box. This magazine has a sense of humor unmatched by any other magazine.

Jueces: Metrópoli eligió un concepto para describir "La Guerra de las galaxias Episodio II: El ataque de los clones", en vez del arte promocional que utilizaron el resto de diarios. Los diseñadores fueron los únicos que pensaron en algo distinto. Esta revista tiene un sentido del humor inigualable.

El Mundo Magazine
Madrid, Spain (A)

Special sections

Rodrigo Sánchez, Art Director & Designer; **María González,** Designer; **Javier Sanz,** Designer; **Natalia Buño,** Designer; **Carmelo Caderot,** Design Director

Sarasota Herald-Tribune
Sarasota, Fla. (B)

Special sections

Nicole Sneed, Graphics Editor; **Lisa McQuaid,** Features Designer; **Sara Quinn,** A.M.E./Visuals

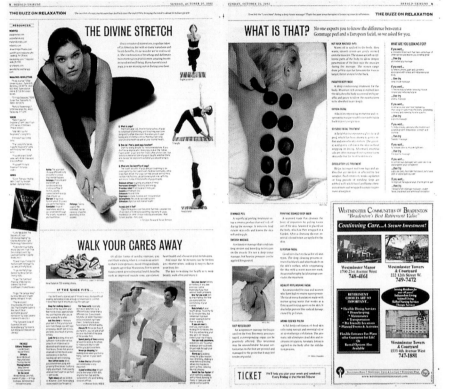

The New York Times Magazine
New York, N.Y. (A)

Page design

Janet Froelich, Art Director; **Claude Martel,** Designer; **Kathy Ryan,** Photo Editor

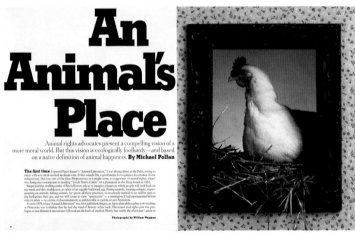

The New York Times Magazine
New York, N.Y. (A)

Page design

Janet Froelich, Art Director; **Nancy Harris,** Designer; **Kathy Ryan,** Photo Editor; **William Wegman,** Photographer

SILVER
El Mundo Metropoli
Madrid, Spain (A)

Cover design

Rodrigo Sánchez, Art Director & Designer; **María González,** Designer; **Carmelo Caderot,** Design Director; **Ángel Becerril,** Photographer

Judges: While the rest of the world used hand-out art to tell the story of the new "Spiderman" movie, Metropoli said that's not good enough. Other papers went big and loud, but it went in the opposite direction. It nailed it.

Jueces: Mientras el resto del mundo utilizaba arte promocional para relatar la historia del nuevo hombre araña, Metrópoli decidió que eso no era suficiente. Otras páginas propusieron gráficos grandes y llamativos. Metrópoli hizo lo contrario y consiguió su objetivo.

Araña: aracnido de 4 pares de patas, que presenta un pequeño cefalotorax no articulado al que se une un abdomen abultado, en el extremo del cual tiene los organos productores de seda. **Hombre araña (Spiderman):** ser humano que ha sido picado por una araña manipulada genéticamente, como demuestra la pelicula de Sam Raimi

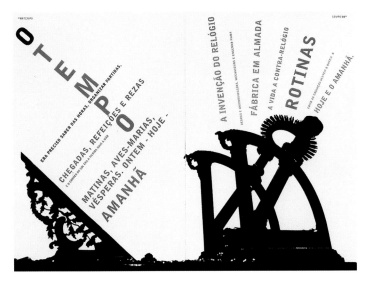

Diário de Notícias
Lisbon, Portugal (B)

Page design

José Maria Ribeirinho, Design Director; **José Sarmento de Matos,** Editor; **Jorge Silva,** Art Director & Designer; **Mário Bettencourt Resendes,** Editor in Chief; **Henrique Ruas,** Photographers

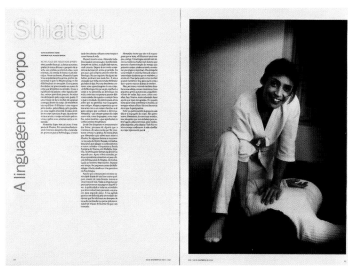

Diário de Notícias
Lisbon, Portugal (B)

Page design

Mário Bettencourt Resendes, Editor in Chief; **José Maria Ribeirinho,** Art Director; **Pedro Rolo Duarte,** Editor; **Paulo Barata Corrêa,** Art Editor; **Augusto Brázio,** Photographer; **Pedro Falcão,** Designer; **Cases i Associats**, Design Consultant

El Mundo
Madrid, Spain (A)

Page design

Manuel de Miguel, Art Director & Designer; **Carmelo Caderot,**
Design Director & Designer

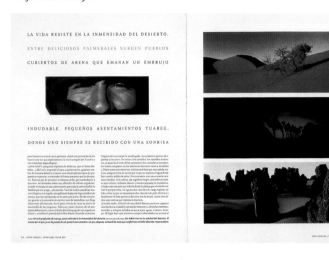

Diário de Notícias
Lisbon, Portugal (B)

Page design

José Maria Ribeirinho, Design Director; **Pedro Rolo Duarte,** Editor;
Mário Bettencourt Resendes, Editor in Chief; **Augusto Brázio,**
Photographer; **Paulo Barata Corrêa,** Art Editor; **Cases i Associats ,**
Design Consultant

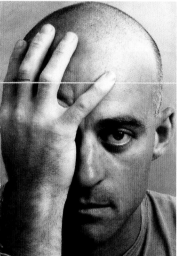

El Mundo
Madrid, Spain (A)

Page design

Manuel de Miguel, Art Director & Designer; **Carmelo Caderot,**
Design Director & Designer

Diário de Notícias
Lisbon, Portugal (B)

Page design

José Maria Ribeirinho, Art Director; **Pedro Rolo Duarte,** Editor;
Pedro Falcão, Designer; **Mário Bettencourt Resendes,** Editor in
Chief; **Augusto Brázio,** Photographer; **Paulo Barata Corrêa,** Art
Editor; **Cases i Associats,** Design Consultant

LLAMA A CASA 20 AÑOS DESPUÉS

SILVER
El Mundo Metropoli
Madrid, Spain (A)

Cover design

Rodrigo Sánchez, Art Director & Designer; **María González,**
Designer; **Carmelo Caderot,** Design Director; **Miguel
Santamarina,** Illustrator

Judges: The magazine is very aware of
everything on its pages, such as highlighting
"ET" in red in the flag. It has such fun in its
design. Using some of the best use of color
we've seen, Metropoli has a consistency of
creative ideas, while the rest of the world
struggles.

Jueces: La revista es consciente de todo en
sus páginas, y así presenta "ET" de forma
destacada y en rojo en la bandera. Disfruta
con el diseño. Con la mejor utilización de
colores que hemos visto, Metrópoli se
mantiene en su línea con ideas creativas
mientras que las demás publicaciones lo
sigue intentando.

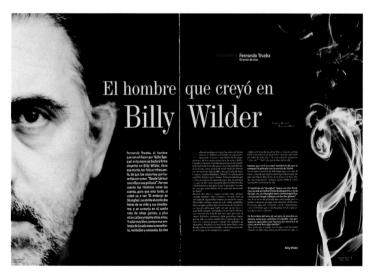

Expansión
Madrid, Spain (C)

Page design

José Juan Gamez, Art Director; **Emilia Peñalba,** Designer

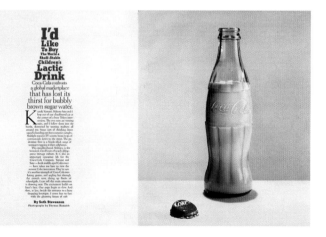

The New York Times Magazine
New York, N.Y. (A)

Page design

Janet Froelich, Art Director; **Lisa Naftolin,** Designer; **Kathy Ryan,**
Photo Editor; **Thomas Hannich,** Photographer/Illustrator

El Mundo
Madrid, Spain (A)

Page design

Manuel de Miguel, Art Director & Designer; **Carmelo Caderot,**
Design Director & Designer

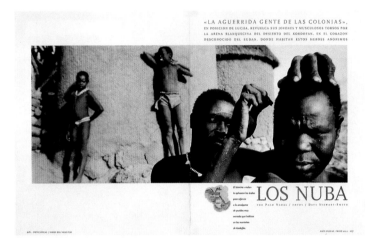

The New York Times Magazine
New York, N.Y. (A)

Page design

Janet Froelich, Art Director; **Joele Cuyler,** Designer; **Kathy Ryan,**
Photo Editor

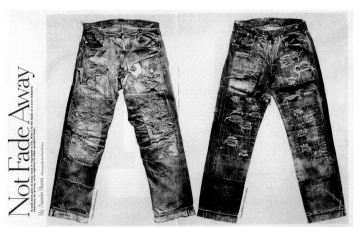

El Mundo
Madrid, Spain (A)

Page design

Carmelo Caderot, Design Director & Designer; **Manuel de Miguel,**
Art Director & Designer

Diário de Notícias
Lisbon, Portugal (B)

Page design

Mário Bettencourt Resendes, Editor in Chief; **José Maria
Ribeirinho,** Design Editor; **José Sarmento de Matos,** Editor; **Jorge
Silva,** Art Director/Designer; **Fotomafia,** Photographer

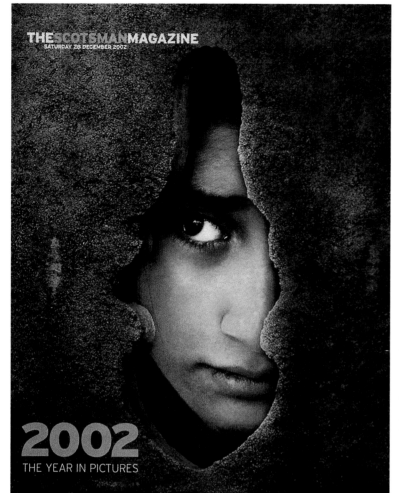

SILVER
The Scotsman Magazine
Edinburgh, Scotland (B)

Cover design

Liese Spencer, Editor; **Alex Aikman,** Picture Editor; **Kevin Waddell,** Art Director

Judges: This photo choice literally says "looking at the year in pictures." The photo editor was really thinking about that when choosing the photo. The woman's eyes move with you. It's a great way to start the section.

Jueces: La elección de esta foto dice literalmente "recordando el año en imágenes". El editor fotográfico pensó precisamente en esto cuando eligió la foto. Los ojos de la mujer se mueven contigo. Es una forma sensacional de empezar la sección.

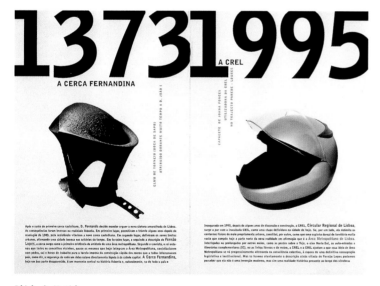

Diário de Notícias
Lisbon, Portugal (B)

Page design

Mário Bettencourt Resendes, Editor in Chief; **José Maria Ribeirinho,** Design Editor; **José Sarmento de Matos,** Editor; **Jorge Silva,** Art Director; **Jorge Silva,** Designer; **Fotomafia ,** Photographer

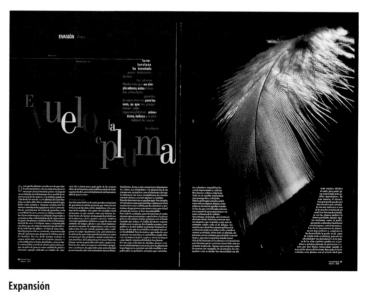

Expansión
Madrid, Spain (C)

Page design

José Juan Gámez, Art Director; **Emilia Peñalba,** Designer

Clarín
Buenos Aires, Argentina (A)

Page design

Gustavo Lo Valvo, Art Director; **Iñaki Palacios,** Art Director; **Adriana Di Pietro,** Graphic Designer; **Hugo Vasiliev,** Graphic Designer; **Laura Escobar,** Graphic Designer; **Paula Mizraji,** Graphic Designer; **Eduardo Longoni,** Photo Editor

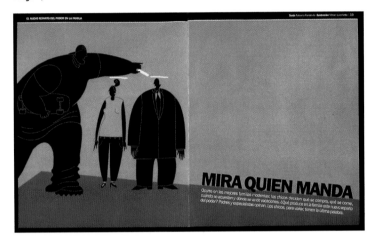

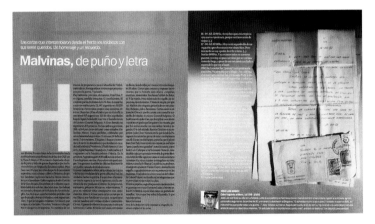

Clarín
Buenos Aires, Argentina (A)

Page design

Gustavo Lo Valvo, Art Director; **Iñaki Palacios,** Art Director; **Adriana Di Pietro,** Graphic Designer; **Hugo Vasiliev,** Graphic Designer; **Laura Escobar,** Graphic Designer; **Paula Mizraji,** Graphic Designer; **Eduardo Longoni,** Photo Editor

Expresso
Lisbon, Portugal (B)

Page design

Henrique Monteiro, Editor in Chief; **Pedro Figueiral,** Design Editor; **Jorge Fiel,** Editor; **Mestre Ribero,** Art Director; **Francisco Bordallo,** Designer; **Rui Ochoa,** Photographer

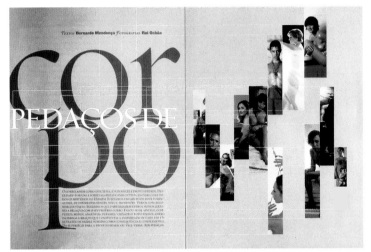

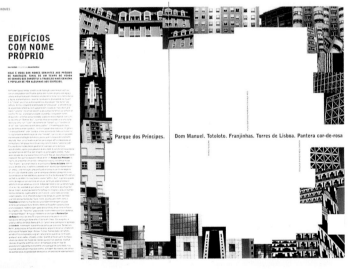

Diário de Notícias
Lisbon, Portugal (B)

Page design

Mário Bettencourt Resendes, Editor in Chief; **José Maria Ribeirinho,** Design Editor; **José Sarmento de Matos,** Editor; **Jorge Silva,** Art Director/Designer; **Levina Valentim,** Designer; **Bruno Portela,** Photographer

LAS TIERRAS DEL NORTE DE LA INDIA MUESTRAN SU ROSTRO MADURO, LOS PROFUNDOS SURCOS POR LOS QUE PASA SIN PRISA EL RIO DE LA VIDA, LA MADRE DE LOS HINDÚES, EL GANGA, EL GANGES, EL RIO SAGRADO, UNA FUERZA FLUVIAL QUE NACE EN EL HIMALAYA, ADQUIERE SU VITALIDAD EN LA CIUDAD SAGRADA DE HARIDWAR Y LANGUIDECE EN EL

CORAZON DEL GOLFO DE BENGALA. EN SU LARGO CAMINO SE ENCUENTRA CON EL PASO TRANQUILO DEL PEREGRINO, QUE BUSCA SUMERGIRSE EN SUS FLUIDAS AGUAS CON EL FIN DE PURIFICARSE, DE LLENAR EL CUERPO Y EL ALMA DE SUS DONES DIVINOS, MIENTRAS EL SONIDO DE SU CORRER INVITA AL REPOSO, INCITA AL PENSAMIENTO Y OTORGA LA PAZ

EL RIO DE LA PUREZA.
UN PASEO POR SUS ORILLAS

RIO GANGES

EL RIO SAGRADO, EL RIO GANGES NACE EN EL HIMALAYA, RIEGA LAS VISCERAS DE TRES ESTADOS: HIMACHAL PRADESH, UTTAR PRADESH Y BIHAR; Y DESEMBOCA EN EL GOLFO DE BENGALA

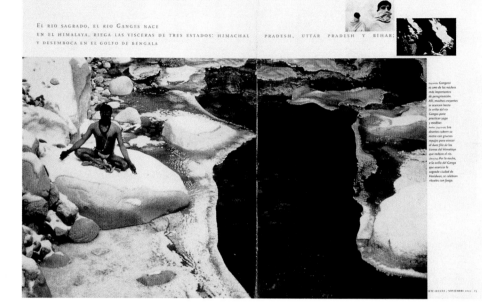

SILVER
El Mundo
Madrid, Spain (A)
Page design

Manuel de Miguel, Art Director & Designer; **Carmelo Caderot,** Design Director & Designer

Judges: Very interesting approach that plays all of the photos first, and then story at the end. Strong photos, a good photo edit and a design with a rhythm that draws you through all the pages.

Jueces: Enfoque muy interesante que juega con las fotos en primer lugar y con la historia al final. Fotos con carácter, una edición fotográfica buena y un diseño con un ritmo que te envuelve en sus páginas.

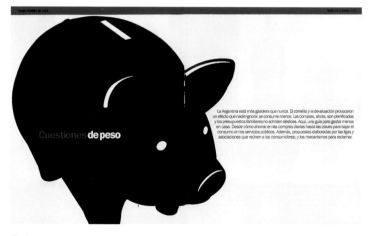

Cuestiones **de peso**

La Argentina está más gasolera que nunca. El corralito y la devaluación provocaron un efecto que nadie ignora: se consume menos. Las compras, ahora, son planificadas y los presupuestos familiares no admiten deslices. Aquí, una guía para gastar menos en casa. Desde cómo ahorrar en las compras diarias hasta las claves para bajar el consumo en los servicios públicos. Además, propuestas elaboradas por las ligas y asociaciones que reúnen a los consumidores; y los mecanismos para reclamar.

Clarín
Buenos Aires, Argentina (A)
Page design

Gustavo Lo Valvo, Art Director; **Iñaki Palacios,** Art Director; **Adriana Di Pietro,** Graphic Designer; **Hugo Vasiliev,** Graphic Designer; **Laura Escobar,** Graphic Designer; **Paula Mizraji,** Graphic Designer; **Eduardo Longoni,** Photo Editor

" Seeing that man shot and seeing his life drift out of him — these are things you don't want to see anywhere. "
—Palestinian sympathizer Larry Flakes

Los Angeles Times
Los Angeles, Calif. (A)
Page design

Roger Gurbani, Designer; **Nan Oshin,** Art Director; **Carolyn Cole,** Photographer

The Philadelphia Inquirer Magazine
Philadelphia, Pa. (A)

Cover design

Lisa Zollinger Tobia, Art Director; **Susan Syrnick,** Assistant Art Director & Designer; **Isabelle Arsenault,** Illustrator

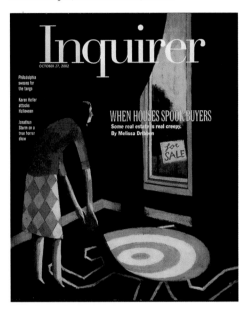

El Mundo
Madrid, Spain (A)

Page design

Manuel de Miguel, Art Director & Designer; **Carmelo Caderot,** Design Director & Designer

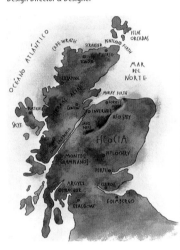

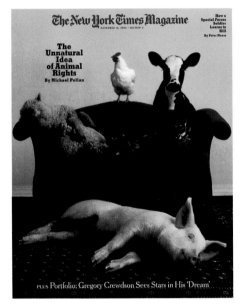

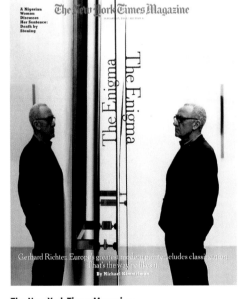

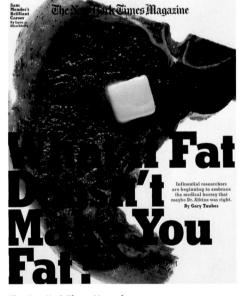

The New York Times Magazine
New York, N.Y. (A)

Cover design

Janet Froelich, Art Director and Designer; **William Wegman,** Photographer; **Kathy Ryan,** Photo Editor

The New York Times Magazine
New York, N.Y. (A)

Cover design

Janet Froelich, Art Director; **Joele Cuyler,** Designer; **Kathy Ryan,** Photo Editor; **Thomas Struth,** Photographer/Illustrator

The New York Times Magazine
New York, N.Y. (A)

Cover design

Janet Froelich, Art Director; **Claude Martel,** Designer; **Kathy Ryan,** Photo Editor; **Lendon Flanagan,** Photographer

MAGAZINE

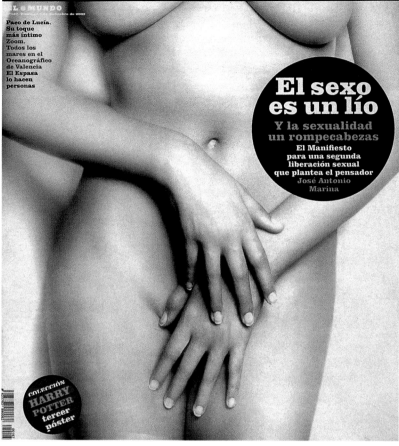

El sexo es un lío

Y la sexualidad un rompecabezas

El Manifiesto para una segunda liberación sexual que plantea el pensador José Antonio Marina

Paco de Lucía. Su toque más íntimo Zoom. Todos los mares en el Oceanográfico de Valencia El Espasa lo hacen personas

COLECCIÓN HARRY POTTER tercer póster

SILVER
El Mundo Magazine
Madrid, Spain (A)

Overall design

Rodrigo Sánchez, Art Director & Designer; **María González,** Designer; **Javier Sanz,** Designer; **Natalia Buño,** Designer; **Carmelo Caderot,** Design Director

Judges: El Mundo takes risks with the use of photography and its content. The nude photo on the cover is cropped in an interesting, non-offensive way. It is sure to get the reader inside the magazine for more content that is well written and displayed.

Jueces: El Mundo se arriesga con el uso de la fotografía y el contenido. La foto del desnudo de la portada aparece cortada de forma interesante y sin ofender a nadie.

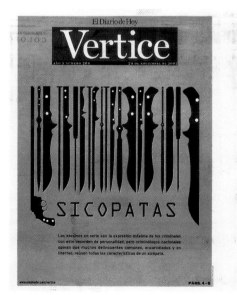

El Diario de Hoy
San Salvador, El Salvador (B)

Cover design

Pablo Salomone, Art Director; **Juan Durán,** Graphics Editor; **Erick Lemus,** Section Editor; **Jorge Castillo,** Graphics Editor/Designer

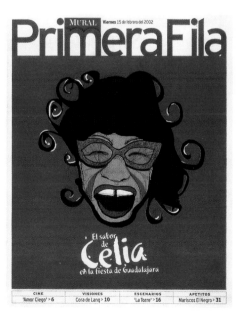

Mural
Zapopan, México (C)

Cover design

Horacio Tortajada, Designer/Illustrator; **Fernando Jauregui,** Design Managing Editor; **Israel Carranza,** Page Editor; **Juan Carlos Garda,** Editorial Coordinator; **Guillermo Camacho,** Editoral Director; **Lázaro Ríos,** General Editorial Director

El Mundo Metropoli
Madrid, Spain (A)

Cover design

Rodrigo Sánchez, Art Director & Designer; **María González,** Designer;
Carmelo Caderot, Design Director

Also winning in magazine design.

Rodrigo Sánchez, Art Director & Designer

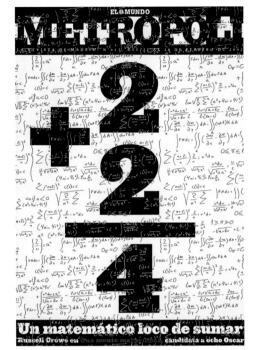

El Mundo Metropoli
Madrid, Spain (A)

Cover design

Rodrigo Sánchez, Art Director & Designer; **María González,** Designer;
Carmelo Caderot, Design Director; **José Belmonte,** Illustrator

El Mundo Metropoli
Madrid, Spain (A)

Cover design

Rodrigo Sánchez, Art Director & Designer; **María González,** Designer;
Carmelo Caderot, Design Director

El Mundo Metropoli
Madrid, Spain (A)

Cover design

Rodrigo Sánchez, Art Director & Designer; **María González,** Designer;
Carmelo Caderot, Design Director; **Ricardo Martínez,** Illustrator

El Mundo Metropoli
Madrid, Spain (A)

Cover design

Rodrigo Sánchez, Art Director & Designer; **María González,** Designer;
Carmelo Caderot, Design Director

El Mundo Metropoli
Madrid, Spain (A)

Cover design

Rodrigo Sánchez, Art Director & Designer; **María González,** Designer;
Raúl Arias, Illustrator; **José Belmonte,** Illustrator; **Carmelo Caderot,**
Design Director

El Mundo Metropoli
Madrid, Spain (A)

Cover design

Rodrigo Sánchez, Art Director & Designer; **María González,** Designer; **Carmelo Caderot,** Design Director

garbage*

todo sobre el verano más musical, que abre el grupo norteamericano *basura

El Mundo Metropoli
Madrid, Spain (A)

Cover design

Rodrigo Sánchez, Art Director & Designer; **María González,** Designer; **Carmelo Caderot,** Design Director

Also winning in magazine design.

Rodrigo Sánchez, Art Director & Designer

El Mundo Metropoli
Madrid, Spain (A)

Cover design

Rodrigo Sánchez, Art Director & Designer; **María González,** Designer; **Carmelo Caderot,** Design Director

Iris Murdoch fue una adelantada a su tiempo. Nació en Dublín en 1919 y estudió en Oxford. Bisexual, tuvo un matrimonio bohemio que duró 40 años con el profesor de literatura John Bayley. Escribió 26 novelas y, por encima de todas las cosas, estaba enamorada del mundo y de la vida. Ahora, el director Richard Eyre cuenta su biografía en la película *Iris*, protagonizada por Judi Dench, Kate Winslet y Jim Broadbent, que ganó el Oscar al mejor actor secundario.

El Mundo Metropoli
Madrid, Spain (A)

Cover design

Rodrigo Sánchez, Art Director & Designer; **María González,** Designer; **Carmelo Caderot,** Design Director

El Mundo Metropoli
Madrid, Spain (A)

Cover design

Rodrigo Sánchez, Art Director & Designer; **María González,** Designer; **Carmelo Caderot,** Design Director

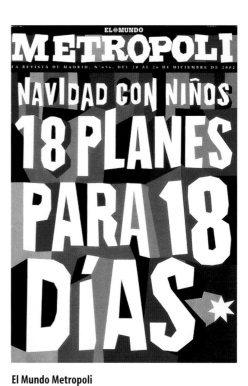

El Mundo Metropoli
Madrid, Spain (A)

Cover design

Rodrigo Sánchez, Art Director & Designer; **María González,** Designer; **Carmelo Caderot,** Design Director

El Mundo Metropoli
Madrid, Spain (A)

Cover design

Rodrigo Sánchez, Art Director & Designer; **María González,** Designer; **Carmelo Caderot,** Design Director

El Mundo Metropoli
Madrid, Spain (A)

Cover design

Rodrigo Sánchez, Art Director & Designer; **María González,** Designer; **Carmelo Caderot,** Design Director

Diário de Notícias
Lisbon, Portugal (B)

Cover design

Mário Bettencourt Resendes, Editor in Chief; **José Maria Ribeirinho,** Design Director; **José Sarmento de Matos,** Editor; **Jorge Silva,** Art Director & Designer; **Staff,** Photographers

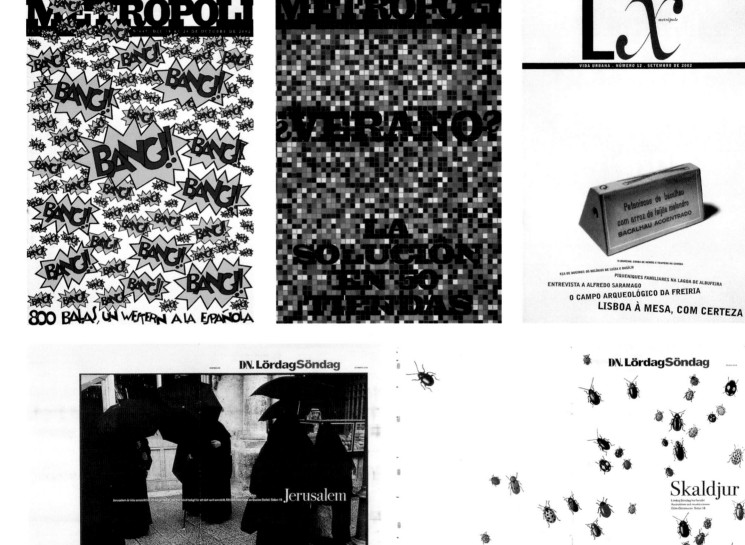

Dagens Nyheter
Stockholm, Sweden (A)

Cover design

Lotta Ek, Art Director; **Pär Björkman,** Photo Editor; **Esaias Baitel,** Photographer

Dagens Nyheter
Stockholm, Sweden (A)

Cover design

Ebba Bonde, Art Director; **Göte Göransson,** Illustrator

Diário de Notícias
Lisbon, Portugal (B)

Cover design

José Maria Ribeirinho, Design Director; **José Sarmento de Matos,** Editor; **Jorge Silva,** Art Director & Designer; **Mário Bettencourt Resendes,** Editor in Chief

Diário de Notícias
Lisbon, Portugal (B)

Cover design

José Maria Ribeirinho, Design Director; **José Sarmento de Matos,** Editor; **Jorge Silva,** Art Director & Designer; **Mário Bettencourt Resendes,** Editor in Chief; **Staff,** Photographers

Diário de Notícias
Lisbon, Portugal (B)

Cover design

José Maria Ribeirinho, Design Director; **José Sarmento de Matos,** Editor; **Jorge Silva,** Art Director & Designer; **Mário Bettencourt Resendes,** Editor in Chief; **Photographers,** Fotomafia

Diário de Notícias
Lisbon, Portugal (B)

Cover design

José Maria Ribeirinho, Art Director; **Mário Bettencourt Resendes,** Editor in Chief; **Pedro Rolo Duarte,** Editor; **Paulo Barata Corrêa,** Art Editor; **Pedro Falcão,** Designer; **Nuno Janela,** Designer; **Augusto Brázio,** Photographer; **Cases i Associats,** Design Consultant

Diário de Notícias
Lisbon, Portugal (B)

Cover design

José Maria Ribeirinho, Art Director; **Paulo Barata Corrêa,** Art Editor; **Pedro Falcão,** Designer; **Mário Bettencourt Resendes,** Editor in Chief; **Pedro Rolo Duarte,** Editor; **Augusto Brázio,** Photographer; **Cases i Associats,** Design Consultant

The Scotsman Magazine
Edinburgh, Scotland (B)

Cover design

Liese Spencer, Editor; **Alex Aikman,** Picture Editor; **Kevin Waddell,** Art Director; **Damian Shields,** Photo Illustrator

Expresso
Lisbon, Portugal (B)

Cover design

Henrique Monteiro, Editor in Chief; **Pedro Figueiral,** Design Editor & Designer; **Jorge Fiel,** Editor; **Mestre Ribero,** Art Director; **Francisco Bordallo,** Graphic Artist; **Rui Ochoa,** Photographer

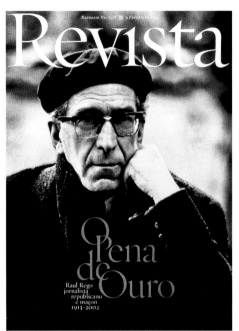

The Boston Globe
Boston, Mass. (A)

Cover design

Keith Webb, Art Director; **Nick King,** Editor; **Dan Zedek,** Design Director

Chicago Tribune
Chicago, Ill. (A)

Cover design

David Syrek, Art Director; **Bob Fila,** Photographer

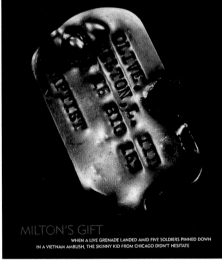

Upsala Nya Tidning
Uppsala, Sweden (B)

Cover design

John Hällström, Design; **Jonas Kihlander,** Designer; **Jonas Andersson,** Illustrator

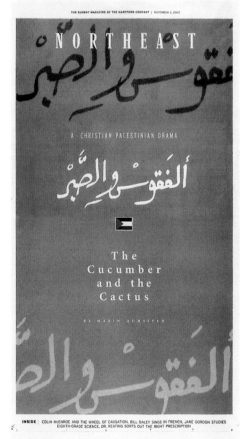

The Hartford Courant
Hartford, Conn. (A)

Cover design

Melanie Shaffer, Design Editor; **Rick Shaw,** Art Director; **Thom McGuire,** A.M.E. Photo/Graphics

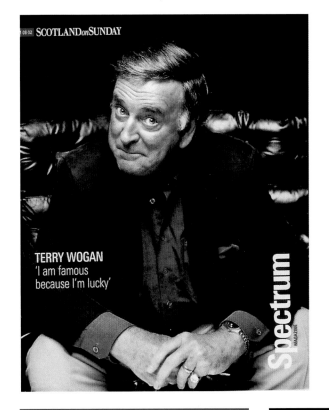

Scotland on Sunday
Edinburgh, Scotland (B)

Overall design

Lee Randall, Editor; **Katie Ferguson,** Art Director

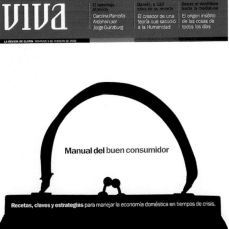

Clarín
Buenos Aires, Argentina (A)

Cover design

Gustavo Lo Valvo, Art Director; **Iñaki Palacios,** Art Director; **Adriana Di Pietro,** Graphic Designer; **Hugo Vasiliev,** Graphic Designer; **Laura Escobar,** Graphic Designer; **Paula Mizraji,** Graphic Designer; **Eduardo Longoni,** Photo Editor

National Post
Don Mills, Ont., Canada (A)

Cover design

Karen Simpson, Art Director; **Tony Keller,** Editor; **Lina McPhee,** Designer; **Sigrun Wister,** Designer

The Scotsman Magazine
Edinburgh, Scotland (B)

Overall design

Liese Spencer, Editor; **Alex Aikman,** Picture Editor; **Kevin Waddell,** Art Director; **Damian Shields,** Image Enhancement; **Angela McKean,** Designer; **Gillian Welsh,** Lifestyles Editor; **Andy Melvin,** Production Editor; **Judy Diamond,** Deputy Production Editor; **Grant Paterson,** Image Enhancement

Album de la Repubblica
Roma, Italy (A)

Overall design

Aurelio Magistà, Editor in Chief; **Andrea Mattone,** Designer; **Elena Dusi,** Editor

Estampa
Sao Paulo, Brazil

Overall design

Angela Klinke, Editor in Chief; **Silas Botelho,** Art Director; **Roberto Nejme,** Art Editor; **Adi Leite,** Photo Editor; **Vanina Maia,** Designer; **Helena Jacob,** Designer

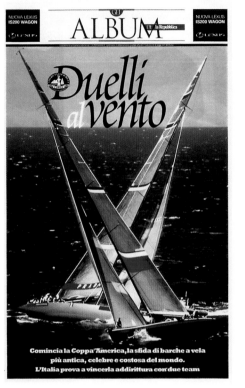

The New York Times Magazine
New York, N.Y. (A)

Overall design

Janet Froelich, Art Director; **Joele Cuyler,** Designer; **Nancy Harris,** Designer; **Claude Martel,** Designer; **Jeff Glendenning,** Designer; **Kathy Ryan,** Photo Editor; **Jody Quon,** Deputy Photo Editor

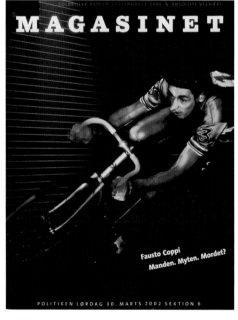

Politiken
Copenhagen, Denmark (B)

Overall design

Søren Nyeland, Design Editor; **Katinka Bukh,** Designer; **Henrik Kjerrumgaard,** Editor; **Henriette Lind,** Copy Editor

The Independent on Sunday
London, England (A)

Overall design

Jonathan Christie, Art Director; **Andrew Tuck,** Editor; **Victoria Lukens,** Picture Editor

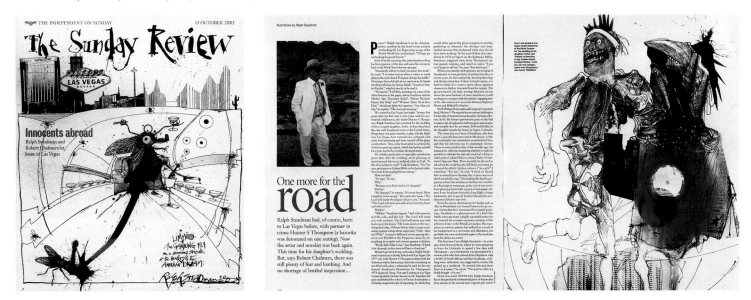

The Herald Magazine
Glasgow, Scotland (B)

Overall design

Kathleen Morgan, Editor; **Mark Smith,** Production Editor; **Jane McKay,** Designer; **Elaine Livingston,** Picture Editor

The Hartford Courant
Hartford, Conn. (A)

Overall design

Melanie Shaffer, Design Editor; **Rick Shaw,** Design & Graphics Editor; **Thom McGuire,** A.M.E. Photo/Graphics; **Bruce Moyer,** Photo Editor; **Josue Evilla,** Designer

News design

Sports design

Features design

Magazine design

Combination design

Illustration/individual

Illustration/staff

Photography/individual

Photography/staff

Information graphics/ extended coverage

Information graphics/ breaking news (individual)

Information graphics/ breaking news (staff)

Information graphics/ non-breaking news (individual)

Information graphics/ non-breaking news (staff)

Awards

AWARDS OF EXCELLENCE, unless designated.

GOLD, exceptional work.

SILVER, outstanding work.

JUDGES' SPECIAL RECOGNITION, worthy of a singular, superior honor in the category, is in Chapter 2, pages 26-37.

Circulation

Indicated after each publication's location
(A) 175,000 & over
(B) 50,000-174,999
(C) 49,999 & under

Chicago Tribune
Chicago, Ill. (A)
News design
Michael Miner, Art Director

San Francisco Chronicle
San Francisco, Calif. (A)
News design
Matt Petty, Designer

The Wall Street Journal
South Brunswick, N.J. (A)
News design
Orlie Krauss, Art Director & Designer
Also winning in photojournalism/illustration.
John Kuczala, Photographer; **Orlie Krauss,** Art Director; **Greg Leeds,**
Executive Art Director

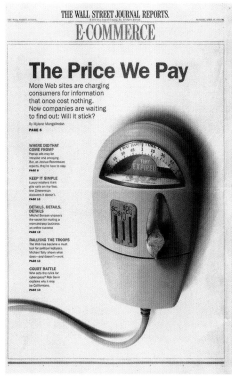

Santa Maria Times
Santa Maria, Calif. (C)
Sports design
Billy Simkins, Design Editor

National Post
Don Mills, Ont., Canada (A)

News design

Gayle Grin, A.M.E./Design & Graphics

Also winning in A-section, A-section page and breaking news topics.

Gayle Grin, A.M.E./Design & Graphics; **Kenneth Whyte,** Editor in Chief; **Martin Newland,** Deputy Editor; **Alison Uncles,** M.E.; **Steve Meurice,** Deputy M.E. ; **Rob McKenzie,** Page 1 Editor; **Denis Paquin,** Photo Editor; **Laura Koot,** News Presentation; **Kelly McParland,** Foreign Editor; **Andrew Tolson,** Night Photo Editor; **Ron Wadden,** Deputy Sports Editor; **Jim Bray,** Sports Editor

The Baltimore Sun
Baltimore, Md. (A) / *Sports design*
Michael Workman, Design Editor

SILVER
The Boston Globe
Boston, Mass. (A)

News design

Gregory Klee, Art Director & Designer

Also winning in feature design/opinion page.

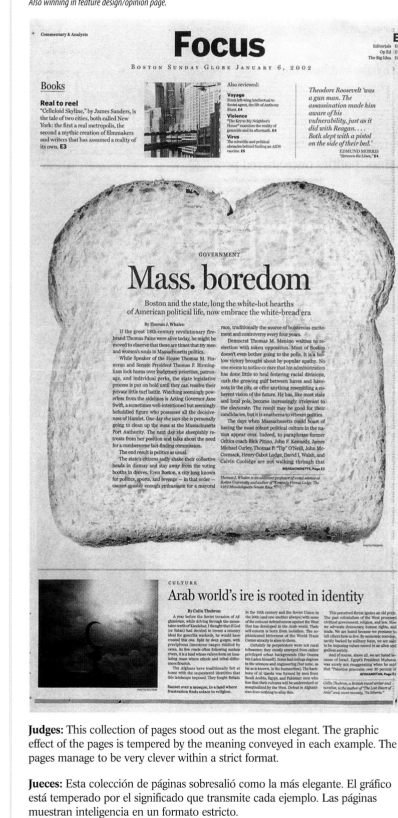

Judges: This collection of pages stood out as the most elegant. The graphic effect of the pages is tempered by the meaning conveyed in each example. The pages manage to be very clever within a strict format.

Jueces: Esta colección de páginas sobresalió como la más elegante. El gráfico está temperado por el significado que transmite cada ejemplo. Las páginas muestran inteligencia en un formato estricto.

The Weekend Australian Review
Sydney, Australia (A)

Features design

Tim Kliendienst, Designer

El Mundo La Luna
Madrid, Spain (A)

Features design

Rodrigo Sánchez, Art Director & Designer

The Boston Globe
Boston, Mass. (A)

Features design

Chin Wang, Art Director & Designer

Also winning in features/home-real estate.

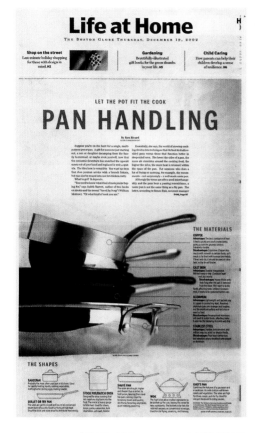

The Orange County Register
Santa Ana, Calif. (A)

Features design

Erick Wong, Designer

El Mundo La Luna
Madrid, Spain (A)

Features design

Rodrigo Sánchez, Art Director & Designer

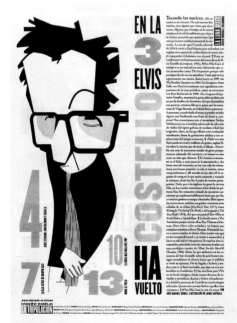

El Mundo La Luna
Madrid, Spain (A)

Features design

Eva López, Designer

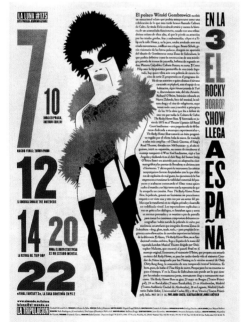

Tiefseebiologie Dunkelheit, Kälte und mörderischer Druck sind die Bedingungen der Tiefsee. Wer hier überleben will, muß sich allerhand einfallen lassen.

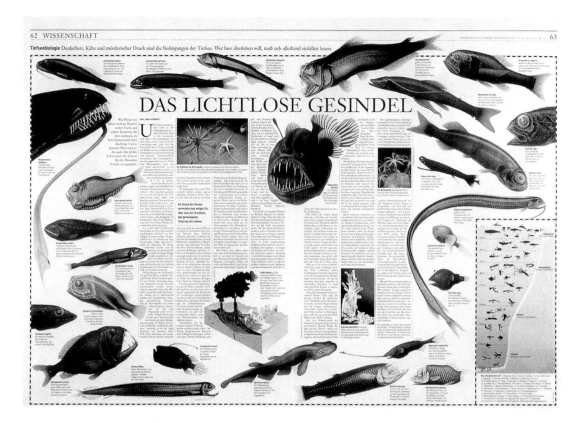

DAS LICHTLOSE GESINDEL

SILVER
Frankfurter Allgemeine Sonntagszeitung
Frankfurt am Main, Germany (A)

Features design

Peter Breul, Art Director

Judges: Awesome illustrations. The craft is incredible. These pages outshine anything we've seen. Nobody else is coming close to this.

Jueces: Ilustraciones sobresalientes. La habilidad es increíble. Estas páginas eclipsan todo lo que hemos visto. Ninguna otra pieza se parece a ésta.

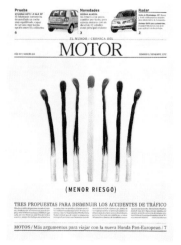

(MENOR RIESGO)

TRES PROPUESTAS PARA DISMINUIR LOS ACCIDENTES DE TRÁFICO

MOTOS / Más argumentos para viajar con la nueva Honda Pan-European / 7

El Mundo
Madrid, Spain (A)

Features design

Carmelo Caderot, Design Director & Designer

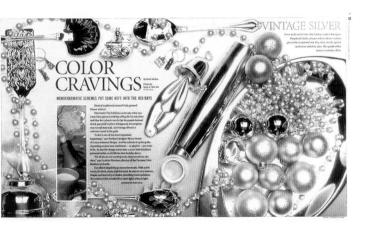

The Oregonian
Portland, Ore. (A)

Features design

Michelle D. Wise, Visuals Editor

Also winning in features/home-real estate.

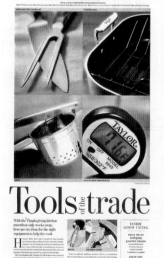

Chicago Tribune
Chicago, Ill. (A)

Features design

Catherine Whipple, Art Director

The Boston Globe
Boston, Mass. (A)

Features design

Cindy Daniels, Art Director

Also winning in features/science-technology.

The Orange County Register
Santa Ana, Calif. (A)

Features design

Erick Wong, Designer

El Mundo
Madrid, Spain (A)

Features design

Carmelo Caderot, Design Director & Designer

The Hartford Courant
Hartford, Conn. (A)

Features design

Chris Moore, Design Editor

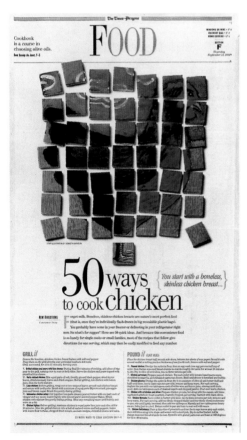

The Times-Picayune
New Orleans, La. (A)

Features design

Beth Aguillard-Straka, Feature Page Designer

Also winning in features/food page.

SILVER
Le Devoir
Montreal, P.Q., Canada (C)
Features design
Christian Tiffet, Art Director

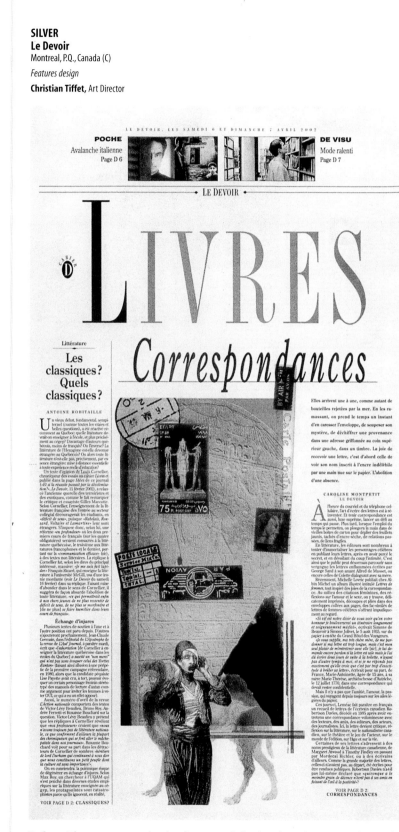

San Jose Mercury News
San Jose, Calif. (A)
Features design
Stephanie Grace Lim, Designer/Illustrator

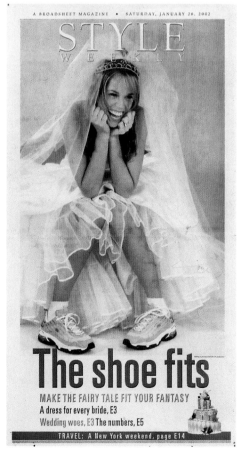

The Ottawa Citizen
Ottawa, Ont., Canada (B)
Features design
Kit Collins, Designer

Judges: These pages are simple, elegant and classic. The color, proportion and creative approach elevate this entry above the rest.

Jueces: Estas páginas son simples, elegantes y clásicas. El color, la proporción y el enfoque creativo elevan esta pieza por encima de las demás.

San Gabriel Valley Tribune
West Covina, Calif. (B)

Features design

Christine Kwon, Page Designer

El Comercio
Lima, Peru (B)

Features design

Milagros Valenzuela, Designer

El Comercio
Lima, Peru (B)

Features design

Jose Blanco, Designer

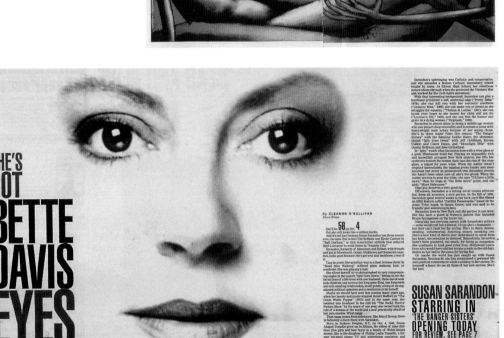

Asbury Park Press
Neptune, N.J. (B)

Features design

Adriana Libreros-Purcell, Designer

Also winning in other page.

Harris Siegel, M.E./Design & Photography;
Andrew Prendimano, Art & Photo Director;
Adriana Libreros-Purcell, Designer; **Kathy
Dzielak,** Editor

The Free Lance-Star
Fredericksburg, Va. (C)

Features design

Catherine Riser, Design Editor

Also winning in features/fashion

York Daily Record
York, Pa. (C)

Features design

Tracey Bisher Cullen, Graphic Artist

Rockford Register Star
Rockford, Ill. (B)

Features design

Brian Scott Ching, Graphic Artist/Designer

Also winning in features/entertainment page.

SILVER
El Mundo Metropoli
Madrid, Spain (A)

Magazine design

Rodrigo Sanchez, Art Director & Designer

Judges: An interesting, creative thought process that is always controlled and refined.

Jueces: Un proceso interesante y creativo que muestra control y es refinado.

Sun Journal
Lewiston, Maine (C)

Features design

Ursula Albert

El Mundo
Madrid, Spain (A)

Magazine design

Carmelo Caderot, Design Director & Designer

Siglo XXI
Guatemala, Guatemala (C)

Features design

Sergio Estrada, Designer

El Mundo
Madrid, Spain (A)

Magazine design

Carmelo Caderot, Design Director & Designer

The Boston Globe
Boston, Mass. (A)

Magazine design

Brendan Stephens, Art Director

Also winning in magazines/cover design.

Brendan Stephens, Art Director; **Nick King,** Editor; **Joel Benjamin,**
Photographer; **Dan Zedek,** Design Director

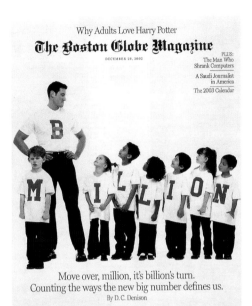

Siglo XXI
Guatemala, Guatemala (C)

Features design

Luis Villacinda, Designer

SILVER
Diário de Notícias
Lisbon, Portugal (B)

Magazine design

Jorge Silva, Designer

Judges: Beautiful color and typography. The designer takes risks. The pages are
very clean and employ good concepts with simple elements.

Jueces: Tipografía y color espléndidos. El diseñador se arriesga. Las páginas
son muy limpias y emplean buenos conceptos con elementos simples.

El Mundo Metropoli
Madrid, Spain (A)

Magazine design

Rodrigo Sánchez, Art Director & Designer

Also winning in magazine/cover design.

The New York Times
New York, N.Y. (A)

Combination design

Steven Heller, Art Director

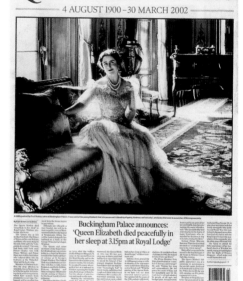

The Independent on Sunday
London, England (A)

Combination design

Carolyn Roberts, Art Director

Also winning in local news page, page 44.

The Hartford Courant
Hartford, Conn. (A)

Combination design

Josue Evilla, Designer

The Register-Guard
Eugene, Ore. (B)

Combination design

Ben Swan, News Designer

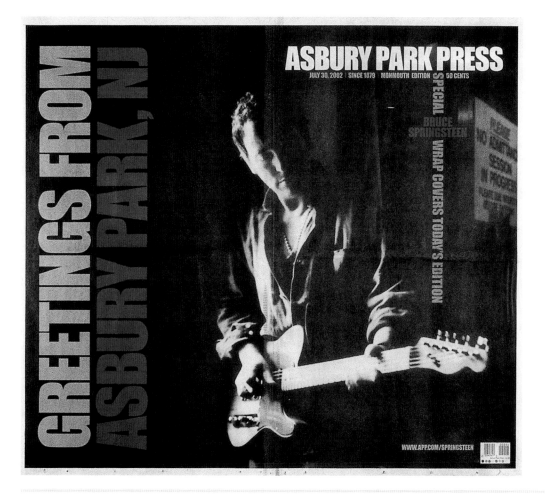

Judges: A great variety of unusual and original work. The creativity on these pages, especially 1A, is very surprising for an American newspaper. The designer takes great risks.

Jueces: Una gran variedad de trabajos poco comunes y originales. La creatividad de estas páginas, especialmente la portada, es muy sorprendente para un diario de Estados Unidos. El diseñador se arriesga mucho.

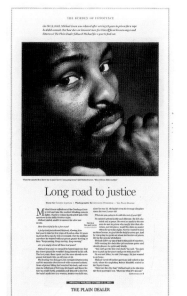

The Plain Dealer
Cleveland, Ohio (A)

Combination design

David Kordalski, A.M.E./Visuals & Illustrator

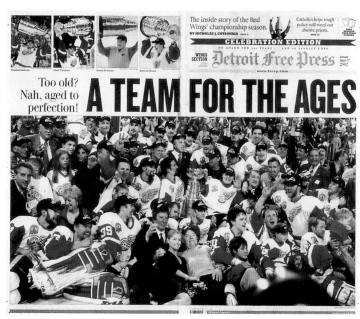

Detroit Free Press
Detroit, Mich. (A)

Combination design

Steve Dorsey, Design & Graphics Director

Also winning in special coverage/cover, page 118, and news design/news pages.

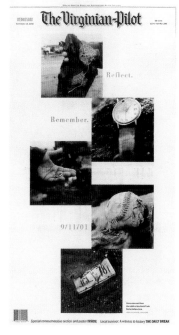

The Virginian-Pilot
Norfolk, Va. (A)

Combination design

Sam Hundley, Designer

The State
Columbia, S.C. (B)
Combination design
Elizabeth M. Smith, Features Designer

Daily Times-Call
Longmont, Colo. (C)
Combination design
K.J. Deacon, Designer
Also winning in features/other pages.

San Francisco Chronicle
San Francisco, Calif. (A)
Illustration/individual
Lance Jackson, Illustrator

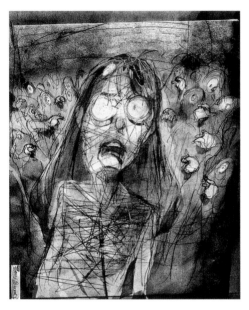

El Mundo Metropoli
Madrid, Spain (A)
Illustration/individual
José Belmonte, Illustrator

Seattle Post-Intelligencer
Seattle, Wash. (A)
Illustration/individual
Wendy Wahman, Illustrator

The Virginian-Pilot
Norfolk, Va. (A)
Illustration/individual
Sam Hundley, Illustrator

VICTORIA POURS IT ON RAWTHER PASSIONATELY

Story by Misha Berson, *Seattle Times* arts critic · Illustrations by Susan Jouflas, assistant art director

AS AFFECTATIONS GO, high tea is a highly delicious one.

With all the coffee mania in the Northwest, tea has become a kind of hot-beverage stepsister to the more prominent and ubiquitous cup of joe.

But for those of us who savor the concept of an afternoon ceremony that involves pots of steaming brew, plates of delicate, crustless sandwiches, delectable miniature pastries, good conversation and an interlude of civilized indolence, we are in luck.

For the capital of tea, at least in this part of the world, is close at hand: It is Victoria, B.C., where afternoon tea service is both a ritual and an industry.

In Victoria, one has a fine choice of tea settings. You can get afternoon tea in elegant or casual circumstances, a tea that constitutes a (high-carbo) meal or one that's light on the tummy, a very pricey tea or one at a more modest tariff.

Though the Chinese first perfected the art of tea, the Anglo high-tea tradition began some 200 years ago, when the trend-setting Duchess of Bedford decided a nice pick-me-up was required late in

the day. She began inviting friends chez Bedford for tea and elegant snacks, and the practice caught on.

In modern-day, global-culture England, where the old-Brit traditions are fraying, the whole tea business has lost much of its cachet. An afternoon coffee break is now at least as common as a tea interlude in contemporary London.

But picturesque Victoria, on Vancouver Island, clings to the English traditions ferociously — even those that are fading across the pond in the Motherland. When we hunted for high tea in the town, here are three of the best options we found.

THE EMPRESS HOTEL

The most famous high tea in the vicinity is, of course, the one that's been offered at this historic hotel on Victoria's attractive waterfront for the past century or so.

Since the Fairmont Hotel chain took over the Empress, high tea there has retained its hefty price tag, but become less calorically opulent. That is not necessarily a bad thing, however: It's now possible to polish off an Empress tea in the afternoon and be hungry for dinner later.

The setting is charming: a big, airy tea room in shades of rose and dusty green, with views of the harbor and the tall windows. A piano tinkles in the background, as specially-trained waiters serve the tea with a flourish.

One begins with a freshly made pot of Empress-blend tea (a melange of Kenyan, Ceylon and Ceylon teas), followed by a light fruit cup, and levels of goodies on a tiered serving dish. These include traditional crustless sandwiches of deviled egg, smoked salmon and a delicious carrot ginger spread, warm (if not piping hot) scones with jam and sinfully rich Devon cream, plus tiny slabs of shortbread and other sweets (which are subject to change).

The atmosphere is enjoyably posh, and the service very attentive — though the waiters do push the add-on alcoholic drinks (champagne, sherry) too aggressively.

Reservations are required for Empress tea each setting. In summer and on Canadian holidays, it's best to reserve weeks in advance.

MURCHIE'S

If you require a heftier, more gourmet tea, and don't mind less tony surroundings, Murchie's is the place.

This well-stocked tea emporium, one of several in a chain run by the Canadian-based Murchie's tea company, offers an enticing repast twice daily, at 2 and 4 p.m. And if you attend the latter, supper may be redundant.

The long, narrow tea room isn't high on decorative charm, and it's a bit cramped. But the food is exceptional.

The menu features the ubiquitous scones with jam and cream and the usual dainty sandwiches. But with them come mini brioches with curried eggs, pâté cheese and sun-dried tomatoes wrapped in flaky phyllo, puffs of honey citrus chicken, and yummy pastries. Devon chocolate cake, eclairs and delightful fruit tartlettes.

Everything is just-baked at Murchie's kitchen, and the tea selection is excellent, too. For others, do yourself a favor and browse in the adjacent Murchie's store, which stocks an array of fine china pots and mugs, and a long list of custom-blended teas, including such rarities as Silver Needle and Downy Pearl.

BLETHERING PLACE

A short car or bus trip from downtown gets you to Oak Bay, a neighborhood with several teahouses worth checking out.

The most beloved and venerable is Blethering Place, a comfortable, unassuming establishment that reverts to a pub at night.

The wooden beams, flowered tablecloths and warm, family atmosphere of Blethering's (which is housed in a 1912 structure that used to be the local post office) make it a good place to bring children.

And the tea is a hearty one, served to color anytime between 11 a.m. and 5:30 p.m.

For the full afternoon tea (there are lighter versions available, you get superb scones, some of the best in Victoria, with cream and Blethering's homemade strawberry preserves.

Also set before you are rich (typically British items as sausage roll, butter tart and English trifle, and slices of palate-clearing fruit. There's also a weird Canadian concoction called a Nanaimo bar, a rich chocolate-cream sandwich.

You may consider dropping by Blethering for their substantial breakfasts and traditional roast-beef-with-Yorkshire-pudding dinners.

By the way, "Blethering" is not a family name. It's a Scottish expression that means "voluble senseless talking" — which goes very well with tea.

Misha Berson can be reached at 206-464-2383 or mberson@seattletimes.com

IF YOU GO

[listing details]

SILVER
The Seattle Times
Seattle, Wash. (A)
Illustration/individual
Susan Jouflas, Illustrator
Also winning in portfolio/illustration/individual.

Judges: The color palette matches Seattle's maritime geography. The abstract watercolors have a looseness that most U.S. papers wouldn't allow. This is European illustration in an American paper.

Jueces: La paleta de colores combina con la geografía marítima de Seattle. Las acuarelas abstractas tienen una vaguedad que muchos diarios estadounidenses no aprobarían. Es una ilustración europea en un periódico de EE.UU.

The Hartford Courant
Hartford, Conn. (A)
Illustration/individual
Joseph Hilliman, Designer

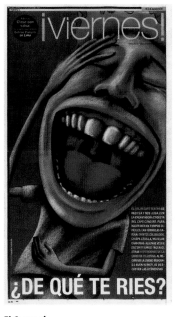

El Comercio
Lima, Peru (B)
Illustration/individual
Claudia Gastaldo, Illustrator

San Francisco Chronicle
San Francisco, Calif. (A)
Illustration/individual
Bill Russell, Illustrator

El País
Madrid, Spain (A)
Illustration/individual
Fernando Vicente, Illustrator

El País
Madrid, Spain (A)
Illustration/individual
Fernando Vicente, Illustrator

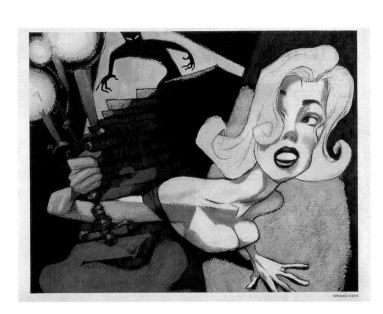

Heraldo de Aragon
Zaragoza, Spain (B)
Illustration/individual
Alberto Aragón, Illustrator

Philadelphia Daily News
Philadelphia, Pa. (B)
Combination design
John Sherlock, Designer

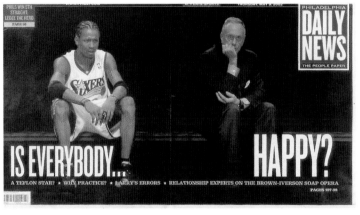

The Akron Beacon Journal
Akron, Ohio (A)
Illustration/individual
Dennis Balogh, Illustrator
Also winning in illustration/single.

Heraldo de Aragon
Zaragoza, Spain (B)
Illustration/individual
Luis Grañena, Illustrator

Seattle Post-Intelligencer
Seattle, Wash. (A)

Illustration/individual
Also winning in illustration/individual, page 141.

David Badders, Illustrator

Reforma
México City, México (B)

Illustration/individual

Fabricio Vanden Broeck, Illustrator

SILVER
El Mundo Del Siglo XXI
Madrid, Spain (A)

Illustration/individual

Ulises Culebro, Artist

Warhol nos dejó unas memorias sólo publicables después de su muerte. Lo principal que anota en ellas son los precios de las cosas. Medio dólar de un taxi, y en este plan

Judges: Its color use is quite clever. The images are very powerful and full of energy. The craftsmanship of line work sets the bar very high for anyone doing caricatures. It's so different than anything else we've seen.

Jueces: Inteligencia en el uso del color. Las imágenes tienen mucho carácter y están llenas de energía. La habilidad de las líneas pone el listón muy alto para cualquiera que realice caricaturas. Es completamente distinto a todo lo que hemos visto.

El Mundo Del Siglo XXI
Madrid, Spain (A)

Illustration/individual

Ulises Culebro, Illustration Editor

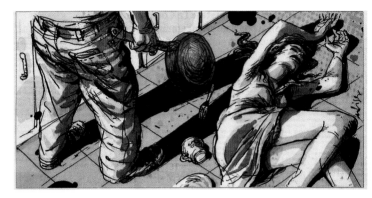

The Oregonian
Portland, Ore. (A)

Illustration/staff

Molly Swisher, Illustrator; **Steve Cowden,**
Illustrator; **David Cutler,** Illustrator; **Tyson**
Mangelsdorf, Illustrator; **Nancy Casey,**
Feature Art Director; **Steve McKinstry,** Art
Director

STEVE COWDEN/THE OREGONIAN

Siglo XXI
Guatemala, Guatemala (C)

Illustration/individual

Alejandro Azurdia, Artist

The Virginian-Pilot
Norfolk, Va. (A)

Photography/individual

Steve Earley, Photographer

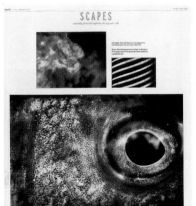

The Spokesman-Review
Spokane, Wash. (B)

Photography/individual

Brian Plonka, Photographer

Also winning judges' special recognition, page 27.

PABLO GARCÍA

SILVER
La Nueva España
Oviedo, Spain (B)

Illustration/individual

Pablo García, Infographic Artist

Judges: There is great craft in the line work. This illustrator has a strong personal style that adapts to a wide variety of subjects. The page design and use of positive and negative space is incredibly important – the white space cares for the illustration.

Jueces: Gran habilidad a la hora de trazar líneas. Este ilustrador tiene un estilo personal intenso que se adapta a gran variedad de sujetos. El diseño de página y el uso de espacio positivo y negativo es fundamental: los espacios blancos juegan con la ilustración.

El País
Madrid, Spain (A)

Illustration/individual

Fernando Vicente, Illustrator

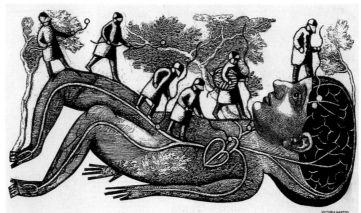

VICTORIA MARTOS

El Mundo
Madrid, Spain (A)

Illustration/individual

Victoria Martos, Graphic Artist

El Mundo Del Siglo XXI
Madrid, Spain (A)

Illustration/individual

Jorge Arevalo, Artist

The Register-Guard
Eugene, Ore. (B)
Photography/staff
Staff

Clarín
Buenos Aires, Argentina (A)
Information graphics/extended coverage
Iñaki Palacios, Art Director; **Alejandro Tumas,** Graphic Director; **Pablo Loscri,** Design Editor; **Staff,** Artist

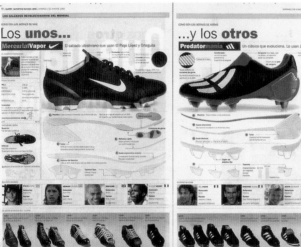

Detroit Free Press
Detroit, Mich. (A)
Photography/individual
J. Kyle Keener, Chief Photographer
Also winning in photography/portrait, page 163.

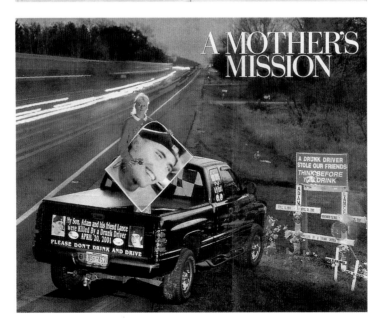

The Hartford Courant
Hartford, Conn. (A)
Photography/individual
Brad Clift, Photographer

The Dallas Morning News
Dallas, Texas (A)
Photography/individual
Also winning in portait photography, page 158.
Damon Winter, Staff Photographer

The Charlotte Observer
Charlotte, N.C. (A)

Photography/individual

Patrick Schneider, Photographer

Also winning in photo series/project or story, page 152.

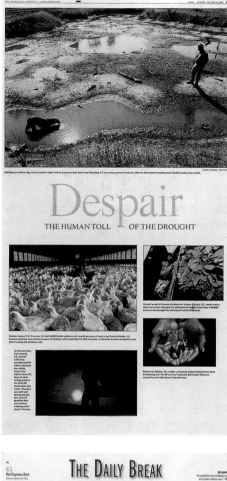

The Virginian-Pilot
Norfolk, Va. (A)

Photography/staff

Steve Earley, Photographer; **Martin Smith-Rodden,** Staff Photographer; **Chris Tyree,** Staff Photographer; **Genevieve Ross,** Staff Photographer

SILVER
The Plain Dealer
Cleveland, Ohio (B)

Photography/individual

Dale Omori, Photographer

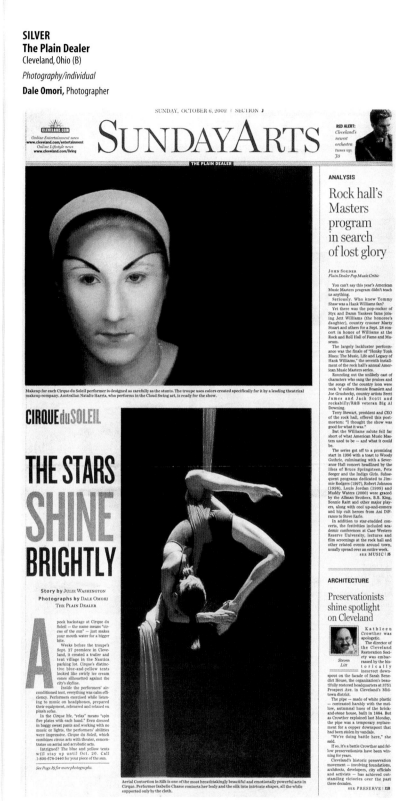

Judges: This portfolio is strong and versatile. It demonstrates great range for one photographer. The images are striking.

Jueces: Este portafolio es intenso y versátil. Demuestra una gran variedad para un fotógrafo. Las imágenes llaman mucho la atención.

Rocky Mountain News
Denver, Colo. (A)

Photography/staff

Janet Reeves, Director/Photography; **Steven G. Smith,** Photographer; **Dean Krakel,** Photo Editor; **Hal Stoelzle,** Photographer; **George Kochaniec, Jr.,** Photographer; **Dennis Schroeder,** Photographer; **Marc Piscotty,** Photographer; **Maria J. Avila,** Photographer; **Randall K. Roberts,** Presentation Editor

Also winning in portfolios/photography/individual and photography/spot news.

The New York Times
New York, N.Y. (A)

Information graphics/non-breaking news (staff)

Graphics Staff

El Correo
Bilbao, Spain (B)

Information graphics/extended coverage

Javier Zarracina, Infographic Editor; **Fernando G. Baptista,** Infographic Artist; **José Miguel Benítez,** Infographic Artist

El País
Madrid, Spain (A)

Information graphics/breaking news (staff)

Tomás Ondarra, Editor in Chief; **Rafael Ferrer,** Editor; **Antonio Alonso,** Infographic Artist; **Nacho Catalán,** Infographic Artist; **Aitor Eguinoa,** Infographic Artist; **Angel Nava,** Infographic Artist; **Rodrigo Silva,** Infographic Artist; **Gustavo Hermoso,** Infographic Artist

The Palm Beach Post
West Palm Beach, Fla. (B)

Photography/staff

Bruce R. Bennett, Photographer; **Allen Eyestone,** Photographer; **Damon Higgins,** Photographer; **Bill Ingram,** Photographer; **David Lane,** Photographer; **David Spencer,** Photographer; **Mark Edelson,** Presentation Editor; **Becky Lebowitz,** Photo Editor

Also winning in photography/feature and portfolios/photography/individual for Bruce R. Bennett.

The Arizona Republic
Phoenix, Ariz. (A)

Information graphics/non-breaking news (individual)

Eric Baker, Graphic Artist

SILVER
Detroit Free Press
Detroit, Mich. (A)

Photography/staff

J. Kyle Keener, Chief Photographer; **Julian H. Gonzalez,** Photographer; **Chip Somodevilla,** Photographer; **Craig Porter,** Deputy Director/Photography; **Nancy Andrews,** Director/Photography; **Mandi Wright,** Photographer; **Diane Weiss,** Picture Editor; **Steve Dorsey,** Design & Graphics Director; **Gene Meyers,** Sports Editor; **Nancy Laughlin,** News Editor

Judges: These images are full of moments that go beyond sports action. The collection shows great range.

Jueces: Estas imágenes están llenas de momentos que van más allá del deporte. La colección presenta una gran variedad.

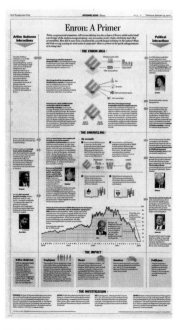

The Washington Post
Washington, D.C. (A)

Information graphics/extended coverage

Staff

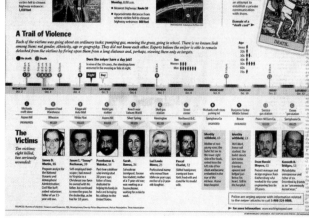

The Washington Post
Washington, D.C. (A)

Information graphics/extended coverage

Staff

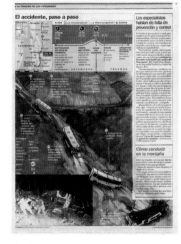

Clarín
Buenos Aires, Argentina (A)

Information graphics/breaking news (staff)

Iñaki Palacios, Art Director; **Alejandro Tumas,** Graphic Director; **Pablo Loscri,** Design Editor; **Staff,** Artist

Also winning in breaking news topics/editor's choice.

El Correo Espanol
Bilbao, Spain (B)

Information graphics/non-breaking news (individual)

Javier Zarracina, Infographic Editor

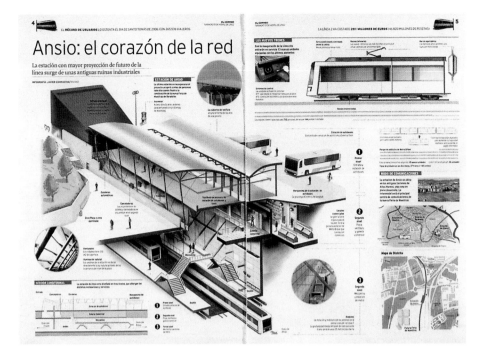

Ansio: el corazón de la red

La estación con mayor proyección de futuro de la línea surge de unas antiguas ruinas industriales

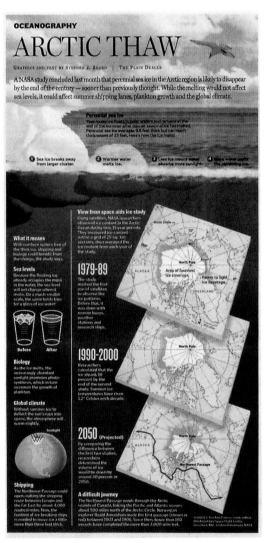

OCEANOGRAPHY
ARCTIC THAW

GRAPHICS AND TEXT BY STEPHEN J. BEARD | THE PLAIN DEALER

A NASA study concluded last month that perennial sea ice in the Arctic region is likely to disappear by the end of the century — sooner than previously thought. While the melting would not affect sea levels, it could affect summer shipping lanes, plankton growth and the global climate.

The Plain Dealer
Cleveland, Ohio (A)

Information graphics/non-breaking news (individual)

Stephen J. Beard, Graphic Artist

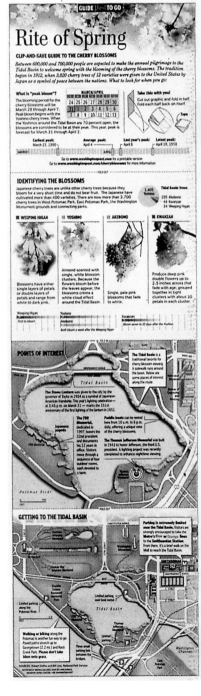

GUIDE [Just] TO GO
Rite of Spring

CLIP-AND-SAVE GUIDE TO THE CHERRY BLOSSOMS

Between 600,000 and 700,000 people are expected to make the annual pilgrimage to the Tidal Basin to welcome spring with the blooming of the cherry blossoms. The tradition began in 1912, when 3,020 cherry trees of 12 varieties were given to the United States by Japan as a symbol of peace between the nations. What to look for when you go:

The Washington Post
Washington, D.C. (A)

Information graphics/non-breaking news (individual)

Laura Stanton, Assistant Art Director

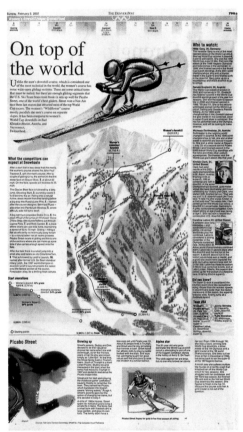

On top of the world

The Denver Post
Denver, Colo. (A)

Information graphics/non-breaking news (staff)

Blair Hamill, Graphics Editor; **Severiano Galvan,** Graphic Artist; **Andrew Lucas,** Graphic Artist; **Jonathan Moreno,** Graphic Artist; **Thomas McKay,** Assistant Graphics Editor; **Cindy Enright,** Graphic Artist; **Devon Morgan,** Graphic Artist

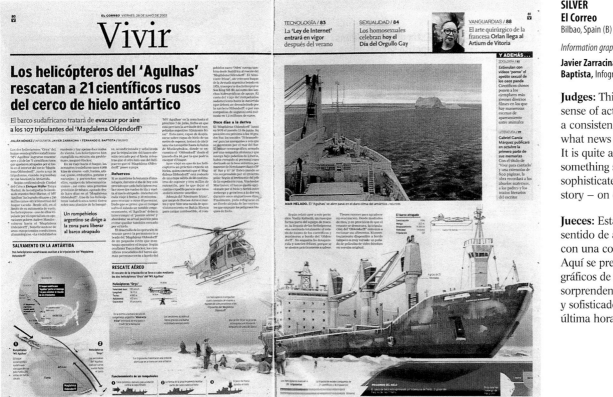

SILVER
El Correo
Bilbao, Spain (B)

Information graphics/breaking news (staff)

Javier Zarracina, Infographic Editor; **Fernando G. Baptista,** Infographic Artist

Judges: This entry gives you a sense of action, some drama, with a consistency of detail. This is what news graphics are all about. It is quite astonishing to see something so strong and sophisticated on a breaking-news story – on deadline.

Jueces: Esta pieza presenta un sentido de acción, algo de drama con una consistencia en el detalle. Aquí se presenta lo esencial de los gráficos de noticias. Es bastante sorprendente ver algo tan intenso y sofisticado en una noticia de última hora.

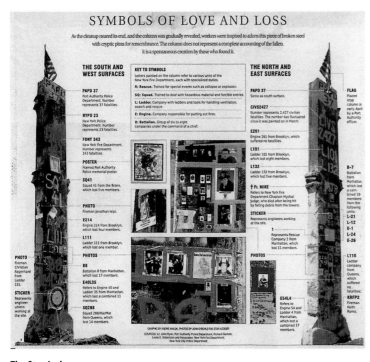

The Star-Ledger
Newark, N.J. (A)

Information graphics/non-breaking news (individual)

Andre Malok, Graphic Artist

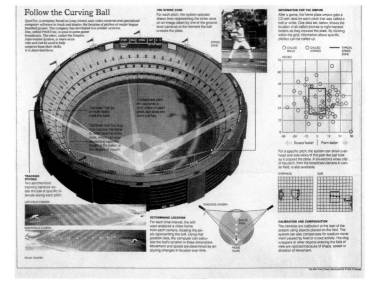

The New York Times
New York, N.Y. (A)

Information graphics/non-breaking news (individual)

Frank O'Connell, Graphics Editor

Clarín
Buenos Aires, Argentina (A)

Information graphics/non-breaking news (staff)

Iñaki Palacios, Art Director; **Alejandro Tumas,** Graphic Director;
Pablo Loscri, Design Editor; **Staff,** Artist

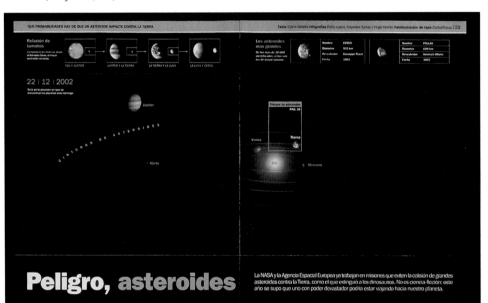

El Correo
Bilbao, Spain (B)

Information graphics/non-breaking news (individual)

Fernando G. Baptista, Infographic Artist

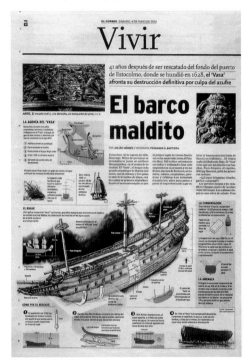

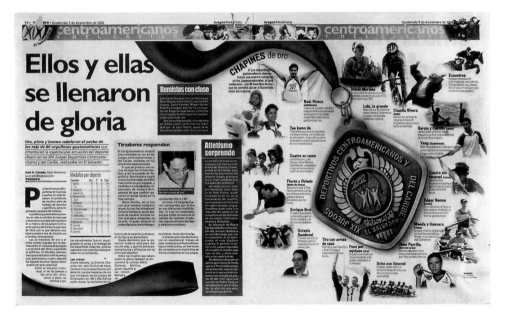

Siglo XXI
Guatemala, Guatemala (C)

Information graphics/non-breaking news (individual)

Daniel Lux, Graphic Artist

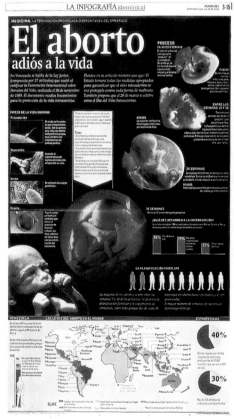

Diario Panorama
Maracaibo, Venezuela (B)

Information graphics/non-breaking news (individual)

Nelson Fernandez, Infographic Editor

Judges: Nice drawing – inviting and beautiful. A nice balance between a fine illustration and the diagrammatical information. This entry offers some of the best use of typography seen in this competition – very clean, not too dense.

Jueces: Bonito dibujo que invita al lector a seguir con él. Un equilibrio entre una ilustración fina y la información diagramatical. Esta pieza utiliza una tipografía magnífica e inigualable a otras piezas de la competición: muy limpia y no muy densa.

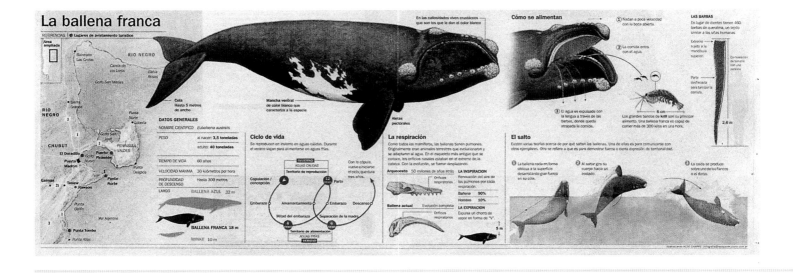

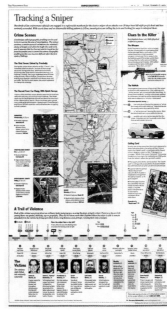

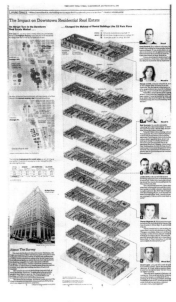

The New York Times
New York, N.Y. (A)

Information graphics/non-breaking news (staff)

Graphics Staff

Also winning in news design/inside pages.

The New York Times
New York, N.Y. (A)

Information graphics/non-breaking news (staff)

Graphics Staff

The Washington Post
Washington, D.C. (A)

Information graphics/non-breaking news (staff)

Staff

The New York Times
New York, N.Y. (A)

Information graphics/non-breaking news (staff)

Graphics Staff

Chapter 9
Redesigns
Rediseños

Overall newspaper

Section

Standing/regularly
appearing page

Awards

**AWARDS OF EXCELLENCE,
unless designated.**

GOLD, exceptional work.

SILVER, outstanding work.

**JUDGES' SPECIAL
RECOGNITION, worthy of a
singular, superior honor in
the category, is in
Chapter 2, pages 26-37.**

Circulation

**Indicated after each
publication's location**
(A) 175,000 & over
(B) 50,000-174,999
(C) 49,999 & under

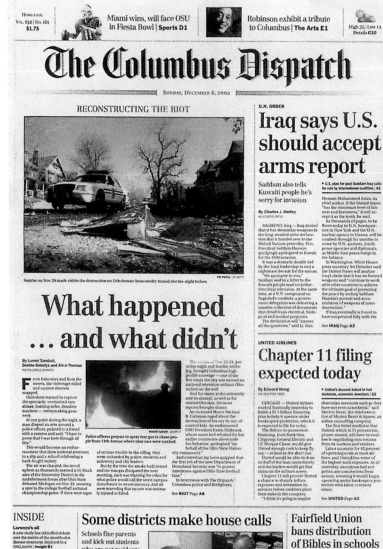

After

Before

The Columbus Dispatch
Columbus, Ohio (A)
Overall newspaper
Staff

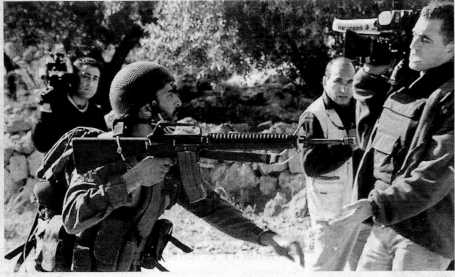

PERIODISMO: LAS FOTOS DE CAPA Y CIEN ARTÍCULOS DEL SIGLO / 2, 3 y 12

CINE: ELEGÍA POR EL GRAN CINEASTA BILLY WILDER / 8

ARQUITECTURA: HOMENAJE A GAUDÍ EN SU 150 ANIVERSARIO / 11

Artes&Letras

HERALDO DE ARAGÓN

Año XX · **Número 3** · 4 de abril de 2002

RYSZARD KAPUŚCIŃSKI PUBLICA "LOS CÍNICOS NO SIRVEN PARA ESTE OFICIO"

Periodismo y realidad

PERIODISMO

Los cínicos no sirven para este oficio

Ryszard Kapuściński. Edición de M. Nadotti.Anagrama.Barcelona, 2002. 124 páginas.

Un día le preguntaron a Borges sobre García Márquez, y éste le respondió: "He leído 'Cien años de soledad' y me ha gustado, aunque lo sobren cincuenta". ¿Cincuenta años, cincuenta páginas? En la respuesta del genial polifemo argentino había mucho de provocación, pero también quería lanzar un aguijonazo a los libros artificiosamente "hinchados",

estirados más allá de sus posibilidades.

Y éste es el principal defecto de "Los cínicos no sirven para este oficio", que tiene 124 páginas y que quizá le sobren un centenar, y que aparece firmado en portada por Ryszard Kapuściński aunque en realidad no haya escrito ni una sola línea.

Cuando entra en liza el nombre de Kapuściński la memoria se remonta a obras maestras como "El Emperador", "El Sha", "El Imperio" o "Ébano", obras en las que el genial reportero polaco sentó los cimientos de lo que pomposamente en Europa se ha denominado "creative non fiction", y que no es otra cosa que un hijo bastardo del "New Journalism" norteamericano. El mé-

todo de trabajo en ambos es muy parecido. El reportero-escritor aborda un tema por inmersión, acercándose a la historia, y a la Historia, no desde el punto de vista de quienes la protagonizan, sino desde la perspectiva de quienes la sufren. Se consiguen así retratos vívidos, certeros y personales de lo que ocurre en una ciudad o en un país. Se logran, de este modo, pequeñas obras maestras que pasan a la posteridad.

Nada de todo esto hay en "Los cínicos no sirven para este oficio", un volumen misceláneo en el que se recogen: las declaraciones de Kapuściński en el VI Congreso Redactor Social; una entrevista realizada

por Andrea Semplici, colaborador de la revista italiana "Airone"; y la transcripción de un encuentro entre Kapuściński y el escritor y crítico de arte inglés John Berger. De los tres, el texto más interesante es el primero, que sirve para dar título al volumen, y en el que se dan las claves para entender el periodismo actual. En el segundo, Kapuściński explica en apenas 25 páginas todo lo necesario para entender la realidad de un continente que quizá sea un Universo: África. Y el tercero, pese a lo que en principio pudiera parecer, no tiene más interés que el de comprobar cuán aburridos pueden llegar a ser los grandes pensadores pues-

tos a hablar de banalidades. El libro, sin embargo, se salva por las 35 páginas de "Ismael sigue navegando". Ahí Kapuściński, sin pelos en la lengua, pero con ciertas dosis de ese cinismo que rechaza para la profesión, vivisecciona el periodismo contemporáneo, entendido como profesión, y visto como fenómeno social en un mundo cada vez más globalizado. El gran problema del periodismo contemporáneo es que "tras el fin de la guerra fría, con la revolución de la electrónica y de la comunicación, el mundo de los negocios descubre de repente que la verdad no es importante, y que ni siquiera la lucha política es importante,

información-espectáculo, podemos vender esta información en cualquier parte. Cuanto más espectacular es la información, más dinero podemos ganar con ella". Y más: "El problema de las televisiones y, en general, de todos los medios de comunicación, es que son tan grandes, influyentes e importantes que han empezado a construir un mundo propio. Un mundo que tiene poco que ver con la realidad". La solución no es otra que volver al periodismo "intencional", que para Kapuściński es "aquel que se fija un objetivo y que intenta provocar algún tipo de cambio". Es en realidad, lo que piensan todos los periodistas de raza, aunque casi ninguno pueda llevar a la práctica sus ideas. **MARIANO GARCÍA**

After

GOLD
Heraldo de Aragón
Zaragoza, Spain (B)

Section

Jose Luis Minondo, Art Director; **Pilar Ostalé,** Designer; **Cristina Salvador,** Designer; **Cristina Urresti,** Designer; **Ana Pérez Errea,** Designer; **Javier Eslava,** Designer; **Javier Errea,** Design Consultant; **Guillermo Nagore,** Design Consultant

Before

Judges: The redesign represented a dramatic change, not only in design but in the content as well. The judges saw a profound, substantial improvement in design. The changes stopped you in your tracks. Outstanding attention to detail and craft.

Jueces: El rediseño representó un cambio muy grande, no sólo en el diseño sino en el contenido. Los jueces observaron una mejora sustancial en el diseño. Los cambios te dejan boquiabierto. Atención al detalle excepcional y gran habilidad.

After

After

The Herald
Glasgow, Scotland (B)

Overall newspaper

Ally Palmer, Consultant; **Terry Watson,** Consultant

Before

Before

Imerissia
Athens, Greece (C)

Overall newspaper

Valentina Villegas-Nika, Design Consultant

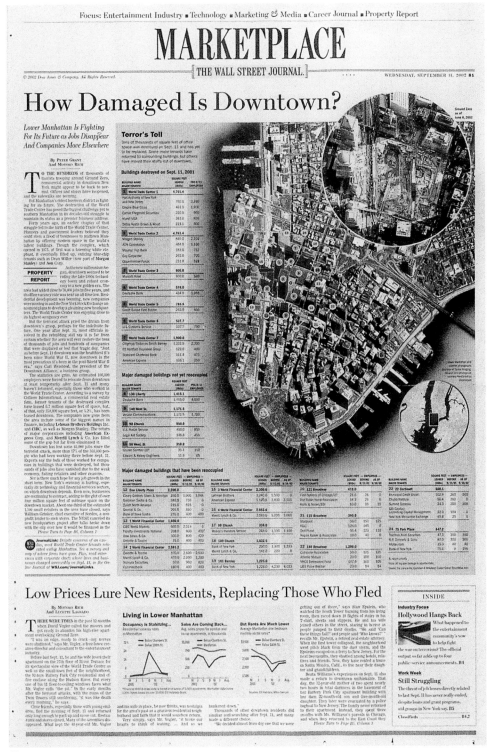

After

SILVER
The Wall Street Journal
New York, N.Y. (A)

Overall newspaper

Paul Steiger, M.E.; **Joanne Lipman,** Deputy M.E.; **Joe Dizney,** Design Director; **Greg Leeds,** Executive Art Director; **David Pybas,** Art Director; **Joe Paschke,** Deputy Design Director; **Dona Wong,** News Graphics Director

Before

Judges: A classic improved. The new content is rich, interesting and better organized. When you look at all sections as a group, the redesign represents remarkable change. The addition of graphics, art direction and color is superb. The changes represent as much as the Journal can do – very nice throughout.

Jueces: Un clásico mejorado. El nuevo contenido es rico, interesante y está bien organizado. Cuando observas todas las secciones en conjunto, el rediseño representa un cambio excepcional. Los gráficos, la dirección artística y el color son exquisitos. Los cambios representan todo lo que puede hacer el diario, un cambio igual en las secciones del periódico.

After

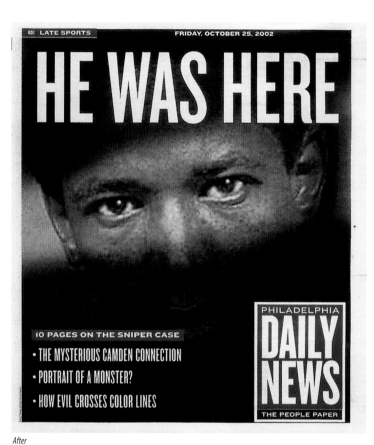

After

Kristianstadsbladet
Kristianstad, Sweden (C)

Overall newspaper

Jacob Nordström, Art Director & Designer; **Jörgen Svensson,** Project Editor

Before

Philadelphia Daily News
Philadelphia, Pa. (B)

Overall newspaper

John Sherlock, Graphics Editor; **Michelle Bjork,** Production Editor; **Deborah Withey,** Consultant

Before

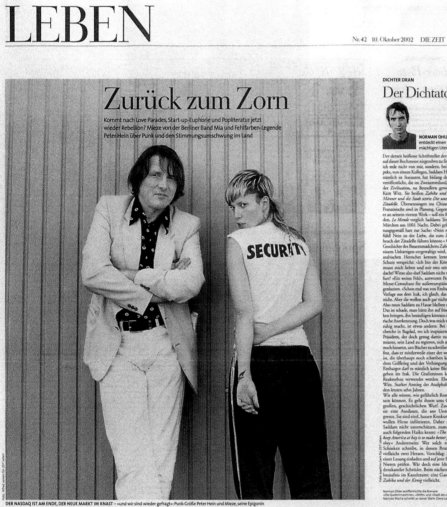

LEBEN

Nr. 42 10. Oktober 2002 DIE ZEIT **51**

Zurück zum Zorn

Kommt nach Love Parades, Start-up-Euphorie und Popliteratur jetzt wieder Rebellion? Mieze von der Berliner Band Mia und Fehlfarben-Legende Peter Hein über Punk und den Stimmungsumschwung im Land

DER NASDAQ IST AM ENDE, DER NEUE MARKT IM KNAST – »und wir sind wieder gefragt«: Punk-Größe Peter Hein und Mieze, seine Epigonin

After

DICHTER DRAN
Der Dichtator

NORMAN OHLER entdeckt einen mächtigen Literaten

Lebensinhalt

LEBENSPLANUNG Etikette für Reisende, die mit den neuen Bahntarifen hadern 52

NIERENSPENDE Wie ein jüdischer Student nach seinem Tod das Leben eines palästinensischen Mädchens rettete 53

BEZIEHUNGSKRAM Das deutsch-amerikanische Verhältnis gilt als gestört. Dabei kennen wir einander doch so genau ... 54

TONEXPERTE Russell Johnson bringt Konzertsäle zum perfekten Klingen 56

NETZGEWERBE Bei eBay handeln findige Unternehmer mit allem. Von zu Hause aus 57

NOMADENTUM Warum der Schweizer Tennis-Profi Marc Rosset nicht aufhören kann 58

SPRACHLOSIGKEIT Viele Dinge begegnen uns täglich. Aber wir kennen ihre Namen nicht 59

BERGGEWÄCHSE Siebeck widmet sich Südtiroler Almen und ältern Winzergütern 60

KANZLERWAGEN Der Golf TDI ist wie Schröder: Er bietet jedem etwas 62

BEFREIUNGSTRAUM Schauspielerin Charlotte Gainsbourg wünscht sich, aus dem Schatten ihrer berühmten Eltern zu treten 64

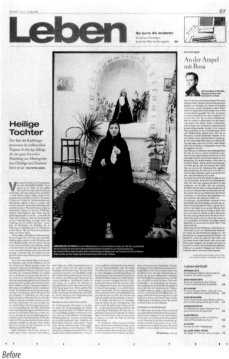

Leben

Heilige Tochter

An der Ampel mit Rosa

Before

Judges: In this entry, the good became better. The judges recognized the risk of using white space so effectively to strengthen the effect of images. Elegant in its simplicity and restraint, the entry offered techniques not seen in other redesigns.

Jueces: En esta pieza, lo bueno se hizo mejor. Los jueces reconocieron el atrevimiento en el uso del espacio blanco conseguido tan eficazmente para fortalecer el efecto de las fotos. Elegante por su simplicidad y moderación, la pieza ofrece técnicas que no se han percibido en otros rediseños.

After

Before

After

Before

Zaman
Istanbul, Turkey (A)

Overall newspaper

Fevzi Yazici, Art Director; **Kerem Öztürk,** Art
Director; **Ekrem Dumanli,** Editor in Chief

Dagens Naeringsliv
Oslo, Norway (B)

Section

Ally Palmer, Designer; **Terry Watson,** Designer

After

SILVER

The Wall Street Journal

New York, N.Y. (A)

Standing/regularly appearing page

Paul Steiger, M.E.; **Joanne Lipman,** Deputy M.E.; **Larry Ingrassia,** Money & Investing Editor; **Joe Dizney,** Design Director; **Greg Leeds,** Executive Art Director; **Joe Paschke,** Deputy Design Director; **David Pybas,** Art Director; **Dona Wong,** News Graphics Director; **Pat Minczeski,** News Graphic Editor; **Manny Velez,** Designer

Before

Judges: A huge improvement for the section. The new, horizontal construction of the market data is a great improvement. The section also shows a better use of illustration and art direction. Throughout, there are many little improvements made, while keeping the paper's personality.

Jueces: La nueva construcción horizontal de los datos de mercado constituye una enorme mejora. La sección presenta un uso mejorado de la ilustración y dirección artística. A lo largo de la sección, hay muchas mejoras pequeñas si bien la personalidad del diario es la misma.

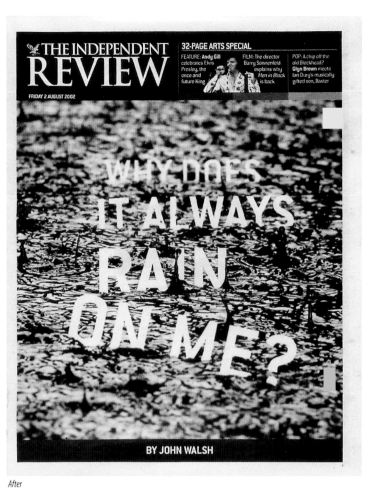

ANGELS FORCE GAME 7

Giants can't get monkey off their backs

Tonight

Dunbar squeaks by Oldham County, 2-1
BOYS' HIGH SCHOOL SOCCER — C4

SPORTS

Lady Knights win, to face East Jessamine
GIRLS' HIGH SCHOOL SOCCER — C4

SUNDAY, OCTOBER 27, 2002 | WWW.KENTUCKY.COM | LEXINGTON HERALD-LEADER ★ SECTION C

GEORGIA 52 || KENTUCKY 24

DOG POUNDING

Georgia defenders sandwiched Kentucky quarterback Jared Lorenzen during the second half. The Cats gained 101 yards after halftime.

Volponi, with jockey Jose Santos, shot past War Emblem coming out of the final turn and pulled away to a 6½-length victory.

Volponi stages $89 Classic upset

WAR EMBLEM TO FINISH 8TH

UK's old problems come home to rout

GEORGIA STUFFS UK IN SECOND HALF

After

Lexington Herald-Leader
Lexington, Ky. (B)

Section

Epha Riche, Presentation Director; **Jason Moon,** Designer; **Stephanie Stivers,** Designer; **Matt Mansfield,** Consultant; **Scott Goldman,** Consultant; **Mat Graf,** Assistant Sports Editor; **Rob Kandt,** Assistant Sports Editor; **Scott Ladd,** Designer

Before

THE Independent REVIEW

32-PAGE ARTS SPECIAL

FRIDAY 2 AUGUST 2002

WHY DOES IT ALWAYS RAIN ON ME?

BY JOHN WALSH

After

THE INDEPENDENT
WEDNESDAY REVIEW

BEAT POET

The Independent
London, England (A)

Section

Kevin Bayliss, Art Director; **Matt Straker,** Deputy Art Director

Before

After

Before

SILVER
Zaman
Istanbul, Turkey (A)

Standing/regularly appearing page

Fevzi Yazici, Art Director; **Kerem Ozturk,** Art Director;
Ekrem Dumanli, Editor in Chief; **Osman Turhan,** Illustrator

Judges: This section was by far the most radical redesign that the judges had seen. The old design offered too much competition between elements. The new design offered control – an elegant, gutsy change. Very clean, very well designed, very organized.

Jueces: Los jueces están de acuerdo en que esta sección ha sido, con mucho, la que presenta el rediseño más radical de la competición. El diseño antiguo ofrecía demasiada competición entre los elementos. El nuevo diseño presenta control: un cambio impetuoso y elegante. Muy limpio, muy bien diseñado y bien organizado.

CALENDAR

E¹
Movies
Television
Style

SUNDAY : PART I

October 13, 2002

calendarlive.com

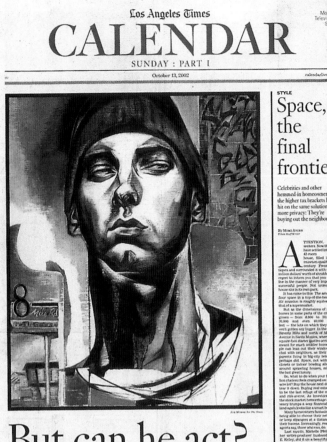

STYLE
Space, the final frontier

Celebrities and other hemmed-in homeowners in the higher tax brackets have hit on the same solution for more privacy: They're buying out the neighbors.

By MIMI AVINS
Times Staff Writer

But can he act?

Eminem goes to Hollywood in '8 Mile,' by way of the hard-knock streets of Detroit. It's a tale of how the worlds of rap and film accepted each other on their own terms.

By GEOFF BOUCHER
Times Staff Writer

After

Los Angeles Times
Los Angeles, Calif. (A)

Section

Joe Hutchinson, Deputy M.E.

Calendar

ON WITH THE (SUPER) SHOW

They said "The Producers," Broadway's biggest hit, wouldn't survive the loss of Nathan Lane and Matthew Broderick. How Brad Oscar proved them wrong. By Josh Getlin, Page 8

Before

ELMUNDO

AÑO IV / NÚMERO 139 / DOMINGO 8 DE SEPTIEMBRE DE 2002

NUEVA ECONOMIA

PETRÓLEO
BARRILES EN PIE DE GUERRA

Anatomía de un engaño

Cómo un ejecutivo agresivo hundió el negocio de Opening

RAFAEL MACÍA, DIRECTOR GENERAL DE LA POPULAR ACADEMIA DE IDIOMAS, SALIÓ DE WALL STREET INSTITUTE PORQUE QUERÍA TENER SU PROPIO NEGOCIO. A ESTE CANARIO, SIMPÁTICO, ARROLLADOR, LE GUSTA APOSTAR A LO GRANDE. ESO SE SABÍA. LO QUE NO SE CONOCE ES DÓNDE HAN IDO A PARAR 36 MILLONES DE EUROS

TURISMO
LAS CLAVES PARA SALIR DE LA CRISIS

MERCADOS
¿QUIÉN SE ATREVE A PISAR EL PARQUE?

ANA LORENZO / ELENA HITA

ARIADNA
Ordenadores a precio de ganga

AGENDA ELECTRÓNICA LINUX

SPIELBERG ADELANTA EL FUTURO

'EL SEÑOR DE LOS ANILLOS'

After

NUEVA ECONOMIA

EN EL ABISMO
Las medidas antifraude frenan la sangría bursátil

Before

El Mundo
Madrid, Spain (A)

Section

Carmelo Caderot, Design Director & Designer

After

Mural
Japopan, México (C)

Section

Karina Aguirre Durán, Designer; **Fernando Jauregui,** Design Managing Editor; **Wendy Pérez Ríos,** Page Editor; **Juan Carlos Garda,** Editorial Coordinator; **Guillermo Camacho,** Editorial Director; **Lázaro Ríos,** General Editorial Director

Before

After

The Washington Post
Washington, D.C. (A)

Section

JoEllen Murphy, Art Director; **Dennis Brack,** Art Director; **Marty Barrick,** Art Director; **Nancy McKeon,** Sunday Business Editor; **Steven Pearlstein,** Redesign Coordinator; **Michael Keegan,** A.M.E. /News

Before

After

Ta Nea
Athens, Greece (B)

Standing/regularly appearing page

Dimitris Nikas, Art Director

Before

The Plain Dealer
Cleveland, Ohio (A)

Standing/regularly appearing page

David Kordalski, A.M.E./Visuals

After

Before

After

The Plain Dealer
Cleveland, Ohio (A)

Standing/regularly appearing page

David Kordalski, A.M.E./Visuals

Before

After

The Plain Dealer
Cleveland, Ohio (A)

Standing/regularly appearing page

David Kordalski, A.M.E./Visuals

Before

After

Rockford Register Star
Rockford, Ill. (C)

Standing/regularly appearing page

Javier Torres, Art Director/Graphics Editor; **Doug Gass,** A.M.E.; **Jenny Pollock,** Features Editor; **Will Pfeifer,** Assistant Features Editor; **Marty Bach,** Graphics Artist/Designer; **Brian Scott Ching,** Graphics Artist/Designer; **Eloisa Oceguera,** Graphics Artist/Designer

Before

After

Before

The Wall Street Journal
New York, N.Y. (A)

Standing/regularly appearing page

Paul Steiger, M.E.; **Joanne Lipman,** Deputy M.E.; **Melinda Beck,** Editor; **Joe Dizney,** Design Director; **Greg Leeds,** Executive Art Director; **Joe Paschke,** Deputy Design Director; **Liz Shura,** Art Director

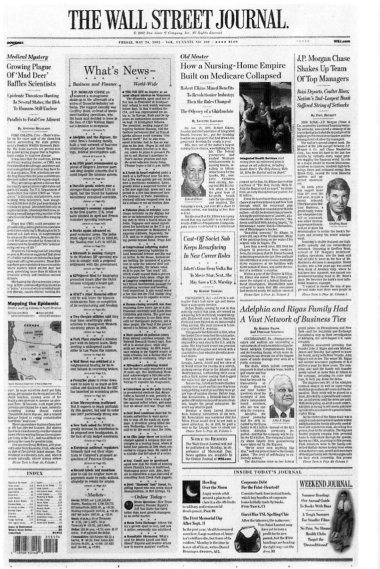

After

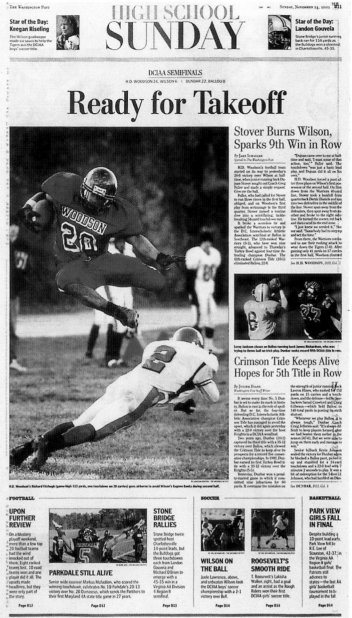

After

The Wall Street Journal
New York, N.Y. (A)

Standing/regularly appearing page

Paul Steiger, M.E.; **Joanne Lipman,** Deputy M.E.;
Mike Miller, Editor; **Joe Dizney,** Design Director;
Greg Leeds, Executive Art Director; **Joe Paschke,**
Associate Design Director; **Jonathan Pillet,** Art
Director; **Carlos Tovar,** Senior News Graphics Editor

Before

Before

The Washington Post
Washington, D.C. (A)

Standing/regularly appearing page

David Murray, Sports Layout Editor; **Scott
Goldman,** Assistant Sports Editor; **High School
Sports Staff** ; **Kevin Clark,** Photographer;
Jonathan Newton, Photographer; **Joel
Richardson,** Photographer; **Ricky Carioti,**
Photographer; **Mark Gail,** Photographer; **Tracy
Woodward,** Photographer

After

The Washington Post
Washington, D.C. (A)

Standing/regularly appearing page

Cheney Gazzam Baltz, Metro Design Editor

Before

After

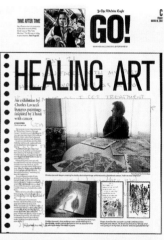

The Wichita Eagle
Wichita, Kan. (B)

Standing/regularly appearing page

Rod Pocowatchit, Designer

Before

The judging
Decisiones de los jueces

> Marshall Matlock, competition committee director and judging director, confers with Denise Reagan, judging assistant.

>> The call for entries announces the competition.

People index

La gente índice

A

Abimerhi, Antonio, 84
Abundis, James, 178
Aburto, Jesús, 80
Acevedo, Mauricio, 77
Ackerman, Peter, 116
Acosta, Edgar, 65
Adams, Elizabeth, 91
Adams, Mark, 174
Adams, Todd, 199
Aggeloussis, Dimitris, 60
Agliano, Kiely, 101
Aguilar, Irma, 85
Aguilar, Victor, 88, 97
Aguillard-Straka, Beth, 100, 226
Aguirre Durán, Karina, 78, 100, 259
Aguirre, Alberto, 137, 144
Åhström, Johan, 114
Aikman, Alex, 209, 218-219
Ainsley, Spencer, 116
Albert, Ursula, 72, 79, 99, 230
Albrecht, Joerg, 89
Alcántara, Yelidá, 50, 88
Alcoba, Natalie, 60
Alemán, Victor, 84
Alexander, Dave, 63
Alfred, K.C., 68
Allegri, Carlo, 163
Allen, Scott, 82
Almanza, René, 71-72, 91, 142, 145
Alonso, Antonio, 37, 242
Als, Roald, 142
Alvadia, Paula, 57
Alvarado, David, 55
Alvarez, Adrián, 58-59
Alvarez, Eduardo M., 149
Alvarez, Lamberto, 140
Alvarus, Fernando, 102
Alvim, 102
Amaya, Daysy, 46
Ambush, Peter, 76, 198
Amieva, Andrés, 63
Amon, Joe, 92
Anaya, Gabriel, 75
Andén, Nina, 99
Anderian, Raffi, 130
Anderson, Dan, 109
Anderson, Scott, 102
Anderson, Steve, 174
Andersson, Johan, 179
Andersson, Jonas, 218
Andrade, Jorge, 58, 88
Andrews, Nancy, 41, 118, 157, 161, 163-164, 167, 174-175, 243
Antillón, Roberto, 100
Apneseth, Oddleiv, 84
Aragon, Alberto, 63, 107
Araya, Rándall, 93
Arce, Carlos, 60
Arevalo, Jorge, 239

Arias, Raúl, 116, 214
Armao, Jo-Ann, 60
Armengol, Joan Carles, 159
Arnold, Alli, 101
Arsenault, Isabelle, 145, 212
Askergren, Jonas, 65, 82
Asplund, Pelle, 75, 99
Asta, Eduardo, 108
Astorga, José Vicente, 67
Ausman, Tom, 51
Avila, Maria J., 113, 164, 242
Avilés del Pino, Rafael, 56
Avilés, Marco, 69
Aycart, Jesús, 42, 64, 93, 111
Aynayaque, Lupe, 77, 97
Azevedo, Ana Lucía, 102
Azurdia, Alejandro, 77, 238

B

Babb, G.W., 55
Baca, Maria, 73, 110
Bach, Marty, 262
Back, John, 72
Badders, David, 135, 140-141, 237
Badeker, Andy, 170
Bailey, Coby, 61
Baires Q., Rodrigo, 63
Baitel, Esaias, 216
Baker, Eric, 242
Baker, Laura, 85
Ball, Tim, 53, 68
Ballantyne, Neil, 68
Ballotts, Ed, 45
Balogh, Dennis, 236
Baltz, Cheney Gazzam, 264
Bannon, Tim, 145
Banuet Guiot, Alejandro, 75, 89
Baptista, Fernando G., 178, 181, 185-186, 188, 242, 245-246
Baquet, Terry, 39
Barata Corrêa, Paulo, 133, 205-206, 217
Barber, Carrie, 102, 136
Barber, Chris, 50, 68
Barbosa, Daniel, 65
Barbotta, Héctor, 67
Barge, Rob, 189
Barnett, Galen, 57
Baron, Joseph E., 62
Barranco, José Manuel, 56
Barreales, Ana, 93
Barrera, Jaime, 45
Barrick, Marty, 259
Barros, José Luis, 47, 64, 66, 84, 105
Barroso, Miguel, 83, 98, 103
Barry, Scott, 42
Bartholomay, Lucy, 42
Bartletti, Don, 154, 167
Baskow, L.E., 150
Batsford, Susan, 60
Batterbury, Sophie, 44, 56, 61, 68, 90

Baulieu, Pierre, 59
Bausmith, Wes, 105
Bautista, Chiara, 74
Bay, Henrik, 88
Bayha, Todd, 119
Bayliss, Kevin, 38, 94, 101, 117, 256
Bayo Rodríguez, Natalio, 133
Bazemore, Betty, 163
Bean, Kerry, 51
Beard, Stephen J., 40, 244
Becerra Gil, Luis Armando, 45, 61
Becerra, Bill, 118
Becerril, Ángel, 205
Bech, Rasmus, 41
Beck, Melinda, 262
Beckerman, Richard, 136
Beckett, Joelle, 90, 192
Begasse, Wayne, 53, 158
Beghtel, Doug, 57
Bejarano, Oscar, 51-52, 57, 67, 86
Belman, Alejandro, 47, 64
Belmán, Gustavo, 46
Belmonte, José, 214, 234
Benítez, José Miguel, 178, 188, 242
Benjamin, Joel, 231
Bennet, Neil, 38, 64, 74
Bennett, Bruce R., 242
Bennett, James, 180
Benschneider, Ben, 112
Benscoter, Cathy, 35, 120
Benwick, Bonnie, 86, 89
Bereswill, Paul J., 157
Bergsbo, Per, 41, 80
Bergstrom, Linda, 94-95, 97
Beriain, David, 186
Berk, Kerwin, 120
Berke, George, 39, 64, 100, 117, 159
Bernal Garza, Nohemí, 71-72, 91
Bernasconi, Pancho, 55, 66, 113
Berri, Luiz, 42
Berteaux, Bryan S., 148
Bertels, Kevin, 115, 125
Bertolotto, Rodrigo, 108
Best, John, 200
Beuno, Rodrigo, 108
Beutelspacher, Alfred, 28
Bianchi, Diego, 105
Bickel, Mark, 116
Bikadoroff, Roxanna, 106
Bin, Stella, 182, 184, 195
Bingham, Maren, 110
Bisher Cullen, Tracey, 229
Bisher, Nanette, 40, 112, 120
Biskup, Agnieszka, 82
Bjork, Michelle, 252
Björkman, Pär, 73-75, 216
Black, JoEllen, 76, 78, 95, 98, 106
Blanco, Jose, 104, 228
Bland, Jeffrey, 89, 93
Blaskovic, Martina, 69
Bloch, Serge, 101, 141

Blow, Charles M., 177
Boch, Benjamin, 48
Bodkin, Tom, 50, 131
Bolin, Chris, 44, 160
Bonde, Ebba, 216
Borda, Juliette, 80
Bordallo, Francisco, 210, 218
Borgman, Tom, 87, 97
Borresen, Jennifer F.A., 134
Bosch, Peter Andrew, 149
Bosler, Clif, 101
Boswell, Mark, 73, 110
Botelho, Silas, 220
Bourély, France, 103
Bousada, Luísa, 44
Boutavant, Marc, 138
Boyd, G. Andrew, 39
Boyd, Teri, 109
Boylan, Desmond, 58
Brack, Dennis, 259
Bradlee, Jr., Ben, 42
Brandon, Alex, 39
Branson, Greg, 148
Braun, Dieter, 83
Bravo, Laura Sánchez, 64
Bravo, Luis, 158
Bray, Jim, 61, 223
Brázio, Augusto, 205-206, 217
Brearley, Adele, 32, 56
Breen, Tanya, 55, 116
Breul, Peter, 43, 48, 66, 86, 89, 103-104, 225
Brewer, Linda, 50
Broadwater, Beth, 52, 69, 109
Brondo, David, 51, 60, 64-65, 70, 83, 88, 98, 103
Bronson, Kevin, 114, 154
Bronstein, Phil, 112
Brown, Alex, 55
Brown, Reid, 57, 108
Browning, David Jack, 39
Browning, Roger, 106
Brud, Ed, 164
Bukh, Katinka, 220
Buño, Natalia, 202-204, 213
Burke, Tim, 62
Burkhart, Richard, 62
Burrows, Alex, 126
Butler, David, 180
Butler, Grant, 168
Bzdek, Vince, 52, 69

C

Caballero, Mabel, 50
Cabiedes, Victor Manuel, 89
Cackowski, David, 60
Caderot, Carmelo, 115-116, 201-208, 211-216, 225-226, 230, 258
Caglage, Evans, 173
Cairney, Joan, 94-95
Calvo, Soledad, 44, 51-52, 57, 67, 69, 86
Calzada, Robert, 55

Camacho, Guillermo, 43, 45, 47, 50, 59, 61, 65, 72, 75, 78, 92, 98, 100, 213, 259
Câmara, Vasco, 76, 93, 96-97, 99
Camhi, Shelley, 113
Camou, Maria, 74
Campbell, Dave, 65
Campo, Iban, 50, 88
Canales, Manuel, 58
Candellero, Javier, 90-91
Cano Rodríguez, José Luis, 133
Canseco, Roberto, 106
Cappillo, Dina, 46
Cárdenas, Gerardo, 62
Cardinale, Carlo, 67-69, 86
Cardo, Horatio, 130
Carignan, Roland-Yves, 102
Carioti, Ricky, 263
Carl, Julie, 60
Carlin, Michelle, 139
Carmine, Scott, 63, 88
Carranza, Israel, 213
Carranza, Mónica, 105
Carrasco, Modesto J., 196
Carrigan, Janelle, 94
Carrilho, André, 30
Carrillo, Guillermo, 66
Carrilo, Ernesto, 67
Carter, Christina, 105
Carvalho, José Carlos, 59
Cases i Associats, 7, 59, 66, 133, 205-206, 217
Casey, Nancy, 238
Cass, Bert, 161
Castagnola, Andy, 56, 94
Castañeda, Roberto, 65, 108
Castellanos, Aida García, 65
Castillo, Jorge, 104, 213
Castillo, Luis, 107
Castro, Humberto, 60
Castro, Ruben, 63
Català, Jordi, 183
Catalán, Nacho, 37, 242
Cato, Christine, 78, 90, 100
Caton, Chuck, 40, 57
Cecala, Frank, 104
Ceja, Paola, 105
Celada, Fidel, 77
Cenicola, Tony, 89
Cepeda, Nelvin, 168
Cercone, Jeff, 72
Cesarino Costa, Paula, 39
Chacón, Rolando, 65
Chaires, Francisco, 60
Chambers, Charles, 48
Chambers, Steve, 110
Chan, Aldo, 109
Chang-ling, Chin, 106
Chapman, Terry, 126
Chappell, Crystal, 70
Charalambidis, Susan, 100
Chauff, Charles, 64
Chavez, Barbara, 64
Chávez, Gil Jesús, 75, 89
Chávez, Miguel Angel, 84
Chen, Yi-Chun, 92

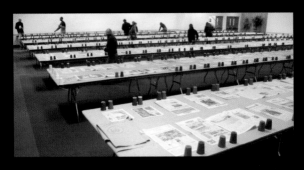

Table after table of entries fills the main hall of Drumlins, the country club that was the site of the competition judging, in Syracuse, N.Y, in February 2003.

Chiappe, Aldo, 184, 193
Chin, Marcos, 137
Ching, Brian Scott, 97, 229, 262
Ching-Huei, Lu, 78, 81, 101, 102
Ching-Ya, Huang, 78
Chou, Constance, 88
Christ, Kirk, 65
Christensen, Steen Kilde, 143
Christiansen, Roar, 84
Christie, Alan, 68
Christie, Jonathan, 221
Chronister, Gregory, 85
Chung, Chris, 148
Churchill, Cam, 88
Clark, Kevin, 263
Clausen, Lisa, 102, 114, 136
Clavero, Cristina, 183
Clement, Gary, 120
Clift, Brad, 240
Clifton, Denise, 42, 109
Clonts, Chris, 50, 57, 164
Clurfeld, Andrea, 116
Coborn, John, 50
Cockburn, Carrie, 176
Cole, Carolyn, 211
Coleman, Nick, 32, 90
Colin, Gianluigi, 67-69, 86
Collins, Kit, 91, 94, 227
Collins, Robert, 59
Colombo, Verónica, 44, 51-52, 57, 67, 69, 86
Colon, Pablo, 109
Colson, Jeff, 136
Concannon, James, 86, 140
Condon Love, Susan, 100
Conlon, Patrick, 48
Conner, Jay, 138
Connolly, James J., 116
Connolly, Mick, 132
Conrad, Fred, 50
Constantine, David, 190
Contreras, Enrique, 46
Contreras, Juan José, 56
Cook, Chuck, 39
Corbel, Alain, 30
Cordle, Stephanie S., 146
Corley, Chuck, 68
Corrêa, Léo, 42
Corstiaensen, Anouk, 112
Cortes, Karen, 50, 88
Corvera, Óscar, 46
Costa Pinto, Luis, 66
Costa, Sérgio, 57-58, 67
Council, Jerald, 154
Courtney, Chris, 40, 58, 63
Coutinho, Isabel, 30-31, 76, 96
Cowan, Lisa, 61
Cowcher, Robin, 132
Cowden, Steve, 195, 238
Crabill, Steve, 110
Craig, Frank, 175
Crawford, Colin, 154
Crawford, Emily, 172
Crespo Freijo, Julia María, 99
Crevier, Glen, 115, 124-125

Croley, Tina, 199
Cronin, Justin, 140
Cronis, Vicki, 57
Cross, Robert, 94
Cross, Todd, 89, 103, 175
Crow, Chuck, 40
Crow, Ted, 95
Cruz Rojas, Alvaro, 104
Cruz, 58, 84, 104, 140, 196
Cruz, Juancho, 196
Cruz, Roberto, 58
Cruz, Victor, 84
Cuadros, Victor, 58
Cuddington, Wayne, 91
Cuesia, Santiago, 178
Culebro, Ulises, 115, 237-238
Cummer, Dean, 102
Cunha Lima, Ricardo, 53
Cunningham, Bill, 109
Cunningham, Cathryn, 97
Curley, John, 112
Currie, Michael, 61
Curry, Dale, 100
Curtis, Dave, 68
Curwen, Randy, 82
Cusick, Kevin, 122-123
Cutler, David, 238
Cuyler, Joele, 172, 174, 208, 212, 220

D
D'Ambrosio, Paul, 116
Dahlström, Karin, 58
Dallal, Thomas, 50
Dalrymple, Laurel, 52
Daniels, Cindy, 82, 226
Dardon, Juan Pablo, 77
Darling, Cary, 88
Darroch, Greg, 54
Das, Andrew, 118
Davidsson, Hannah, 104
Davies, Tristan, 44, 56, 68
Davis, Paul, 136
Davis, Robert A., 54
Dawson, Eric, 100
de Almeida, Moacir, 39
de Coss, Isaac, 46
de Fenoyl, Dianne, 142
de Jesús Fajardo, José, 65
de la Vega, Lola, 93
de la Vega, Miguel, 137, 144
De León, Beatriz, 104, 132
de León, Beatriz, 104, 132
de León, Erick, 77
de Lorenzi, Miguel, 90-91
de los Monteros, Raúl Espinoza, 106
de Lucena, Eleonora, 39, 41
De Luxe & Associates, 6, 55, 78, 100, 105, 114
de Miguel, Manuel, 201, 206, 208, 211-212
de Oliveira, Jair, 108
De Souza, Zuleika, 59
de Tellez, Joanne, 93
de Velasco, Julian, 187
Deacon, K.J., 107, 234

Deal-Zimmerman, Michelle, 6, 86, 119, 124
Dean, Lee Svitak, 98
Dedijek, Miki, 73
Deerin, Chris, 89
Deering, John, 139
DeGroot, Len, 193
Deheza, Emilio, 55, 63, 65, 76, 85, 106, 108, 132, 137, 144, 154
DeJarnette, Danny, 44
del Carmen Navarro, Maria, 93
del Castillo, Ricardo, 65, 108, 137, 144
del Pino, Rafael Avilés, 56
Delesert, Etienne, 120, 141
Delfino, Bruno, 67-69, 86
Delgado Ballesteros, René, 65, 108, 137, 144
DeMocker, Michael, 39
Demusey, Scott, 113
Denney, Dave, 110
Derblom-Andersson, Tiia, 60
Derksen, Bob, 112
Derrington, Leah, 97
Descôteaux, Bernard, 59
Dewairy, Christine, 100, 142
Di Pietro, Adriana, 210-211, 219
Diamond, Judy, 219
Diana, Peter, 158
Dias, Miguel, 58
Díaz de Cerio, Xabier, 58, 63, 69, 77, 82, 88, 97, 104, 145, 147
Diaz, Oswaldo, 66
Dick, David, 38, 64
Diegmueller, Karen, 85
Digilio, Ruben, 195
Dijamco, Kathleen, 116
Dillon, Rosana, 44, 51-52, 57, 67, 69, 86
DiMarzo, Dean, 116, 194
Dinham, Clive, 68
Dishal, Peter, 101
Dizney, Joe, 48, 251, 255, 262-263
do Lago, Edgar, 61
Doe, Kelly, 144
Doirow, Moe, 87, 94, 133, 172
Dombrowski, David, 50, 57, 164
Donaldson, Bob, 172
Döring, Karl-Heinz, 28, 103, 187, 197
Dorsey, Steve, 41, 49-50, 57, 89, 103, 118, 121, 157, 161, 163-164, 167, 174-175, 193, 199, 233, 243
Drew, Michael, 116, 198
Duarte, Cláudio, 128
Dubeux, Ana, 53
Ducassi, Nuri, 72, 88
Duenes, Steven, 50
Dufalla, Anita, 138

Duke, Brett, 39
Dumanli, Ekrem, 56, 254, 257
Dunn, Steven, 123
Duplain, Marc, 74
Durán, Juan, 46, 63, 104, 213
Dusi, Elena, 220
Dye, Christopher, 51
Dzielak, Kathy, 228

E
Earley, Steve, 238, 241
Eccles, Merry, 98
Economopoulos, Aris, 160
Edelson, Mark, 242
Edú Rodriguez, Victor, 47, 66
Edvardsen, Arne, 80, 84, 97, 107
Edwards, Ellen, 116
Edwards, Virginia B., 85
Eguinoa, Aitor, 37, 242
Ek, Lotta, 58, 73-75, 216
Eklund, Scott, 175
Ekström, Sofia, 74
Elder, Erin, 68, 87, 94, 172
Elins, Michael, 173
Elissetche, Juan, 44, 51-52, 57, 67, 69, 86
Elizondo, Ricardo, 154
Elman, Julie, 40, 57, 66
Ely, Bruce, 61
Emery, Francisco Jurado, 44, 51-52, 57, 67, 69, 86
Engström, Guje, 139
Enna, Renée, 98
Enright, Cindy, 244
EPA, 159
Eriksson, Dennis, 88
Eriksson, Inga-Karin, 89
Erisson, Tobias, 116
Errea, Javier, 45, 49, 54, 56, 59, 62-64, 68-69, 98, 105, 107, 249
Escalona, Alejandro, 60, 62
Escobar, Laura, 210-211, 219
Eslava, Javier, 45, 49, 54, 56, 59, 62-64, 68-69, 98, 105, 107, 249
Espinosa de los Monteros, Raul, 104
Espinosa, Leo, 122
Espinosa, Mireya, 75
Espligares, Ana, 42, 64, 93, 111
Esquinca, Barbara, 80, 84
Estevao, Osvaldo, 44, 51-52, 57, 67, 69, 86
Estrada Arce, Lilián, 108
Estrada, Rafa, 196
Estrada, Sergio, 77, 230
Evilla, Josue, 68, 95, 123, 134, 221, 232
Ewan, Julia, 116
Eyestone, Allen, 62, 242

F
Fabris, James A., 40
Fadely, Chuck, 70
Fair, Gloria, 67
Falcão, Pedro, 133, 205-206, 217
Falcón, Alma Cecilia, 76, 132
Faller, Mark, 118
Falsetti, Sandro, 41
Farach Handal, Antonio Enrique, 183
Fararo, Kim, 70
Farley, Catherine, 60, 68
Farr, Bill, 55, 114
Faux, Nichole, 107
Fava, Gigi, 131
Fawcett, Tony, 200
Fazenda, João, 31, 96
Fazenda, Rui, 133
Feigenbaum, Lynn, 86-87, 102, 142
Fenelon, Andy, 68
Feng-mai, Wang, 84, 99
Ferguson, Katie, 219
Ferguson, Susan, 102
Fernandes, José Manuel, 58
Fernandez, Andres, 113
Fernández, Homero, 55
Fernández, Hugo, 99
Fernández, Juan Ignacio, 42
Fernández, Lafitte, 63, 104
Fernandez, Nelson, 246
Ferreira, António Ribeiro, 59, 66
Ferreira, Brian, 63
Ferreira, Juan, 178
Ferrer, Rafael, 37, 242
Fiel, Jorge, 210, 218
Fielder, Carla, 52, 109
Figueiral, Pedro, 210, 218
Figueiredo, Nel, 57-58, 67
Figueroa, Tonatiuh, 45, 59
Fila, Bob, 98, 145, 170, 218
Filho, Melchiades, 41, 108
Finkelstein, Jim, 57
Finley, Denis, 40, 57, 66
Fisher, Gail, 154
Fisher, Kathryn, 88
Flanagan, Lendon, 212
Fleming, John, 193
Flores, Andrea, 84
Foley, Steve, 114
Forbes, Melinda, 101
Formoso, Chelo Banal, 100
Fotomafia, 208-209, 217
Fox, Wendy, 80, 101
Francis, Jamie, 127
Frank, Rickard, 69, 104, 116
Frank, Tim, 88, 92
Franquet, Sarah, 62
Frantz, Kate, 88
Frazier, Craig, 120
Frazier, David, 106
Frederick, George, 76, 110, 198
Frederick, Sara, 88
Freeland, Alexandre, 57-58, 67
Friedmann, Jane, 73, 110

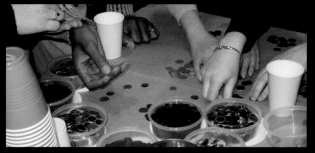

<< Assistants sort the thousands of chips for another round.

< Andrew Garcia Phillips, the 24th-edition coordinator.

Friesen, Mark, 57
Friis, Jesper, 88, 91
Froelich, Janet, 132, 171-174, 204, 207-208, 212, 220
Fuente, Teresa, 65, 67
Fuhrmans, Christoph, 121, 193
Furno, Richard, 194

G

Gail, Mark, 263
Gallegos, Erick, 58
Galvan, Severiano, 244
Gamero, Juvenal, 58
Gámez Kindelán, Carlos, 176, 179, 185, 188, 197
Gámez, José Juan, 187, 209
Gamez, José Juan, 207
García Lugo, Leopoldo, 59
García Macías, Mikel, 42, 64, 111
García Rivera, Cristina, 176, 179, 185, 188, 197
García Rodríguez, Edgar, 72
Garcia, Adrianna, 39, 117
García, Ana Patricia, 60
García, Dórica, 84, 105
García, Francisco, 70, 88
García, Galia, 45
Garcia, Magdalena I., 60
Garcia, Pablo, 178, 239
García, Pedro, 67
García, Wendy, 77
García-Travesí, Karime, 80
Garda, Juan Carlos, 50, 72, 75, 78, 92, 98, 100, 213, 259
Garduño, Karla, 72, 92
Garrison, Ron, 50
Garrote, Aurelio, 42, 64, 93, 111
Garza, Ricardo, 47, 62, 64
Garza, Viviana, 60
Gascon, Daymond, 56, 94
Gaspard, Bill, 44, 154
Gass, Doug, 262
Gastaldo, Claudia, 235
Gaudêncio, Rui, 96
Gaumer, Thomas, 189
Gawenda, Michael, 55
Gazzola, Franca, 67-69, 86
Geiger, John, 114, 120
Gensheimer, Jim, 68
Gentile, Massimo, 39, 41, 108
George-Palilonis, Jennifer, 121
Giase, Rick, 113
Gibson, George, 97
Gil, Isidro, 54, 68-69
Gil, Jesus, 69, 186, 191
Gil, Luis Armando Becerra, 45, 61
Gilbert, Susan, 52, 151-152
Gillo, Marco, 67-69, 86
Gittlesohn, John, 109
Gjerde, Anne, 107
Glendenning, Jeff, 220
Glick, Jeff, 87, 110

Glynn, Matthew, 32
Godtfredsen, Carsten, 41
Gogick, John, 91
Goldman, Scott, 256, 263
Gómez, Francisco, 65
Gonzáles, Mario, 104
Gonzales, Paul, 114
González Morales, José Juan, 65
González, Alejandro, 105
Gonzalez, Carlos Avila, 158
Gonzalez, Eduardo, 60
González, Fernando, 67, 93
González, Jesús, 45
Gonzalez, Julian H., 118, 157, 243
González, Laura Cristina, 65
González, Manuel, 56, 65
González, María, 202-205, 207, 213-216
González, Mariangel, 187
Gonzalez, Renata, 65
Gonzalez, Rodolfo, 169
González, Xoang, 69
Göransson, Göte, 216
Gordon, Mary, 60
Görman, Calle, 88
Gormus, Mark, 175
Gorski, Pete, 71, 88
Gottschalk, Angela, 68
Graalheim, Sophie, 89
Graf, Mat, 256
Grajeda, José Francisco, 47, 58-60, 62, 64
Gram, Marianne, 78, 90, 100
Grañena, Luis, 105, 236
Grayson, Mark, 89
Greene, Jeff, 40, 153
Grice, Samantha, 142
Griffis, Lisa, 57, 98, 100, 108, 147, 153
Grimmer, Steve, 103
Grin, Gayle, 44, 50, 54, 57, 61, 67, 69, 102, 111, 114, 120, 142, 160, 163, 223
Grinbergs, Linda, 110
Groenhout, Chris, 200
Gröndahl, Mika, 191
Gross, Brian, 61, 68, 118
Grossman, Eduardo, 182
Grunfeld, David, 39, 159
Guadarrama, Acelia, 59
Guerra, Kido, 91
Guerrero, Ignacio, 154
Guerrero, Tadeo, 59, 63, 93
Guersch, Mike, 68
Guevara, Angel, 47
Gugliotta, Bill, 6-7, 40, 57, 108, 153
Guillén, Toni, 190
Guimarães, Jorge, 30, 96
Guldan, Dale, 124
Gunter, Joshua, 57, 108
Gurbani, Roger, 211
Gustafsson, Kristofer, 116
Gutierrez, Barry, 152, 167
Gutiérrez, Leticia, 108

Gutiérrez, Mauricio, 89, 103, 118, 175, 199

H

Haag, Jim, 57
Haar, Dan, 54
Hacker, Gabriel, 156
Hadar, Mary, 116
Haddix, Carol, 98, 170
Haliechuk, Rick, 48
Hall, Michael, 123
Halleraker, Marvin, 107
Halley, Jim, 199
Hallstrom, John, 104
Hällström, John, 218
Hamann, Amanda, 100, 147
Hamersly, Kendall, 88
Hamill, Blair, 244
Hamilton, Robert K., 124
Hamilton, Rolf, 66
Hancock, John, 62
Hank, Rainer, 48
Hannich, Thomas, 207
Hansen, John, 166
Hansen, Paul, 58
Hansen, Søren-Mikael, 41
Hanus, Nancy, 94
Harden, Tine, 78, 90
Hardy, Kerry, 94
Haring, Scott J., 124
Harker, Laurie, 102
Harmel, Greg, 42
Haro, Erika, 61
Harris, Nancy, 204, 220
Harrison, Kenny, 64, 100
Harriston, Keith, 60
Hartsell, Mark, 124
Hartz, Marianne, 86
Hau, Helena, 50
Hayt, Teri, 74, 150
Healy, Ryan, 56, 94
Heaslip, Steve, 166
Heath, Sally, 74, 132
Heidebrecht, Andreas, 94
Heinz, Tom, 145
Heisler, Todd, 113
Helf, Bob, 124
Heller, Scott, 94-95
Heller, Steven, 134, 138, 142, 145, 232
Hendricks, Jon L., 90
Henriques, Mário, 66
Henriquez, Hiram, 88
Henry, Sharon, 192
Hensley, Roger, 87, 97
Herman, Michael, 69
Hermans, Birgitta, 112
Hermoso, Gustavo, 37, 242
Hernández Garcia, Gaspar Enrique, 71
Hernández, Alfredo, 46
Hernández, Rubén, 85
Herrera, Bertha, 85
Herrera, Osmín, 63
Heumann, Thomas, 28, 103, 187, 197
Hewitson, Jennifer, 98, 128
Hidlay, Skip, 59
Hiebert, Wayne, 94
Higgins, Damon, 242
Higgins, Mike, 56, 61

Hildebrandt, Edel, 78, 90, 100
Hill, Angela, 117
Hill, Chris, 94
Hill, Joannah, 95
Hilliman, Joseph, 90, 94, 101, 235
Hilston, James, 186
Hippertt, André, 42, 44, 57-58, 67
Hjerpé, Mikael, 103
Hlavaty, Laurie, 116
Ho, David, 143
Ho, Hui-Tse, 92
Hoeg, Joergen, 74
Hoelstad, Peter, 90
Höglund, Anne-Marie, 74
Holahan, Michael, 91
Holck, Poul, 134
Holm, Lotta, 73, 101
Holmquist, Beata, 89
Holtgreve, Alfons, 86
Honeywell, Rodrigo, 55, 113
Hopper, Susie Eaton, 73, 110
Horn, Anja, 103
Horner, R. Scott, 193
Hossain, Farhana, 195
Howitt, Keith, 32, 44, 56, 68, 90
Howlett, Kathleen M.G., 84
Høyland, Elin, 93
Hsu, June, 92
Hsu, Kevin, 88
Hubbard, Tim, 114
Hughes, Brian, 48
Humphrey, Eustacio, 153
Hundley, Sam, 86-87, 102, 130, 142, 233-234
Hutchinson, Joe, 105, 114, 258
Hvidsten, Mark, 124-125

I

Ibargüen, Alberto, 149
Ibarra, Carlos, 61
Igartua, Pacho, 42, 64, 93, 111
Ilic, Mirko, 131
Ilsøe, Christian, 88, 91
Inden, Matt, 150
Ingram, Bill, 242
Ingrassia, Larry, 255
Ingvaldsson, Barbro, 179
Iñiguez, Lorena, 6-7, 154
Innerst, Stacy, 95, 141, 186
Innes, Claire, 143
Ireland, John, 58
Islas, Alejandro, 154

J

Jackson, Lance, 234
Jackson, Ted, 160, 165
Jacob, Helena, 220
Jacobs, Susan, 192
Jacobsen, Henrik, 80
James, Brian, 113, 117
Janela, Nuno, 133, 217
Januszewski, Zygmunt, 106

Jarnestad, Johan, 179
Jarzomb, Leo, 146
Jaskol, Ellen, 162, 166
Jaspan, Andrew, 74
Jauregui Barrientos, Jorge, 63
Jauregui, Fernando, 50, 72, 75, 78, 92, 98, 100, 213, 259
Jeffords, Brandon, 90
Jenkins, Anthony, 131
Jennings, Mary, 95
Jensen, Mai-Britt Bernt, 88
Jensen, Thorgerd Broni, 105, 143
Jensen, Walter, 80, 84, 97, 107
Jiménez, David, 59
Jiménez, Jhonny, 88
Jiménez, Marcos, 187
Jiménez, Rodolfo, 59
Jindra, Christine, 57
Joelsson, Bo, 102
Johansson, Martin, 58
Johansson, Pelle, 60
Johnson, Cort, 93
Johnson, Jenny, 27
Johnson, Jerry, 87, 133
Johnson, Kerry, 175
Johnson, Taylor, 55
Johnston, Skip, 44, 60
Jolley, Cecelia, 57
Jorge, Carlos, 66
Jouflas, Susan, 79, 131, 235
Joyce, Denise, 143
Judge, Jay, 86, 119, 124
Junco, Victor, 101
Jurado Emery, Francisco, 44, 51-52, 57, 67, 69, 86
Juravich, Diane, 95, 138
Juste, Carl, 149

K

Kalman, Maira, 132
Kandler, Ricardo, 58
Kandt, Rob, 256
Kaplan, John, 166
Karaian, Jim, 180, 196
Karas, Jason, 45
Karklis, Laris, 196
Karlsson, Anne-Li, 132
Karnopp, Kris, 90
Katsuda, Miyoshi, 66, 91
Katz, Stephen M., 148
Kaufhold, Marcus, 48
Keegan, Michael, 60, 116, 198, 259
Keener, J. Kyle, 49-50, 161, 163-164, 167, 174-175, 240, 243
Keister, Kevin, 166
Kellams, Michael, 62-63, 106, 136, 141, 170
Keller, Martina, 187
Keller, Tony, 219
Kelso, Karen, 109
Kempton, Dan, 178
Kenner, Herschel, 57
Kenney, Kirk, 68
Kepka, Mike, 40
Kettlewell, Vickie, 148
Kihlander, Jonas, 218

> Watching the judging are Matt Mansfield, SND's publications director, and Jonathon Berlin, Update newsletter editor.

>> Judge Ann McGettigan studies an entry before voting.

Kilpatrick, Jeff, 200
King, Brennan, 62, 142
King, Nick, 137, 218, 231
King, Phil, 68
Kinnari, Ari, 92
Kirby, Joe, 97
Kircher, Lukas, 28
Kjerrumgaard, Henrik, 220
Klee, Gregory, 86, 94, 140, 223
Klein Bros., 104
Kliendienst, Tim, 224
Klinke, Angela, 220
Knegtel, Fons, 112
Kobayashi, Alicia, 104, 132
Koch, Finn, 74
Kochaniec, Jr., George, 146, 242
Komives, Stephen, 62
Koot, Laura, 44, 54, 67, 69, 102, 223
Kopun, Charlie, 111
Kordalski, David, 40, 54, 57, 87, 89, 100, 108, 134, 147, 153, 189, 195, 233, 260-261
Kourtis, Ioannis, 60
Kover, Becky, 119, 122
Kowalewski, Alicia, 100, 142
Kowalski, Janice, 94
Krakel, Dean, 113, 150, 242
Kramer, Patrick, 107
Kraus, Jerelle, 145
Krauss, Orlie, 120, 122, 128, 141, 222
Kriegsman, Teresa, 70
Ku, Becky, 92
Kuczala, John, 222
Kumata, Michelle, 138
Kuntz, John, 54, 156, 162, 168
Kunz, Anita, 133
Kuther, Andreas, 43, 48, 66, 86, 89, 103-104
Ku-ying, Tung, 78, 81, 84, 99, 101-102, 106
Kuykendall, Jim, 48, 98, 104
Kwon, Christine, 228

L
Lacombe, Brigitte, 174
Ladd, Scott, 256
Lancaster, Craig, 68
Landa, Regina, 85
Lane, David, 242
Lanuza, Joan, 63
Lapierre, Louis, 59
Larios, Rodolfo, 91
Larsson Meyer, Lena, 179
Lauer, Ralph, 175
Laughlin, Michael, 46
Laughlin, Nancy, 57, 243
Lawrence, Mary Ann, 52, 151
Lázaro, João, 76
Lazcano, Hugo, 76
Lazo, Orlando, 58
Leal, Lorena, 64
Lebowitz, Becky, 242

Leeds, Greg, 6-7, 120, 122, 128, 141, 222, 251, 255, 262-263
Leigh, Anne, 50, 113
Leite, Adi, 220
Leiva, Jose, 92
Lemus, Erick, 213
Leon, Gustavo, 84
León, Vicente, 51, 60, 64-65, 70, 83, 88, 98, 103
Leone, Steve, 58
Leturia, Elio, 89, 103
Leung, Lewis, 101
Levin, Susan, 140
Levy, Andrea, 87, 89, 147, 173
Lewis, Scott, 162
Lewton, Jason, 92
Libetti, Thomas, 95, 144
Libreros-Purcell, Adriana, 116, 228
Life, Nikki, 90
Lillash, Richard, 119
Lim, Stephanie Grace, 106, 227
Lima, Daniel, 144
Lind, Henriette, 220
Lindkvist, Jonas, 156
Lino, 129, 143
Lipman, Joanne, 251, 255, 262-263
Little, Tom, 89
Livingston, Elaine, 94, 221
Lizárraga, Manuel, 66
Lo Valvo, Gustavo, 210-211, 219
Lobato, Xurxo, 69
Lobo, Francisco, 96
Londero, Jorge, 90-91
Long, Traci, 62
Longoni, Eduardo, 210-211, 219
López Aquirre, Eliseo, 75, 89
López, Ernesto, 63
López, Eva, 224
López, Javier, 65-67
Lopez, Juan, 88
López, Julio, 184
López, Leticia, 108
López, Lourdes, 106
Loprete, Renata, 39
Lorén Berdusán, Santiago, 133
Loscri, Pablo, 182, 184, 188, 190, 192-195, 198, 240, 243, 246-247
Lourenço, Gil, 58
Löwstedt, Staffan, 160
Lucas, Andrew, 244
Lucero, Felipe, 45, 47, 61
Lucia, Ellis, 117
Lui, John, 125
Lukens, Victoria, 221
Lum, Fred, 68, 172
Lund, Rick, 68, 112
Luther, Mei Lisa, 168
Lutz, Rosa María, 43, 59
Lux, Daniel, 77, 246
Luxenberg, Steven, 86, 89
Lyle, Carrie, 90

Lyttle, Kirk, 122-123
Lyttle, Melissa, 110

M
Maartinez, Rubén, 61
Macias, Eddie, 142, 145
Macias, Mikel Garcia, 93
MacMullin, Donna, 114
MacPhee, Donald, 89
Madeira, Miguel, 96
Madigan, Charles M., 86
Magalhaes, Chica, 91
Magerl, Chris, 199
Magistà, Aurelio, 220
Magnusson, Ylva, 90, 99
Magree, Dan, 200
Maher, Fran, 97
Maia, Vanina, 220
Malik, Asmaa, 68
Malok, Andre, 109-110, 245
Maloney, Brenna, 181
Mangelsdorf, Tyson, 238
Mangs, Giannie, 93
Manifold, Greg, 68
Mann, Ron, 112
Mansfield, Matt, 57, 70, 158, 256
Mar, Rod, 68, 112
Marañon, Rafael, 64, 93, 111
Marcelo, Carlos, 59
Marcos, Diana, 80, 84
Marín, Celia, 85
Mariño, Manuela, 191
Marinucci, Steve, 106
Márquez, Agustin, 154
Márquez, Ramón, 65
Marra, Fabio, 39, 41, 108
Marroquin, Gonzalo, 93
Marsh, Bill, 180
Marsh, Tony, 89
Marshall, Alan, 68
Marshall, Ken, 40, 57, 108, 189, 195
Marshall, Richard, 174
Martel, Claude, 173, 204, 212, 220
Martín Hervás, Antonio, 187
Martin, Jane, 95, 143-144
Martínez, Ángel, 50
Martínez, Carlos A., 71-72, 91
Martínez, Claudio, 63
Martínez, Georgina, 65
Martinez, Jorge, 178
Martínez, Mauricio, 46, 65
Martinez, Ricardo, 214
Martos, Victoria, 239
Marturello, Mark, 118, 143
Mast, Suzy, 70
Matia, Chema, 196
Mattisson, Birgitta, 61, 69
Mattone, Andrea, 220
Mattos, John, 119
Mattsson, Jonny, 79
Mauri, Vanessa, 63
Mauter, Larry, 57
Maxwell, Robert, 171
Mayer III, Emmett, 117
Mayer, Robert, 110

Mazzola, Randy, 180
McAllister, Steve, 68
McAndrews, Michael, 63, 106
McAuley, Lynn, 91, 94, 102
McBride, Cliff, 158
McCarthy, Heather, 71, 88
McClard, Gerald, 168
McClure, Liz, 42, 68
McCubbin, Pat, 87
McGuire, Thom, 48, 63, 104, 123, 218, 221
McIntosh, Jean, 100
McIntyre, Elizabeth, 100
McKay, Jane, 221
McKay, Thomas, 244
McKean, Angela, 219
McKean, Jason, 62, 82, 109-110
McKenzie, Rob, 44, 54, 67, 223
McKeon, Nancy, 259
McKinstry, Steve, 195, 238
McKoy, Kirk, 168
McLaughlin, Joan, 196
McLaughlin, Paula, 94, 102
McLellen, John, 89
McNichols, Moira, 62
McNulty, William, 180, 183, 188, 191-192
McParland, Kelly, 67, 223
McPhee, Lina, 219
McQuaid, Lisa, 204
Medema, Randy, 58
Medina, Christian, 56
Medrano, Cristina, 65
Mejia, Dennys, 93
Mejía, Francisco, 46
Meléndez, Jorge, 51, 60, 64-65, 70, 83, 88, 98, 103
Melgar, Billy, 77
Mellichamp, Jennifer, 87
Mellon, Steve, 164
Melvin, Andy, 219
Melvin, Jim, 61
Menacho, Ines, 147
Mendoza, Carlos, 51, 65, 70, 83, 88, 103
Mendoza, José Manuel, 63, 65, 132
Mercante, Marcio, 58
Merino, José Luis, 138
Merino, José, 6, 8, 74, 138
Mertins, Lisa, 64, 90
Mervis, Scott, 95
Mestre, Guillermo, 59, 98
Metzger, Pete, 114
Metzker, Gary, 65
Meurice, Steve, 44, 54, 67, 69, 223
Meyers, Gene, 243
Meza, Erik, 60

Micheletti, Enza, 102
Millener, George, 58
Miller, Andrea Smith, 52
Miller, David, 68
Miller, Joanne, 51
Miller, Mike, 263
Miller, Robert, 166
Millhouse, Elissa, 56, 68, 90, 201
Millikin, Eric, 45
Minczeski, Pat, 255
Miner, Michael, 86, 97-98, 106, 130, 222
Mingora, Kevin, 152
Mingueza, Javier, 111
Minister, Scott, 119, 122
Minondo, Jose Luis, 45, 49, 54, 56, 59, 62-64, 68-69, 98, 105, 107, 249
Miranda, Adriano, 30
Miranda, Magdalena, 99
Miranda, Randy, 73, 110
Misthos, Toni, 116, 136
Mizraji, Paula, 210-211, 219
Molen, Jan, 102, 136
Mollering, David, 139
Moncín, Carlos, 45, 49, 63, 69
Monsalve, Xavier, 200, 202
Montauk, Tracy, 63, 73, 107
Monteiro, Henrique, 210, 218
Monteith, Kenny, 60, 116
Monterrosa, Rolando, 104
Montes de Oca, Ernesto, 137, 144
Montesino, David F., 43, 58
Montgomery, Robb, 54
Moon, Jason, 256
Moonen, An, 114
Moore, Chris, 42, 71, 78, 98, 106, 226
Mora, Miquel, 44
Moral, Gerardo, 190
Morales, Ferran, 44
Morales, Jose Antonio, 63
Moreira, Walter, 102
Morel, Gerardo, 194
Moreno, Jonathan, 244
Morgado, Mariana, 65-66
Morgan, Devon, 244
Morgan, Kathleen, 221
Morgan, Paul, 107
Morris, Don, 61, 127
Morrison, Laura, 57
Morrissey, Mark, 104
Morrow, Sue, 113, 166
Morton, Neil, 56
Moschella, Nick, 62
Mosqueda, Carlos, 45
Mota, Jorge Luis, 60
Moyer, Bruce, 123, 221
Moyer, Suzette, 40, 42, 63, 76, 82, 94, 98, 106
Muhs, Angie, 58
Muller, Ingrid, 40, 42, 76, 94
Munar, Nosh, 123
Mundet Poch, Rosa, 200, 202
Muñoz, David, 62

<< Stacks of cups await the next round.

< Judges Lawrence Mason, Tom Penix and Mark Thompson-Kolar work in the small-newspaper and photography divisions.

Muñoz, Emilio, 47
Muñoz, Julio César, 59, 83
Munro, Gavin, 89
Murakami Rios Velasco, Ileana, 65
Murphy, JoEllen, 259
Murphy, Robin, 192
Murray, David, 263
Murray, Ed, 104
Myers, Gene, 41, 118, 121, 193
Myller, Corinne, 33, 89, 113

N

Naftolin, Lisa, 171, 207
Nagore, Guillermo, 56, 98, 105, 107, 249
Nájera, Alejo, 47, 64, 66, 84, 105
Nakamura, Motoya, 168
Nascimento, Antonio, 61, 65-66
Nassar, Angeles, 80, 84
Nathanson, Mel, 166
Nava, Alberto, 47, 64, 66, 84, 105
Nava, Angel, 37, 242
Navarro, María del Carmen, 42, 64, 111
Negreiros, José, 53, 66
Nejme, Roberto, 220
Nelson, Eric, 68
Nelson, Fred, 68
Nelson, Hulda, 40, 112, 120
Nelson, John, 27
Nelson, Paul, 40, 66
Neumann, Jeff, 76-77
Neustaedter, Carl, 68, 198
Newland, Martin, 44, 54, 67, 69, 223
Newman, Craig, 62
Newton, Jonathan, 263
Ngoc Ho, Rick, 97
Nguyen, Peter, 90, 97
Niebergal, Rachel, 100
Nikas, Dimitris, 60, 260
Nilson, Maria, 61, 69
Noblat, Ricardo, 66
Nocito, José Luis, 64
Nordström, Jacob, 252
Notarianni, Julie, 99
Nowlin, Mark, 68, 112
Nozolino, Paulo, 96
Nuñez, Alonso, 145
Nuño, Daniela, 50, 98
Nutt, Amy, 109
Nyeland, Søren, 41, 78, 80, 88, 90-91, 100, 220
Nyvang, Annette, 78, 90, 100

O

O'Boyle, John, 109
O'Byrne, James, 100
O'Connell, Frank, 245
O'Connor, Gavan, 55
O'Keefe, David, 138
O'Neill, Annie, 146
Öberg, Johnny, 179

Oberneder, Doris, 28, 103, 187, 197
Obregón, Jorge, 47, 62, 64
Oceguera, Eloisa, 262
Ochoa, Rui, 210, 218
Oleniuk, Lucas, 171
Olmos, Raúl, 59, 83
Olson, Sheree-Lee, 94
Olsson, Roger, 100
Omori, Dale, 40, 153, 241
Onandia, Losu, 42
Ondarra, Tomás, 37, 242
Orea, Felix, 62
Orellana, Manuel, 104
Orfanopoulos, Mike, 175
Ortín, Antonio, 93
Ortiz, Christian, 59
Ortiz, Enrique, 61
Ortíz, Gabriel, 65
Oshin, Nan, 211
Osler, Mark, 113
Osorio, Porfirio, 104
Ostalé, Pilar, 45, 49, 54, 56, 59, 62-64, 68-69, 98, 105, 107, 249
Østergren, Thomas, 100
Ottosson, Lasse, 61, 69
Owens, Nate, 62
Öztürk, Kerem, 254
Ozturk, Kerem, 56, 257

P

Padilla, Jorge, 43, 59
Page, Clif, 35, 101, 120
Palacios, Iñaki, 44, 51-52, 57, 67, 69, 86, 105, 182, 184, 188, 190, 192-195, 198, 210-211, 219, 240, 243, 246-247
Pälivärinta, Jukka, 92
Palla, Chaz, 175
Palmer, Ally, 250, 254
Palmer, Richard, 68
Palomo, Bella, 67, 93
Paniagua, Roberto, 154
Panzenhagen, Tom, 121
Papasian, John, 89
Paquin, Denis, 44, 54, 67, 69, 111, 160, 163, 223
Parker, Doug, 39, 117, 148, 159-160, 165
Parry, Dale, 199
Parson, Kim, 42, 50
Pascale, Neil, 56
Paschke, Joe, 251, 255, 262-263
Paslay, Jeff, 68, 112
Pasternak, Mike, 68
Patel, Shyam, 70
Paterson, Grant, 219
Paterson, Hugh, 102
Payne, Liz, 91, 94
Pearlstein, Steven, 259
Pedreda, Maria, 69
Peetre, Benjamin, 112
Pei-feng, Lu, 102
Peiter, Hans-Michael, 187
Peltersson, Dick, 60
Peña, Cecilia, 144
Peñalba, Emilia, 207, 209
Penman, Stephen, 38

Pérez de Rozas, Emilio, 159
Pérez Errea, Ana, 45, 49, 54, 56, 59, 62-64, 68-69, 98, 105, 107, 249
Pérez Rios, Wendy, 78, 100
Pérez, Antonio, 60, 62
Pérez, Fabiola, 64, 83, 103
Pérez, Gonzálo, 55
Pérez, Olín Augusto, 59
Perry, Helayne, 81
Petek, Barb, 60
Peterson, Brian, 148
Pettersen, Scott, 143
Petty, Matt, 40, 112, 120, 222
Peyton, Tom, 6, 8, 46, 72, 87, 110, 122
Pfeifer, Will, 97, 262
Philippidis, Evangelia, 131
Phillips, Andrew Garcia, 113, 191
Phillips, Kent, 57
Piedra, Laura, 42, 64, 93, 111
Pike, Catherine, 48, 60, 68-69
Pilgrim, Mike, 109
Pillet, Jonathan, 263
Pilone, Sergio, 67-69, 86
Pinkela, Eric, 158
Pinkney, Matt, 101
Pinto, Hugo, 30, 76, 96-97, 99
Pipe, Simon, 115
Pirrón, Ivan, 64
Piscotty, Marc, 155, 242
Pisetzner, Joel, 109
Pitts, Patty, 64
Pliske, Bill, 141
Plonka, Brian, 27, 238
Plonka, Kathy, 154
Plunkert, Dave, 106
Pocowatchit, Rod, 97, 264
Podesta, Gonzalo, 58
Pollock, Jenny, 97, 262
Poole, Lisa, 150
Pope, Rich, 140
Port, Andy, 132
Portaz, Jorge, 182, 184, 188, 192, 194, 198
Portela, Bruno, 210
Porter, Aaron, 139
Porter, Angela, 110
Porter, Craig, 157, 161, 163-164, 167, 174-175, 243
Porter, Cristina, 84
Porter, Kent, 150
Porter, Tracy, 90, 130
Potter Drury, Christian, 82, 97, 113
Powell, Cory, 51, 57, 115, 122, 152
Power, Peter, 69, 154-155, 162, 170
Powers, Colin, 60
Prast, Rhonda, 73, 98, 110
Pratt, David, 68, 87, 94, 129, 131, 133, 143, 172, 176
Preece, Gordon, 59

Prendimano, Andrew, 46, 104, 116, 122, 136, 228
Prichard, James W., 85
Priddy, Ralph D., 146
Probst, Alexander, 63
Pröckl, Eddie, 65, 82
Prowe, Marcia, 109
Pucci, Rino, 67-69, 86
Pudenz, Martin, 66
Pulido, Omar, 45
Pullen, Zachary, 145
Pybas, David, 251, 255
Pyle, Chuck, 110
Python, Tifenn, 141

Q

Quennerstedt, Magnus, 66
Quillen, Kim, 64
Quinn, John, 55
Quinn, Sara, 134, 161, 204
Quintana, Enrique, 65
Quintana, Hugo, 93
Quintiero, Victoria, 44, 69
Quon, Jody, 220
Qvarnström, Daniel, 75, 90, 101, 114

R

Racovali, John, 54, 69
Rainey, Matt, 160
Ralha, Ivone, 31, 93, 96, 99
Ramberg, Anders, 124
Ramírez Santillán, Jorge Alberto, 108
Ramirez, Antonio, 93
Ramírez, Héctor, 63
Ramírez, Nelly, 59
Ramos, Patricia, 65, 70, 88
Randall, Lee, 219
Rangel, Mauricio, 43, 59, 65
Rasmussen, Tim, 63
Ravenscraft, Stephen, 106, 130, 136, 141
Raymond, Amanda, 90
Reagan, Denise M., 73, 110
Reck, Timothy, 42, 48, 62
Redniss, Lauren, 142
Reed, Rochelle, 94
Rees, Petra, 115
Reeves, Janet, 46, 113, 117, 242
Reid, Paulina Garces, 87
Reksten, Patty, 57, 61
René, Carlos, 66
Resendes, Mário Bettencourt, 59, 66, 133, 144, 205-206, 208-210, 216-217
Reuters, 58, 65-66, 159
Reyes, Gary, 68
Reyes, Guillermo, 71-72, 80, 84, 91
Reyes, Jorge, 46
Reyes, Miguel Ángel, 89
Reyna Yupanqui, Rolly, 63
Rhodes, John, 72, 87
Rhyner, Ellie, 132
Ribeirinho, José Maria, 59, 66, 133, 144, 205-206, 208-210, 216-217

Ribero, Mestre, 210, 218
Rice, Steve, 125
Rice, William, 170
Richards, Roger, 40
Richardson, Joel, 263
Riche, Epha, 42, 50, 58, 256
Richer, Barbara, 83
Richer, Jules, 59
Rios, Gladys, 169
Ríos, Lázaro, 43, 45, 47, 50, 59, 61, 65, 72, 75, 78, 92, 98, 100, 213, 259
Riser, Catherine, 92, 228
Ritter, Denise, 40
Ritter, Jon, 140
Roberts, Carolyn, 32, 44, 56, 61, 68, 90, 201, 232
Roberts, Randall K., 46, 113, 117, 242
Robin, Laura, 94
Robinson, Dave, 41, 118
Robinson, Walter V., 42
Rocha, Michael, 64
Rochette, Jennifer, 88
Rodas, Esteban, 46
Rodríguez, Jorge, 64
Rodríguez, Luis Enrique, 45
Rodríguez, Remberto, 46
Rojas, Luis Roberto, 58, 93
Rokicki, Rich, 193
Rolo Duarte, Pedro, 133, 205-206, 217
Romero Tortosa, Manuel, 176, 179, 185, 188, 197
Romero, Nacho, 187
Rosander, Albert, 86, 102
Rosén, Hans, 57
Rosenhouse, Sharon, 110
Ross, Daniel, 91
Ross, Genevieve, 241
Ross, James A., 100
Ross, Rachel, 48
Rothmaier, Stefan, 179, 182
Royo Romeo, Enrique, 133
Ruas, Henrique, 205
Rubio, Marlone, 100
Ruis, Thomas, 67
Ruiz Carrera, Sergio Alberto, 108
Ruiz Garrido, José María, 56
Ruiz, José Juan, 67
Ruiz, Pablo, 105
Ruiz, Rafael, 67, 93
Ruiz, Viviana, 93
Ruscitti, Joe, 60
Russell, Bill, 235
Russell, Fiona, 94
Russell, Jack, 51
Russell, Richard, 117
Russell, Sharon, 109
Russell, Steve, 198
Rutberg, Ingela, 104
Rutherhagen, Johan, 88-89, 93
Rutz, Dean, 68
Ryall, Zach, 156, 169
Ryan, Andrew, 74
Ryan, Dominic, 94
Ryan, Greg, 87

Ryan, Kathy, 171-172, 174, 204, 207-208, 212, 220
Ryan, Susan, 86

S

Sætternissen, Peter, 91
St. Angelo, Bill, 67
Sáinz, Carolina, 84
Saiz, Jose Carlos, 115-116
Salas, Eugenio, 78
Salavera Moreno, Eduardo, 133
Salazar, Arturo Adrián, 98
Saldaña, Esteban, 132
Sale, John, 27, 154
Salem, Verónica, 69
Sales, Fabio, 53, 59, 66, 91
Salomone, Pablo, 213
Salvador, Cristina, 45, 49, 54, 56, 59, 62-64, 68-69, 98, 105, 107, 249
Salvia, Stefano, 67-69, 86
Sánchez Ruano, Francisco, 67, 93
Sánchez, Arturo, 154
Sánchez, Graciela, 84
Sánchez, Héctor, 60, 62
Sánchez, Hugo A., 64, 66
Sanchez, Jeanette, 99
Sánchez, Juan Manuel, 60
Sánchez, Laura, 51, 64
Sanchez, Monica, 58
Sánchez, Rodrigo, 202-205, 207, 213-216, 224, 229, 231-232
Sanchez, Rodrigo, 229
Sanders, David, 150
Sansfaçon, Jean-Robert, 59
Santacruz, Beatriz, 196
Santamarina, Miguel, 207
Santos, Dan, 54, 111
Santos, Liliana, 66
Sanz Cerrada, Jorge, 43, 59
Sanz, Javier, 202-204, 213
Sapone, Patti, 109
Sapp, Darrell, 150
Sarmento de Matos, José, 144, 205, 208-210, 216-217
Saucedo, Alejandro, 60
Savage, Stephen, 134
Saxton, Malanda, 138
Sayão, Marcelo, 102
Scanlon, John, 40, 42
Schaal, Elizabeth, 100
Schaben, Al, 167
Schaffner, Barbara, 97
Scheffler, Axel, 89
Scherman, Tove, 66
Schiller, Bill, 130
Schmid, Paul, 42
Schmid, Thomas, 43, 86
Schmidt, Greg, 115
Schneider, Cody, 104, 107
Schneider, Patrick, 152-153, 241
Schneider, Rob, 124
Schneider, Sandra, 116
Schrader, Steve, 193
Schreurs, Eric, 112

Schroeder, Dennis, 156-157, 242
Schulz, Pauline, 200
Schutz, David L., 42
Schwarz, Glenn, 120
Schwarz, Herman, 58, 147
Sciamarella, Agustín, 128, 135
Scott Ching, Brian, 97, 229, 262
Scott, Chuck, 68
Scott, David, 52, 151
Seabrook, Don, 152
Secco, Adilson, 108
Sedam, Stephen, 105
Sedlar, Patrick, 118
Seidel, John, 121
Seil, Larry, 116, 192
Sell, Dave, 122
Severino, Roberto, 88
Shackelford, Lucy, 198
Shafer, Norm, 57
Shaffer, Mel, 123
Shaffer, Melanie, 68, 123, 218, 221
Shaffer, Meleisa, 56, 94
Shantz, Diane, 107
Shapton, Leanne, 100, 136
Sharpe, Scott, 70
Shaw, Rick, 48, 68, 95, 104, 108, 123, 218, 221
Shaw, Stan, 168
Shayevich, Sergey, 150
Shea, Dan, 39, 1170
Sheldon, Scott, 89, 100, 153
Shelley, Allison, 85
Sherlock, John, 236, 252
Sherman, Merrill, 118
Shield, Helen, 105
Shields, Damian, 218-219
Shiraishi, Tsuki, 85
Shoun, Brenda, 109
Shura, Liz, 262
Siegel, Harris, 46, 55, 59, 63, 104, 107, 116, 122, 136, 191, 228, 233
Sierra, José Luis, 59
Sikes, Bill, 63
Silva, Daniel, 69
Silva, Jorge, 144, 205, 208-210, 216-217, 231
Silva, Rodrigo, 37, 242
Silva, Severano, 57
Simkins, Billy, 45, 222
Simmons, Derek, 115, 124-125
Simmons, John D., 52, 57, 151
Simms, Brian, 42, 50
Simon, Julie, 106
Simon, Meri, 158
Simon, Nina, 43
Simpson, Karen, 219
Sinova, Ana, 187
Sirkia, Jarkko, 92
Sizgoric, Edi, 115
Sizgoric, Viki, 115
Skalij, Wally, 172
Skelding, Laura, 156
Skoglund, Calle, 75

Skoglund, Carl Anders, 90, 114
Slover, Daryn, 72
Smallwood, James, 116
Smith, Andrew, 138, 158
Smith, Elizabeth M., 234
Smith, Emmet, 121
Smith, Erica, 58
Smith, Greg, 69, 138
Smith, John V., 46, 122
Smith, Kevin, 175
Smith, Mark, 221
Smith, Rodney, 172
Smith, Steven G., 117, 156, 160, 162-163, 242
Smith-Rodden, Martin, 241
Sneed, Nicole, 134, 204
Snow, Constance, 100
Solares, Francisco, 45, 47
Sólis, Alejandra, 51, 64
Solís, Javier, 65
Somerville, Ian, 130
Somodevilla, Chip, 243
Soprych, Chris, 86, 190
Sorooshian, Roxanne, 74
Sosa, Federico, 44, 51-52, 57, 69, 86
Soto, Ricardo, 75, 92
Sotomayor, Carlos, 58, 63, 69, 77, 82, 88, 97, 104, 106
Sotomayor, Marco A., 106
Sottardi, Drew, 86
Spencer, David, 242
Spencer, Liese, 209, 218-219
Stanczak, Ray, 94
Stanford, Chris, 52
Stanton, Laura, 60, 244
Stanton, Mike, 42
Starr, Charles, 68, 118
Staublin, Grant C., 39, 148
Steber, Maggie, 149
Steiger, Paul, 251, 255, 262-263
Steiner, Robert, 39
Steinhauser, Rick, 48
Stensrud, Whitney, 68, 112
Stephens, Brendan, 137, 231
Stephenson, David, 50, 168
Steven, Doug, 181
Stewart, Elizabeth, 173
Stivers, Stephanie, 256
Stoelzle, Hal, 161, 242
Stokes, Deborah, 102
Stollorz, Volker, 28, 103, 197
Størksen, Arne, 107
Strachan, Eric, 107
Straker, Matt, 94, 101, 117, 256
Strand, Knut, 107
Strawser, Kris, 70
Strobel, Christine, 58
Stroby, Wally, 198
Strong, Otto, 62
Struth, Thomas, 212
Strzeszkowski, Deborah, 134

Stuenkel, Nancy, 54
Stulce, Corey, 92
Subrannian, Sarmishta, 100
Suils, Mercedes, 187
Sullivan, Kelli, 114
Sullivan, Patrick, 168
Summers, Mark, 142
Sutter, Mike, 94
Suzuki, Lea, 152
Sveningson, Ulf, 82, 86
Svensson, Jörgen, 252
Svensson, Tommy, 69
Swan, Ben, 232
Swenson, Dan, 117
Swisher, Molly, 238
Symonds, Dianna, 50, 57, 111, 120
Sypniewski, Michael, 107
Syrek, David, 218
Syrnick, Susan, 138, 141, 145, 212

T

Tajes, Luis, 66
Talbott, Kerry P., 137
Tapia, José Luis, 64
Tarica, Joe, 44, 56, 94
Tarlofsky, Malcolm, 144
Tavejnhansky, Leo, 102
Tay, Miranda, 100
Taylor, Lesley, 198
Taylor, Mark, 200
Taylor, Nikola Maria, 97
Tedesjö, Eva, 165
Teghammararell, Karin, 103
Tenreiro, Luis, 66
Thamer, Jorge, 47
Thanner, Lisa, 100, 103
Theobald, Marcelo, 61
Theophilopoulos, Makis, 60
Thiede, Ed, 52, 69
Thierry, Martha, 121
Thomas, Steve, 186
Thompson, Mike, 193
Thurfjell, Anna, 93, 116
Tiffet, Christian, 59, 227
Timmons, Susanna, 65
Tirado, David Nateras, 89
Tjernberg, Urban, 116
Tobia, Lisa Zollinger, 138, 141, 145, 212
Todd, Chuck, 138
Tolson, Andrew, 223
Tomasini, Carlos, 106
Toohey, Tannis, 60
Torregrosa, Alberto, 42, 64, 67, 90-91, 93, 111
Torres, Antonio, 93
Torres, Enrique, 63
Torres, Javier, 97, 262
Torres, Nilton, 76
Tortajada, Horacio, 72, 213
Tortosa, M. Dolores, 67
Tovar, Carlos, 48, 263
Tozer, Tom, 51, 57, 115, 122, 152
Trahin, Mayela, 107
Treijs, Erica, 116
Trejo, Martha, 65

Treola, Michael J., 55
Trevino, Jessica, 50, 163-164, 174
Treviño, Martha A., 47, 58-60, 62, 64, 71-72, 80, 84, 91
Tribble, Michael, 51, 115
Triller, Rhonda, 92
Triviño, Alfredo, 67, 93
Trufyn, Jason, 100
Truslow, Hugh K., 183
Tse, Archie, 50, 178, 192
Tuck, Andrew, 201, 221
Tumas, Alejandro, 182, 184, 188, 190, 192-195, 198, 240, 243, 246-247
Turhan, Osman, 257
Turner, Davis, 73
Turner, Fred, 46
Turner, James, 94
Turner, Lane, 95
Turner, Lonnie, 124, 144
Tyree, Chris, 241

U

Uncles, Alison, 44, 54, 67, 69, 223
Unger, Jonas, 75
Urban, Mike, 155
Urdiales, Raúl, 75
Urresti, Cristina, 45, 49, 54, 56, 59, 62-64, 68-69, 98, 105, 107, 249
Utsi Klemmetsen, Fred Ivar, 97

V

Valdés, Fernando, 64
Valenti, Michael, 86
Valentim, Levina, 210
Valenzuela, Hugo, 65
Valenzuela, Karla, 91
Valenzuela, Milagros, 82, 228
Valiño, Alvaro, 186
Valoncini, Marcello, 67-69, 86
van Eerderwijk, Erna, 112
Van Hemmen, Pim, 110
van Overzier, Cas, 112
van Ryn, Aude, 64
Vanden Broeck, Fabricio, 137, 144, 237
Vander Brug, Brian, 148
Varela, Lucas, 182
Vasiliev, Hugo, 210-211, 219
Vazquez, Carlos, 44, 51-52, 57, 67, 69, 86
Vega, Gustavo, 59, 83
Vega, Jezlia, 106
Vega, Omar, 94
Velez, Manny, 255
Veloz, Glenny Elizabeth, 50
Venegas, Camilo, 50
Venne, Michael, 59
Venouziou, Ester, 110
Versiani, Claudio, 53, 66
Vicente, Fernando, 235-236, 239

<< Team leader Michael Whitley prepares for a judging session.

< Stacks of sorted entries await the judges.

Viesselman, Kris, 109, 192
Vignoles, Mary, 107
Villacinda, Luis, 77, 231
Villanueva, Baldomero, 67
Villanueva, Mellania, 93
Villariba, Lynett, 100
Villarreal, Rosa Ma., 76, 85, 104, 106
Villarrocha Ardisa, Vicente, 133
Villegas-Nika, Valentina, 250
Voger, Mark, 136
von Brömssen, Anna, 103
von Randow, Gero, 28, 66, 104
von Rauchhaupt, Ulf, 28, 103, 187

W

Waddell, Kevin, 209, 218-219
Wadden, Ron, 61, 223
Wahlberg, Per, 103
Wahman, Wendy, 136, 234
Waldersten, Jesper, 93, 129, 135, 141
Walker, John, 163
Walker, Kylie, 78
Walker, Richard, 74
Wallace, Dick, 88, 100
Wallace, Donna, 110
Wallace, Tom, 73, 98, 110, 124-125
Walter, Ralph, 154
Walter, Robert, 48
Walters, Brad, 67
Walters, David, 149
Wambold, Jim, 178
Wang, Chin, 80, 95, 101, 224
Warnecke, Ian, 78
Warner, Brianne, 101
Warren, Jim, 129-130, 137, 143-144
Washington, Jeffery, 61
Waters, Susy Pilgrim, 98
Watkins, Rick, 94
Watson, Terry, 250, 254
Weaver, Jim, 52
Webb, Keith, 218
Wegman, William, 204, 212
Weinberger, Peter, 51, 115, 152
Weinstein, Elizabeth, 48
Weiss, Diane, 41, 118, 157, 243
Weissman, Sarah, 86
Wei-Wei, Wang, 78
Welch, Adam, 107
Welsh, Gillian, 219
Welsh, Moira, 69
Wendt, Kevin, 57, 70
Wernhamn, Gunilla, 79, 82, 103
Westerberg, Sara, 65
Whaley, Jason, 55
Whipple, Catherine, 97-98, 170, 225
White, Eric, 54
White, Rodney, 155

Whitley, Michael, 51, 57, 115, 122, 152
Whyte, Kenneth, 44, 50, 54, 57, 61, 67, 69, 100, 102, 111, 114, 120, 136, 142, 160, 163, 223
Widell, Liv, 104
Wigstrand, Kerstin, 57
Wilkinson, Leslie, 51
Williams, Doug, 68
Williams, Greg, 138
Williams, Karen, 51
Williams, Margot, 198
Williams, Sherman, 164
Williams, Tom, 147
Williamson, Cameron, 100, 136
Wilson, Dave, 123
Wilson, David, 149
Wilson, George, 46, 87, 110
Wilson, Jon, 127
Wilson, Paul, 50, 57, 111
Winter, Damon, 158, 240
Wintermans, Julius, 176
Wirsén, Stina, 99, 140
Wise, Michelle D., 80, 85, 225
Wishaw, Liz, 45
Wishna, Robyn, 49
Wisniewski, Leszek, 145
Wister, Sigrun, 219
Withers, J.R., 57
Withey, Deborah, 252
Wittekind, Don, 193
Woike, John, 78, 98
Wojnar, Rose, 50
Wolf, Andrew, 74, 78, 100, 105
Wollemann, Mark, 115, 125
Wong, Dona, 48, 251, 255
Wong, Erick, 224, 226
Wong, Grace, 66
Wood, Stephanie, 94
Woodside, David, 87, 94, 129, 131, 133, 143
Woodward, Tracy, 263
Workman, Michael, 223
Wright, Mandi, 41, 243

Y

Yasukawa, Mitsu, 110
Yazici, Fevzi, 56, 254, 257
Yeager, Kim, 73, 110
Yebra, Yolanda, 55
Young, Steve, 88
Yucel, 95
Yuill, Peter, 86, 90, 95, 101
Yule, Dorothy, 40
Yu-pei, Tu, 81

Z

Zacchino, Narda, 112
Zajakowski, Mike, 97
Zamarripa, Roberto, 65, 108
Zambrano Herrero, Juan Carlos, 56
Zaramella, Juan, 182, 190, 195
Zarracina, Javier, 93, 178, 181, 185-186, 188, 242, 244-245
Zedalis, Joe, 63
Zedek, Dan, 6, 9, 42, 60-62, 64, 80, 82, 86, 94-95, 101, 109-110, 137, 140, 218, 231
Zeff, Joe, 59, 128
Zehr, Jeff, 67
Zertuche, Ramón, 64
Zettermark, Per, 66
Zinkant, Kathrin, 28
Zueck, Christine, 87
Zurowski, Monica, 88

Publications index
Las publicaciones índice

A

Aftonbladet, 40, 42, 61
Age, The, 55, 74, 78, 100, 105, 114, 132
Akron Beacon Journal, The, 48, 236
Album de la Repubblica, 220
Albuquerque Journal, 97
Arizona Daily Star, 8, 74, 150
Arizona Republic, The, 178, 242
Arkansas Democrat-Gazette, 139
Asbury Park Press, 9, 46, 55, 59, 63, 104, 107, 116, 122, 136, 191, 228, 233
Asian Wall Street Journal, The, 94
Augusta Chronicle, The, 62, 91
Austin American-Statesman, 55, 94, 156, 169

B

Ball State Daily News, The, 121
Baltimore Sun, The, 6, 86, 90, 95, 101, 119, 124, 223
Bangor Daily News, 148
Beaver County Times, 35, 120
Bergens Tidende, 80, 84, 97, 107
Boston Globe, The, 5, 9, 42, 44, 54, 60-62, 64, 80, 82, 86, 94-95, 101, 109-110, 137, 140, 143-144, 180, 196, 218, 223-224, 226, 231
Boston Herald, 84
Brabants Dagblad, 72, 112, 176
Bradenton Herald, 98

C

C.A. Diario Panorama, 62, 158
Calgary Herald, 88, 100
Cape Cod Times, 52, 129-130, 137, 144, 152, 166
Caribe, El, 50, 88
Charlotte Observer, The, 51-52, 57, 115, 122, 151-153, 241
Chicago Sun-Times, 54

Chicago Tribune, 82, 86, 94-95, 97-98, 106, 130, 136, 141, 143, 145, 170, 190, 218, 222, 225
Cincinnati Enquirer, The, 180
Clarín, 5, 44, 51-52, 57, 67, 69, 86, 105, 182, 184, 188, 190, 192-195, 198, 210-211, 219, 240, 243, 246-247
Columbus Dispatch, The, 119, 122, 131, 248
Comercio, El, 58, 63, 69, 77, 82, 88, 97, 104, 145, 147, 228, 235
Contra Costa Times, 138
Correio Braziliense, 53, 59, 66, 91
Correo, El, 42, 64, 93, 111, 178, 181, 185-186, 188, 242, 244-246
Correo Espanol, El, 64, 244
Corriere della Sera, 67-69, 86

D

Dagens Naeringsliv, 93, 254
Dagens Nyheter, 57-58, 73-75, 88-90, 93, 99, 101, 114, 129, 132, 135, 140-141, 156, 165, 179, 182, 216
Daily News, 8, 67, 78, 107, 121, 148, 236, 252
Daily Times-Call, 107, 234
Dallas Morning News, The, 6, 95, 123, 140, 158, 173, 240
Democrat and Chronicle, 87
Denver Post, The, 101, 244
Des Moines Register, The, 118, 143, 155
Detroit Free Press, 9, 41, 49-50, 57, 89, 103, 118, 121, 157, 161, 163-164, 167, 174-175, 193, 199, 233, 240, 243
Detroit News, The, 45, 94
Devoir, Le, 59, 227
Dia, O, 42, 44, 57-58, 67
Diario de Hoy, El, 46, 63, 104, 213
Diário de Notícias, 59, 66, 133, 144, 205-206, 208-210, 216-217, 231
Diario de Sevilla, 56, 176, 179, 185, 188, 197
Diario Panorama, 62, 158, 246

E

Eagle-Tribune, The, 150
Eastside Journal, 56
Education Week, 85
Estampa, 220
¡Exito!, 60, 62
Expansión, 207, 209
Expresso, 210, 218

> Radios assist judging-team leaders in organizing their work over three days.

>> David Gray, SND's executive director, copies entry forms of winners as they're submitted to the processing table.

F

Folha de São Paulo, 39, 41, 108
Fort Worth Star-Telegram, 61, 101, 121, 175
Frankfurter Allgemeine Sonntagszeitung, 19, 21, 28, 43, 48, 66, 86, 89, 103-104, 187, 197, 225
Free Lance-Star, The, 63, 73, 88, 92, 107, 228
Fresno Bee, The, 163
Frontera, 99

G

Gazette, The, 9, 102
Globe and Mail, The, 68, 87, 94, 129, 131, 133, 143, 172, 176
Globo, O, 61, 65-66, 102, 128, 140
Göteborgs-Posten, 79, 82, 86, 100, 102-103
Guardian, The, 9, 61, 87, 105-106, 110
Guardian Review, The, 106

H

Hartford Courant, The, 5, 38, 40, 42, 48, 62-63, 68, 71, 76, 78, 82, 90, 94-95, 98, 101, 104, 106, 108, 123, 134, 218, 221, 226, 232, 235, 240
Herald, The, 39, 52, 56, 70, 72, 88, 94, 146, 149, 200, 221, 250
Herald Sun, The, 52, 200
Herald-Journal, 67
Heraldo de Aragon, 45, 49, 54, 56, 59, 62-64, 68-69, 98, 105, 107, 133, 236, 249
Honolulu Advertiser, The, 43, 58

I

Imerissia, 250
Imparcial, El, 8, 66, 91
Independent, The, 11, 13, 32, 38, 44, 56, 61, 68, 90, 94, 101, 117, 201, 221, 232, 256
Independent on Sunday, The, 11, 13, 32, 44, 56, 61, 68, 90, 201, 221, 232
Indianapolis Star, The, 134

J

Jacksonville Journal-Courier, 92
Journal News, The, 118, 139

K

Kristianstadsbladet, 61, 69, 104, 252

L

Lexington Herald-Leader, 42, 50, 58, 168, 256
Liberty Times, 78, 81, 84, 99, 101-102, 106
London Free Press, The, 60
Los Angeles Times, 7-8, 44, 54, 65, 102, 105, 111, 114, 128, 136, 148, 154, 167-168, 172, 211, 258

M

Marca, 187
Metro, 9, 54, 60, 154, 264
Miami Herald, The, 70, 72, 88, 149
Milwaukee Journal Sentinel, 8, 124, 144, 164
Morgenavisen Jyllands-Posten, 74, 105, 143
Mundo, El, 9, 115-116, 196, 201-208, 211-216, 224-226, 229-230, 232, 234, 237-239, 258
Mundo Del Siglo XXI, El, 196, 201, 237-239
Mundo Deportivo, 44, 63, 190
Mundo La Luna, El, 224
Mundo Magazine, El, 202-204, 213
Mundo Metropoli, El, 203, 205, 207, 214-216, 229, 231-232, 234
Mural, 8, 43, 45, 47, 50, 59, 61, 65, 72, 75, 78, 92, 98, 100, 213, 259

N

Nación, La, 58, 93
Naples Daily News, 107
National Post, 44, 50, 54, 57, 61, 67, 69, 100, 102, 111, 114, 120, 136, 142, 160, 163, 219, 223
Nea, Ta, 60, 260
New York Times, The, 5, 9, 33, 50, 52, 55, 66, 83, 86-87, 89, 113, 131-132, 134, 138, 142, 145, 171-174, 177-178, 180, 183, 188, 191-192, 195-196, 204, 207-208, 212, 220, 232, 242, 245, 247
News & Observer, The, 51-52, 57, 70, 88, 115, 122, 151-153, 162, 166
Newsday, 62, 157
Norte, El, 47, 58-60, 62, 64, 71-72, 80, 84, 91, 142, 145
Nueva España, La, 178, 239
NY Teknik, 65, 82

O

Opinión, La, 59, 63, 93
Orange County Register, The, 8, 64, 81, 90, 97, 109, 192, 224, 226
Oregonian, The, 57, 61, 80, 85, 168, 195, 225, 238
Ottawa Citizen, The, 91, 94, 102, 227

P

País, El, 37, 65-67, 128, 135, 235-236, 239, 242
Palabra, 51, 60, 64-65, 70, 83, 88, 98, 103
Palm Beach Post, The, 6, 62, 142, 242
Periódico de Catalunya, El, 159, 183
Periodico Provincia, 59, 83
Philadelphia Daily News, 236, 252
Philadelphia Inquirer Magazine, The, 138, 141, 145, 212
Philippine Daily Inquirer, 100
Pittsburgh Post-Gazette, 6-7, 95, 138, 141, 146, 150, 158, 164, 172, 186
Pittsburgh Tribune-Review, 175
Plain Dealer, The, 5, 7, 40, 54, 57, 65, 87, 89, 98, 100, 108, 132, 134, 147, 153, 156, 162, 168, 173, 189, 195, 233, 241, 244, 260-261
Politiken, 41, 78, 80, 88, 90-91, 99-100, 134, 142, 220
Portland Tribune, 150
Post-Star, The, 92
Poughkeepsie Journal, 116, 192, 194
Prensa Gráfica, La, 46
Prensa Libre, 93
Press Democrat, The, 58, 148, 150
Público, 5, 31, 58, 76, 93, 96-97, 99

R

Récord (México), 14-17, 47, 64, 66, 84, 105
Record, The (Canada), 107
RedEye, 40, 58, 62-63
Reforma, 55, 63, 65, 76, 85, 104, 106, 108, 132, 137, 144, 184, 237
Register-Guard, The, 8, 232, 240
Richmond Times-Dispatch, 137, 175
Rockford Register Star, 97, 229, 262
Rocky Mountain News, 46, 113, 117, 146, 150-152, 155-157, 160-164, 166-167, 242

S

St. Augustine Record, 146
St. Louis Post-Dispatch, 87, 97, 124
St. Paul Pioneer Press, 122-123, 174
St. Petersburg Times, 61, 90, 97, 113, 127, 166
Salt Lake Tribune, The, 199
San Diego Union-Tribune, The, 50, 64, 68, 102, 118, 139, 168
San Francisco Chronicle, 40, 112, 120, 152, 158, 222, 234-235
San Gabriel Valley Tribune, 146, 228
San Jose Mercury News, 53, 57, 67-68, 70, 106, 158, 227
Santa Barbara News-Press, 60
Santa Maria Times, 45, 222
Sarasota Herald-Tribune, 134, 161, 204
Savannah Morning News, 7, 62
Scotland on Sunday, 89, 219
Scotsman Magazine, The, 209, 218-219
Seattle Post-Intelligencer, 106, 135-136, 140-141, 155, 175, 234, 237
Seattle Times, The, 42, 68, 76-77, 79, 90, 99, 109, 112, 130-131, 138, 235
Siglo XXI, 77, 196, 201, 230-231, 237-239, 246
Sol, El, 75, 89
Soleil, Le, 74
South Florida Sun-Sentinel, 8, 46, 49, 72, 87, 110, 193
Spokesman-Review, The, 154, 238
Star Tribune, 6, 52, 73, 98, 110, 115, 124-125, 148
Star-Ledger, The, 76, 104, 109-110, 160, 198, 245
State, The, 5, 7, 107, 121, 189, 234
Style Weekly, 89, 93
Sun Journal, 71-72, 79, 88, 92, 99, 230
Sun News, The, 174
Sunday Herald, 38, 64, 74
Sur, 67, 93
Svenska Dagbladet, 93, 116, 139, 160
Sydsvenska Dagbladet, 112

T

Taipei Times, 78, 81, 84, 88, 92, 99, 101-102, 106
Taloussanomat, 92
Tampa Tribune, The, 101, 138, 158
Telegraph, The, 92
Telegraph Herald, 156
Tiempo, 5, 7, 177, 179, 183
Times of Northwest Indiana, The, 58, 90
Times-Picayune, The, 39, 64, 100, 117, 148, 159-160, 165, 226
Toronto Star, The, 48, 60, 68-69, 130, 154-155, 162, 170-171, 198
Tribune, The, 6, 44, 56-57, 94, 101, 138, 158
Tuscaloosa News, The, 44

U

United Daily News, 78
Upsala Nya Tidning, 60, 66, 104, 218

V

Vanguardia, La, 7, 200, 202
Virginian-Pilot, The, 40, 57, 66, 86-87, 101-102, 126, 130, 142, 233-234, 238, 241
Voz, La, 69, 90-91, 107, 186, 191
Voz de Galicia, La, 69, 186, 191
Voz del Interior, La, 90-91

W

Wall Street Journal, The, 7, 48, 94, 120, 122, 128, 141, 222, 251, 255, 262-263
Washington Post, The, 52-53, 60, 67, 69, 86, 89, 109, 116, 144, 181, 194, 196, 198, 243-244, 247, 259, 263-264
Washington Times, The, 124, 140
Weekend Australian-Review, The, 115, 224
Wenatchee World, The, 147, 152
Wichita Eagle, The, 97, 264
Winnipeg Free Press, 59

Y

York Daily Record, 229

Z

Zaman, The, 56
Zeit, Die, 23, 25, 38, 40, 42, 57, 61, 87, 90, 102, 106, 253